A Dry and Thirsty Land

Eleanor Froiland Andrews

Goose River Press
Waldoboro, Maine

Library of Congress Card Number: 2021948176

ISBN: 978-1-59713-242-8

First Printing, 2021

Cover photo by George H. Tappan, Acacus Arch
Fezzan, Libya.

Published by
Goose River Press
3400 Friendship Road
Waldoboro ME 04572
e-mail: gooseriverpress@roadrunner.com
www.gooseriverpress.com

FOR MOM AND DAD

INTRODUCTION

During the eleven years I taught English at the Oil Companies School in Tripoli, Libya, I wrote letters once a week, sometimes more, to my mother and father, Torger and Gladys Froiland, in Clear Lake, Iowa. They saved every letter I wrote. When I returned to the States, I stored the letters in a box in the attic of my home in Maine. Decades later, they called to me. I knew that along with memories that would warm my heart, I was sure to open wounds that had been a long time healing. First among these is the death of the man with whom I shared these adventures. My husband, Peter Mott Nowell, died in a diving accident in Brazil on November 29, 1983, at the age of 44. We were teaching at Escola Pan Americana in Salvador Bahia, and in addition to the sadness and terror of losing a loving husband in a foreign country, I felt regret for the loss of a teacher rarely encountered. Peter loved life, teaching, and telling stories. He would have loved to tell this one. In the end, as in life, memories of good times and hopes for discovery tipped the scale. I opened the box of letters as one with a newfound treasure.

Acknowledgements

Thank you to my parents, Torger and Gladys Froiland, for encouraging my brother and me from an early age to write letters and save the ones we received for posterity. As much as we depend on and enjoy our telephones, e-mails, Skype, and Zoom, without letters, especially handwritten ones, much of family history goes missing. That is our loss.

Thank you to George H. Tappan for the cover picture of the Acacus Arch and ten years of delightful correspondence.

To Jonathan Tappan, my student at OCS, for reaching out and reconnecting our families after four decades.

To Gray Tappan for his exquisite photographs, help with translating Arabic to English, skill in restoring priceless old photos, and sharing treasured memories of Libya.

To Jim Ebert for organizing Tripoli Reunions in Houston and publishing the *Chicken on Wheels Gazette* for everyone's enjoyment.

To Mary Waldum for coming to the rescue with her invaluable diaries.

To John Monson who at age 96 is always available to answer questions when I call.

To Tom and Doris Mohr for a lifetime of friendship, treasured memories, and outstanding photographs so generously shared.

To my students around the world who have gone on to do great things.

To William Andrews, my husband, my editor, my friend, my everything. We met in Paris in 1963, stayed in touch for a while, then went our separate ways. In 1991 he tracked me down in Stavanger, Norway, 5,135 miles away from his home in San Jose, California. We were married in 1993. But that's another story.

A Dry and Thirsty Land

by

Eleanor Froiland Andrews

"I've heard Tripoli called romantic, and maybe it is. It's a flattish place, bristling with palms like feather dusters; its houses are flat and square, gleaming white against a background of two low hills, with here and there domes and minarets rising from the feather dusters. I know this though; no matter how romantic a city or a village or a house may seem, you'll find some mighty unromantic things if you take the trouble to look beneath the surface."

—Lydia Bailey, Kenneth Roberts

1970

Spring Grove, Minnesota. 1970. I was teaching English and speech at Spring Grove High School, and my husband Peter was finishing his Master's Degree in history at the University of Wisconsin—La Crosse. As spring approached and Peter started looking for jobs, Robert Waldum, director of the Oil Companies School in Tripoli, Libya, came to the campus to interview teaching candidates. At that time, few people in our neck of the woods had even heard of Libya. The exception was my superintendent, Mr. Lewis, who had been stationed at Wheelus Air Force Base and said it was so hot they could fry eggs on the wings of their airplanes. Many recognized "From the halls of Montezuma, to the shores of Tripoli" as the opening lines of the Marine hymn, but that was the extent of it. No one in Spring Grove would seriously consider going to Libya. They were happy in their peaceable little town of 1,290, most with Norwegian blood in their veins. The first Norwegian settlement in Minnesota, some of the store signs were still in Norwegian, and it was not unusual to hear the language spoken on the street.

La Crosse was more cosmopolitan and one might have expected at least a little interest in a job in Libya, but not a single candidate at the University signed up to talk to Mr. Waldum. Libya, as we soon discovered, had just gone through a revolution, King Idris was in exile, and in his place was a young revolutionary named Muammer Gaddafi. In desperation, the placement director pleaded with Peter. "Just talk to Mr. Waldum. He's come all this way. You don't even have to be interested in the job. Just talk to him."

Peter agreed, and from the moment they met, Robert R. Waldum and Peter M. Nowell hit it off like two brown cows. Mr. Waldum needed both a history teacher and an English teacher, so Peter drove the thirty miles back to Spring Grove, picked me up, and by 7:00 p.m., after a full day of teaching, we were seated in a conference room at the student union talking to the founder of the Oil Companies School. Mr. Waldum was tall, blue-eyed, fair-haired, and had a clean Nordic look. He related the events of the

1

September 1, 1969 Coup as calmly as a Lutheran minister, and I remember thinking, "If this man lives in Libya, it can't be too bad." On the conference table in front of us was a copy of *The Ghibli*, an English language newspaper published by expatriates in the community, and a professional looking red and blue OCS yearbook entitled *Ambassador*.

After presenting the school and the country in a favorable light, Mr. Waldum excused himself so Peter and I could talk things over, and when he returned we told him we were interested. He seemed pleased and said he would send us a telegram on the Thursday before Good Friday if we had jobs. He took us out to dinner, and after saying good-bye we drove home past a majestic display of northern lights. When we arrived at our upstairs apartment we spread a map of the world out on the formica kitchen table, and on a section still crisp from lack of use we found Libya. The country looked like something out of my dreams. In my youth I had spent hours perusing hand-me-down *National Geographic* magazines with pictures of the neon glaciers of Alaska, jungles of South America, the white, chilling Antarctic, and the buff-colored sands of the Sahara. I longed to see such places.

True to his word, Mr. Waldum sent a telegram on the appointed day with the good news that we were hired. Two weeks later on April 9, 1970, 12:09 p.m. CST, the official invitation came with an offer of junior high social studies and English positions at base salaries of $8,900 and $9,500. Because I had more years of teaching experience, I got the higher salary. The cable closed with, "Please cable acceptance." We did.

On April 20 we got a letter from Mr. Waldum that served as a guarantee of employment until contracts were in our hands. The letter requested a list of documents that would make the U.S. State Department look like amateurs. We were to send, without delay, originals or excellent reproductions of:

1. Birth Certificate
2. College Diploma
3. Teaching Certificate
4. College Transcript
5. Letter from Chief of Police or Sheriff on letterhead stationary stating that no criminal action had been taken against us in the past

five years.
6. Medical examination letter
7. Alien's Information sheet, including valid passport numbers and other pertinent information
8. Twelve passport size photographs

When received, these documents had to be translated into Arabic, then presented to the Libyan Ministry of Education, Ministry of Immigration, and Ministry of Labor. No individual document could be submitted to the next Ministry until it had been cleared by the previous one. Even then, our contracts would go into effect only if we passed the required physical examination and were cleared by local authorities. With luck, after 2 or 2 1/2 months, we would be granted a visa permitting us to work in Libya.

We were warned that at no time should we attempt to enter Libya on a visa secured by a travel agent. Only the school could secure employment visas and when they did, they would cable the documents to the Libyan Embassy in whichever country we wished to pick them up. Then, and only then, were we to present our passports to the Libyan Embassy of our choice.

We went to work gathering up all of the necessary documents and made an appointment for a physical with Doc Hanson. We went in together, Doc Hanson asked how we felt, and when we said "Fine," he passed us on the strength of our reply. A breast examination was required, so Peter left the room. As I stripped from the waist up, Doc turned his head to one side, shielded his eyes, gave each breast a gentle poke with his index finger, and pronounced me O.K.

We still knew very little about Libya. We knew that diplomatic relations between the U.S. and Libya were tenuous, but Libya still had an embassy in Washington, D.C. We wrote a letter requesting any printed material available and received a pamphlet informing us that Libya had been conquered by every major power in the world including the Phoenicians, Greeks, Romans, Vandals, Byzantines, Normans, Spaniards, Knights of St. John, Turks, and Italians. On the last page of the pamphlet was a recipe for stuffed grape leaves.

Letters from the Oil Companies School informed us that Tripoli was located in the temperate zone and that year round weather was comparable

to that of San Francisco, California. The cost of living, we were told, was generally considered to be high. Recreation was varied and ranged from bowling to Great Books Club. Churches included Baptist, Catholic, Greek Orthodox, Anglican, Interdenominational, and of course, mosques. There were restaurants and cinemas, but most entertaining was done in the home.

As letters from Tripoli continued to arrive at the Spring Grove Post Office, the postmaster got curious. He asked Peter if he was going to Libya, and Peter said, "Yes." Then he asked if I was going too, and Peter, a man with a sense of humor said, "No. She likes it here. She'll probably stay."

We did not have many possessions, but we had to dispose of my 1965 Karmann Ghia and Peter's Volvo P1800, both bright red. I left my Ghia with my parents, and Peter let a friend take over the payments for the Volvo. We moved to my parents home in Clear Lake, Iowa, to save money and prepare for our adventure. We were allowed two suitcases apiece, twenty-two pounds of accompanied excess baggage, and 220 pounds of unaccompanied air freight. We packed clothes, books, and toiletries, and made plane reservations for Washington, D.C., where we hoped to get our visas. My father, who had immigrated to Iowa from Norway in 1929, told us to see everything twice. Once for him, once for us. My Mom didn't really want to let us go, so she came along with us to D.C. to see the sights of the American Capital and hang on to us for as long as possible.

We left on our overseas adventure from the Mason City, Iowa, airport on August 4, 1970. Our first stop was Washington, D.C. where Mom enjoyed sightseeing while Peter and I tracked down the Libyan Embassy. We spent most of the day there and were not encouraged when we left. The exterior of the embassy building appeared ambassadorial enough, all white and columned, but the interior looked as if the movers had just cleared the place out. A massive desk still remained in the center of the main room and beside it, a waste paper basket. On the wall above the fireplace, a large empty white square marked the spot from which the portrait of King Idris, now in exile in Egypt, recently looked down. It had been almost one year since the "Great First of September Revolution" in which Muammer Gaddafi overthrew, in a nearly bloodless coup, the hereditary monarch of Libya. Chairs were scattered throughout the room like afterthoughts, and relaxed young men with shirts open at the collar lounged about ready to

serve. They were friendly, seemed grateful for something to do, and tried their best to get us visas, but after several days of getting nowhere, we were advised to press on to Paris. We booked a flight to Paris, packed our bags, and waved goodbye to Mom as she boarded her flight to Iowa.

In Paris, we found a little room in Montmartre, located the Libyan Embassy, and once again found a staff that tried its best for several days to acquire visas for us without success. We were not too upset. Paris was not a bad place to be stranded. On August 17 we started to get nervous, so we took the advice of the embassy staff in Paris and booked a flight for Rome, our last chance. The magnificent buildings and grounds of the Embassy of the Libyan Arab Republic in Rome were an encouraging sight. We met a couple of other teachers who were trying to get the same visa, and on August 18, the long-awaited, ardently pursued, hard-won piece of paper that said we could enter Libya legally was finally in our hands. The Consular Section issued us a work visa, charged us 3500 lire, and sent us on our way.

The following afternoon we caught a cab to Fiumicino Airport, twenty-six kilometers from the city, and boarded an Alitalia aircraft for Tripoli. We crossed the legendary Mediterranean, and as we approached the African continent, I looked down on endless stretches of rust-colored sand relieved only by a crescent of green along the coast. Cabin attendants gave the usual instructions to fasten seat belts and extinguish cigarettes, and as the pilot put down the flaps, cut back on the power, and began the descent to Tripoli International Airport, Peter took my hand and said, "Congratulations! You just made it to Africa!"

As the last syllable of "Africa" faded, the pilot gunned the engines in a sudden desperate attempt to gain altitude. The ascent was so steep it plastered our backs to our seats. The sudden change of course, we were informed, was occasioned not by hijackers, bombs, politics, or mechanical difficulty, but by cholera. The disease had "broken out" in Libya, and at the last minute our plane was refused permission to land.

Back to Rome we went, not happy this time. We stayed at a hotel close to the airport, got cholera shots, and worried about money. It was low, we had no credit cards, so we cabled Mr. Waldum and asked for an advance.

As it turned out we didn't need it. Friday evening, August 21, 1970, our Alitalia flight landed at Tripoli International Airport. The cholera out-

break was, for the moment, contained. Our shot records had the official stamp of Il Medico di Aeroporto in Rome testifying that we had received cholera shots, so we had no problem getting in.

The terminal in Tripoli was a bullet-riddled World War II hangar. When I stepped out of it, two things struck me. First the heat, reluctantly dropping from the 110° mark reached earlier in the day. The second was the sand. It was everywhere. The fields were sand, the ditches were sand, the roads were ribboned with drifted sand.

We were met by OCS fourth-grade teacher Robert who acted as if arriving in Tripoli was as commonplace as landing in Milwaukee. He hustled our bags into his vintage VW van, got behind the wheel, and chauffeured us into the city. He informed us that it had rained four days in Libya that year.

Since it was dusk, I could see only shadowy outlines of palm trees, verandas, arches, barred windows and shutters, and flat-roofed, square stucco buildings. Strings of bright white lights illuminated vegetable stands along the road. On every corner, it seemed, stood a man in a military uniform. The soldiers wore holsters, all empty.

We stopped first at Robert's villa. He and his wife, Sheryl, had lived in Libya long enough to be established if not downright comfortable. After admiring their home, their paintings of Bedouins and ancient water wells, hand woven rugs, Tunisian pottery, and hand-tooled brass trays, we were served a refreshing fruit salad. I felt reassured that people here ate well and lived comfortably. I couldn't wait to see our new home.

<p style="text-align:center">***</p>

Oil Companies School Villa 12 was located west of Tripoli in a suburb called Giorgimpopoli, just a block and a half off the North African Highway, aka Zavia Road. Our street was one of the older ones in the area. Thirty to forty year old pines and mulberry trees furnished the neighborhood with precious shade. Orange trees, mimosa, acacia, oleander, hibiscus, and bougainvillea spilled over villa walls and cascaded onto the street. The only tree-lined street within a twenty mile radius, it was alternately known as Shady Lane, Lovers Lane, and on occasion, Flashers Paradise. The street was sand.

The villa was a square, flat-roofed, one-story cinder block structure covered with white stucco and trimmed in traditional Mediterranean blue. In spite of the fancy name, the villa was typical middle-class expatriate housing and was surrounded by six-foot walls. The only entrance to the yard was through a creaky wrought iron gate. An uneven red brick sidewalk led to our front door which we opened, stepped into a small foyer, and walked into an L-shaped living room with a fireplace. The walls of the villa were fourteen feet high, and the living room alone was the size of a racquet ball court. Coming from a small upstairs apartment, the place seemed cavernous.

The furniture was a mixture of Early American, Danish Modern, and French Provincial. Drapes of gold satin framed the French windows and a large piece of avocado-green carpet covered part of the white marble floor. The long narrow galley kitchen had an inch-thick gray marble counter top and French doors that opened up to the back yard. Adjacent to the kitchen was a bathroom with the usual conveniences plus an old warhorse of a Sears Kenmore washing machine with a discharge hose that emptied into the bathtub. The villa was completed by a long hallway which opened onto three good-sized bedrooms. Once housing for Italians and ex- patriates, the whole place now had the appearance of a neglected motel. I loved it.

When we arrived on Friday night, I was too excited to sleep, so I wandered from room to room, opened windows, looked out the French doors to the back yard, pulled out drawers, examined cupboards, turned on faucets, tested lights. At last, because it was past my bed time and I supposed I should get some sleep, I went to the back bedroom, already made up by the reception committee, and stretched out on the bed. It was hopeless. I got up and returned to the kitchen to admire the cupboards and drawers all stocked with flatware, blue and white plastic dishes, pots and pans. I opened the refrigerator and was comforted by the sight of bread, butter, eggs, and milk in plastic bags decorated with friendly looking faces of Holstein cows.

I returned to bed, and in the midnight stillness heard a rooster crow and a sheep bleat. I was curious to know who lived on the other side of the walls that surrounded us. Everything was new and different: bed, house, country, continent. As these thoughts rolled around in my head, our bed collapsed. We got up off the floor, turned on the lights, put the thing back

7

together, and tried to get back to sleep. When I finally drifted off, I was awakened by the ring of a telephone. I followed the sound to a black sixties style phone perched on the marble window ledge in the foyer. When I picked it up, it went dead. It was 3:00 a.m.

I didn't know it at the time, but I was being introduced to "I.B.M.", Libya's fundamental operating principle.

"I" stood for "*Inshallah*," or "God willing," as in, "Will the plane be on time?" *Inshallah*.

"B" stood for "*Bukrah*," "Tomorrow," as in "When will the power be back on?" *Bukrah*.

"M" stood for "Malish" and meant "What the heck." "Never mind." "It doesn't matter." "So what." "Forget it." As in "Your son totaled my car." "Your villa flooded while you were on vacation." "Your letter is at the bottom of the mountain of mail at the post office."

Malish. Good night.

<p style="text-align:center">***</p>

Early the next morning, August 23, Robert, our friendly chauffeur, came to our villa with a welcome Libyan £100 advance from the school. One Libyan dinar (LD), also called a pound, equalled 1,000 dirhams. Tens, fives, and ones were the most widely circulating paper currency. Coins, called piastres, came in denominations of 100, 50, 20, 10, 5, and 1. Our advance amounted to about $280.00. We gratefully accepted the money, boarded Robert's trusty VW van and embarked on a tour of the shops on Zavia Road, a strip of the North African highway that stretched from Egypt to Morocco. The only paved road in the area, it was replete with pot holes. There were no street signs, so Americans gave them names like California Street, Grungy Road, and Ha-Ha-Beatcha-To-It-Boulevard. Due to the high walls surrounding the villas, nearly every intersection was blind and one had to slow down, honk to warn oncoming cars, look both ways, and inch on through. Drivers did not use headlights at night, only parking lights.

The shops on Zavia Road were mostly one-story cinder block squares painted in a variety of bright colors. The Blue Shop. The Green Shop. Others were known for a distinguishing physical feature such as the Blue

Awning, the Upstairs Butcher, or the Fat Man's Shop. All shop signs were in Arabic, a requirement that began with the Great September 1 Revolution one year earlier. Most shops retained their pre-revolutionary names: the Sahara Market, the Jolly Shop, the Florist, the Lux, Frozen Foods, Foodland, Sherif's, the Super Market, the Last Resort, the Med Shop, Dabnum Dime Store, even Safeway, no relation to the U.S. grocery chain.

Shops ranged from one room hole-in-the-wall hovels with dirt floors to the rare cool, clean, air-conditioned establishment with plate glass windows, frozen foods, and shopping carts. All had rolling shutters called *ghiblis* that were lowered at closing time. Produce was sometimes left outside overnight where it remained, untouched, until the following morning. Toyota pickups drove up and down Zavia Road making deliveries of fragrant, golden loaves of French bread straight from the oven. The bread was stacked like cordwood on their flatbeds, and if a loaf fell onto the street, it was brushed off and tossed back onto the top of the stack. Malish. The crust was crisp and the inside chewy. The bakers used no preservatives, so the bread was good for one day only. One loaf cost the equivalent of 6¢.

On one corner of Zavia Road, or the "Strip" as some called it, was a newsstand where one could buy the *International Herald Tribune* always at least a day late, as well as *Time, Newsweek*, and other magazines all censored for references to Israel and pictures of women in bras or bathing suits. Next door was a closet-sized shop that sold bright blue canisters of bottled gas for cook stoves. Across the road was a pharmacy where one could walk in, describe the symptoms, get an accurate diagnosis from the pharmacist, and buy prescription drugs right over the counter. Close by was the Danish Shop with teak products for sale at dirt cheap prices and the Russian shop selling alabaster hedgehogs and little carved, hand-painted nesting dolls.

One block off Zavia Road was Dabnum Dime Store, the closest relative to a K-Mart in the area, with hoses, lawn chairs, notebooks, hangers, you-name-it. Two gas stations near our villa, Shell and Esso, sold gas for 37¢ a gallon. A mile or so up the road at the crest of a hill was a post office from which we could send mail and telephone home. Just down the road from our villa was the locally famous Chicken on the Wheels Restaurant which offered gelato in a half dozen pastel flavors, sweet layer cake, and an assortment of entrees. The official name of the restaurant was the Omar

9

Khayam, but since their logo was of a proud chicken riding in a roadster, everyone called it Chicken on Wheels. A fabric shop, a hair dresser, the Sahara Bank, the police station, a prison, and a mental institution, among other buildings, completed the Strip. We had everything within easy reach. Locally grown fruit and vegetables were reasonably priced, and a pound of hamburger was a bargain $1.50, but imported goods were three times the stateside price. Canned goods were available, though not always in good condition. I could get a bargain on a live rabbit or an aubergine, but if I bought Campbell's Soup or SOS pads, our £100 advance wouldn't last long.

Four days after we arrived in Tripoli, we had our first faculty meeting and learned more about the Oil Companies School. Robert R. Waldum, the man who hired us, founded it in 1958 to provide education for the children of oil company personnel and supplier firms working in Tripoli. The campus was situated at the edge of a housing development several miles west of the center of Tripoli. Much of the expatriate population was concentrated in this "suburb" which extended along the Mediterranean coast for a couple of miles and inland for about the same distance. The area was known locally by the Italian name "Giorgimpopoli." In Italian *Giorgio* means "George" and *popoli* means "people," so it could be called "Georgetown." After the revolution the name was officially changed to the Arabic Hai Al-Andalus. Americans called it "GP."

The school consisted of seven single-story rectangular wings and a two-story elementary building. From the air all the buildings combined looked like a giant "L." On the ground, the campus would have looked right at home in Southern California. Each wing had five classrooms, all opening to the outdoors and connected by covered hallways. Off by itself stood a large gymnasium and beside it, an athletic field of sand. A parking lot completed the complex. The whole campus was enclosed by a concrete block wall. As conflicts, misunderstandings, and tensions between Libya and the United States increased, the wall grew higher. The building exteriors were neat, clean, and freshly painted in pale blue. The grounds sported one of the most impressive crops of precious grass in Tripoli.

10

OCS followed the administrative guidelines of a typical American public school with a superintendent, elementary and junior high principals, and a school board comprised of representatives from five major oil companies: Oasis, Occidental, Amoseas, Mobil, and Esso. Mr. Waldum met regularly with the board, anticipated and dealt with problems with the Libyan government, went on annual recruiting trips to the U. S., and kept the school operating smoothly. The decisions of the superintendent were virtually unchallengeable. We were told that staff members who disagreed with an administrative decision were welcome to pack their bags and head for the airport. Their ticket would be waiting.

The school year typically began around the first week of September and continued through the first week of June. The school week consisted of four full days, Monday through Thursday, and a half day, 8:00–12:00 noon on Friday, the Moslem holy day. The school day officially ran from 7:45 a.m. to 3:30 p.m., but students often arrived early and stayed late. The campus was just about the only public place in Libya that the kids could call their own, and they took care of it. Graffiti and vandalism were rare.

Mr. Waldum originally started the school in a villa close by with just a handful of teachers and students, moved to an old school which later became a Libyan school, and finally supervised the construction of the present campus. Under his direction, the National Junior Honor Society, a Youth Center, and a Little League Program were established. The school was generously funded, so he had few financial worries. In just ten years, Mr. Waldum turned a tiny villa into a highly accredited American overseas school.

The opening day of classes this year depended largely on clearance from the Department of Health saying that cholera was no longer a threat. It was impossible to determine if there were actually any cases of cholera in Libya, but we took the matter seriously. We consulted medical journals and learned that cholera is a disease of the gastrointestinal tract usually found in people living in poor socioeconomic or unsanitary conditions. Symptoms were severe dehydration and acute diarrhea. Filth was often the carrier of the disease, and the mortality rate was high if untreated. One thing we knew. We did not want it.

Out of habit, we washed our hands well and often, ate no fresh produce, and washed canned goods before opening them. We boiled our

11

drinking water or treated it with halizone tablets, used purified water to brush our teeth and make ice cubes, and added a drop or two of Clorox to water used for washing dishes, clothes, and bathing. We rinsed our mouths and washed our lips with disinfectant after coming into contact with a crowd. We lived on expensive cans of Franco-American spaghetti bought at Foodland.

Potential spreaders of the disease were flies, commonly known in the ex-pat community as the "Libyan National Bird." Big, black, engorged, rife, indiscriminate, they zeroed in on the eyes and lips of children and held on for dear life. They loved all orifices, lips, nostrils, ears. They swarmed on carcasses of swollen sheep on the sides of the road. They fought for food, latching onto morsels as we popped them into our mouths and attaching themselves to the rims of Pepsi bottles as we took a sip. They dove into our coffee cups just as we were about to drink from them. Their timing was perfect.

Libyan schools closed and so did the beaches until further notice. OCS hoped to open as scheduled on August 28 but would postpone that date if necessary. Even if the disease was only a remote possibility, everyone showed good sense in being cautious. For us the cholera scare was, for the moment at least, mostly an inconvenience. We had to take extra precautions at home and our mobility within the community was restricted, but that was a small price to pay for staying healthy.

The evening before school was scheduled to start, Dot, an elementary teacher, hosted a garden potluck for all the new arrivals. The "old-timers" served us a mouthwatering meal of Sloppy Joes on homemade hamburger buns, coleslaw, potato salad, baked beans, homemade pies, iced tea, and lemonade. It was a taste of home. Just the sight of "American" food whetted our appetites and replenished our souls.

As guests began to line up at the long tables laden with food, the sunset call to prayer erupted from the neighborhood mosque a half block away. Amplified by loud speakers, the blast sent our drinks and potato chips flying. I had heard the call before, but not this loud, not this close. When I asked what the muezzin was saying, someone joked, "I don't know. I think it's 'Mohammed, come to dinner.' " We weren't green enough to believe that, but the timing was perfect and it tickled us. We soon learned that the words are "Allahu akbar. Ashhadu anna la ilahu ill'

Allah. Ashhadu anna Muhammadan rasul Ullah." They mean, "There is no God but Allah and Mohammed is his prophet." For a long time, however, every time a call came from a mosque late in the afternoon I couldn't help but thinking, "Mohammed, come to dinner."

The next morning, as scheduled, the school year began. At 8:00 a.m. on August 28, we all met in the gymnasium, students on the bleachers sizing up the new teachers seated on folding chairs on the gym floor. I had made the mistake of mentioning on my application in the category of "Other Talents" that I played the piano. When Mr. Waldum asked me, I agreed to accompany the assembly in the singing of "The Star Spangled Banner." It was a reckless decision. Suffice it to say I was never asked to play again. It felt strange to be singing our beloved national anthem in a land with little love for the American government.

In general, the faculty seemed like one of the most congenial groups of educators one could hope to work with. A couple of old timers, Keith and Gloria, had been in Libya almost since the school opened its doors. Keith was a baldheaded bustler from Fonda, Iowa, and Gloria a round little Italian from Philadelphia. Both taught sixth grade and in addition to providing stability and continuity to the school, they acted as guides to newcomers who arrived each year. Five years was the average stay for a faculty member at OCS. Keith and Gloria were well beyond that and appeared to be happy in their work.

Students from kindergarten to grade nine seemed for the most part eager, competitive, and polite. The absence of television maximized the opportunities for learning. The only TV available was the local station on which one could watch the reading of the Holy Koran, unremitting reruns of the Great First of September Celebration, the news, a horse show or a camel race, all in Arabic. Students elected to do their homework.

I was pleased with my teaching assignment, ninth grade English. Classes were small. My largest class was eighteen, the smallest thirteen, unheard of at home. The total enrollment in 1970 was 1,100 students, kindergarten through ninth grade, two or three hundred fewer than the year before. The student body was 90% American, many of the students from Texas and Oklahoma. When a young man with a charming Southern accent answered one of my questions with, "Yes, ma'am," I thought he was being a wise guy. In my experience, only impudent teenagers and peo-

13

ple in the movies did that. Later in the afternoon, when I heard the teenager address his own father as "sir," I realized he was sincere. I was pretty sure I was going to like my new job.

After a week in Libya, we started adjusting to our new surroundings. The day began at sunrise with the morning call to prayer from the neighborhood mosque. The cry of the muezzin echoed over the rooftops and set off a chorus of wild dogs and stray cats. The neighbor's rooster crowed and his sheep greeted the dawn with a muted bleat or two. The smell of the sea and burning charcoal drifted through the open bedroom window, aromas both fresh and ancient. Every day brought sunshine and the clear blue sky. The warm, seductive Mediterranean coastline was enhanced by palm trees, villas, Roman ruins, an ancient castle, and an ornate prince's palace. Rusted carcasses of refrigerators, kitchen ranges, air-conditioners, and cars diminished the splendor. They were all easier to dump than to repair. Shaggy, fragrant eucalyptus trees rumored to have been planted by Mussolini lined the road to Homs, a village about 65 miles east of the city. Groves of orange trees and dusty olive trees ripened under the sun. Left over from the days of Italian occupation, colonial farm houses and deserted train stations cropped up at regular intervals along the North African highway. They were unvarying in style and differed only in stages of neglect.

Libyan women were wrapped from head to toe in white sheet-like barracans anchored by perfect white teeth. Only one eye was left uncovered. Their hands and sandaled feet were streaked with henna, and a small indigo tattoo adorned their chins and foreheads. They looked straight ahead and did not loiter.

Young men, dark and proud, walked down the main streets of Tripoli hand in hand, a practice linked to tradition, not sexual orientation. Old men wrapped in wheat colored barracans looked like bearded prophets. They shared hubbly-bubblies and discussed the day's events at sidewalk cafés under the cool, high vaulted passageways in front of the shops on Istiklal, one of the main streets in downtown Tripoli. They sipped tiny glasses of thick, heavily sugared mint tea and small cups of dark sweet espresso.

They did not seem approachable.

The Arabic language sounded harsh to me. When I first heard Libyans speaking, I thought they were perpetually angry with one another. Heavy emphasis on consonants, especially the letter "k", produced by a deep throat-clearing sound, came across as harsh, raspy, and a little juicy. "Kaif halak? Kuwais kateer. Kaif halak enta? Bahee. Kuwais. Al Hamdoolillah," sounded threatening to me, but it only meant, "Good morning. How are you? Good. Praise be to Allah. And you?"

Five times a day the haunting, plangent call from the mosque summoned the faithful to prayer. Devout Moslems stopped what they were doing, faced Mecca, and prayed to Allah. Even truck drivers pulled their Calabresi and Mitsubishi trucks off the highway, spread their prayer rugs out on the ground, and knelt in prayer beside the road.

Thursday was wedding day in Libya. On Thursday nights shortly after dusk, the sound of automobile horns honking in celebration filled the air. It was a joyous sound, spontaneous, ecstatic, proclaiming the marriage of, one would hope, a happy bride and groom.

On Gold Street, small shop windows gleamed with 18-carat-gold necklaces, bracelets, and earrings. In the covered souk, rug dealers sat cross-legged in little cubicles ready to serve tea and roll out carpets for prospective buyers. Copper Alley rang with the hammering of coppersmiths, their fires blackening the floors of the shops and filling the air with greasy smoke. On Friday, the Moslem holy day, all was quiet.

I learned early on to check what I was wearing before I went out my front door. Western women who wore shorts and halter tops were always ogled, often pinched, and sometimes spit upon by Libyan men. By edict of the Grand Mufti in 1970, women wearing miniskirts in downtown Tripoli would have their legs spray-painted red.

Rumors were rampant. Gaddafi had three wives. Abdul Salam Jalloud, Gaddafi's second in command, was a womanizer. Americans were going to be evacuated. Our school was going to be closed.

Though not yet afflicted, I learned about "Tripoli Trots," a common malady among foreigners brought on by different foods, change of weather, questionable water, or a weak constitution. One day while I was riding the bus to the Teen Club, a private beach and clubhouse for the students and staff of OCS, I heard myself referred to as an "expatriate" for the first

time. The word simply means "one who takes up residence outside of his native country," but it seemed to separate me from my homeland and question my allegiance. I did not like the sound of it.

Colleagues and friends who had lived in Libya for a year or more tried their best to help us, the newcomers, settle into new, unfamiliar surroundings. Within a week our trunks were delivered to the school, and we were both surprised and pleased that customs officials didn't bother to go through them. We opened a bank account at the Sahara Bank on Zavia Road and bought a car, a dull gray 1966 four-door Fiat sedan. Our next door neighbor led us to it and assured us that the previous owner had babied it, so we took his word that would be in good condition. We paid about $800 for the car, not bad considering that a brand new Volkswagen beetle with nothing on it, not even a gas gauge, cost well over $2,000. We had no experience with Fiats and hoped we wouldn't be disappointed. We named our car Freddie.

People visited one another more often in Tripoli than they did back home. They threw dinner parties, organized beach outings, had pot luck dinners, dessert evenings, and garden parties. One of our first evenings there, veteran teachers organized a Scavenger Hunt to acquaint rookies with various landmarks in the area. Armed with maps and clues, we embarked on a mission to find the Old Castle, the Gazelle Fountain, the Marcus Aurelius Arch, the Cathedral, the Karamanli Mosque, the American Embassy, the Royal Palace, and the Uaddan Hotel. Our team did not win, but we had a great time and were introduced to places we would come to know well in future years.

A few days after the Great First of September Revolution celebration, several female colleagues and I went to Ladies' Day at the Tripoli International Fair. The Fair originated in the late 1920s and was reputed to be the oldest trade fair in the Arab world. It provided foreign companies and artists an opportunity to display and sell their products. We viewed the exhibits from African nations including Chad where we saw sand-cast brass figures made from melted-down shell casings left behind after World War II. We bought gazelles, elephants, giraffes, deer, and precious little

donkeys. As we wandered through the exhibits, we suddenly felt a of a stir of excitement around us. Gaddafi was about to exit one of the pavilions. We waited outside with a cluster of other ladies and caught a glimpse of him as he came out flashing a smile. He was wearing a pale green western style suit and had great teeth. He did not stop to talk to us.

By the second week of September, the temperature dropped a bit, never over 100°F during the day and cool in the evenings. I was slowly getting adjusted to a climate that came with a reputation. The highest recorded shade temperature in the world was generally accepted to be 136.4 degrees recorded in Azazia, Libya, on September 13, 1922. For years meteorologists had questioned the instruments used in Azazia, the qualifications of the untrained observers, and considerably different weather observations in the surrounding area. Ninety years after the Azazia temperature was recorded it was debunked, and the World Meteorological Organization awarded the dubious honor to Furnace Creek Ranch in Death Valley, California, with a record 134 degrees recorded on July 10, 1913. To me, anything over 80° was hot, and since we had no air-conditioning, I was thankful to have the Mediterranean nearby to help me cool off. On the bright side, I found I did not have to worry about drying clothes. Most garments on the line were dry in fifteen minutes.

We were getting so comfortable and settled in our new home that we decided to adopt a puppy from teachers whose dog had just had a litter. She was a black poodle-Maltese terrier mix, six weeks old and not yet house-trained. We named her Josephine. Since we had room to spare in our villa, she had a whole bedroom to herself. If we had not taken her, she would probably have been euthanized. It was pitiful to see the wild cats and dogs roaming the streets in Giorgimpopoli. When they woke up at 5:30 in the morning, cats thundered over the roof and dogs raided the garbage cans for food. The whole neighborhood sounded like a kennel gone berserk and every trash can on the street was tipped over. Later in the day, a little Tunisian with a donkey and cart came along to clean up the mess.

Within a month of our arrival in Libya, we took the first of many trips to Sabratha, one of three ancient Roman cities that gave birth to the name

Tripolitania, or land of three cities. The other two were Oea, present day Tripoli, and Leptis Magna. After a forty-five mile drive west, we pulled into a parking lot near the ruins and got out of the car. We saw no one, and the only sounds we heard were the buzzing of bees harvesting honeysuckle nectar and the braying of a donkey standing under a dusty olive tree in a nearby field. We found no attendants, no admission fee, no vendors hawking guidebooks and postcards, no weenie-wagons. We had a whole ancient Roman city to ourselves.

At the time, Sabratha's ruins were about 90% excavated, mostly by Italians between 1923–1936. Houses and shops had been built with local limestone, but more important buildings were constructed from marble and granite brought in from Italy, Greece, and Egypt. The most notable of these was the theater, a magnificent structure of hewn sandstone built in the 2nd Century A.D. Its most remarkable feature was a stage with a backdrop of three tiers of red granite columns. It is thought to be the best surviving theater of its kind in the world. The stage of the theater was restored and still used for plays, operas, and folk dances. I walked onto the stage, turned my back to my friends in the audience, and said "Hello." My voice carried up over the stone seats to the very top row of the theater.

Roman audiences were not known for elevated tastes in entertainment. They would most likely have watched a comedy or farce, a spoof on Zeus and Hera, a schoolmaster trying to get his students to pay attention, klutzy servants dropping dishes, romances, dances, or mimes. Musicians still played concerts on stage during our stay in Libya, and audiences still gathered to watch plays and Libyan folk dances. The theater could seat 5,000. Even as we left, I looked forward to returning to Sabratha. I made a mental note to bring a cushion to put on the stone seats if we were lucky enough to attend a performance.

On September 18 we got bad news. The Oil Companies School was officially closed. Cholera had once again raised its ugly head. In the interests of national health, all schools in Tripoli were shut down for two weeks, possibly a month. We had just gotten our courses launched, so no one was happy, not even the students. Since we had taught for only fifteen

days, rumor had it that we would have to work one Saturday a month and lose our Easter vacation to make up for lost time.

A couple of nights after we got the news of our unscheduled holiday, thirty-five faculty members decided to prepare a favorite dish and get together for a potluck supper and moral support. I had done little more than open a can since my arrival, but I had my recipes with me, and when I browsed through them, my eye stopped on Frostie Chocolate pie, a favorite recipe from home. Looking through the ingredients, I was fairly certain I had seen milk chocolate flavored frosting mix, corn syrup, and nuts on the grocery shelves, but I wasn't certain about whipping cream. When I went to Sherif's, I spotted unrefrigerated pyramid-shaped paper cartons of cream imported from Scotland. I bought a carton, took it home, and when I cut it open, I found the contents separated and sour looking. I took a tiny taste and to my surprise, it was good. It was thicker than Iowa cream, much like pudding, so I used it. Since it was my first effort with different ingredients, I was apprehensive about the results, but in the end I was pleased. Not a crumb was left.

With a possible month on our hands, we decided to take a week to work on our villa. We got a kerosene heater installed for warmth during winter. The school's head painter Salah, who painted exclusively with a brush, painted all the rooms in the villa except for the bedrooms and hall. I took down all the curtains and drapes, washed them, and made valences. I put a skating rink shine on the marble floors, washed the windows, replaced screens, weeded and seeded the yard, finished unpacking and got caught up on the ironing. I organized cupboards, closets, and drawers. The villa was in pretty good shape when we moved in, but I had to put my touch on everything. When we finished, the place felt truly mine.

I did the same for my classroom. I inventoried books, started a filing system, wrote lesson plans, put up a bulletin board, arranged chairs, organized my desk, washed the black board, beat the erasers, and vacuumed sand from the bookshelves and floor. Everything was in order. The persistent heat was alleviated by three days of rain, rare for September. It woke me up about 5:30 in the morning, and when I heard Josephine crying, I got up to let her in. Josephine preferred sleeping outside on the patio in her basket. She had her own soft blankie and was protected from sand and wind by a roof and walls on three sides. This morning was her first

19

encounter with rain, and it frightened her. I comforted her, dried her off with a towel, and put her back to bed in her room.

On the good side, the rain washed off trees and buildings and made everything look fresh and clean. On the bad side, downtown Tripoli was flooded, and the sand streets were full of wadis, or deep crevices. Drivers who got a tire hung up in one of them were hopelessly stuck. I observed that the Libyans never drove through standing water. They drove around it. When the water drained off, the reason was obvious. Some wadis were large enough to swallow a pickup truck. We were warned early on never to camp in a wadi. Flocks, tents and the people camped in them could be washed away in an instant.

My work finished, I decided I might as well enjoy our holiday, so one day I picked up three friends and took Freddie on an outing to the Teen Club. It was located on Zavia Road, kilometer 6, just past the Shell station in Gargaresh, and as we approached the beach, I accidentally drifted off the beaten path and got pitifully stuck in loose sand. My friends got out and pushed while I rocked Freddie back and forth, but the more I spun the wheels, the worse it got. Since calling AAA was not an option, my friends and I looked to the resources at hand. We found two weathered planks and positioned them in front of Freddie's back wheels to act as a sort of ramp. With three ladies pushing as hard as they could, Freddie advanced a measly ten feet. That was better than nothing, so we replaced the boards and started all over again. After thirty minutes we finally managed to get back onto the beaten path. We were covered with sand and ready for a swim, so we left Freddie in the parking lot and washed off our cares and woes in the clear soothing waters of the Mediterranean.

We had our cameras and were anxious to take pictures of our new surroundings and send them home, but later we were advised to send the film home and ask our families to develop the photos. Arabs, we were told, were fussy about getting their pictures taken. Some thought that a picture captured the soul. It was best to photograph scenery and buildings, not people.

Our villa and classrooms were in good order and we still had time on

our hands, so we picked a day to go back to Sabratha. This time we decided to take snorkels and flippers to see if we could locate a part of the city that we heard was underwater. Research about Sabratha informed us that it was first established as a port by the Phoenicians, one of several they planted along the sometimes treacherous North African coast. It provided a rest stop for traders in need of shelter, provisions, and repairs. Since the Phoenicians were more interested in commerce than in colonies, they left few remains. The Romans arrived at the end of 1 B.C. and turned Sabratha into a thriving market and trade center. Expanding south and east, they laid the city out in what archeological evidence shows is typical Roman rectangular fashion. The street layout remains unchanged, but the surfaces are worn and rutted and bordered by the uneven remains of foundations of houses and shops. Today, once again, we walked these streets alone.

Arches and columns, some standing, some lying where they fell centuries ago, protruded through drifts of fine sand. Underwater aqueducts, canals, and earthenware pipes stood exposed for easy viewing. They led to reservoirs where rain water was stored for later distribution to buildings and baths. Remnants of mosaics dotted the floors of the public baths. Latrines stood in rows, ready for use. Of course, we had to have our picture taken sitting on them.

The most beautiful mosaic I had ever seen, the Ocean Mosaic, stood on a wall in a small onsite museum. It was a portrait in a hexagon frame of the head of Neptune looking as if he had just risen out of the sea, all misty and magnificent. His eyes were focused on an object on his right, and his hair and beard looked like wispy seaweed in opalescent grays, delicate pinks, and smoky blues. It took my breath away.

It was easy to imagine the empty markets full of merchants selling grain, fish, olive oil, even ivory transported all the way from Central Africa through Ghadames and the Fezzan. Centuries had worn the paint off the buildings and left soft sandstone surfaces. The theater, especially, was an exquisite sight against the sapphire blue of the sea and the sky.

From a distance, we saw something shiny and black in the harbor area, and when we went down to investigate, we discovered a beached whale. The stench was overpowering, so we decided to leave exploring underwater cities for another day.

It was nearly the end of September and the prospects for school open-ing were not great, so we decided to take a trip to Tunisia with two other couples—if we could get the proper visas. Driving from Libya to Tunisia was not like driving from Iowa to Wisconsin. We had to get exit/re-entry visas to travel outside of the country, a requirement involving time, bureaucracy, and luck. We submitted our passports to the business office at school where Hafid, the government relations man, picked them up and delivered them to the Libyan Arab Republic Passports and Aliens Department. For a fee, they stamped a full page in our passports stating that we had permission to exit Libya and re-enter within a specified period of time. The visas could be obtained quickly in emergencies; otherwise, they took an unpredictable length of time. One never knew, so it was wise to get passports submitted well in advance of the travel date. This trip was on rather short notice. We would travel in two cars so in case one had trou-ble we wouldn't all be stranded along the North African Highway. We planned to be gone for a week, and when we got home we hoped to get the word that school would reopen.

Hafid got our visas on time and we embarked on the first of many crossings from Libya to Tunisia, none of them smooth. When we arrived at the Libyan border we got out of the car and walked past a long line of cars into a crowded border outpost with gritty floors, grimy windows, and irascible officers. Mobs of travelers in long white robes called *jalabiyas* held their passports high and strained together towards the closest window to have their passports stamped. It was plain to see that the length of time needed to clear passport control depended on the number of travelers and the mood of the officers. On this day, it seemed to take forever.

Once this hurdle was overcome, our cars were cleared to drive the short distance of No Man's Land between the two countries and go through the same ordeal on the Tunisian side. This time, the ladies of the company took the passports in, and we were processed immediately. Western women in a crowd of Arabs sometimes got groped and pinched, so border patrol officers cleared them as quickly as possible. We resolved to do this from now on.

When we crossed the border into Tunisia, the atmosphere was trans-

formed. We relaxed. People appeared friendly and fun-loving, and children waved and smiled as we drove by. Through the open windows and doors of stucco farmhouses we could see the shadows of a cozy fire flickering against the walls. The houses did not have electricity.

At twilight, we reached the mile-long causeway to the island of Djerba, our destination. The wheels of the car dug into the blacktop, still warm and doughy from a day of baking in the sun. On either side of the causeway, fishing boats drifted on the still, smooth water. Empty lobster traps stood lined up along the banks, and a lonely domed marabout's tomb seemed to sink into the evening sky as we drove by. Squat palms and soft white sand bordered the road on either side.

According to legend, this was the Land of the Lotus Eaters. Weary and hungry after leaving Troy and being tossed about on stormy seas for nine days, Ulysses and his crew landed on these shores to a warm welcome and a feast of lotus blossoms. Those who ate of the flowers forgot the past and wanted to stay in this enchanted land. Ulysses had to drag his crew back to the ship and put them in chains to keep them there. They wanted to stay so badly they cried, and the taste of the sweet flowers stayed with them forever.

We found rooms in the sparkling new Hotel Meninx located right on the Mediterranean coast. We had a swimming pool, white sand beach, palm trees, sunshine, and blue skies, all for $7.00 a day, meals included. We hit the sack early after a long day's drive and the next morning went to Houmt Souk to shop for rugs, pottery, donkey saddles, wrought iron sconces, candle holders, and trivets. In the afternoon we enjoyed a drink and fresh fried potato chips at the Ulysses Hotel. That evening after dinner we listened to the band at our hotel and danced to "Sugar, Sugar," "Yellow River," and "Strangers in the Night." The weather was perfect, 80s during the day and 60s at night. We were in heaven.

The next morning, September 28, 1970, I had my first camel ride. To get the beast going, I had to say, "Zurrr, Zurr." As I rocked in the saddle surveying the landscape, I noticed the Tunisians walking along the road with transistor radios glued to their ears. When my ride was over, the camel lurched to his knees to let me off, and I heard news as jarring as the dismount. Gamal Abdel Nasser was dead. He had suffered a heart attack and died several hours later. He was only 52. In my mind, he was a giant,

the king pin of the whole Middle East. After the 1967 War, I wondered just how much more the Middle East could be destabilized. Now this had happened. The Tunisians were inconsolable. Nasser gave the Arab people a sense of dignity and pride. When the Middle East became a snake pit, he could control it. Who would do that now?

It was a good thing we took two cars to Tunisia. On the way back to Tripoli, Freddie the Fiat made it as far as the Tunisian border and there, on the barren frontier, the water pump died. We pushed him across the hot stretch of No Man's Land, then rolled him onto the shoulder of the road when we reached the Libyan side. The guys stayed with Freddie, wiping sweat and swatting flies while the ladies drove back to Tripoli to get someone to tow the car back.

First we went to the school, but it was deserted, so on we went to Spiro's villa where we found him just sitting down to Helen's every day a gourmet Greek dinner. We told him the guys were stranded on the Libyan-Tunisian border, and without saying a word or taking a bite, he stood up, folded his napkin, grabbed his hat and keys, and went to the school to get a vehicle that could tow Freddie back. I went home, and Josephine, who had been staying with our neighbors, greeted me with many licks on the ear. It was good to return to a happy face. As expected, the men returned at midnight safe and sound. Freddie's water pump problem was confirmed, and since it was an integral part of the engine, it cost $60.00 to replace. We calculated that it was 7.5% of the original price of the car. Spiro's act of kindness was free.

Like Ulysses' crew, I longed to stay in the Land of the Lotus Eaters, but we had work to do. Everyone was hoping to go back to school on October 5, but there was a strong possibility that we wouldn't be able to return until the 19th. That would make the rest of the year extremely pressured. If we didn't open on the 5th, the faculty planned to go to school every Monday and give out weekly assignments until we could meet our classes again.

Though we had worked only fifteen days, we still got paid and were pleased to discover that had enough money to live on for a month, take a

trip to Djerba, and bank nearly $1,000.00. Not bad, considering that in Spring Grove we had to turn in our empty Coke bottles at the end of every month to buy a pound of hamburger at Bob Bunge's IGA. We were allowed to send 90% of our salary out of the country, though most people we knew were never able to do that. We sent our savings back to the U.S. in drafts from the Sahara Bank. We were advised not to send them as registered mail since those were the envelopes that were most often opened and examined by Libyan postal workers. We put the bank drafts in plain airmail envelopes, addressed them to my parents in Clear Lake, Iowa, and prayed to God they would get there safely. My parents took the drafts to Clear Lake Bank & Trust and deposited them in an account that I had opened when I was eight years old, so young I could barely see the teller. In the eleven years we sent bank drafts home, we had only one mixup which turned out to be our fault. It was eventually straightened out.

We were also advised that getting packages into the country from home was uncertain, so we told our parents not to send us anything. Sometimes postal employees took things they admired. Other times customs charged more than the item was worth. In spite of this, my Mother could not resist sending me a birthday present, a dress which I received three weeks after my birthday and for which I paid 66 piastres duty, about $2.00. It fit perfectly, and I was glad to get it.

<center>***</center>

After my success with Frostie Chocolate pie, I woke up one morning and decided to try making hamburger buns. When I looked at the recipe, I knew immediately I was in trouble. It called for a package of dry yeast, and the only yeast I had found locally was in a 4-ounce can from France. I had no idea how many ounces were in the little yellow, blue, and red packages of Fleischmann's yeast that I used at home. Thus began my education in adjusting to ingredients locally available, to kilos instead of pounds, grams, liters, milliliters, deciliters, and all things metric.

After finding out in a letter from my Mom that each packet of Fleischmann's yeast contained 1/4 ounce, about 2 1/4 teaspoons, I made my hamburger buns and was pleased with the results. I continued my baking experiments by making a couple of cheesecakes. Success again. The

<center>25</center>

ingredients were so different in my new surroundings that I never knew how things were going to turn out. The flour was heavy and unrefined, the salt and sugar coarse. To avoid salt and sugar crystals in cookies, I softened them both for a while in shortening or liquid. Fresh milk was packaged in plastic bags and seldom available. I had to use yogurt instead of sour cream in my cheesecakes, apparently a good substitute. I was getting the hang of things.

Shopping for food in Libya became a second job, and in the beginning was not altogether unpleasant. In some ways, it was like a scavenger hunt. We had no supermarkets with orderly displays of bakery, deli, produce, fish, meat, dairy, pharmacy. No one-stop shopping. Our quest for food took us to many little shops. A typical native shop, one that didn't cater to expatriates, was a flat-roofed, single story stucco cubicle with a low doorway leading into a cramped, dark interior. Inside, bare light bulbs exposed a floor that hadn't come into contact with a broom recently and aisles so narrow one could hardly turn around. Shelves were lined with tomato paste, olive oil, tuna, harissa, tea, canned milk, and soap powder. Canned goods were sometimes scratched or dented and cost three times as much we paid for them at home. At dusk, strings of festive white lights outside the shop glistened onto wooden crates and burlap bags full of parsley, tomatoes, carrots, and oranges, all rinsed with water from a hose and cooled down from the heat of the day. When Libyans stopped on their way home from work to shop for their evening meal, the atmosphere was festive.

After an eighteen-day hiatus from classes, the Oil Companies School opened its doors again on October 6 to all grades but kindergarten through grade three. The little ones were still considered at risk. To make up for lost time, we would have eight half-days of classes on Saturdays, one per month, and lose four days of Easter Vacation. If we didn't have any more setbacks, that seemed reasonable. Students and teachers alike were glad to be back in business.

As incoming faculty members, it did not take us long to determine that Bob Waldum had high expectations for his teachers. In addition to being in our classrooms on time every day and teaching to the best of our ability,

we were expected to assume extra duties as required. Not written but understood was attendance at all school sponsored events: dances, plays, concerts, graduation. If we did not show up, our careers at OCS would probably be over before they got a good start.

The dress code for faculty at OCS was fairly strict. Skirts were required for women and ties for men. Bob Waldum set the example by wearing impeccable suits during the day and golf shirts or Pat Boone-style sweaters for casual functions in the evening. In hot weather, he preferred short-sleeved white shirts for work, but rain or shine, he wore a tie. He expected the same from the male faculty members.

Organized protests were not tolerated at the Oil Companies School. Faculty members who strongly protested the requirements were offered an all expense paid ticket home. OCS was a relatively smooth running institution that had come through some challenging hurdles, and if teachers didn't like their circumstances, they were welcome to look for some place more suitable. OCS was for those who were satisfied with their situation or for those who could adapt without compromising too many of their principles. We did not foresee any problems.

When school resumed, we still had 80° temperatures during the day, but nights and early mornings were chilly. A mild strain of flu started circulating. One trip to the bathroom to throw up and it was all over. According to the Libyans, it came with the change of weather. We started to wear light winter clothes during the day and jackets at night, lit the space heater in our villa, and started to learn how to deal with the ever-present sand. I wore contacts, so when the wind came up I went snake-eyed to keep the grit out of my eyes. To keep it out of my sandals, I scrunched my toes up and stepped high so my foot came to rest on top of the sand, not in it. I always tapped the front of my shoes on the doorstep before entering the villa so I didn't drag the stuff inside. About this time, we had our second cholera shots. The old timers warned us to make sure the needles had not been used. Of course, they weren't. As far as we knew, no cases of cholera in the community had been confirmed.

Our sweet Josephine had grown large enough by this time to enjoy playing in the yard. She particularly enjoyed pulling all the clothes off my line, but when she started doing it twice a week, she was in the dog house. Pets became part of our families and were even included in birthday par-

ties. Fifth grade teacher Gloria, a single woman from Philadelphia, sent us an invitation to a party for her Great Dane, Skipper. We all brought presents and laughed as they were opened. Skipper tolerated us for Gloria's sake, but was just as happy to see us leave. Skipper loved anyone who loved Gloria. He went everywhere with her, proud passenger in the front seat of her VW bug. Just his size sent a message to anyone who even thought of bothering her. Don't mess with this lady.

Now that school was in full session and the cholera scare had subsided, life seemed almost normal again. Our school day began at 7:45 a.m. and ended at 3:30 p.m. The upper grades started the day with a half-hour home room to hear the announcements and participate in extracurricular activities. The day continued with seven 45-minute class periods and a 40-minute break for lunch. Students brought their lunch from home and ate in their homerooms. They could buy a cold Pepsi from the "Pepsi Boys" for 5 piastres a bottle, about 15¢. Pepsi in Libya was extra sweet to accommodate the local taste. Fanta orange was a second choice, also seriously sweet. Students always scrutinized their bottles before drinking. They regularly found little extras floating in them such as a cigarette filter or a dehydrated mouse. I gave up soft drinks entirely at this point and drank only liquids I could see through.

We had the usual school rules. No smoking on campus, near campus grounds, or on field trips. No drugs. No early dismissal. While this was the official policy, little could be done if parents decided to pull their children out early for the summer or for vacations throughout the year. This resulted in a lot of material missed by the student and extra work for the teacher. Most teachers ran a tight ship. They called students out for things might overlook in a public school at home. Teachers were identified by their favorite sayings: "Are we awake?" "Don't you have any work to do?" "You're skating on thin ice." "Is your notebook open, and do you have two pens?" "You guys are of an above average intelligence. You're supposed to know this stuff!" "Cover your papers, please." "Get the banana out of your ear." "I'll throw you through the roof!" That one was Peter's. "Can you handle it?" That was mine.

Ever since our arrival in Libya, we had heard about the wonders of another ancient Roman city about eighty miles east of Tripoli, Leptis Magna. On Saturday, October 10, fifteen OCS faculty members took a trip to the magnificent Leptis, 250 acres of cobbled streets, triumphal arches, columns, markets, forums, baths, basilicas, temples, palestra, light house, theater, circus, and amphitheater. In its day, the city was second only to Rome. Forty to fifty thousand people lived there at one time. The Roman Emperor Septimius Severus was born there in A.D.146. As in Sabratha, we had the whole place to ourselves.

The buildings were of hard limestone and originally covered with sheets of multicolored marble imported from Italy and Greece. Whatever remained of the marble now rested on the ground. On the walls were holes for the brackets that once held the slabs in place. Giant monoliths of granite from Egypt slept half-buried in the sand. One could only wonder how many more fabulous treasures lay beneath it.

The main artery of Leptis was a wide colonnaded street flanked on both sides by stately columns and leading to structures in varying stages of ruin. The market still stood, two circular kiosks with tall arched openings and broad sills that once displayed linen and cotton, leather, perhaps spices from India. Wheat, millet, vegetables, dates, olive oil, and wine would have been sold here. One of the counters had deep knife grooves left by butchers and fishmongers. On one counter, the marks of standard measures were still clearly visible.

Continuing down the street we passed a dozen carved heads of Medusa, an oversized carved phallus announcing the Street of Prostitutes, and public toilets with marble seats arranged in a most sociable manner. Some of the baths showed evidence of a central heating system.

The theater was not as impressive as the one at Sabratha, and the amphitheater, built into a former quarry, was an incredible jumble of rocks. The Hunters' Baths, on the other hand, were almost perfectly preserved after being covered with sand for centuries. It was a lovely vaulted, domed structure with paintings on the interior walls of hunters, leopards, and Barbary lions which once roamed Libya. A small brown viper was the only other visitor that day, and since it was coiled and looked ready to strike

from one of the window openings, we left the interior quickly and quietly. Sad to say, recent visitors to Leptis report that the baths are once again covered with sand. No one would even know they had been there.

The traditional founding of Leptis Magna was between 9–7 B.C. Phoenicians, Romans, Byzantines, and Vandals can be traced in its ruins. The basilicas were converted into churches during the reign of Justinian. The day we visited, the large baptismal font was full of water from recent rains.

When the Roman Empire collapsed, Leptis went with it. Irrigation was neglected, tribes from the interior invaded, and Vandals demolished the walls. In A.D. 365 a great earthquake toppled many buildings, and in time the all-embracing sand buried the city for centuries. A great deal of plundering occurred during the 16th-18th centuries. Columns and slabs of marble were used in the construction of mosques. Louis XIV appropriated columns and statues for use in the construction of Versailles. Windsor Palace, The Louvre, and the Chapel of St. John in Malta all contain the riches of Leptis Magna.

Some say one-half of the ruins of Leptis Magna have been excavated; others say one-tenth. Most say it is the best preserved ancient Roman city in the world. Already we could see that Sabratha and Leptis would forever diminish visits to more popular and accessible archeological sites. Why go to Rome and fight the crowds when we could have Leptis Magna all to ourselves?

<div align="center">***</div>

As promised, Bob Waldum called his faculty in to work on Saturday morning, October 24. It wasn't a particular hardship, but we felt the effect of the extra half day when we went back to work Monday morning. I was starting to feel at home in my classroom, Room 3, end of the hall, first wing to the right upon entering the campus. The room was approximately 20' x 20', and not unlike a stateside classroom. I had a blackboard on one of my universal green walls, and on the opposite wall a bulletin board that I decorated before classes started in the fall and left up for the rest of the year. A third wall was almost all plate glass windows, and near the ceiling on the remaining wall facing the corridor were small rectangular windows

that could be cranked open but were impossible to close completely, an open invitation to blowing sand. I had two large bookcases, a teacher's desk, and a chair that I appropriated from a departing faculty member. It swiveled and rocked, and to my delight, even had arms. I inherited a U.S. Top Secret filing cabinet left behind by Wheelus Air Force Base, and I borrowed a music stand from band director Andy to use as a lectern. I was good to go. Student desks filled the center of the room. The number depended on the enrollment. *Gaffirs*, the Libyan equivalent of janitors, came in at 4:00 p.m. daily and moved dry mops across the floor, shifting sand from the east to the west. If the blackboard needed washing, I did it myself. The room had no air-conditioning. The only rooms on campus with air-conditioning were the offices of the superintendent and principals.

The first day of class, I established my boundaries with the usual three rules: 1) Be on time. 2) Come to class with homework finished. 3) Raise hands for permission to speak. The day before school started, I caught the principal in the hall and told him my rules in case I had to send an offender to his office. Much to my dismay, the first student to speak out of turn was the meekest little girl in class, but off she went to the principal who obliged me by giving the student a simple reinforcement of my requirements. I followed this procedure for years and rarely had discipline problems. It wasn't because of my size, physical strength, or what my Mom described as my "English teacher look." I believe it was because I let the students know within the first ten minutes that good behavior was expected and we were in class to learn. I didn't anticipate any problems. These were good kids.

October 31 was a big night in Giorgimpopoli. OCS Villa 12 had a visit from all the goblins in the neighborhood. One kid had so much stuffing in his pumpkin costume he could barely walk. Everyone had a good time, including Josephine. She was beside herself with excitement. The Libyans couldn't quite figure out what was going on, but they loved kids and were amused to see them roaming the streets all decked out for Halloween.

When November arrived we began to appreciate the temperate climate of Tripoli. It was still shirtsleeve weather during the day, but at night

we needed a sweater or jacket. We felt smug when we thought about our families in the Midwest bracing for snow and freezing temperatures. The first Saturday of the month we got up at the crack of dawn and drove downtown to the Italian Market, a white Mediterranean-style covered market with vaulted roofs, domes, and arches. Bare lightbulbs illuminated the dark cool passageways inside, and dangling from meat hooks in front of vendors' stalls were the heads of camels, goats, and cattle, all gazing down with expressions of surprise or acquiescence. Beneath them, whole carcasses of beef and lamb hung suspended from iron hooks. Live chickens and rabbits bided their time in wire cages.

The fish market stood off by itself under a large domed rotunda. Thick marble counters were covered with grouper, octopus, tuna, swordfish, San Piero, moray eels, sardines, squid, sole, lampuki, and mountains of shrimp. One huge, surprised looking shark lay sprawled across the middle of the market floor, waiting for bidders. The gleaming display cases of supermarkets back home were becoming a distant memory.

Pineapples, pears, apples, melons, grapes, peaches, fresh figs, apricots, blood oranges, lettuce, tomatoes, radishes, peppers, and avocados cascaded down vendors' stalls. In the spice market, the tops of large burlap bags were rolled down to display fragrant mounds of freshly ground red, yellow, and orange savory spices. The most common of these, a red hot pepper called fil fil, was a main ingredient in the Libyan soup called shorba.

We bought four 2-inch thick T-Bones, a four pound rib roast, and two sirloins for about $10.00. Lamb, camel, and goat were available, but mostly, the choice was beef, beef, or beef. Pork was a no-no.

In anticipation of the upcoming Thanksgiving holiday, one of the grocery stores in Giorgimpopoli ordered and received 200 turkeys. They were all spoken for before the shopkeeper could collect them from the plane. Since I was not one of the chosen few, we made plans to go to Malta on Wednesday evening, November 25, and stay until Saturday. At 7:30 the night before Thanksgiving, we joined fifteen other faculty members for the one-hour flight to Malta. We joked that there were so many of us, we could

hold a faculty meeting, but that was the last thing on our minds.

Malta was a quaint, beautiful little island, 96 square miles of rock, a pleasant change from sand. The island had deep natural harbors, bastioned walls, and bays full of colorful fishing boats. The buildings were constructed of native limestone and looked old, but not neglected. The streets were steep and narrow, some so steep they were steps. Balconies enclosed by decorative wrought iron railings adorned houses bordering the streets.

The Maltese were short, stocky people with black hair. They were very Catholic and very clean. I walked past one old woman scrubbing her front steps and sidewalk on her hands and knees. On every other corner was a church or a statue of a saint. Some sources say that the deep Christian tradition of the island dates back to the unscheduled visit of St.Paul who was shipwrecked on the island on his way to Rome for an audience with Nero in A.D. 60.

Valletta, the capital, looked like a medieval fortress. Charles V ceded Malta to the Knights of St. John of Jerusalem in 1530, and the place became a staging point for travel to the Holy Lands during the Crusades. During their 250 year presence, the Knights fortified the island and built churches, palaces, and lodges. Valleta was named for Grand Master Jean de Valette who with his knights and about 9,000 men fought off 29,000 Turks during a four month siege in 1565. The island took a terrible beating during World War II, but the people never gave up. Churchill called Malta the Allies' only "unsinkable aircraft carrier." Archeological remains on the island date from 4,000 to 6,000 B.C., depending on the source. Two-hundred years seemed old in the States. Two-thousand years was more or less standard in the places we were now privileged to visit.

Malta had two official languages: English and Maltese. Maltese was a mixture of Italian, Arabic, and Turkish, the result of powers that occupied the island at some point in their history. Some of the place names showed the unusual character of the language. Ghajn Tuffieha Bay, Bahar-ic-caghaq, Marsaxlokk. I was glad I didn't have to spell them on a regular basis. On this our first trip to Malta, we stayed on the eleventh floor of the Preluna Hotel in Sliema, at the time Malta's tallest building. Our room had a large picture window overlooking the Mediterranean, and when I went to bed the first night I left the drapes open so I could wake up to the sight of Homer's "rosy-fingered dawn." The next morning I was shocked. When

I opened my eyes I saw a gigantic ship coming straight at us. I was afraid the island was being invaded, but when I looked through my binoculars, I discovered that it was the aircraft carrier *John F. Kennedy* entering the harbor with an escort of seven large warships. It got my heart pumping.

Later in the morning word got around that any American on the island would be granted a free tour of the carrier. By mid-afternoon, feeling privileged to be Americans, we were sitting in a small ship's tender chugging out into the harbor to see the *JFK*. It was immense, a quarter of a mile long, equivalent in area to about four football fields. Our guide told us that the area of the flight deck alone was 4.56 acres. It had 200,000 horsepower and could reach the speed of 34 knots. The two anchors weighed 30 tons each. In 1963, when funds were set aside for the ship, its name was *Attack Aircraft Carrier 67 (CVA-67)*, but when President Kennedy was assassinated, Lyndon Johnson declared it should be named the *U.S.S. John F. Kennedy*. We met a few of the 5,000 crew members onboard and talked to many more when we got back to the island. They all liked their stop in Malta. I expect the shopkeepers and restaurants liked to see the sailors too.

Just up the coast from the Preluna was the Villa Dragonara, a majestic building that looked like a Greek temple. Built in 1870 as a summer place for a wealthy family, it stood all alone on a point between two bays and was now a casino. It had no slot machines, lions, tigers, noise, or other casino trappings. Instead, it was replete with crystal chandeliers, French painted furniture, sedate men in black ties, and elegant, bejeweled ladies in long gowns and furs. The only noise in the casino besides the shuffling of cards and the rattle of poker chips came from the crap tables where the Sixth Fleet had gathered. Even they were subdued. A Las Vegas gambler would have been dumbfounded.

In addition to soaking up local history, we did lots of shopping, sightseeing, and eating. Instead of Thanksgiving turkey, I had swordfish, a fine substitute. On Saturday night at 8:00, four days after we arrived, we boarded a plane back to Tripoli. I carried with me the treasures I bought: a heavy brass dolphin door knocker, a little brass bell topped by a Maltese cross, and a ceramic chess set of sea horses, octopus, dolphins, and squid, all ruled by King Neptune and his mermaid queen. The Maltese glass was beautiful, but I left that for another time. I bought two midis, in fashion at the time. I also bought fine-ground sugar and salt for my Christmas bak-

ing, and canned ham, a rare treat in Tripoli.

When we got home, Josephine was happy to see us. She now knew two tricks. She could sit and she could shake hands. I rewarded her with small pieces of food, and she learned her tricks in two sessions. As she caught on, she tried to raise two paws at once. Smart girl. Since Josephine stayed outside in our yard much of the time, she got regular baths. She didn't like bathing alone, but loved to get in the tub with me. She put her front paws up on the edge of the tub and barked to get in. She looked like a little rat when she was wet.

<p align="center">***</p>

Soon after we returned to Tripoli, I stoked up the fires to begin my Christmas baking. We planned to have a joint Christmas Open House for 50–60 people with our friends, Helen and Spiro. Helen would provide her Greek pastries, and I would bake my Norwegian favorites. We planned to serve punch and decided not to spike it. Libya was a dry country. The laws concerning drinking were clear. Don't do it. In private homes, however, one could find anything from bathtub gin to Johnny Walker Black Label. The standard choices were flash (bathtub gin), beer, and wine, all home-made.

Flash was made from ordinary tap water, granulated cane sugar, and baker's yeast. It needed to ferment at 78° Fahrenheit for about fourteen days and remain standing until the sediment settled. It was then ready to be decanted and distilled. Stills ranged in size from stove top cookers to room-sized units that could put out thirty liters a day. Home stills were so common that kindergartners playing kitchen at school occasionally pretended to make flash instead of cookies.

Making flash was a lengthy, smelly, dirty, messy, risky business, but the pay was good. "Distillers" charged in the neighborhood of $30.00 a liter, uncut. The hourly wage brought in earnings approaching those of doctors, lawyers, and dentists. The risk was a stiff fine, an extended stay at a local prison, or immediate eviction. The unofficial advice to Westerners was if one made and consumed booze in his own home, didn't drive under the influence, didn't sell, and didn't serve to Libyans, he should be fairly safe.

The quality of flash varied. Those who were serious about their business and concerned about their customers' health followed guidelines such as those set up by fellow distillers in Saudi Arabia in the "The Blue Book," *Perfected Techniques on the Ebullition of Sugar, Water & a Suitable Catalyst To Form An Acceptable Aramco Imbibable Potion Appropriate For Consumption/Or How To Make Good Booze.* We were told that dependable "distillers" had their product tested in the laboratories of the oil companies down town. Those who were not concerned about quality got plenty of business too.

"Bad" flash came with a guarantee of dragon breath, killer methanol hangovers, or worse. It could blind or even kill you. "Good" flash was clear and had more of a sting than a taste. It was purchased uncut and mixed in equal portions with bottled water. Flash and Pepsi, flash and Seven, flash and Mirinda (orange soda), flash and Ben Gashir (fizzy water), and flash and water with a touch of bitters and a twist of lemon were standard combinations. When oranges were in season, people mixed "Old-Flashioneds:" orange juice, flash, bitters, and a cherry. "Flashy Marys" were popular for brunch when tomato juice was available.

A number of liquors could be made with flash: crème de menthe, crème de cocoa, cointreau. Brandy could be produced by pouring uncut flash over oak chips, soaking it for 24 hours, filtering, adding water, and aging for at least 3 months. It tasted like the tree.

Brewers of beer had several options. Non-alcoholic "Near beer" was available from Oea, the local brewery. Amateurs bought cases of the stuff, dumped it into stainless steel vats, added yeast and let it brew. Some simply opened the small brown bottles, dumped a little sugar and a few pieces of macaroni inside, and recapped them. Bona fide brewers started from scratch, using their own openly shared and highly debated proportions of water, hops, sugar, and yeast. Bottles had to be washed and baked in the oven to sterilize them before bottling. A real effort was made to age the beer at least ten days.

Whatever the method, the result could only be measured in degrees of badness.

1. Not bad
2. Not too bad, considering

3. Disgusting
4. Vile
5. Ghastly
6. Gruesome

The taste could be improved by refrigerating the daylights out of the beer and pouring it into frosted glasses carefully so as not to disturb the sediment at the bottom of the bottle. If the taste was disappointing, the kick was not. The alcohol content hovered around 18%.

Vintners favored two variations of the same recipe: White or rosé wine made with Pampryl or Joker, the two brands of grape juice available. Those going into the business big time combined 34 liters of juice, 20 liters of water, 13 1/2 teaspoons of yeast, and 13 cups of sugar in jerry cans or glass carboys, then watched and waited. Some people stomped grapes; others ground up raisins or ginger. Some produced a decent product, but most of it was the proverbial wine of astonishment.

Teetotalers who came to Libya sometimes went astray. It may be because no hometown eyes were watching. Perhaps telling people they couldn't have alcohol made them determined to get it. One thing was certain. I was living in a dry and thirsty land. I had never in my Midwest Lutheran life seen so much booze.

On Saturday night, December 12, we had our Christmas Open House, the first venture into big time entertaining since we arrived. We pushed the furniture against our villa walls, set out the goodies, and during the course of the evening, fifty or sixty of our friends dropped by. The house looked lovely all decorated with poinsettias picked from our back yards. I came to Libya thinking poinsettias were decorative little Christmas plants that grew in pots, but here they grew on trees 10–15 feet tall. Some yards had trees so laden with blossoms that they cascaded over villa walls in a blanket of red. I discovered that when a poinsettia branch was cut, a white substance oozed out the severed end. If I dipped the end in boiling water and held it for a few seconds, the flowers stayed fresh for days. Although we had agreed not to, Helen and Spiro decided at the last moment to serve

booze. We compromised by having one punch bowl "with" and one "without." It made me nervous.

During the weeks leading up to Christmas we were out every evening, one night at an elegant sit-down candlelight dinner with friends, the next in the cold, cavernous gym helping students decorate for the Christmas dance. Our students had a dance for every occasion: Halloween, Christmas, Valentine's Day, Sadie Hawkin's Day. The gym was decorated accordingly: a haunted house or graveyard, a Winter Wonderland, hearts and Cupids. Although we called these gatherings dances, the gym floor remained empty much of the evening. A few songs brought dancers out. No one could resist The Archies singing "Sugar, Sugar" and Jim Croce's "Bad, Bad Leroy Brown." Slow dancing couldn't really be called dancing. Couples leaned against each other and swayed back and forth to songs like Simon and Garfunkel's "Bridge Over Troubled Waters." Santa, a.k.a. Principal Jim, put in an appearance halfway through the dance. He even knew his way to Libya. One of my students gave me a silver Cristofle bottle opener for Christmas. I also got a heavy two-inch silver Bedouin bracelet and a Baccarat crystal ashtray. I wasn't used to getting Christmas gifts from students, especially not ones of this value.

After a round of parties and open houses, I complained to a few of my colleagues about a feeling of general achiness and discomfort. They told me it was probably from drinking punch made with bad flash. From that point on, I avoided punch at all gatherings and continued my policy of drinking only those liquids I could see through.

<p style="text-align:center">***</p>

We had an invitation to spend our Christmas vacation with my Dad's family in Norway and were considering it until we learned the price of the tickets, almost as much as it would cost to fly home to the U.S. Instead, we decided to go on the Circle Tour to Cairo, Beirut, Istanbul, and Athens. The air fare was about $150 apiece, so we bought tickets from Saudi Arabian Airlines, arranged for a friend to care for Josephine, packed our bags, and the evening of December 20 landed at the Cairo International Airport. The flight was smooth and the food, Arabian lamb stew with prunes and rice, was one of few airline meals I had eaten that didn't taste like cardboard.

We checked into the Hotel Phoenix, a moderately priced hotel on one of the busiest squares of Cairo, at the time a city of five million people. We were shocked to see men and women hanging from the doors and spilling out of the windows of dilapidated buses spewing black smoke as they roared down the crowded streets. The banks of the main thoroughfare along the Nile were lush, green, and glittering with elegant hotels. One block in from the Corniche el Nil, however, the scene abruptly changed to crowded alleys and grimy hovels where people lived and sold their wares.

Our first stop the morning after we arrived was the Egyptian Museum. At the time, it looked like a junk yard, display cases coated with grime, guards slouching on bannisters. But what treasures it held. Tutankhamen's funeral mask, 22-carat solid gold inlaid with precious stones. The mummy of Ramses II, widely thought to be the Pharaoh who sent Moses and the Israelites packing. After 3,000 years, he still had blondish hair, even on his chest. Ramses II was said to have been taxed as imported dried fish when he was transported from a secret royal cache at Deir el-Bahrithe to Cairo after his discovery in 1881. While that is speculation, records show that in 1974 Egyptologists concerned about Ramses II's deterioration flew the mummy to Paris for examination. He was issued a passport that identified him as King and welcomed in Paris with full military honors. Later in the day as we toured Cairo, a guide pointed out the island where Moses was supposedly hidden in the bulrushes. We questioned the veracity of much of the information we received throughout the day but were not inclined at the time to let the truth stand in the way of a good story.

We felt a sort of reverence as we looked at the pyramids and the Sphinx for the first time. Thinking about all they had witnessed throughout history and reflecting on legends of the past, I was brought back to the present by hawkers selling scarabs, ankhs, and post cards, young men recruiting tourists for camel rides, and little boys holding out their hands crying, "Baksheesh." We went inside the pyramid of Khufu, the oldest and largest of the Giza pyramids. The oldest of the Seven Wonders of the Ancient World, it was still pretty much intact. The passage to the interior was so low that even at 5'3", I had to duck my head. When we came back out, I saw an Olympic athlete in training running up and down the exterior of the pyramid. It was a remarkable sight, one I think Khufu might have approved. The Sphinx was carved from natural limestone of the Giza

39

Plateau during the reign of Khefren about 2650 B.C. One guide said that Napoleon's troops were so moved they laid down their arms when they saw it. Another said they used it for target practice.

After a tour of the historic sights, we went to the Khan el-Khalili souk where Omar the Essence Dealer spotted a couple of suckers and hustled us into a shop decorated in the style of a Bedouin tent. He showed us wondrous vials of essences squeezed from roses, gardenias, and lotus blossoms. One, he said, was the base of Chanel N°5. These precious liquids contained no alcohol, and one dot was all it took to use as perfume, bath oil, or clothes freshener. It would last for years, said Omar. Even if we left the bottle open, it wouldn't evaporate. Omar was so convincing that I bought two big bottles and sent them home to my parents in a velvet lined wooden veneer box. A couple of months later, Omar's essences arrived in Iowa smelling like a brothel, so my parents sent them to the dump with my blessing. I thought I was a wary shopper, but Omar outfoxed me.

Another mistake I made was leaving an opal pendant on the dresser in our hotel room when we left one morning. Of course, when I returned later in the day, it was missing. I reported the theft to the front desk and the employee in charge of our floor was sent up to our room. He stood the doorway and made an award winning plea with us not to press charges. If we did, he said, he would lose his job and he had babies and grandparents depending on him for support. Although I had been robbed and was quite sure this individual was lying, I couldn't bring myself to press charges. I was stupid to leave anything of value in the room. I wouldn't make that mistake again.

The morning of December 23 we were at the Cairo International Airport before daybreak waiting for a plane to Luxor. Except for a few tourists, the place was nearly empty, and we began to get concerned about our flight. We finally spotted an airline employee and asked him how we would know when the plane to Luxor was leaving. He looked at us a bit puzzled, bowed to us and said, "Simple. I'll come around and say,'Luxor. Luxor.'" A few minutes later he made his announcement, and we were on our way to the Valley of the Kings where sixty or more Pharaohs were buried between 16–11 B.C., all with obvious pomp. Some of the figures on the walls and ceilings of the tombs looked as fresh as if they had been painted the day before. The treasure inside most of the tombs was stolen

during the Pharaonic, Greek, and Roman periods, some more recently. The only tomb found intact was that of King Tutankhamen, the "boy king," buried at the age of nineteen. One could see why the kings chose this as a burial place. It was majestic, peaceful, quiet.

Our guide was from Cairo University and known simply as "The Professor." He gave us a personalized tour of the Valley of the Kings and Queens, then we visited the Temple of Karnak on our own. The columns were massive, thirty-three feet in diameter and sixty-nine feet high. They made us feel insignificant. We walked down the famous Avenue of the Sphinxes and ended the day at Hapshetsut's Temple, a lonely colonnaded structure carved into the base of the cliffs at Deir el Bahri.

We were constantly reminded of the contrast between the grandeur of the past and the poverty of the present in this country. Farmers lived in mud brick houses and tilled their fields behind ancient plows drawn by cattle. They looked graceful in flowing robes and turbans, but theirs was no easy life. Only 4% of the land in Egypt was arable, and at the time, 96% of the population lived on it. A narrow strip of land on both sides of the Nile was rich and fertile, but where the black earth stopped, the desert began. The ancient Egyptians called their country "Kemet," meaning "black earth." The romanized Arabic word for Egypt is "Misr."

On Christmas Eve I sat alone on an Aeroflot aircraft at Cairo International Airport ready to take off for Beirut. Peter, who should have been sitting beside me, was detained by airport authorities for allegedly black-marketing U.S. dollars. Tourists could bring foreign currency into Egypt, but we had to declare it upon arrival and leave the country with the same amount or show receipts for what we spent during our stay. We had saved receipts, but restaurants and tourist sites didn't give them, so our totals didn't match. Assuming we were black-marketing dollars, customs officials let me board the plane but hustled Peter off to an adjoining room for interrogation. Peter had a twenty dollar bill and some singles in his pocket, and after doing their best to make him squirm, one customs official took him aside and whispered, "Put the twenty on top of the ones. That will make it look like you have a stack of twenties. Lie." Peter followed his advice and after a tense half hour, they let him board the plane. He came down the aisle just as the attendants were closing the door.

This was our first flight on Aeroflot, and we were not impressed.

Because there weren't any tourist class seats left, we traveled first class, but when we arrived at the airport in Beirut we felt as if we had spent two hours on a vibrator. All of the passengers clapped, cheered, and whistled when we landed. None of them seemed very pro-Russian.

After we landed at Beirut International Airport and cleared customs, we took a short cab ride into the city, checked into the Alcazar Hotel, and immediately reserved two telephone lines to call our parents in the U.S.A. at 1:00 a.m. The time difference between Iowa and Wisconsin and Beirut was eight hours, so we hoped to find our families at home getting ready to sit down for dinner at 5:00 p.m. The calls were transmitted via satellite, and when our parents heard the operator say "Beirut calling" they were so excited they were nearly speechless. We talked fifteen minutes to each family, hanging on every word. The connections were perfectly clear, and although it was late when we hung up, we found it impossible to go to sleep. It was our first Christmas away from home, and it warmed our hearts to hear our parents' voices again. The cost was $100, a gift to ourselves.

The next morning we looked out our hotel window at sunbathers on the beach of St. George's Bay and in the distance, the snow covered Lebanon Mountains. Known as the Paris of the Middle East, Beirut was one of the few places in the world where one could go skiing in the mountains during the day and come back later for a swim in the bay. The city was decked out for Christmas. At the time the population was about 50% Moslem, 50% Christian. It was not unusual to see sheiks, Jews, Christians, and oil barons walking side by side on The Hamra, one of the main streets of the city. In 1970 Beirut was the commercial, cultural, and banking center of the Middle East. It was a free city with no taxes or duty, so it was a shopper's paradise. The shops were laden with gold, brocades, antiques, jewels, Persian carpets, designer clothing, boots, shoes, table cloths. I treated myself to a new pair of boots and a pair of shoes, some green brocade for a dress that I never made, and an embroidered tablecloth and napkins that I use to this day for lobster fests. I found an 18-piece hand-carved olive wood nativity set for $14.00 and sent it to my parents for Christmas.

Peter couldn't resist a fake "Persian" helmet, shield, and battle axe, as well as a beautiful book on the Middle Ages. We did not consider ourselves shoppers, but the place gave us the fever.

The following day we visited George Monsour, a jeweler that many of our friends in Tripoli recommended. We called his phone number, 229461, and he sent a limousine to the Alcazar to pick us up. We were chauffeured to the Monsour villa where a laid back, casually dressed George showed us nondescript cardboard boxes full of rings, bracelets, necklaces, and earrings. For my Mom I bought an Emerald Artichoke, a stylized triangle with thirty-one emeralds in an 18-carat gold setting. It was available in emeralds, rubies, or pearls, all for $30.00 each. The same ring in diamonds cost $225.00.

I didn't particularly care for jewelry at the time, but I was in the market for a four-band puzzle ring, so George pushed a box about half the size of a shoe box in my direction. I pawed through the rings until I found the size and style I wanted. He tossed the ring on a scale and quoted me the price of $9.00. I bought it, enjoyed wearing it, but never have learned how to put the thing together. Peter got an 8-band ring for $25.00. When we finished, we rode back to the hotel in the limo feeling like members of the international smart set.

After Beirut, we flew to Istanbul and checked into the Hilton Hotel. From the veranda, we could see the Golden Horn and Asia to the north, the Sea of Marmara to the south, and all around, the misty Bosporus separating Europe from Asia. The city was founded by the Greeks in 7 B.C., made the capital of the Roman Empire by Constantine in A.D. 330, and in A.D. 395 became the Byzantine capital. William Butler Yeats considered Byzantium a place where body, mind, and spirit existed in proper balance, a place where the soul "claps its hands and sings."

We visited the Palace of Topkapi with its rare jewels, robes, treasures of the Sultans, and the footprint of Mohammed. We went to Hagia Sophia built by Justinian I in A.D. 537 and facing it, the Blue Mosque built in the 17th century. Standing between the two mosques gave me the illusion of being in the middle of a giant space station with rockets poised on all sides ready for launching.

We were driven around Istanbul in a privately owned vintage 50s Buick taxi. The streets were full of old cars in mint condition. At the time,

43

the city had 2.7 million people. Outside the tourist areas one saw a great deal of improvised housing and dismal living conditions. I saw an old man, a "tattered coat upon a stick," carrying a refrigerator on his back.

We did the last of our Christmas shopping in the Grand Bazaar, a maze of shops under arched passageways with over sixty streets, close to twenty entrances, and thousands of shops selling jewelry, spices, clothes, shoes, brass and copper, meerschaum pipes, and leather. We bought my Dad a soft suede jacket for Christmas.

The last stop on the Circle Tour was Athens where our friends Helen and Spiro were waiting for us. Athens was Helen's home territory, so she took us on a tour of their favorite lunch places. We started with a small glass of ouzo in a neighborhood standup bar. Ouzo, the Greek national drink, had the flavor of anise. Mixed with water, it turned milky white. One glass was enough for me. I would not need to have it again.

We stopped next for gyros, a sandwich of roasted lamb dripping with juice shaved off a giant spit and packed into a freshly baked pocket of pita bread along with yogurt, shredded lettuce, onions, and diced tomatoes. It was wonderfully messy and delicious. The juices ran down our arms as we ate. The floor was covered with sawdust and not one piece of furniture in the place matched, yet a long line of people were standing in line to get in.

For dessert we went to a small eatery that served only simple foods like fried eggs, bread, yogurt, loukoumádas, and rice pudding. Through the front window of the café we watched loukoumádes frying in huge vats. They were puffy balls of deep fried yeast batter served piping hot and drizzled with honey, cinnamon, and powdered sugar. Golden brown, crispy on the outside, warm and chewy on the inside, they brought tears of joy.

I wondered if Athenians ever got used to the beauty of their city. The Acropolis looked down from the highest point of the city, and on moonlit nights the floodlights were turned off so those below could see the elegant white columns as they would have appeared centuries ago. Vowing to return, we flew back to Tripoli with memories still fresh today. All four stops on the Circle Tour were peaceful in December of 1970, at least on the surface. That would change.

1971

Three weeks into the new year, a change in the work week was inaugurated at OCS, and it drove us nuts. Instead of working from Monday morning through Friday noon, we now worked Sunday through Thursday, five full days, and had Friday and Saturday off. The change was made as a gesture of respect for the Moslem Holy Day, a day when shops were closed and mosques held services. For us, Friday was now Sunday, our "day of rest." Saturday was still Saturday, but Sunday was Monday, the day we headed back to work. Confused? So were we. It took months to readjust, but the change was well received by our host country. In addition to getting accustomed to a different schedule, we lost our half day off on Fridays. Bob Waldum assured us that we would get it back in time. We never did.

Still, I could not complain about my classes. They were small, none over twenty, and one had only ten. That gave me plenty of time to work with each student. Most of the students got pressure from home to get good grades. Since OCS went only through grade nine, students had to leave home at a young age and continue their education at a boarding school in Europe or in the United States. The social and emotional adjustment for a fourteen year old was considerable, so both teachers and parents did their best to insure that students were prepared academically. For the most part, they were. Many went on to complete high school at Choate, Phillips Andover, Phillips Exeter, Kent, Miss Porter's School in Farmington, Connecticut, Notre Dame International in Rome, The American School of Switzerland, or the Collège du Léman in Geneva. Many did so with honors.

The Saturday morning after the big change, I went with my friend Keith to the Souk El Telat, a.k.a the Tuesday Market, to buy fruit and check out the camel market. We found huge baskets of vegetables and fruit, kitchen supplies, and camels of all sizes: tall, short, most of them thin, some alarmingly emaciated. They looked arrogant, but their eyes were big and kind and their lashes long and beautiful. These were the one-

humped variety. Dromedaries. They had an average life expectancy of twenty-five years and could survive for a month on desert vegetation.They did not store water in their hump as some believed, but fat. I was told they had a nasty disposition and held a grudge. They bit, kicked, and spit slimy smelly green stuff on anyone who annoyed them. An acquaintance who worked in the oil fields said that he made the mistake of offending a camel once, and it charged him. When he sought refuge in his Volkswagen, the animal started to attack the vehicle. He had heard that unlucky souls who got on the bad side of a camel sometimes stripped off all their clothes and let the camel stomp the daylights out of them until they worked out their aggressions. He did this and much to his relief, it worked. The angry camel sauntered off, and the man and his VW were spared.

Every Thursday afternoon at OCS we watched a camel caravan amble by the far end of the athletic field on the way to market. They traveled about four miles an hour and made no sound as they passed. Their feet were padded, and even if they numbered in the hundreds we could not hear a sound. Camels were rough riding and tough tasting, but owning one put one fairly high up on the social scale. At the bottom of the ladder were owners of sheep and goats, next came donkeys, then camels, and finally at the top, the owner of a horse. A good camel, I was told, cost about $900.00.

Keith and I ended the day with a visit to our friend Abdu, owner of a gold shop in the Tripoli Souk. The small shop was full of gleaming gold bracelets that cost about $25 apiece. At the end of the day, workers carefully swept up every speck of gold from their workbenches and floor.

When we went home, we prepared for work Sunday morning. Two-day weekends seemed too short.

<p style="text-align:center">***</p>

Letters from home informed us that my mother's emerald ring and my Dad's suede jacket had arrived safely a few weeks after we sent them. My mother wrote that she had just finished a book about Israel and offered to send it to me, but I told her I would read it when I got home. Any references to Israel in letters, articles, or books could result in unpleasant consequences for us. I didn't relish riding backwards on a donkey through the streets of Tripoli with sheep guts hung around my neck, one of the juicier

rumors floating around, or doing time in a Libyan jail. Mom, a woman with strong opinions, wrote "Israel will prevail" on the outside of the envelope of one of her letters. I was relieved when I saw that my Dad caught it and tucked it inside his own envelope.

At school we carefully censored any "J" words or "I" words found in our books. I blacked out the words "Jew" and "Israel" in my brand new set of Webster's dictionaries. The "I" volume of the encyclopedia was removed from the shelves of the library. All maps were censored upon entering the country, and Israel was blacked out with a magic marker. Of course, the first question students asked when they entered their history classroom was, "What's that black spot on the map?" The standard reply was, "That's the country we're not allowed to talk about." Though Jews settled in North Africa before the first century and had lived and worked among the Moslems until relatively recently, the word "Jew" was now taboo. After the Revolution, the property of Jews in Libya was confiscated and the people deported. One reportedly escaped to Malta in a cello case. Expatriates with Jewish names or heritage kept a low profile.

<center>***</center>

The first weekend in February was a long one celebrating the Eid al-Adha, the Moslem religious holiday also known as the Feast of the Sacrifice, the Abraham Eid, the Sheep Eid, or the Big Eid. The celebration came at the end of the Hajj, or pilgrimage to Mecca, and lasted three to four days. It commemorated Abraham's willingness to sacrifice Ishmael to God. All Libyans who could afford it bought a lamb to sacrifice and share with family and friends. During the Eid, the streets ran with the blood of slaughtered sheep. Our neighborhood was littered with wheelbarrows full of bloody sheepskins, clumps of fur blown hither and yon by the wind, and hides and entrails hanging from clothes lines. Blood was everywhere. I even found clumps of bloody fur in our yard.

Since we had a long weekend, we took a day trip to Garian, a village in the region of Jabal Nafūsa about 50 miles south of Tripoli, to see the locally famous painting of the Lady of Garian. There we found an unpaved road leading to a disintegrating Italian Army barracks from WWII. On one entire wall of the barracks was our Lady, a 30' x 15' mural of a classy

<center>47</center>

naked pinup painted in 1943 by Clifford Saber, an American volunteer with the British 8th Army. The Lady, drawn in red paint, followed the North African coastline from her lovely face, inviting smile, open arms, and cascading locks on the Libyan-Egyptian border to the tips of her toes in Tunisia, over a thousand miles to the east. Key cities along the coast were identified by a breast, a knee, an elbow. Miniature British troops swarmed all over her body engaged in army duties from digging trenches to lining up for chow. Many brought a smile to our face. Tanks, armored cars, planes, rushed about performing their missions, and parachutists tried their best to land on her. It is said that Clifford Saber painted the mural to lift the morale of the troops in this desolate post. We were sure he succeeded. We knew we were seeing something extraordinary and wondered how long the mural would be allowed to stand. We were justly concerned. A year or so later we heard that it had been demolished.

One of many Middle East cease-fires between Egypt and Israel was extended about this time, and everyone breathed a sigh of relief. Rumors flew, and people stocked up on food, water, and kerosene. We assumed we'd go through the same thing again in March when this cease-fire ended. To make matters even more unsettling, we had a series of stormy days along with the inevitable power outage and water cut off. During times like this, Tripoli lost its romantic appeal. I longed for a bath.

On February 22 we held a Patriotic Assembly at OCS in honor of George Washington's birthday. It was my Mom's birthday too. She was always proud to share it with our country's first President. Part of the assembly was the National Junior Honor Society Induction Ceremony, a dramatic occasion recognizing inductees and their parents. The elections were held in secret and parents were notified by phone or in a clandestine meeting in the school's parking lot that their son or daughter was one of the "elect." NJHS was one of many organizations available to students. They also had a Student Council, French Club, Drama Club, Glee Club, band, chorus, Girls' Athletic Association, a young but professional yearbook staff, and sports of all kinds. But being elected to NJHS was one of the highest honors the school bestowed.

In addition to school sponsored activities, students enrolled in OCS automatically belonged to the Teen Club, OCS's Youth Center. The center offered swimming, tennis, bowling, ping pong, billiards, ballet, chess,

cards, and movies. Teenagers had their own private beach and a clubhouse where they could barbecue hamburgers and buy chips, candy bars, and Pepsis. The Teen Club sponsored open gyms throughout the year for pick-up sports and dances with what at the time seemed like wild themes like "The Year 2000." Dances began at 7:30 p.m. and ended at 10:30 p.m. and were always chaperoned. Transportation to and from the dance had to be arranged prior to the event, and junior high students were required to be home one-half hour after the dance. Dances for students below seventh grade were discouraged. Girls had to wear dresses or skirts except during the summer when shorts and slacks were allowed. Boys got by with school clothes, but many dressed in sports coats for the occasion. Students were not lacking for activities, but they sometimes complained that they had nothing to do. They were normal.

I, on the other hand, had plenty to do. Classes kept me busy. When I taught composition, I had eighty essays a week to grade. The compositions were short and focused on a central thesis statement, and I tried to help students get the feel of a clear beginning, middle, and end. Many of their writings touched me deeply. Some tickled me and made me laugh.

In my spare time during the evenings, I tried to teach myself how to crochet. I found a magazine with a pattern for a skirt I liked at the newsstand down the street from our villa, so I bought a crochet hook and some dark green yarn and gave it a try. It wasn't hard. Josephine came in for pats on the head while I worked. She was such a good girl. We needed to get her spayed in another month. She already had boyfriends.

<p style="text-align:center">***</p>

March began with rain, rain, rain. The sand streets were full of deep gullies, and we were forced to find an alternate route to school. Sand cascaded down our neighborhood streets onto Zavia Road and covered sections with 20-foot wide stretches of the soggy stuff. Drivers who got stuck in this mess had to get out and wade in water and muck up to their knees to push their cars out. On the bright side, the birds were chirping, flowers were budding, and the days were getting longer. When I left for school one morning the lawn was bare, and when I came home, hundreds of little green shoots were poking up through the sand. If I could get our sweet

black four-footed friend to quit digging holes, we had a chance for a green lawn. The orange tree in the back yard was just about ready to blossom; unfortunately, the fruit was bitter and inedible. I considered making marmalade, but the tree was located right over the septic tank, so I decided to pass.

Flu, mononucleosis, and cold bugs floated around, but Peter and I were lucky enough to avoid them. We had an exit re-entry visa, so we drove to Djerba to get away for the weekend. I brought my magazine, yarn, and crochet hooks with me in case I had time to work on my skirt. I didn't of course, and to add insult to injury, my magazine was confiscated at the Libyan border on our return. I explained to the customs agent that I had bought the magazine at the news stand just down the street from my home and proudly showed him the pattern and my work in progress. It was like talking to a brick wall. He adamantly refused to give the magazine back. He must have been hard up for something to read out there on the bleak border outpost. At any rate, my short, brilliant career as a *crochetier* was over.

March 26 was the annual opening of Little League at OCS, always a festive occasion. TWA flew hot dogs and Dr. Pepper in for the opening ceremony, and U.S. Ambassador Palmer threw out the first ball to commence the season. The Little League Baseball and Softball organization included Seniors, Majors, and Minors, and baseball clinics that helped develop the skills of millions of young players. The Tripoli Little League, I was told, was the largest league outside the Continental United States.

Libya was a dream for OCS students who liked athletics. The weather allowed outdoor sports all year, we had excellent physical education instructors, and newly arrived from the Kwajalein Schools a crackerjack Athletic Director named Skender. We had a good-sized gym with rollout bleachers as well as a huge sand athletic field on which students played everything from Little League Baseball to Powderpuff Football, much of the time in bare feet. Students could choose from basketball, netball, baseball, softball, Pigtail Softball, football, soccer, volley ball, field hockey, floor hockey, track and field, wrestling, bowling, ballet, trampoline, tumbling, gymnastics, croquet, and shuffleboard. Their choices were many and varied. There were few local teams with which to compete, but students generated plenty of rivalry by competing in intramural leagues or

challenging a faculty team to a competitive but good-natured game of basketball or softball. Extramural basketball games for the boys were sometimes arranged with the Libyan Junior Olympic Team, the team from Marsa Brega, Notre Dame in Rome, or a couple of teams from Malta.

Parents got involved with sports as well by coaching, refereeing, and raising funds for athletic equipment. Later that spring on April 7, 1971, the first night game in the history of the school was played under lights financed by the Community Bazaar. People went crazy. Fathers screamed, "Kill 'em," "Smash 'em," "Knock 'em dead." Coaches paced the sidelines. Girls formed cheerleading squads, and the student council sold hamburgers and bottles of cold Pepsi. It felt just like small town Friday night back home.

At the end of March we were informed of another three-day weekend. We celebrated both American and Libyan holidays, and by now I never asked questions when informed of another one. I just gave thanks and enjoyed the day. The occasion this time was Tobruk Evacuation Day commemorating the day the British were expelled from Tobruk. Since we had time off, we took Josephine to the veterinary hospital to have a hysterectomy and possibly an abortion. The number of dogs "courting" her was staggering. Our neighbors got up at the crack of dawn and came out in their pajamas to chase off the suitors. No one could sleep through all the barking and howling. Poor Josephine. We had to leave her with the vet, and it seemed empty around the house without her. She came home in a week, stitches out, and all recovered from her operation. She was such a lady. She loved soft-spoken people, but if friends with loud voices came to visit, she went to her room and hid in the corner.

Every Sunday I wrote my parents a letter, and as long as mail was flowing regularly, I received a letter from them the same day. If anything special came up, I wrote more often. Every day but Friday, our school driver Milad collected all incoming Oil Companies School mail from the Central Post Office in downtown Tripoli and delivered it to the superintendent's office. Secretaries then distributed letters and packages to our individual boxes in the faculty lounges. Receiving mail was a joyous occasion.

It restored our souls. When we didn't get mail, we were downhearted. Men waited for football scores, women waited for recipes they had left behind, and we all waited for family news and clippings from newspapers and magazines. We reveled in news from home.

Mail typically arrived in Tripoli from the States in a week or ten days, although there were peculiar exceptions. In March we got a letter from Iowa dated December 14, cause unknown. During Ramadan, a month of fasting for Moslems, work slowed down and mail piled up all over Libya. That was understandable. But now at the end of April, mail abruptly stopped at both ends. Determined to get to the bottom of the delay, our friend Keith went to the main post office in downtown Tripoli to try to track down a package he was expecting. He was taken to the bowels of the Central Post Office where he saw two men perched on a huge mountain of mail nonchalantly sorting through packages and letters. That was our answer. It was a wonder that anything got through, but it usually did. Eventually. It was a way of life. Inshallah, bukrah, malish. Most of the mail into or out of Libya was channeled through Rome and this time, to be fair, the culprit was a strike in Rome. It caused a tremendous backlog in both cities, and all we could do was wait and hope. We rejoiced when we heard that the strike was over and looked forward to delivery soon getting back to "normal."

<p style="text-align:center">***</p>

At the beginning of May we had yet another three-day weekend, this time in honor of Mohammed's birthday which Sunni Moslems celebrate on the 12th day of the Islamic month of Rabi' al-awwal. The sound of fireworks echoed through the city all weekend and sounded like the Fourth of July. At OCS Villa 12, we celebrated the holiday with a dinner of hot dogs. One of the single guys on the faculty had connections with the American Consul, so somehow he managed to get me two packages of them. We had four of our friends over for the feast: hot dogs, homemade buns, baked beans, potato salad, dill pickles, and sliced tomatoes. They were the first hot dogs we had the pleasure of eating since leaving the U.S. I never dreamed I would see the day when I served hot dogs as the *pièce de résistance*, but my, they were good.

<p style="text-align:center">52</p>

The closing days of the school year were busy with tests and activities. Students took the Iowa Tests of Educational Development, the same fill-in-the-little-circles standardized tests that students had taken at home for years. I remembered taking them in grade school. Since no automated correcting machines were available, we corrected them by hand. Once again, the National Junior Honor Society, OCS's finest, honored the faculty with a Teacher's Appreciation Day. They delivered a gourmet lunch and flowers to our desks, spread the feast before us, lit a candle, poured the wine, and fawned over us as we dined. After feeding us, they escorted us to the gym where we received a standing ovation from the student body. Then they roasted us.

This year's program was a spoof called the "Academic" Awards. The most athletic males in the organization dressed up like Bo Derek and Farrah Fawcett in slinky gowns, heavy makeup, and wigs to present the awards. They made every effort to appear sexy and increased the suspense and hilarity by first fumbling with the winner's envelope, then opening it most deliciously. In the few months that Peter and I had been at OCS, we had established a reputation for being strict and demanding. Many students mourned the fact that we had ruined their carefree, idyllic life on the shores of the Mediterranean by raising the bar in the English and history departments. As a result, we received the "Academic" Award for Best Actor and Best Actress in our roles as Bonnie and Clyde. We were impersonated by Ginny and Mark who dressed up in 20s clothing and came out onto the stage with guns blazing. They fired away at their victims, ninth grade history and English students, shooting them with the grade "F" -"F" -"F"- "F"- "F". We all laughed till our sides ached. Students who thought we were the two meanest individuals on the face of the earth left the gym thinking, "Yes, there is a God!"

On May 22, 1971, Freddie the Fiat died. Earlier in the month, the reverse gear quit. Shortly thereafter, first gear bit the dust, and with a great deal of strategy we learned to drive using second and third. Then one fine morning, the passenger door refused to close and the horn and lights quit working. Finally, all systems crashed and Freddie gave up the ghost. The

thought of having him repaired was too pointless to consider. His problems were terminal. He had been an affliction since we bought him. The previous owner, we discovered, was the boyfriend of one of the British secretaries at school. In retrospect, the fact that he was leaving the country the day after we bought Freddie should have raised red flags and sounded alarms, but we missed the signals. People we considered friends watched in silence as we bought a notorious dud. The seller was a veteran on his way back to Texas after years in the oil fields. We were rookies. Rank had privilege in expatriate communities. He deserved the break. We had no hard feelings. We learned a lesson, and if we ever became veterans, we would expect the same consideration.

Freddie was a good reminder of the maxim "Buyer beware." All was not lost, however. We sold him to our good friend Abdu the gold dealer. Even in his pitiful condition, he brought £170, about $500. To this day I don't know if he really wanted Freddie or just felt sorry for us. His size was his selling point. In a country inundated with Volkswagen bugs, a 4-door sedan was a prize. Even dead. Freddie taught us something else. Germans should make automobiles. Italians should stick to pasta.

On the bright side, we had good news for the next school year. We would have a houseboy at least once, maybe twice a week. His name was Mobrouk and he was not a "boy," but thirty-two, our age. He loved to clean floors, polish furniture, and iron. It was going to cost us about $30 a month, but it would be money well spent. The villa was so large I couldn't keep up with it. Peter helped, but our approach to cleaning was totally different. I searched for dirt. He swept it under the rug. When he did the dishes, everything got drenched, including the floor, the counter, and himself. Mobrouk had worked for friends of ours for four years and was highly recommended. He agreed to watch over our villa while we were away during summer so it wouldn't be knee deep in sand when we returned.

Joy at getting out of school must be universal. The kids were happy, and so were we. I worked to get the villa cleaned up before summer vacation. I shampooed the couch, washed and waxed the marble floors, and made arrangements with our neighbors to take care of Josephine while we

54

were away. With our young friend and fellow teacher Doug, we planned to buy Honda motorcycles in Rome and embark on a grand tour of Europe, England, and Ireland.

On June 8 we flew to Rome and started looking for bikes. We found a dealer, but he told us we would have to get a letter from the American Embassy and wait at least twenty days to complete the paper work before we could do business. Then, just as we arrived at another dealer, he closed for siesta. As we continued our search, people we talked to told us that it was too expensive to buy bikes in Rome. Everything seemed to be working against us. Finally, the sky opened, the rain poured down, and we got soaked. That was the last straw. Discouraged, Peter and I decided not to buy bikes, but Doug planned to keep on looking as we traveled north. I quickly warmed up to the idea of having a roof over my head as we traveled, and now my mother, a nurse who had spent plenty of time in ER patching up motorcycle casualties, would not have to worry about us being splattered all over the Autobahn.

We squeezed in some sightseeing at the Castel Sant'Angelo, walked to the Vatican, and stopped for lunch along the way. Pasta, of course. We took the bus to the train station to check on fares to Florence and found out that tickets would cost $8.00. Not happy with that, we went to Hertz and were delighted to hear they had a Peugeot that needed to be delivered to Calais. The rate was $81.00 a week, mileage included. We snapped it up and faced our first challenge: getting out of Rome. Italian drivers, we concluded, were seriously deranged. Libyans toyed with pedestrians, but at the last minute they chickened out. Italians were calculated. They plowed right into pedestrians and never looked back. Between the wild drivers and confusing signs for *stradas, vias, piazzas, viales, piazzales, circonvallaziones,* and *rotatories,* we doubted that we would ever get out of the city. I feared we would spend the whole summer going the wrong way down one-way streets and spinning around traffic circles. Finally, after an hour and a half, we came across the Autostrada and headed north towards Florence. No wonder Rome was called The Eternal City. It took an eternity to get out of it.

On the way to Florence we stopped in the sweet little village of Orvieto. We visited the magnificent 14th-century Duomo di Orvieto that dominates the town square, then found a place nearby for lunch. After we

had eaten, the owner of the restaurant took us on a tour of his wine cellar two floors deep into the earth. We walked through cool dark tunnels lit only by bare light bulbs. The walls were cold and wet, and wooden casks and dusty bottles of wine stood lined up on shelves in front of them. Thick layers of purple and yellow mold grew over everything. We sampled several wines, some three years old. Coming out into the hot sunshine after being in the cool damp cavern felt like an electric shock.

In Florence we found a hotel near the Medici Chapels for 3,700 lire a night, about five bucks. A toothless old cleaning lady ensconced in the lobby took an immediate shine to Doug. She followed him around like a puppy, watched every move he made, and got the most adoring look on her face whenever he came into the room. She was in love.

The money we saved on our hotel we spent for dinner at the Buca Lapi. The restaurant was down one flight of stairs and had a dim, cave-like interior. Colorful travel posters from India to Israel covered the vaulted ceiling and walls. As soon as we sat down, a waiter brought a large straw-wrapped bottle of wine to our table. At first we thought we were expected to drink it all, but before we made complete fools of ourselves, we found that it was weighed before and after the meal. The customer paid accordingly. We had a dessert called "Bonga Bonga," a pyramid of tiny cream puffs filled with a creamy vanilla custard, covered with warm chocolate sauce, and surrounded by fresh, sweet strawberries. Italians didn't how to drive, but they knew how to eat.

We visited the renowned Medici Chapels and stopped at the tombs of Dukes Giuliano and Lorenzo. Machiavelli dedicated *The Prince* to Lorenzo, the more famous of the two. Duke Lorenzo died young but lives on in his marble chair lost in thought, immortalized by Michelangelo. In front of the tombs were the statues of *Night, Day, Dawn, Dusk*, considered to be the most poetic of Michelangelo's sculptures. They glowed with grace and beauty.

We walked to the nearby Cattedrale di Santa Maria del Fiore, elaborate on the outside, somewhat bare inside. After some searching, we found Michelangelo's *David*, more exquisite in real life than we could have imagined. We finished our tour at the Uffizi Gallery and the Pitti Palace, the most famous galleries of Florence. We saw Botocelli's *The Birth of Venus*, masterpieces by Rembrandt, Leonardo da Vinci, Velasquez,

Rubens, Van Dyck, Filippo Lippi, Andrea Del Sarto, Titian, treasures that up until now we had seen only in pictures. It was a good art day.

When we left Italy, we enjoyed a beautiful drive through the Alps. Except for smog around the larger cities, the sky was perfectly clear. We drove through the Mont Blanc Tunnel, a little over seven miles long. The toll one way was $5.00. Today it is closer to US $50. We saw fire extinguishers, phones, and pull-offs every kilometer in case of an emergency. The air got a bit thick towards the middle of the tunnel, but the breathtaking view of snowcapped Mont Blanc at the end, 15,781 feet high, made it worth it.

We arrived in Geneva in the afternoon and couldn't find a hotel, so on we drove on to Lausanne, Doug at the wheel. He went the wrong way down a one-way street and got us a police escort to the outskirts of the city where we found a pension. The next day, Doug finally found a motorcycle, so we parted ways. Peter and I drove to Berne in the rain, happy to be in a car with a roof over our heads. Dazzled by watches and clocks in the shop windows of Berne, we each bought a wristwatch, mine a Girard-Perregaux, still ticking away after fifty years. Together we spent about $200, a shock to our budget and one we would have to avoid in the future. We went to see *Love Story*, and by the time the lights came on my lips were quivering and tears were running down my cheeks. I was glad no one was there to witness it. English teachers are not supposed to be taken in by sentimentality.

The autobahns in Germany were too fast for us and they did not provide much scenery, so we followed the Rhine, driving at our leisure and enjoying the small German villages. We stopped in Heildelberg, visited the University founded in 1386, and Heidelberg Castle currently undergoing reconstruction and restoration. After touring the castle with fifty other tourists we realized how spoiled we had become in Libya exploring entire Roman cities by ourselves. We went to a grocery store and bought bread, cheese, and milk and had a picnic on the banks of the Neckar River.

Just outside Luxembourg, we visited the American Cemetery, a sea of graves marked with white crosses or the Star of David. The sight made us

shudder. Over 5,000 American service members from WWII were buried there, General Patton among them. We stopped at Bastogne, the site of the Battle of the Bulge. During World War II, the Germans had the town surrounded and called upon the Americans to surrender, to which Brigadier General Anthony C. McAuliffe replied, "Nuts." The nearby "Nuts Museum," contained a collection of pictures and memorabilia from the battle.

In Brussels, our next stop, we drove directly to the old section of the city with its lovely façades of banking houses from the 1690s. There we saw the Hotel Europa, clearly more posh than the $7 a night places we had been staying, but we were tired, needed a bath, and decided to splurge. For $26.00 we got a spacious room for the night complete with both bath and shower. We felt like royalty.

On the way to Calais, our final destination on the Continent, we drove via Oostende and Dunkerque, traveled past WWI and WWII bunkers, and caught a glimpse of the cathedral in Dunkerque, still riddled with bullet holes. As arranged in Rome, we dropped the car off in Calais and took the ferry to the small, pleasant coastal village of Dover. It was so quiet that only the sound of the sea and the gulls echoed through the stillness. Since it was Sunday and everything was closed except the churches and Dover Castle, we visited both. The castle dated from the medieval ages and had an impressive collection of armor. It was good to be in England and hear the English language spoken everywhere.

We had arranged to pick up mail from our families at the American Express office in Rome, Florence, Geneva, Cologne, Dublin, and London. To contact us they simply sent letters to us c/o American Express in one of the designated cities. There was no charge for this service. To keep in touch with family and friends at home, we sent post cards or letters from nearly every place we stopped.

We lucked out again by finding a car in London that needed to be delivered to Liverpool, this time at a rate of $150 for three weeks. Driving on the "wrong" side of the road was a new experience, totally unnatural, like breathing out of our ears. The roads we took were mostly two lanes,

and getting stuck behind trucks was frustrating. Passing was dangerous if not impossible. We averaged about forty-five miles per hour, stopped in Canterbury, Bath, and Monmouth, then headed toward the coast to Aberystwythe on Cardigan Bay. We drove on winding, narrow roads with barely enough room for two cars, had a soul-satisfying dinner at the Red Lion in Dinas Mawddy, and visited a Welsh Woolen Mill. We drove through Snowdonia, stopped at the lookout across from Mt.Snowdon, then drove to Caernarfon where we toured the castle reconstructed by Edward I in 1283. Edward II, born here in 1284, became the first Prince of Wales in 1301, a title bestowed on him by his father Edward I. Ever since, heirs to the British throne, including Prince Charles on July 1, 1969, have been invested with the title of Prince of Wales at Caernarfon Castle.

We arrived in Liverpool in the afternoon, turned in the car, and booked tickets on the night ferry to Dublin. We killed time waiting for the ferry by getting haircuts and going to see *Lawrence of Arabia*. Watching it made me homesick for Libya.

In Dublin, we found The George, a temperance hotel with a reasonable room rate for poor travelers. We went to see the magnificent *Book of Kells* and a pop art exhibit at Trinity College, then watched *The Trials of Oscar Wilde* during the evening. That seemed appropriate. The following day we drove to Waterford to visit the crystal factory. I must have been dazzled by the profusion of crystal because when we got to Tipperary, I discovered that my purse was missing. I had left it hanging on the back of a chair at a Waterford café where we stopped for lunch. In it were all of our travelers checks, my passport, wallet, every important paper I owned. We went directly to the Tipperary police station where the policeman on duty called the Waterford police. Within fifteen minutes they located my purse and had it in their possession. We drove back to Waterford and breathed a sign of relief when we found everything intact. The police chief looked at me and shook his head in disbelief, then he turned to Peter and said, "I'd kill 'er." If we had been any other place but Ireland, I may never have seen my purse again.

The west coast of Ireland was barren and bleak, but somehow beautiful. We drove on tiny roads, our only company the cows, horses, and sheep in the pastures. We saw tinkers and as many as eighteen rainbows a day. If we stopped to ask directions, we learned to be prepared to chat a while. A

simple question could take a half hour to resolve. An answer was always something like, "See that road up there? Don't take that. It leads to Bettystown. That one there? It will take you to Inniscrone where my dear departed mother was born..." And so on.

From Ireland we decided to fly to London. We'd had enough of ferries. We arrived at Heathrow about 11:30 in the morning, took a cab into the city, and with the aid of the ever-helpful, all- knowing British taxi driver, tried to find a hotel. The American Bar Association was meeting in London, and hotel rooms were at a premium. We finally found a place to stay in Nottinghill Gate, had to move the next day to the Braham Court Hotel, and the following day to the Beaver Hotel. As suggested by the names, the quality of the hotel diminished with each move. Never mind. We hadn't come to London to sleep. We came to visit museums, see plays and movies, and shop.

We went to the British Museum to see the Rosetta Stone and the Elgin Marbles. We shopped at Foyles - the book lover's paradise, Fortnum and Mason, the Scotch House, Marks and Spencer, and Harrods. I should say we toured Harrods, marveling at the elegant halls and exquisite merchandise. We saw everything from hams to harpsichords and didn't expect we'd ever be able to afford to buy anything there. Marks & Spencer, or Marks and Sparks as locals called it, was comparable to K-Mart, more in my league. We were told that Queen Elizabeth bought her underwear there. We were impressed.

1971 was a good summer for movies. We saw *Cromwell, Waterloo,* and *Anne of a Thousand Days.* We went to *Little Big Man, Summer of '42, Cold Turkey,* and *Diary of a Mad Housewife.* We saw theater performances of *The Song of Norway, The Canterbury Tales,* and *Hair.* We watched so many plays and movies in such a short time that all the plots and characters started spinning around in my head. We were storing up for the cultural drought ahead when we returned to Libya. One evening shortly before we left London, we met Mr. Sirhan, the Minister of Education in Qatar, who was staying at our hotel. We started talking and enjoyed each other's company so much that he took us to an Arabic restaurant for dinner. It was good to have "real" food again.

At the end of July we started thinking about returning to Libya. Saturated with beautiful scenery, good food, and rich culture, we headed

south. We stopped in Chartres to see the cathedral, visited the royal apartments at Fontainebleau, and spent the night in Lunéville. We went out for dinner, and when we ordered milk to drink with our meal, our waiter looked at us as if we had lost our minds. He thought he misunderstood us, so he asked us a second time. We repeated the order, but he was incredulous. He tried to talk us out of it, told us milk was for babies, but we persisted. Of course, he had to give in though he looked very, very sad for us.

Continuing south, we found Munich preparing for the 1972 Olympics, visited Berchtesgaden and the Eagle's Nest, stopped for the night in Baden Baden, and arrived in Salzburg on the opening day of the Salzburg Music Festival. Rooms were scarce, but we finally located a restaurant on the outskirts of the city with a couple of cheap second-floor rooms for rent. It was so hot during the night that I had to get up and run a bathtub full of cold water and lie in it just to cool off. Venice was so packed we had to stay outside the city and take the bus into Piazza San Marco. There I was refused admittance to St. Mark's Basilica because I was wearing a sleeveless dress. Europe had become so crowded with tourists, mostly Americans, that it wasn't worth fighting anymore.

Our last stop was Rome where we found Alitalia on strike. Fortunately, flights to Tripoli were not affected. Before leaving, we went to the Borghese Gallery, to the church of St. Peter in Chains to see Michelangelo's Moses, the Capitoline Museum to see the poignant sculpture *Dying Gaul* and the bronze *She Wolf of Rome* suckling Romulus and Remus, and finally the Colosseum where we climbed to the top in spite of the heat. Our last evening in Rome we went to the Piazza Navona to see the Bernini Fountain. Fellini was there getting ready to shoot a part of *Fellini's Roma*. It seemed as if we had been away for a long time. If we didn't see it all, no one could say we didn't try. On Friday, August 6, after nearly two months on the road, we boarded an Alitalia flight to Tripoli. Home.

We returned to sad news. Josephine had been staying with our neighbors, and during the summer their yard was invaded by snails, so they sprinkled snail pellets all over to get rid of them. Josephine ate some and

died. They felt terrible, of course, and so did we. She was a sweet little girl, a good friend. They buried her in our backyard.

Mobrouk was faithful all summer. The house was clean and the plants were flourishing. Many houseboys took the summer off while their employers were away. Not Mobrouk. He was our age, thirty-two, not exactly a boy, and he moved so fast he made me dizzy. His primary job was a gofer at the Ministry of Information. The probable need for a second job was his family of a wife and five children. He spoke Arabic, pidgin Italian and English, but could neither read nor write. He called me "Signora" and Peter "Mr. Noma." Libyans pronounced "P" as "B" and had difficulty with "W", so Peter Nowell came out as "Beeter Noma," Pepsi was "Bebsi." "Stopped" was "istobbid" and "eggs" were "eggis." Arabic books read from back to front and individual lines from right to left. I learned several words including "floos" which meant "money," "mumpkin" meaning "possible," and "mish mumpkin" was "not possible." I had one full sentence mastered: "Ana medreset fe cherkat al betrol." "I am a teacher at the Oil Companies School."

School started again on September 5. That gave me time to get things in order both at home and at school. We bought a brand new no frills white VW bug, named her Velda, and hoped to have better luck with her than we did with Freddie. Unlike the previous year, OCS ran smoothly all fall. We had the odd unexpected holiday but no closures for cholera or other health reasons. Our English department had five teachers and a schedule that was any English teachers's dream. Students took their regular English class every day for instruction in grammar, composition, vocabulary, and the history of the English language. Every other day they met for literature and read books by authors from Sophocles to Faulkner. The list included *The Iliad* and *The Odyssey, A Midsummer Night's Dream, Animal Farm, Frankenstein,* and *The Red Badge of Courage*, to name a few. Students brought selected works to life by dramatizing scenes from *Great Expectations, A Tale of Two Cities,* and *Romeo and Juliet.* Speech was also available as an elective. To fulfill an assignment for a "speech to inform" in my class, ninth grader Ron brought his horse to school and on a bright sunny day our whole class marched out to the parking lot to see him demonstrate how to put a saddle on a horse. The horse seemed to enjoy it and so did we, especially since we were all pretty sure we would never

have an opportunity like this in the States.

<p style="text-align:center">***</p>

The last weekend in September we were invited to a Libyan wedding in Homs, a village about sixty miles east of Tripoli. The groom, the mayor of Homs, was a friend of ours. Peter had a softball game at school, so I went with several lady friends. Libyan weddings lasted an average of four days. We got in on the last day. The celebration took place in a villa a few blocks from the center of the village. The men stood outside the villa or leaned against inside corridor walls. Women sat cross-legged on straw mats in the courtyard. Men and women did not mix. With my friends, I sat cross-legged on the floor until long after midnight studying the faces of women I had never seen before. These were country women, women of the desert. Their faces were dry and wrinkled, weathered by the sun. Their hands, hair, and feet were dyed with henna, and tattoos decorated their faces. They wore bright-colored lengths of floral cloth draped over one shoulder and belted at the waist. We could not converse, but by the time the evening was over their faces were burned into my memory. I felt as if I had known them all my life.

We drank sweet tea, ate candy-coated almonds, and waited. Every once in a while a Bedouin woman would get inspired, ululate, and rouse everyone in the room. We shifted around, exchanged bits of conversation, then settled down again. My friends and I felt accepted, much as one accepts that night follows day, but we were not extended any special welcome.

While the ladies sat on the floor of the courtyard conversing and observing each other, the bride and groom were in a room upstairs consummating their marriage. When the deed was accomplished, the groom would step out onto the balcony and display the sheet with blood on it to prove he had married a virgin. We waited and waited, but nothing happened. We had more tea and almonds. In the early hours of the morning, the groom stepped out and we all felt relief. Alas, no sheet. He went down to join the men for a break, perhaps for advice and encouragement. At that point, we felt the need to put our bodies to bed in the room we had rented, so we said our m'assalamas and left our Bedouin friends to wait for the

proof. On our way out, we met the groom in a corridor, shook his hand, and extended our congratulations. The marriage would have to be consummated without us.

The marriage contract, we were told, was also a divorce contract stating what each party got if the marriage didn't work out. If it didn't, all the man had to do was throw down three stones and say, "I divorce thee. I divorce thee. I divorce thee." A man could have four wives as long as he was able to provide for them equally. Later, when I talked to Mobrouk about it, he said he would like to have another wife. That way, if one got sick, he'd have a backup. Just for fun, I asked what he thought of my having more than one husband. He laughed and shook his head as if I had lost my mind.

<center>***</center>

The end of September brought Ramadan and a month of fasting for Moslems. During Ramadan, no devout adult Moslem ate, drank, smoked, or "engaged in pleasurable activities" from sunrise to sunset. They could rinse their mouths with water, and if a woman was pregnant, she could observe the fast after her pregnancy. The fasting was intended to help develop self control. Some suffered nobly. Others partied all night and suffered all day. Every evening at sundown the cannon went off in downtown Tripoli signaling that the day's fast had ended. One evening as we were having dinner at the Andalusia restaurant in the city, we watched several older Libyan men seated at tables, hands folded on their laps, bowls of shorba on the table in front of them. When the cannon went off at sundown, they slowly picked up a spoon, dipped it in the soup, lifted it to their mouths and took the first food of the day. They did not gobble their food as some might have done, but broke their fast with dignity.

After a month of fasting came the Eid al-Fitr or Festival of Fast Breaking. People decorated their houses and prepared special holiday sweets. They got up early, dressed in their new clothes, top to bottom, went to the mosque to say their prayers, then started the rounds of visiting friends and family. Kids got money, candy, soft drinks, listened to music, and played games in the streets. Celebrating went on day and night for three days. It was a festive, joyous occasion. Christmas, Arabic style. We

gave Mobrouk a wallet.

The evening of October 6, 1971, I was sitting at our kitchen table listening to the local radio station and waiting for my oatmeal cookies to bake when I heard the news that we would not have school the following day. Another holiday had been added to our already rather long list. This one was Italian Evacuation Day celebrating the eviction of the Italians, the latest group to be expelled from Libya. We were aware of their departure. Villas, shops, and personal goods of Italians were being confiscated. The cathedral was closed and the bells and chalices were now for sale in the Junk Yard. Stories of desperate attempts to save valuables circulated in the ex-pat community. Women hid jewelry in their wigs on their way out of the country. Our friend Gloria smuggled Father Polycarpo's robe and chalice to Malta in a suitcase. This made us all consider what we would take if we had to evacuate in twenty-four hours.

Italians had been a major presence since they invaded Libya in October of 1911. They made positive contributions to the country in the form of schools, banks, roads, farms, and businesses. During their stay, they were the minority, but held the good jobs and political power. Mussolini was the first Italian to make a serious effort to take over the country, and over about a ten-year period, he did. During that time, reports circulated of rapes, civilian bombings, throwing Libyan prisoners out of airplanes, and running over them with tanks. The Libyans were poor, uneducated, inexperienced, had few weapons, and were unable to defend themselves. On September 16, 1931, Libyans were forced to watch as their eighty year old resistance hero, Omar al-Mukhtar, "The Lion of the Desert," was hanged. That was the ultimate blow. If the rest of the world knew what was going on, they did nothing. Although the Italians currently living in Libya were not responsible for brutal past offenses, it was not hard to see why resentment lingered. With Gaddafi's backing, financial and otherwise, Moustapha Akkad produced and directed *The Lion of the Desert* in 1981. With Anthony Quinn as Omar al-Mukhtar and a cast that included Oliver Reed, Irene Papas, Rod Steiger, and Sir John Gielgud, it became one of the most popular films of all time in the Arab world.

A couple of weeks into October, we did it again. We got another dog, this one from our British neighbor down the street. This one was a black poodle puppy, the first and only dog for which we paid money. We named him Gus. When we brought him home I was horrified to find ticks in his little ears. I got the critters out, and although he let me know he thought I was torturing him, he was happier after the ordeal. Once again we went through potty training, about a month of Gus learning that he was not allowed to pee all over the floors. We were proud that he had only the occasional accident.

Halloween was soon upon us and trick or treaters dressed in costumes roamed the neighborhood streets ringing doorbells. Gus couldn't wait to answer the door and nearly wore himself out greeting the goblins. Junior high students held a Halloween Dance in the gym, had a contest for the best costume, and awarded a prize for the best theater flat depicting a Halloween scene. One flat that caught everyone's attention was the scene of a spooky looking graveyard overgrown with weeds and weathered tombstones on which were painted the names of selected faculty members. The name on Peter's headstone was "Peking Nowell" with the epitaph "Give the man credit where credit is due," a phrase he used often in his world history class. Art teacher "Sexy Rexy" was immortalized with "How he loved his 9th Graders." Math teacher "Chuckles" Wally's inscription was, "Let's have a quicky quiz."

During Thanksgiving break we took a quick trip to Malta and found the atmosphere changed from our previous visit. Prime Minister Dom Mintoff had denied docking privileges to the Sixth Fleet during the summer, and without the American sailors the island seemed deserted. Merchants and businesses were suffering financially. Still, Malta offered much to enjoy and explore. It was a remarkable place, one we hoped to return to often.

This little island had an intriguing history. In 1565, it was attacked by forty-thousand Moslems and two-hundred ships. During the first assault, eight thousand Moslems died in battle while the Knights of St. John lost only twenty of their men and eighty militia. The Knights that were captured or killed were decapitated and their heads fixed on poles. Not to be outdone, Grand Master Vallette reportedly ordered the decapitation of Turkish prisoners and shot their heads into the enemy lines.

When the Knights of St. John eventually defeated the Moslems, they became the heroes of the Christian world. Money poured in from the Pope and several European monarchs. The island flourished, and at one time Valletta had the greatest hospital in the world. Surgeons used the most advanced medical techniques, had plenty of medical supplies, and paid strict attention to cleanliness and hygiene.

Back home again, students and faculty started counting the days until Christmas Vacation. Students got in the spirit of Christmas rehearsing a Christmas program for the ex-pat community, bobbing for apples during homeroom parties, decorating the gym, dressing up for the Christmas Dance, playing in the band, and singing in the choir. This year's program featured "Omar the Two-Humped Camel," a song written especially for the occasion by the popular and talented Miss Guthrie and sung to the tune of "Rudolph the Red-Nosed Reindeer." Like Rudolph with his red nose, two-humped Omar felt out of place in a one-hump camel country, but in the spirit of Christmas he was made to feel welcome. It was a crowd pleaser.

My friend Helen and I planned another Christmas Open House in our villa on December 3 and invited about one-hundred friends to join us between 4:00–8:00 p.m. The day of the party we moved most of the living room furniture to the back bedroom and pushed the rest up against the walls. We decorated the place with pine boughs, lots of red candles, and two huge bouquets of poinsettias. During the course of my baking, I decided to make three giant androgynous gingerbread cookies for decoration. I cut out a pattern about sixteen inches tall, made the dough, rolled it out, placed the pattern on top of the dough, and cut. Each one took up an entire cookie sheet, and when I started frosting them, I decorated one as a Libyan lady in a barracan with only one eye showing. My gingerbread lady looked charming hanging on the wall behind the buffet surrounded by her male companions. Never mind that the heat from a hundred bodies in the room caused her full-length white frosting barracan to start dripping on the buffet. She got many compliments. We served a buffet of ham, roast beef, turkey, cranberry salad, several kinds of different nut and fruit breads, cookies and candies, and cranberry punch. A fire in the fireplace and Christmas music playing in the background made it a festive, cozy evening.

In a gesture of appreciation for work well done, or perhaps for other motives we didn't know about, Bob Waldum added 4 1/2 days to our Christmas Vacation, giving us a total of seventeen days off. This was great news to several of us who were thinking about traveling home to spend Christmas with our families. When we checked airfare, we found it was about $800 apiece, really too much for two weeks, so we went to our trusty travel agent Denise, and by the end of the month we had a special group fare of $515 each. We booked a 9:30 a.m. Alitalia flight to Rome on December 22, and a connecting flight to Chicago where we would catch an Ozark Airlines flight to Mason City, Iowa. Soon after we booked our tickets, we started counting the days until we would see our families. We got out our suitcases, rummaged through closets and drawers for the warmest clothes we could find, and started looking for someone to take care of Gus. In the end, we entrusted him to the care of our neighbors who welcomed the chance to make amends for the loss of our sweet Josephine. On December 22, fifteen OCS faculty members joined other Alitalia passengers bound for Rome. Everyone was in a festive mood, including the pilots who came back to the cabin before takeoff and invited one of our pretty young elementary teachers to join them in the cockpit for the flight to Rome. We made all of our connections, and at 10:00 that evening Peter and I arrived at the Mason City Airport, tired but happy. It was past my family's bedtime, but they were all there to greet us. After hugs and kisses, they packed us and our bags into the car and we drove home past snow-covered fields and festive displays of outdoor Christmas lights, nativity scenes, and decorations. Home at last, we stepped out of the car to a foot of snow and a frigid sixteen degrees, a difference of fifty degrees from the temperature we left in Tripoli.

Christmas is a major production for Norwegians, and my family was no exception. Bona fide Norwegian women made seven different kinds of cookies for Christmas, but in addition to working the 3:00–11:00 p.m. shift at Mercy Hospital in Mason City, my mother always exceeded that number. In the weeks prior to Christmas, her kitchen was transformed into a bakery and confectionary turning out scores of delectable cookies, candy, cakes, and puddings. She made my dad's Norwegian favorites: sviske-suppe, risengrøt, krumkake, sandbakelse, julebrød, Fattigmand's bakkelse, rosettes, lefse, and kringle. She made Russian tea cakes, spicy peppernuts,

and frosted sugar cookies in shapes of bells, reindeer, angels, stars, and snowmen. In addition to these, she made divinity and fudge, caramels and peanut brittle, not to mention the "real food," meatballs, potatoes, and lutefisk.

620 Ninth Avenue North was all decked out for Christmas. Lights glowed from the tree, and on the buffet in the dining room stood the hand-carved olive wood nativity set we had sent from Beirut last year. On Christmas Eve we put a festive cloth on the dining room table, set out the good china, crystal and silver, and enjoyed a dinner of meatballs with potatoes and gravy. A platter of lutefisk was passed around the table for the strong of heart. After dinner we gathered in the living room to hear Mom read Luke's account of the birth of Jesus, then we stood by the piano to sing Silent Night and other carols. After my father sang "Jeg Er Så Glad Hver Julekveld" (I Am So Glad Every Christmas Eve) in Norwegian, it was time for gifts. Norwegians always opened gifts when the Julenisse came on Christmas Eve, so we did too. The best gift was being home.

The day after Christmas we flew to Appleton, Wisconsin, to visit Peter's family and discuss hot topics like the Green Bay Packers, Bart Starr, and Ray Nitschke. We watched *All in the Family* and *The Odd Couple*, programs we had not seen for over a year, and got caught up on the news, some of it sad. The war in Vietnam continued even though 60% of Americans were against it. Not much had changed since we were last home, but we couldn't help thinking about the contrast between our lives in Libya and life in the U.S. We didn't know it at the time, but that would be our last Christmas at home for ten years.

1972

We were half-way hoping for a giant snowstorm so we would get stranded in the States with our loved ones, but no luck. We made it back to Tripoli on January 4, ready to begin a new year. After the deep freeze of the Midwest, the snowmen, skating rinks, lights, music, and warming houses, Tripoli felt tropical. The average daytime temperature in January was a pleasant 60°, warm enough to do some gardening. I mowed and watered the lawn and got some beds ready for planting flowers and the shamrock seeds I had bought in Ireland the previous summer. They liked sandy soil, and of that we had plenty. I hoped to have them ready for St. Patrick's Day.

Gus enjoyed his time with our neighbors and was happy to see us, but that changed when I decided he needed a haircut. I had never given a dog a haircut before, and the result showed it. The poor boy looked bad and he knew it. He was embarrassed to come out when we had company, but he got his revenge. My old Sears washer was on the blink, so I had washed every piece of laundry by hand and hung it out to dry. Gus got even with me by pulling my wash off the line and dragging it around the yard while we were at school. He got reprimanded, and for that he pretended he didn't know me.

The last weekend in January, our group of twelve intrepid explorers packed a picnic lunch, boarded our VW bugs, and followed our trusty guide Keith to Mizdah, a town in the Nafusa Mountains about 115 miles south of Tripoli. Located on the threshold of the Sahara Desert and the last village before the open desert, it was home to many of Libya's Berbers. For the first leg of the trip, we took the Gharyan Road which was paved, but ribbons of drifted sand of various heights made it a driving hazard. The drifts looked soft, but they were as hard as a speed bump. If a driver hit one at high speed, the vehicle and everyone in it went airborne and landed with a jolt for both passengers and suspension. We learned our lesson.

As our fleet of VW bugs headed south, we passed Roman mile markers, an occasional tall spire of stately clay blocks which Keith told us were mausoleums, wandering camels, and flat barren stretches of ubiquitous red sand. Just before we reached Mizdah, we ventured off the main road onto a camel path and our hearts dropped as we felt our VW's back tires slowly sinking into the sand. We got out of the car, sized up the situation, and were relieved when veteran campers in our group came to the rescue. Time after time six strong men grabbed our back bumper, lifted the rear-end of the car, then pushed, kicked, and scooped sand into the depression left by the tires. Each time, we ever so gently inched ahead, and with a sigh of relief reached a surface solid enough to support us. We were learning the ropes of desert travel.

Since no olive trees were in the area to provide shade and we had nothing on which to sit, we circled the wagons and stood by them while we ate lunch. Our picnic consisted of meatloaf, cheese, or tuna and harissa sandwiches, carrot and celery sticks, and dill pickles so juicy we sprayed ourselves and each other when we bit into them. This struck us as hilarious. We topped off our picnic with homemade cookies and a drink of cold water from a clean Clorox bottle filled with water and frozen to stay cold for our travels. The food was good and a Lawrence of Arabia style sand dune provided pleasant scenery, but we soon began to feel a call of nature. We searched in vain for a bush big enough to offer some privacy, but not even the occasional scrub brush was available. We finally agreed that everyone would turn their heads while we went off in the distance to take care of business. Nobody peeked. In time we became comfortable enough to return from the bush and report on shape, size, and volume of our efforts to gales of laughter from fellow campers.

Wednesday, February 16, 1972, students and teachers were given another unexpected day off. This time it was the Lunar New Year, 1392 by the Moslem calendar. Our group of campers took advantage of the holiday

71

to go on an overnight campout to Nalut, a village south and west of Tripoli, about forty miles from the Tunisian border. The inhabitants were descendants of the ancient tribe of Berbers. Indigenous to North Africa and once the dominant ethnic group, Berbers retreated to the desert or remote mountain areas like Nalut to escape Arab invaders. They were blonde, blue-eyed, and friendly. They were "Arabized" as Islamic forces spread throughout North Africa, but the ones we talked to considered themselves different from Arabs. They preferred to be called *i-Mazigh-en* which means "free people" or "noble men." They identified with their families, clans, and tribes, and were unified by their language which consisted of many dialects, some in danger of disappearing. We were told that when the Italians occupied Libya, Nalut was the last city to capitulate. The town itself is perched on top of a mountain in the Jebel Nafusa Range, about two-thousand feet above sea level. It looks out over a vast, barren plain and has sometimes been referred to as "The Eagle's Nest." The locals we talked to told us that the natives were starved out, not defeated, and committed suicide by throwing themselves off the pinnacles rather than yield to the Italians.

This time we did not get stuck in a sand dune, but we got caught in a raging sandstorm. At high noon we still couldn't see three feet ahead with our headlights on. Even with windows closed, sand filled the VW. We had to put wet cloths over our noses and mouths in order to breathe. When we finally stopped, we found that the sand had worn much of the paint off our license plates and some off the cars themselves.

We set up camp, but the sandstorm raged on through the night. Finally, a few of us decided to try the hotel in the village. We did not have great expectations but thought we would at least be able to breathe. About 9:00 p.m. we checked into "The Nalut Hilton." The friendly concierge took us to a large room with several iron cots, the legs of which were standing in cans of kerosene to keep the cockroaches at bay. Indentations of the last guests' heads were still on the pillows. We suspected the beds had small occupants, so we put our sleeping bags down on them, laid our weary bodies down and nodded off to the sound of howling wind, blowing sand, and

the smell of kerosene. When we woke up we were relieved to find that if there were fleas, they weren't interested in us. We had nary a bite.

The next day the wind vanished, the sand settled, and the day was sunny and warm. We joined our group and visited three ancient Berber grain banks, some of the best preserved in the world. To get inside, we were told to contact the eldest person in the village or the mayor who had been entrusted with the twelve-inch key that would allow us to enter. We located the mayor, and when he opened the door we walked into a large round courtyard encircled by a high wall made of mud bricks and stones and fortified against thieves. The wall had three tiers of nearly four-hundred compartments in which families stored their oil, grain, and other crops. The upper levels were reached by primitive wooden ladders and scaffolding. At times, we felt as if we were walking through a set of *The Flintstones*. These grain banks were at least a thousand years old. They were in such good shape many residents of Nalut still used them.

When we returned to Tripoli we were informed that we had yet another day off, this time for the National Elections on Sunday, February 27, 1972. We couldn't vote, but it didn't matter. We knew who was going to be elected. We were required to take off all the days that Libyans did, and we were beginning to feel resigned to it.

The month of March came in like a lion. The wind was ferocious. It howled so loud outside our villa windows that we felt as if we were in a ship at sea. When I drove down by the shore and looked at the twenty-foot waves pounding the coastline, I was thankful to be on dry land. The storms continued for a week, the sand got into every nook and cranny of the villa, and we lost our power and water for thirty-six hours. Malish. Being without made us appreciate it that much more when it returned.

About this time of year, Superintendent Bob Waldum left for the States to recruit new teachers. Just fifteen minutes before he left for the airport he called me in for my evaluation. He said he was happy with my work and gave me a $1,200 raise. That bumped my salary up to $11,010.00. Peter got a raise as well, and we were covered by Blue Cross International Health Insurance. We decided to stay another year.

One weekend in March when the weather settled down, we were invited to a Libyan farm for lunch. It was owned by Mohammed, a man who started working as a truck driver and over time made himself a millionaire. His home was impressive, more like a ranch than a private residence. He had a zoo with a well-fed tiger, a baboon, gazelles, horses, peacocks, and parrots. Caretakers fed the tiger raw steak and every now and then, a live lamb. Mohammed was a friend of a faculty member and came to the school's rescue on several occasions.

Gus was beginning to give us problems. He was a needy dog. He loved to be petted and wouldn't take "No" for an answer. Even when I sat on the couch writing my weekly letter to Mom and Dad, he put his nose on the page I was writing. Evidently his need was greater than we could provide, so he started escaping from our yard and running away with Rags, the next door neighbor's dog. We could not figure out how he was getting out. Our villa walls were high, and our wrought iron gate was secured with a substantial chain. One of the first times he went missing, we got in the car to track him down and finally found him in a Libyan's yard. In Arabic, I excused myself to the woman, pointed to Gus, and told her I had a "mish qwais kelb." A bad dog. She laughed, I grabbed the runaway, and we returned home.

As mentioned before, every year at OCS the NJHS Induction Ceremony was held on or about George Washington's birthday. The English teacher who had advised the Honor Society had returned to the States with her husband the previous year, and I inherited her job, time-consuming but rewarding. The day was combined with a Patriotic Assembly and declared a Dress Up Day in honor of the occasion. The gym was decorated in red, white, and blue. Candelabra held candles representing the five qualifications for admittance: Scholarship, Leadership, Citizenship, Character, and Service. Chairs were set up on the gym floor, and the bleachers were pulled down for the overflow audience. This year a guest speaker from the U.S. Embassy, Mr. Kallas, spoke about patriotism in Tripoli. He said that in America's early life, she required foreign aid, and now that she was strong, we as Americans should help fledgling countries.

On the day of the ceremony, parents who had secretly been informed of their son's or daughter's election to the organization came to campus early and were secreted away in the Athletic Director's Office until the appointed time. The highlight of the ceremony was the "tapping." The unsuspecting but hopeful students, who needed to have maintained a "B" average and fulfilled all the other requirements of the organization, waited in the audience for a tap on the shoulder by a faculty member. The gym was silent. Teachers, all of whom had been coached in advance, rose from their seats one by one and began to "search" for their student. Some wasted no time, but went directly to the student, tapped the new member on the shoulder, and escorted the boy or girl to the seats reserved for inductees. Teachers with a sense of drama generated suspense by pretending they couldn't find the student they were assigned to "tap." Lighthearted students with absolutely no aspirations to the organization relieved the tension by waving and shouting, "Here I am, Mr. Carden!" Eventually, each honored student was tapped on the shoulder then, amid cheers and clapping, escorted to the front of the gym. As the students were tapped on the shoulder to join fellow inductees, the parents were escorted from their hiding place to seats in the front rows to beam blessings onto a surprised son or daughter. The look on students' faces when they saw their parents was always one of complete surprise. It was a happy event, full of suspense and pride.

Often referred to as "Walking With The Teachers," many students considered election to the National Junior Honor Society their greatest achievement at OCS. Being elected to this prestigious organization was a vote of confidence for students who worked hard and perhaps did not fit into the popular social circles of the school. After the ceremony, honored students and their parents, faculty, and guests met in the library for tea and cookies. New inductees got NJHS pins, membership cards, corsages and boutonnieres. The surfeit of good feelings made the top-secret elections, clandestine meetings in the parking lot, private phone calls, and efforts to keep a secret worthwhile.

On Friday, March 17, 1972, the OCS men's faculty softball team was invited to go out to the desert to play a softball game with the employees of Occidental Oil Company, one of the five major oil companies supporting OCS. At the time, Occidental exported twenty-two percent of the total Libyan crude exports and was the leading single oil producer in the country. Wives and children got to go along to watch the guys play and cheer them on. Our private plane left at 8:00 a.m. and arrived about 10:00 a.m. The camp was located south of Benghazi in a vast, flat expanse of desert. As we approached, I expected to see oil rigs and derricks from the window of our plane. Instead I saw open flames shooting up out of the sand in three locations, black smoke, storage tanks, and several buildings of different sizes and shapes. The wells were all natural flow which meant the oil, called "sweet oil," didn't have to be pumped. It was safer to extract, easier to refine, and commanded a higher price per barrel than "sour" crude. We went into the control center and found a completely computerized operation. The fields where I came from were of corn, beans, hay, and oats, so the only previous exposure I had to oil fields was watching Jett strike oil on his land in *Giant* and John Wayne in *Hellfighters* putting out fires from wellhead blowouts all over the world. This operation was not at all what I expected. I was impressed.

Our hosts took us to their living and dining quarters, a solid looking concrete block and stucco structure that was a cut above the portable offices and other buildings in the camp. They fed us a sumptuous lunch of crab, shrimp, steaks, French fries, and soft ice-cream, a delightful change from the fare we had become accustomed to in Tripoli. The desert camps also had an unlimited supply of beer, so many took advantage of that. The workers had a swimming pool and an 18-hole golf course. All sand, as one would expect.

Wind and blowing sand nearly knocked us over in the morning, but the afternoon was perfect for a ball game. After lunch the workers lugged easy chairs and sofas out from their lounge for the ladies to view the game

in comfort. We felt like queens and burst with pride when our team caught flies and made home runs. Who won? No one really cared. We all did. We just reveled in the day and in each other's company.

After the game, we visited two camps, Occidental #103A and #103D, both oil and natural gas stations. Guys and gals piled in the back of Toyota pickups for the twenty-mile ride between camps. We were like a bunch of kids, laughing, carefree, hair blowing in the wind. Not a scrap of vegetation was to be seen out in the wide open spaces. It was a day to remember.

We got home about 10:00 p.m., tired and happy, but our joy took a nosedive when we walked into our villa and found we were without electricity and water, one more of the many power outages we had during the spring due to the rainy, windy weather. We did the sensible thing. Thought "Malish" and went to bed.

Shortly before Peter's thirty-third birthday on March 25, all OCS faculty members got their mandatory biannual cholera shot. The first day our arms got stiff and sore and we felt sleepy and lethargic, but our discomfort didn't last long. Some people got sick and ran a temperature. Everyone was glad to know we would not have to go through it again for another six months.

Our temporary discomfort vanished when the father of our Hungarian student, Andrea, showed up at school with a six-pack of Löwenbrau for Peter's birthday. Vilmos was the commercial attaché to the Hungarian Embassy in Tripoli and had access to delicacies of food and drink not available to common folk. His daughter Andrea came to OCS as a seventh grader speaking very little English. She had no friends, knew nothing about the American system of education, and knew no teachers. Her parents enrolled her on the advice of the family priest who said, "Just start. Someone will adopt her." That someone was Peter. Each day after school, she came to him for extra help and he was happy to give it. She took all her class assignments home, translated them into Hungarian, then back

into English. It was usually two o'clock in the morning before her work was finished to her satisfaction. Each day, she turned in perfect papers. She was a little black-haired, brown-eyed trooper, and for all her effort she won the Seventh Grade Achievement Award at the end of her first year, quite an accomplishment for a girl who didn't even speak English when she first enrolled. The following year she was elected to the National Junior Honor Society and completed grade nine at the top of her class. Today she has four grandsons and teaches high school English in Budapest.

But back to the beer. As soon as we got home, the six-pack of beer went immediately into the refrigerator to chill. The following day, Peter looked forward to going home after work and not necessarily drinking the beer, but admiring the sight of it on the refrigerator shelf. Imagine our dismay when we got home and found only five cans. We counted, then counted again. We were sure there were six. There definitely were six. We looked in the waste basket. No empty cans. We went out to the garbage can. Nothing. We concluded that it had to be our houseboy. We might understand him helping himself to the homemade stuff, but the real thing? Unthinkable.

"Mobrouk? Did you take a can of beer?"

"No," he said. "No take beer." Never having had any reason to doubt him before, we decided it was one of those mysteries of life and put it to rest. The next day when we came home, the lawn had been watered, the house cleaned, and on the kitchen counter stood a note that a friend had written for him:

Mr. Noma.
Dear Sirs,

 I was very sorry for any thing
was happened from me and the thing which
I had taken, it indicate to our friendship.
Please forgive me. We remain.

Yours faithfully

Mobrouk

Mystery solved.

On March 28 we had another day off, this time to observe British Evacuation Day. Officially it was a celebration of the day the British military forces were withdrawn from Tobruk in 1970. For us, and for most Libyans, it was simply a day we didn't have to go to work. I didn't mind. Easter came early in 1972, so after a day off thanks to the British, we had only two days to work before leaving for Easter Vacation. This trip involved both business and pleasure. I had lost two fillings, so I made an appointment with a dentist in Malta to have them replaced. After the dental work was taken care of, we spent a couple of days walking the narrow streets of Medina, enjoying the sight of horse-drawn carriages and bread wagons on Kings Way, treating ourselves to bacon breakfasts and pork dinners, then on we went to Sicily.

When we arrived, Mt. Etna smoking away. One of the Earth's highest and most active volcanoes, Etna was visible from almost every part of the island, including the hotel in Taormina where we were staying. Ancient Greeks believed Etna was the home of the Cyclops and Vulcan, the God of Fire. Sicilians considered the volcano both a curse and a blessing. It could be destructive, but it also provided rich volcanic soil for their crops and vineyards. We drove up the volcano as far as we were allowed on a road that had been graded through a thick black lava flow. One flow was three-hundred yards wide and still warm from the 1971 eruption. I stepped out on it but jumped back onto the path when I felt my feet warming up. Standing on a hole that I knew went all the way to the center of the Earth was a first time experience, and it was slightly unsettling. Another lava flow went right through a bright yellow wooden house and seemed a perfect metaphor for the brave souls who lived in Etna's shadow. Half of the house was untouched, and the owners simply built on to the part that was

left standing. I'm not sure it was allowed, but I took three lava samples. I didn't think anyone would miss them.

Unlike sunny Malta and Sicily, the spring of 1972 in Tripoli was long remembered for wind, rain, and power failures. The temperature at night was so cool that as late as the first of May, I kept a fire going in the fireplace every evening. Everyone groaned about the amount of rain we had and only later did we discover that the clouds were being seeded as a part of an irrigation program. That explained why everything looked lush and green and my flowers and grass were flourishing. If only we could have the rain without losing our power and water supply, we would be less likely to complain. Blackouts were so common that our movie theaters posted signs saying: NOT RESPONSIBLE FOR POWER FAILURE. In other words, no refunds. If we weren't having a power failure, we often had a surge. During one terrific power surge, my refrigerator blew up and the pipes on our neighbor's water heater burst spewing hot water all over their villa. It was getting harder to say "Malish."

The first weekend in May, my friend Mary and I paid a visit to the Junk Yard. The Junk Yard, I must explain, was not a dump, but a series of stalls with appropriated or abandoned goods from confiscated villas, churches, and cathedrals in Tripoli. Each stall had a "dealer" with whom one negotiated when a treasure was found. Grabby Feely was the dealer in charge of one of the more popular stalls with ex-pats.

Grabby was a loose-faced, one-eyed man of indeterminate ripe age. He slept in his day clothes and smelled of stale booze. He drooled when he spoke and his voice gurgled like a bubble that needed to burst. His stall was as filthy as he was, but his long tables of antique brass and copper pots and trays, cathedral bells, and Stalin medals held such allure that we couldn't resist. On this particular day, I found a huge heavy copper cauldron with brass handles, hand made by the Bedouin. As I worked my way down the length of the tables absorbed in my find, Grabby Feely magically

80

appeared behind me and grabbed a piece of my backside. I looked up in surprise at his leering pockmarked face, grabbed my prize, and hustled to the front of the stall to pay. When we got to the car, Mary asked the usual question. "Did he get you?" I replied, "Of course. He always does. That's part of the bargain."

So, Grabby Feely got his feel. I got my cauldron. I planned to enjoy my prize for a lifetime. Grabby had only fleeting memories. I got the better end of the bargain. My cauldron was still black, but I heard that I could get it cleaned at one of the shops in the copper souk in the Old City. There I found an old man who dipped copper pieces in sulfuric acid, heated them, scrubbed and shined them. For this he charged $3.00. And he didn't pinch.

As we later found out, Grabby Feely was a nuisance compared to the Bum Biter. Standing in my kitchen one Saturday morning and having a last spot of coffee before Mary came to do some shopping together, I heard someone scream my name. I rushed out of the villa to see Mary running down the street chasing a man in his early twenties. It was the Bum Biter. His moves were calculated. Spot a victim with bags in both hands, wait until she was engaged in opening a gate or door, run up behind her, drop to his knees, bite her on the bum, and run like hell. Mary called out his license plate and I wrote it down. Somewhat shaken, but with her British stiff upper lip intact, Mary came inside, and after a cup of coffee, we carried on with our day as planned. The Bum Biter was eventually caught, and in time he became just one more mind- boggling story.

Year end activities abound in every school, and OCS was no exception. The Drama Club put on a production of *Our Town*, and the band and chorus presented music from *Jesus Christ Superstar* at their annual Spring Concert. Students exhibited their projects at the Science Fair and Art Show and were honored for their achievements at an Awards Assembly. They showed off their natural and cultivated gifts at the Talent Show and their athletic ability at Field Day. They even enjoyed a good-natured but now

politically incorrect Slave Day. At the Spring Bazaar, the Dunking Booth was especially popular this year since Peter agreed to be one of the dunking victims. Ninth graders celebrated the end of the year with a Prom at the Uaddan Hotel, a hotel and casino dating back to 1936 and once known the "Waldorf Astoria of Tripoli." It overlooked the bay, had a 500-seat theater, and in the good old days, a casino. Students dressed to the nines, dined on fancy finger sandwiches and cream puffs, and led by the Prom King & Queen, danced the evening away to music provided by a group with the attention grabbing but innocuous-by-today's-standards name of Brain Damage. Finally, the Class of 1972 said goodbye to OCS with the class motto "Come, let us build tomorrow from the experiences of yesterday."

In addition to all of these activities, we had to squeeze in two more holidays, Mohammed's birthday and Sudan Independence Day. In light of this, during the winter months I covered heavy-duty participles, gerunds, infinitives, the *Odyssey* and *Iliad*, and saved speech and poetry for the spring. Both subjects lent themselves to student involvement, didn't require exams, and could withstand the inevitable unscheduled holiday or early dismissal. One product of the poetry unit was a ditty that students made up and chanted as they came into my classroom.

"Ben Gashir, kwayis kateer. We drink it instead of beer." Ben Gashir was fizzy bottled water. "Kwayis kateer" meant "excellent." What could I say? It did rhyme.

At home, I worked hard to get everything in order before we left for summer vacation. I cleaned closets and cupboards, refrigerator and stove, and got things stored away for the summer. Our next door neighbors were preparing to move home to Pittsburgh and asked if we wanted to send anything back to the U.S. in their shipment, so we took them up on their offer. We packed up five handmade Bedouin pots that I got at the Junk Yard, my Grabby Feely cauldron, a copper pail, kettle, and round colander, and took them next door. Our villa looked bare without our treasures, but it was hard to pass up this opportunity. They would ship our goods on to Appleton when they arrived in the States, and we looked forward to having an interesting collection by the time we moved home. Lois and Stan were good

neighbors, and I was sorry to see them leave. If we were working late, Lois might pop over with a piece of carrot cake for us, and we could always count on them to take care of our dogs when we were away. Now we needed to find a new dog sitter. Fortunately, it wasn't hard. Our neighbors across the street had a soft spot for Gus and agreed to care for him. He was beginning to look like a hippie, so I gave him a summer haircut and a bath, then dried him with my hairdryer. This time he loved it. Finally, I went up to the campus to clean my classroom, take inventory, and finish up my records before turning them in. It had been a good year. The students did everything we required and more.

A few days before leaving for vacation, we were invited to dinner by the German Ambassador to Libya. As we turned into the residence, we were stopped by guards and felt slightly nervous, but we were waved on through. At the end of the lane, we were greeted with courtesy and grace by Herr and Frau Ambassador and their son, our student. The German Embassy was a three-story stately mansion complete with butler, cooks, and servants, but somehow we were made to feel relaxed and at home. It was a warm Mediterranean night, and dinner was served on the terrace under umbrellas and a full moon. Surrounded by luxurious bougainvilleas, azaleas, and hibiscus, the setting seemed like a dream. We felt as if we had taken a turn onto a road that led to another world.

Back at our villa, on a more modest scale, I had the junior high teachers, secretary, principal, and superintendent for lunch, forty all together. We had homemade pizza, Pepsi, and hot fudge and strawberry ice-cream sundaes. It was a good way to end the school year.

<p style="text-align:center">***</p>

Since we had spent the previous summer in Europe, we planned to explore Greece, Yugoslavia, Czechoslovakia, Hungary, and Berlin this year. Three teachers, two of whom were young single gals, planned to go with us. They loved to tease Peter, and he enjoyed teasing them back. We left Tripoli at 11:00 a.m. on a Monday, a little later than scheduled. We had

to wait for two Mirages to land before we could take off. So few passengers were on the plane that we were all asked to move up front for "balance." For some unknown reason, we stopped in Benghazi to clear customs, but the agents were very friendly. One asked where our babies were. We told him we didn't have any and he looked sorry for us. We landed in Athens about 2:00 p.m. The airport was packed.

We took a cab to the Dio Mia Hotel, 370 drachma a night, and a poor choice. The staff was petty, trite, and the epitome of poor service. We went to work right away trying to rent a car and secure visas for Hungary, Yugoslavia, and Czechoslovakia. Hungary was the only one we got, and that was a challenge. Our first stop was the Kosmos Travel Agency where we were told that to obtain a visa we had to go to a bank, cash travelers checks, then come back to the Agency and buy vouchers for expenses. We did that, and vouchers in hand went to the Hungarian Embassy where we finally got our visas. We had no luck with Yugoslavia and Czechoslovakia, but travel agents told us we could get visas for both countries at their borders. We did not need a visa for Berlin.

When we were not chasing visas and trying to rent a car to drive north, we wandered around the Plaka looking at the shops. We visited the National Archaeological Museum and saw the gold masks from Mycenae, one of which Heinrich Schliemann claimed to be the mask of Agamemnon. We visited the Acropolis, magnificent as always, but crawling with tourists. The effect of pollution on the surfaces of the ancient structures was all too evident. Sad as it was to think that the Elgin Marbles were in the British National Museum in London, at least there they were protected.

The next day the car rental agency delivered an orange VW to the Dio Mia without the requested luggage rack. Five of us were traveling together: Driver Pete and first passenger Ellie; Sue from Wichita Falls, Texas; Darlene from Mankato, Minnesota; and Helen from Mykonos. Five people in a bug left little room for baggage, so the luggage rack was a must. We waited until the car was returned with a rack and finally got on the road about 10:30 a.m. We stopped for gas and a cold drink, drove on to the toll

booth, then hailed Zeus and his court as we drove by the lofty heights of Mt. Olympus, an inspiring 9,573 feet high. It was easy to imagine the gods dining there on ambrosia and drinking nectar from golden goblets.

The road to Delphi, our destination, was narrow and flanked on both sides by steep ravines. As we rounded the sharp curve into the village of Aráchova, our orange VW smacked right into the front end of a local bus inching its way down the precipitous slope. In a heartbeat, the passengers on the bus swarmed around our car pointing fingers, shaking heads, and clucking their tongues. We got out of the VW, none of us hurt, and as soon as they discovered that we had a Greek in our midst, the locals changed their tune. The left front fender of the VW was demolished, but the villagers told us not to worry about it. Accidents happened on that corner all the time. They started smiling, crossing themselves, and saying how glad they were that no one was hurt. The police were kind, giving us neither a ticket nor a chewing out. We renamed the village "A-wreck- ova."

After all the paper work was completed, the car rental agency arrived to tow our damaged VW away. We grabbed our possessions, piled into a cab, and rode to Delphi, about two-thousand feet above sea level. It was an immaculate little village with a breathtaking view of the plain of Amphissa and the Corinthian Gulf. We checked into the Hermes Hotel, then headed to the ruins. It was still too early for swarms of tourists, the wildflowers were in bloom, and the only sound was the buzzing of bees. The aura was one of pristine solitude. It was easy to see why ancient Greeks chose this spot for their most important sanctuary, the Oracle of Pythian Apollo. Oracles were delivered by a virgin priestess who chewed on laurel leaves until she fell into a trance. Her prophecies were recorded by a priest and set in verse for pilgrims, kings, statesmen, anyone who asked. The answers were usually common sense solutions.

Although only the ruins of ancient Delphi remain today, it was easy to imagine the splendor of the place in its prime. Stirred by the glory that must have been, we sat at the Temple of Apollo until sunset, a quiet and majestic end to a frazzled day. We did not leave until the guard blew his whistle.

The next day we continued our adventure, this time in a blue Volkswagen. The road through the mountains was tedious and slow, and we were all still a bit shook up from the accident. Our destination was Meteora, a group of jagged stone giants rising up two-thousand feet from the plains of Thessaly. They were isolated, windswept aeries that one came upon suddenly, a sight so awe-inspiring it was hard to grasp. Wild and inaccessible, these pinnacles were chosen as far back as a thousand years ago by hermits and monks as places to get away from mankind and close to God. Gradually, they built over twenty small monasteries on the pocked, weather-beaten peaks. Today, only a handful remain. The word "meteora" means "hovering in the air," a perfect description of these monasteries.

At first, primitive ladders and scaffolds were the only way up the sheer sides of the cliffs. In time, nets were used to haul both people and provisions up, and eventually steps were carved into the sides of the rock. Roads came later. These we took to the Monastery of Barlaam which dated back to A.D. 1350. Barlaam was an ordained monk who after spending some time as a hermit, built this small church and a few cells for fellow monks. The exterior of the monastery was austere, but the interior walls were covered in lavish frescoes. The treasury contained richly embroidered vestments, illuminated manuscripts, relics of saints, and a priceless library.

At Barlaam, the monks told us about St. Stephen Nunnery where only women could visit, so that was our next stop. When we arrived, we four ladies got out of the car and knocked on the door. The nun in charge opened the door just a crack, looked us over, and told me in sign language that only I could come in. I was the only one not wearing a miniskirt. I took my tour, then went out to the car where I found three very disappointed women. It didn't take long to make the decision. In the passenger seat, I draped a jacket over my lap, wriggled out of my long skirt, and handed it back to Helen. She put it on and made her way to the entrance where she was admitted without question. Sue followed, then Darlene, as for the next half hour, suspended at the top of a mountain, we played musical skirts. Peter was highly entertained.

We were not allowed to drive a rented car out of Greece, so we managed to get as far north as Salonika, then four of us boarded a train to Yugoslavia. Helen had returned to Athens after Meteora. Our first look at Eastern Europe was one of contrasts. From the train windows, the cities looked bleak. We stopped in Skopje, deserted and depressing on a Sunday afternoon. Several of the buildings, gray and blocky, still had large cracks on their sides, the result of the 1962 earthquake.

The following day we rented a car and drove through the magnificent countryside of Macedonia. Fields were bursting with sunflowers, tomatoes, wheat, corn, and plum trees. Women in the fields wore long, colorful pantaloons tied at the ankles. They worked alongside the men using primitive handmade wooden rakes, pitchforks, and wagons. The farm buildings were quaint, dark gray, and squat. Storks built giant nests on the thatched roofs, usually next to the chimney.

When we reached the Adriatic coast we stopped at the medieval walled city of Dubrovnik, the "Pearl of the Adriatic." It stood on a promontory, the city walls rising right up out of the sea. It was one of the most intact walled cities in the world, pretty much unchanged since the late 17th Century. At the time of our visit, cobblestones in the square around the church of St. Vlaho were worn so smooth that they shone like polished ice. The city venerated its churches, convents, palaces, and charming old homes on narrow, winding streets. An intellectual center for centuries, just being there inspired one to take time out to consider poetry, music, drama, and the finer things in life.

We checked into the Hotel Argentina, $14.00 a night, got a laundry bag and turned in the clothes that needed washing, then went down to the beach and swam in clear, cold, water with the fragrance of freshly cut watermelon. The evening was balmy, so we dined outside on the hotel terrace under a vintage grape arbor. Our view of the Adriatic and the walled city below was a sight beautiful enough to inspire romance, and sure enough, it did. Sue was hustled by our waiter who took us all to a dis-

cotheque later in the evening.

I hoped nothing would ever happen to this rare city, but in 1991 the Yugoslav People's Army bombed the Old City in an attack that shocked the world. Dubrovnik, a UNESCO World Heritage site, was supposed to be spared from attack, but it wasn't. People were killed, the ancient walls sustained over one-hundred direct artillery hits, and intensive shelling damaged the marble streets as well as over three-hundred baroque buildings. When the attacks ended in 1992 the estimated cost of reconstruction was ten-million dollars. Even the Hotel Argentina was shelled from both land and sea. Now renovated, the same room we had in 1972 would cost $486, breakfast included.

When we left Dubrovnik we drove through mountainous, rugged country on narrow roads that were full of potholes and had no guard rails to prevent vehicles from plunging down the steep cliffs. The pollution-spewing trucks were impossible to pass, so we were stuck at a maximum speed of thirty to forty kilometers an hour all day. We drove by Sarajevo, stopped in Belgrade, and eventually made it to Budapest, the "Paris of the East," just in time to celebrate the Fourth of July.

Buda, located on the hills of the west bank of the Danube, and Pest, spread out on the flat east side, were joined by eight elegant bridges, all of which were blown up when the Germans retreated in WWII. During the uprising of 1956 the city was also severely damaged, but like the Hungarian spirit, Budapest kept rising from the ashes. Hungarian soldiers, we were told, shot rifles into the sky to bring down Russian planes in '56. On the banks of the Danube stood the stately neo-Gothic parliament buildings and government offices. Only the lurid Red Star marred the façade.

Andrea, our student at OCS, met us and along with her family took us to the National Museum, St. Stephen's Cathedral, Fisherman's Bastion, and the Castle, badly damaged during World War II, but undergoing reconstruction. Many of the Eastern European cities we visited were dull, drab, and depressing. Not this one. The people treasured their history and music. They relished their food and wine. Pride was written on their faces, and freedom was the sweetest word they knew. The night before we left we

went to the Citadel Restaurant, enjoyed chicken paprikás, a white wine called Debrui Harshlevilu; Barotszk, an apricot brandy; and a most entertaining group of gypsy musicians. We learned to say "Egészségére!" Cheers!

After two weeks in Communist countries, Vienna, our next stop, seemed upbeat, vibrant, positive, noticeably different. The Eastern Europe experience made all four of us appreciate living in a free country. Vienna was like being home again. We shopped the Mariahilfer Strasse, listened to open air concerts of Strauss waltzes, and watched older couples waltz gracefully together. We walked the banks of the Danube, rode the roller coaster and bumper cars at Prater Park, and spent a whole day at the Schönbrunn Palace visiting forty-five out of the total 1,200 rooms. The gold leaf, frescoes, immense tapestries, porcelains, parquet floors with different kinds of wood were rococo run rampant. The last evening in Vienna we went to see *The Barber of Seville* in the elegant Schönbrunn Theater. By the time we departed, my soul was saturated with beauty.

Clutching the visas we had secured at the Czechoslovakian Embassy in Vienna, we boarded a plane to Prague, an hour's flight away. We arrived about 5:30 p.m. and were shocked to find no hotel rooms available. An International Fly Fishing Competition was in progress, and the only accommodation we could find was a "Boatel," a houseboat on the Vltava River. It was comfortable enough, and from our window we had a perfect view of the Prague Castle on Hradcany Heights. Within fifteen minutes of our arrival, Sue had a proposal of marriage from a young man in the lobby who, besides admiring her porcelain beauty, was looking for a ticket to the West. She politely declined.

At one time Prague rivaled Vienna as a cultural center. Mozart lived in the city for a time, as did Dvorák, Kafka, and Jan Hus. The city was full of castles, churches, and palaces, mostly in the baroque and rococo styles, but we didn't even get a good start. The Boatel was fully booked. We had to leave the next day.

At 8:30 the following morning we boarded OK Airlines for a flight to Berlin. When we arrived, a passport control officer asked for our visas.

Brimming with self-assurance, we reminded her that we did not need a visa to fly into Tempelhof. Our mouths dropped when she said, "You're not in Tempelhof. You're in East Berlin." Duly humbled, we paid $5 for a visa, then were ushered to a bench in front of the terminal and told to sit there until a bus came to take us to West Berlin. We were as obedient as school children. Airport security watched us closely, but they seemed sympathetic. After a short wait, we boarded a bus that soon stopped for a mandatory border inspection. Mirrors were used on the underside of the bus to detect illegal aliens and contraband. They found neither so we went on, all of us breathing a sigh of relief.

When we arrived in West Berlin, we checked into a large, light, airy room at the Ariane Hotel, then went exploring on foot. One could not go far without encountering the twenty-nine mile scar that had divided the city since August of 1961. In front of The Brandenburg Gate stood a sign that read: "ACHTUNG! Sie verlassen jetzt WEST-BERLIN." "WARNING! You are now leaving WEST-BERLIN." It sent chills up our spine.

The following day we boarded a bus with other tourists and made our way to Checkpoint Charlie and a tour of East Berlin. Everyone snapped pictures as we passed through the Checkpoint, and as we entered the Eastern sector the contrast between the two sides was palpable. The West was modern, vibrant, flourishing. The East bleak, lifeless, depressing. Many buildings were pockmarked from bombing and shelling, and piles of rubble still stood in vacant lots. The ruins of the bunker in which Hitler met his end was deserted and overgrown with weeds. We thought that appropriate. Our movements were controlled by the guide at all times. We saw the changing of the guard at the War Memorial, the goose-stepping soldiers a chilling reminder of past power. We visited the Pergamon Museum and saw the impressive Pergamon Altar as well as the reconstructed Istar Gate and Procession Street, part of the walls of ancient Babylon. As we left East Berlin, our guide pointed out a tall television tower topped with a shiny metal globe rising up from the ruins of the city. When the sun hit it just right, as it did that day, the globe reflected a cross. This ticked off atheists in the city but emboldened the Christians. Back in

90

West Berlin we took a break from museums and historical sights to visit the aquarium, the zoo, and shops and cafés on Kurfürstendamm. Our final visit was to Charlottenburg Palace to see the bust of Queen Nefertiti. The spoils of war, again. It didn't seem right somehow, but my, she was beautiful.

After Berlin, Peter and I left the girls and made our way to Copenhagen where we met my Norwegian cousin Per and his wife Signe. We took the ferry from Helsingør to Helsingborg and stopped for a night in Göteborg, Sweden, before driving to Oslo. The day was warm and sunny, and the air was crisp and clean. In Oslo we stayed in a student dormitory at the University of Oslo where Per was completing a Master's Degree in fluvial geomorphology. We had to share a bath, but the rooms were clean and pleasant. Per said that during the school year, sheets were changed once a month. Students slept on one side of the sheets for two weeks, then flipped them over and slept on the other side for the remaining two weeks. On the day the sheets were changed, everyone went to bed early. Sending clothes to a laundry was extremely expensive in Norway. Dry-cleaning, too. It was cheaper to buy a new suit than to get one dry-cleaned.

We went to Bygdøy to see Thor Heyerdahl's *Kon-Tiki*, the balsa raft on which he and five companions crossed the Pacific in 1947. It took them 101 days, but looking at the raft, it seemed remarkable that they made it at all. In another building just a few steps away was the *Fram*, the sturdy vessel that Fridtjof Nansen and later Roald Amundsen used to explore the Poles. Close by was the Viking Ship Museum with the Oseberg and Gokstad ships. The Oseberg, the more elaborate of the two, was the burial ship of Queen Aasa, grandmother of Harold the Fairhaired. Their lines were exquisite, and I felt my Viking pride surge as I viewed them.

We stopped at the Munch Museum to view the paintings of Edvard Munch, the Norwegian artist who bequeathed his famous painting *The*

Scream as well as most of his other work to Norway. Finally, we couldn't leave the city without a visit to Frogner Park to see the sculptures of Gustav Vigeland, 192 of them depicting the journey of man from the womb to the tomb. Late in the evening, people in the park were still basking in the sun, men with their shirts off, women in their bras. The sun did not go down until almost midnight.

On the drive southwest to visit my father's family, we took a side trip to Rjukan, a town on the fringe of the Hardangervida, the largest mountainous plateau in Northern Europe. Here, during World War II, German troops invaded the Vemork Norsk Hydro plant and took over the heavy water project, a necessary ingredient in the production of the atom bomb. In 1943, Norwegian commandos parachuted into Rjukan to bomb the facility in a raid both dramatic and dangerous. The resistance movement eventually prevailed, but the town paid a terrible price. Hostages were rounded up and shot and the town was leveled by bombs and fire.

Our final destination in Norway was Frøyland, a place dear to my heart. Located in Hommersåk, a small village about a half-hour drive from Stavanger, Frøyland was my father's ancestral farm and the hub of the universe for everyone who shares our name. The 1850 wooden house, small and white, had a red tile roof, was surrounded by a stone fence, and at one time housed parents, twelve children, and a dearly beloved crippled aunt. A one-hundred year old oak tree spread its branches over the front yard, and a Viking burial mound stood near the old red barn. Hommersåk, with its natural harbor for ships, had been a farm settlement since Viking times. The Froiland family has lived there since 1492 and counting.

My father was born in 1905, the year that Norway gained its independence from Sweden. He grew up surrounded by mountains and fjords, the second oldest child in a happy and close knit family. As the eldest son, Torger had the right to inherit the farm, but in 1929 he left Stavanger on the *S/S Venus* with his sixteen year-old brother Emil and arrived in New York on the *RMS Aquitania* on September 6, 1929. It was not an auspicious time to arrive in the U.S., but Norway was so poor at the time he had to work twelve hours a day, six days a week just to break even. He did not

return to Frøyland for twenty-five years, but letters kept the family in close touch.

Listening to stories of my dad's family when my brother and I were kids, I couldn't wait to meet them, so in 1963 after my first year of teaching, my college roommate and I boarded the *Bergensfjord* and sailed away to the Promised Land. When I walked in the door of that little house at Frøyland, I felt as if I had come home. Aunts, uncles, and cousins were there to greet me, and although I had never met them, I knew them by name. Now, as on that first visit, the aunts fussed over us, fretting over us getting enough sleep and food. The latter was not likely since the Norwegian idea of hospitality was feeding one eight times a day. We ate fresh trout from Frøylandsvatnet "scientifically" fried by Uncle Arne, potatoes, and cream cakes until they came out of our ears. We drank good strong coffee, climbed Preikestolen, fished in the fjords, climbed steep stairs to tiny beds, then totally spoiled by doting aunts, loving uncles, and twenty-one first cousins, we said goodbye, flew to London, on to Tripoli, and back to work.

The enrollment at the Oil Companies School at the beginning of the 1972–73 school year was 750 students, K-9, down from 1,100 students when we first arrived. The Libyan government had begun the process of nationalization, and many families who worked for the major oil companies and service companies had been reassigned to other oil producing countries or packed up and sent back to the United States. Classes were smaller and more diverse. In addition to students from Texas, California, and Oklahoma, new arrivals came from Venezuela, Peru, Spain, Greece, Great Britain, Holland. The students lacked the homogeneity and camaraderie of the previous year's group, but they were a good bunch of kids.

By the end of September, the enrollment suddenly and unexpectedly skyrocketed. During the course of one week, seventy-five students were added to my classes. Desks were no problem, but books were hard to come

by. The cause of the sudden increase was the reconfiguration of oil company staff and students transferring in from other expatriate and Libyan schools. The result for me was a total of two-hundred students, five preparations, and six classes a day. The days of 125 students and two preps were over. The English department was not the only one affected. Other departments were overloaded, and elementary classes were bulging at the seams. One of our junior high English teachers was re-assigned to the elementary, and those of us who remained absorbed her classes. We were promised reinforcements at the end of the first nine weeks. That never happened.

To get away from it all, we spent the weekend with a group of friends camping on a beach about forty miles east of Tripoli. We left about 5:00 Thursday afternoon and got to our campsite, Garabulli, an hour or so later. It was a picturesque place with long stretches of sandy beach, sandstone cliffs, palm trees, and of course, the radiant Mediterranean. We set up camp, went swimming, then enjoyed a dinner of shorba, the traditional Libyan soup; kofta, a spicy ground beef mixture grilled on a skewer; fresh crusty French bread, olives, and brownies for dessert. We sang songs around the campfire, toasted marshmallows, and talked until the wee hours of the morning. The sound of the sea lulled us to sleep at night and woke us up at dawn. Watching the sun coming up over the warm, misty Mediterranean was like witnessing the dawn of civilization. After a quick trip to our designated bathroom dune, we got the coffee boiling and the eggs frying, then spent the morning swimming, strolling the beach, jogging, reading books, and toasting our bodies in the sun. At noon we roasted a whole lamb over an open fire. It was plugged with garlic and basted with lemon juice, salt, and pepper. Lamb never tasted so good.

On October 7, one month to the day before the Presidential election in the U.S., we got the day off for Italian Evacuation day, a harbinger of things to come for Americans in Tripoli. Many families employed by the oil companies were leaving Libya, and our school population was once

more declining. My teaching load was lighter, but the trend was not promising for our school. In a weak moment, I bought a huge heavy upright piano from one of the departing families. It was an old hulk of a thing, but it sounded fine. I couldn't have been more pleased with a baby grand.

Thanks to the holiday, we had three days off so sixteen of us packed up our VW bugs and drove four-hundred miles or so southwest to the town of Ghadames, the "Jewel of the Desert." Our trip took us deep into the Sahara, a word derived from the Arabic word for "desert." This three-million square miles of desert was more than sand. Much of it was rough, rock-strewn plains. We passed through high mountains in Yefren and Nalut, through deep valleys, salt flats, scrub brush, shifting dunes, steppes, tablelands, and oases with clusters of palms. Colors changed from hour to hour as the sun climbed into the sky then descended behind distant mesas.

Our destination, Ghadames, was a large oasis in the midst of this vast emptiness. The inhabitants were Tuaregs. They were of Berber origin and thought to be descended from the Garamantes, ancient Hamitic people who lived in the Eastern Sahara. Tuaregs spoke a language called Tamahaq and were the only modern Berbers known to have an alphabet. They were Caucasian, and in contrast to most Moslem societies where women had to be veiled in public, the men's faces were covered by a turban that left only a slit open for the eyes. Called a *tagelmust*, the covering acted as a screen from the wind-borne sand of the Sahara. Tuaregs have had the run of the desert for centuries, navigating by the sun, stars, rocks, and dunes. Proud and handsome, they called themselves *Imuhar*, free men. A Tuareg, veiled, tall, aloof, robed in black and seated on a white horse was a sight as regal as a king.

Ghadames was formerly a market for caravans traveling between Tripoli, Tunis, and the old Sudan, which included such remote places as Timbuktu and The Congo. Ivory, salt, and slaves were the primary commodities. We were told that the last slave was sold from the now silent slave market in 1927. A vast cemetery for slaves who died before they were sold stood on a hillside, their graves unmarked except for the occasional rock.

The old town, which had about a four-mile circumference, was surrounded by whitewashed walls with gates that opened up onto streets of sand. Outside the walls of the village, sand and palm trees stretched as far as the eye could see. Inside, a maze of dark, winding corridors passed right through the ground floor of some of the houses. Goatskins hung from the ceilings of the walkways, and on the day we visited, men with shovels and wheelbarrows were filling square wooden molds with mud to form bricks for their buildings. A mosque and graceful minaret looked down over the old town. Men had the run of the cool, troglodytic lower levels of the buildings, but the rooftops were reserved for women who chatted amicably and passed freely from one flat roof to the next. Even casting their eyes upon the rooftops was off-limits for men.

Whoever designed the buildings of Ghadames must have loved geometry. Sharp pyramid-shaped finials perched on each corner of the simple, flat-roofed exteriors of buildings, and doors and windows were a combination of triangles, rectangles, squares, and arches. Bars of decorative wrought iron scrolls covered the windows. The total effect was aesthetically pleasing. Water gurgling from wells, tall graceful palms, silent sand streets, and freshly whitewashed mud brick buildings created an atmosphere of quiet, clean contentment. The inhabitants, about seven- thousand of them at the time we visited, looked as if they wouldn't trade anything in civilization for what they had right there in the middle of the desert.

In contrast to the clean, white lines of the exterior, the interiors were bright and busy. From floor to ceiling, whitewashed walls were ablaze with red lattice designs, stylized trees, and frilly eight-pointed stars and triangles. On the walls hung colorful straw couscous covers, tiny mirrors, and hand-beaten copper pots. Rows of brass water cups hung from narrow shelves. A single vase of native pottery stood in its own little niche. On the floor, a profusion of straw mats, Persian carpets, and red and black striped Bedouin carpets mingled together, and pillows covered with Berber weavings rested against the walls. Recessed sleeping alcoves with canopies, pillows, and carpets looked like snug little Bedouin tents. Double wooden doors were wonders of color and design. Cool even in the height of sum-

mer, the rooms emanated comfort and cheer.

We had reservations at the Tourist Hotel and found the rooms clean and simple and our hosts warm and hospitable. After feeding us, they escorted us to a patio under a thatched roof to enjoy music and dancing. Accompanied by *darbukas*, hourglass-shaped drums made of pottery and goatskins, the chief musician, a sweet-faced blind man, entertained us with the *ghita*, a flute-like instrument that looked and sounded like a recorder. Women wrapped in floral patterns and polka dots sat on a colorful Bedouin carpet at the feet of the blind musician. A Taureg in a flowing tan and white striped kaftan danced for us, a white *tagelmust* covering all but his eyes. He came up to me, politely took me by the hand, slipped a long black kaftan over my head, wrapped a white hijab around my face and neck, then led me onto the dance floor. I attempted to follow the primitive dipping, twirling, swooping, movements of my partner, thankful that arm and hand movements were more important than my two left feet. My friends told me they couldn't tell which one was the Tuareg. They were kind. In the evening our hosts built a giant bonfire, and we stood around it watching the Dance of the Sword, the Dance of the Bedouins, the Dance of the Scarves, and the Dance of the Jugs.

The following day we drove to a point just outside of Ghadames where we climbed a bluff to see the remains of an old Roman fort. From this spot, we could look out over three countries: Libya, Algeria, and Tunisia. Before heading home we needed to fill up with gas, so we went to a fairly large modern looking flat-roofed building with not especially clean plate glass windows. In front of it stood a solitary primitive gas pump with a lever on the side, a device that gave new meaning to the phrase "pumping gas." We lined up in our little VWs and watched while the men of our company pumped the lever up and down to fill our tanks for the homeward journey. Every squeak of the lever echoed in the morning stillness. Red buckets of sand stood by the lonely pump in case of fire.

On the way to Ghadames and back we camped out. Along the way we saw Bedouin tents, primitive wells, herds of sheep, donkeys, and camels, all no more than a half-mile from the main road. I spied a Tuareg camel

saddle outside a primitive white stucco souvenir shop in the middle of nowhere and bought it for six dinar, about $21. We stopped to slide on the dunes, sat around the campfire after dinner, had long talks, and later settled in for the night under a canopy of stars. They were so brilliant and our campsite so dark and remote, we felt as if we were in outer space. People have never really seen the stars until they see them in the desert.

Meanwhile, back at OCS Villa 12, we had not seen our houseboy Mobrouk for a month. From the gaffirs at school we heard that he had been painting his house, but that didn't seem like a reason to be away so long. We began to doubt that we would ever see him again, and since he had the key to our villa, we made plans to change the lock on the door. In the meantime, Peter washed the floors and dusted the furniture, I did the shopping, cooking, and laundry, and we took turns doing the dishes. Together we tackled the task of bathing Gus, one to hold him, the other to scrub and rinse. When I was in the tub taking a bath, Gus wanted to jump in with me, but when it was his turn, he rebelled. When his bath was over and he was toweled off, he felt fresh and frisky. Peter and I, on the other hand, were exhausted.

Gus had been spending a lot of time with a girlfriend down the street recently, but we weren't overly concerned since he always came home to eat and sleep. One day on the way home from school we spied him with his beloved, a big, beat-up German shepherd twice his size. She was no looker, but he didn't mind. Gus loved everybody. Anyone who patted him on the head could walk in and take over the villa, something that had been happening frequently in the expat community lately. The father of one of our students woke up one morning and saw evidence that a burglar had been prowling through their villa during the night. Knowing he would get few if any results from reporting the intruder to the police, he decided to take the law into his own hands. For several nights he sat on the living room couch in the dark, his son's baseball bat at the ready. When robber

returned, the man barely breathed while in the faint light the unsuspecting interloper surveyed the room for loot. At precisely the right moment, Dad stood up, got into position, and took a mighty swing with the bat. The burglar fell to the floor, and without checking the extent of the damage, the man of the house picked him up, threw him over his shoulder, carried him out the front door, and rolled him over the villa wall onto the street. The next morning the thief was gone. The family was never bothered again.

The problem was so widespread that we began hearing rumors of enacting an old Islamic law against stealing. The penalty was cutting off the offender's right hand which, in addition to the pain and inconvenience, made one a social outcast. Eating from the communal couscous bowl with the left hand was tabu. That was the hand used to clean oneself after going to the bathroom.

Just as we were ready to give up on Mobrouk, he showed up. His hair was all shaved off and he had several deep scars on his skull from a terrible fall that he took while working on his house. We felt guilty that we had doubted him. He got right to work washing windows, doing laundry, and polishing floors. We were relieved that he had recovered and glad to have him back.

<p style="text-align:center">***</p>

Always behind on the news, we did not know the result of the 1972 presidential election when we went to bed the night of November 7. We listened to the election news on Voice of America until midnight, but there was a seven hour time difference. When I finally turned the radio off, Nixon was reported to be carrying every state but Massachusetts. The next morning we found out that Nixon had won with a 62% majority.

When November arrived we started planning for the holidays, and since I could not find several ingredients I needed for my Thanksgiving and Christmas baking, we found a cheap flight to Malta to buy finely ground salt and sugar, nuts, molasses, and candles, none of which were available on the local market. Flying to another country to shop for gro-

ceries was still new territory, but I was proud to return with everything on my list.

By the beginning of December, the poinsettias were once again in full bloom, the blossoms cascading like red waterfalls over villa walls. They arrived just in time for Christmas parties which, for us, began with a dinner at our superintendent's home in Gargour. Gargour was a suburb where the rich folks lived, heads of oil companies and their employees, Libyan doctors and lawyers. Bob's villa was an elegant, sprawling ranch-style house that could have been transplanted from an upscale Houston suburb. He had a live-in houseboy who took care of the domestic chores, served Bob's guests when he entertained, and cleaned up afterward. Bob had a massive dining room table with an inset revolving Lazy Susan. I was honored to be placed at the head of the candlelit table around which were gathered other couples, bachelors, and gorgeous single ladies on the faculty who made Bob the envy of his buddies. We never asked about Bob's personal life, and he didn't volunteer. He wore a chunky gold ring on the third finger of his left hand, and it was understood that he had been married, but he was now clearly a bachelor. He cultivated a debonair image, but there was never a hint of scandal concerning his conduct.

With December came sinus infections, sore throats, and so much rain that roads washed away and made driving hazardous. One day it rained for twenty-four hours, and all day at school we were without heat, lights, or water. I was relieved to get home, go to the bathroom, light a fire in the fireplace, and thaw out.

The evening before the annual Christmas dance we helped students roll back the bleachers in the OCS gym, decorate the stage, and paint eight-foot murals of turtle doves, French hens, ladies dancing, and pipers piping for "The Twelve Days of Christmas" theme of the dance. Every dance had to have a king and queen, and at this age the queen sometimes towered over the king by at least a foot. A few songs like "It Never Rains in Southern California" or Johnny Nash's "I Can See Clearly Now" brought students onto the dance floor, but most of the evening the boys, looking sharp in suits, double-knit sports coats, bell-bottom trousers and

ties, stood on the sidelines waiting for the food to be set out on long tables. Girls dressed in elegant long gowns or mini-skirts gathered in the bathroom to gossip about who was going steady or crying over who had broken up. In junior high, going steady was an agreement made beside one's locker in the morning and often broken by the end of the day.

We had discussed returning to the U.S. for Christmas, but in the end we decided to spend the holiday with friends from Dubuque who had asked us to visit them in Crete. Greg, a U.S. Air Force officer, was stationed at Heraklion, so on the evening of December 22 we were on standby in Athens hoping to catch an Olympic Airlines flight to Crete at 9:30 p.m. To pass the time we walked the empty sidewalks of a small suburb near the airport feeling lost and alone. Just as I was thinking, "What a way to spend Christmas," I heard the crackling of loudspeakers anchored on the lamp posts above us, and soon Mahalia Jackson's voice filled the night with her angelic version of "Silent Night." Her deep, rich voice gave hope to a little individual in a cold, dark world. I love that woman. As it turned out, we didn't have to worry about getting on the flight. The ticket agent told us they normally overbooked by 20%. The cabin of the plane was draped in festive evergreens, shiny Christmas ornaments, and tinsel. Islanders going home for the holiday were full of cheer and good will and sang their hearts out as we flew through the night to the island of Crete.

We stayed in a hotel in Heraklion but spent most of the time with our friends in their unheated apartment. Most of the year heat was not needed, but right now the place was as cold as a mausoleum. I felt sorry for them, but they didn't seem to mind. Christmas Eve we played games and exchanged little gifts, and Christmas Day we enjoyed a midday meal together. It wasn't home, but it was good to be with friends. On an after dinner drive through small villages near Heraklion we saw the islanders cutting up fat pigs for their Christmas dinner, and as we drove through the mountains, a shepherd with his herd of sheep emerged from the brush alongside the road. The man was bearded, his hair matted and uncombed, and he was wrapped in a coarse wool blanket. He carried a staff, and in spite of the cold, his feet were bare. He could have stepped right out of the

Old Testament.

Long, narrow, and covered with rugged mountains and barren plains, Crete is the largest of the Greek islands. It is claimed by some scholars to be the birthplace of civilization, and as we toured the island the day after Christmas we saw evidence of four of them: Minoan, Greek, Roman, and Modern. We visited the Palace of Minos at Knossos, the center of Minoan culture dating back to 2400 B.C., the Diktian Cave where according to mythology Rhea gave birth to Zeus, and Mt. Ida where his grandmother Gaea brought him for safekeeping. We stopped at St. Titus church, built on the site where Titus received a letter from Paul in A.D. 65, saw the famous white-sailed windmills of Crete, and took a quick look at Matala where during the sixties and seventies hippies, dropouts, and hitchhikers from Europe and the U.S. formed a commune on the beach and lived in man-made caves carved out of the cliffs thousands of years ago. The hippies had recently been kicked out by the church and local police for posing a health hazard.

In the Museum of Heraklion we saw the finest collection of Minoan treasures anywhere in the world including statues of Snake Goddesses, bare-breasted priestesses of the earth-mother. The youngest one was clutching a writhing snake, an ancient symbol of fertility, in each hand. On the main square, old timers sat under the trees playing backgammon and looking like characters from *Zorba the Greek*. Nikos Kazantzakis was born on this island. So was El Greco, but only one of his paintings hangs in the museum.

Glowing with happiness from spending Christmas with friends and saturated with memories of the treasures of Crete, we took a quick trip to Beirut before returning to Tripoli. We visited the Big Oriental Market in the city's duty-free zone and bought an 8'x10' Kirman carpet with a rich cream-colored field, center medallion and border in shades of smoky blue and sapphire, accents of milk chocolate brown, tiny highlights of mustard yellow, and stylized lotus blossoms, scrolls, and leaves. It had a retail value of $2,500, or so we were told. We bought it for $720 including shipping to Appleton, Wisconsin, but the price was inconsequential. The

minute the dealer rolled it out, it called to me. Still feeling spendy, we bought each other rings, an oval-shaped opal in a lacy gold filigree setting for me, and a heavy, rough 24-carat gold band in a 1,000 year old design for Peter. Good for a history teacher.

1973

We returned to Tripoli a few minutes before midnight on New Year's Eve, thankful that we had visas and work permits to present to customs officials. Tourists were in for a shock. As part of a recent effort to get Arabic accepted as an International Language, they were no longer being admitted into Libya unless their passports were in Arabic. One of our friends brought his parents all the way from Wisconsin for Christmas, but when they arrived at Tripoli International Airport they were immediately put on a plane to Malta. There they waited the twenty-one days required to retain their excursion fare, then back they went to La Crosse. We felt sorry for them, especially since the couple was older and not particularly adventurous.

The new year in Tripoli started with rain, rain, rain. For two weeks in January it rained so hard that the sand streets became saturated, many of them washing down to Zavia Road, the main thoroughfare and the only route we had left to get to school. Those streets still remotely safe to drive were gouged with deep ruts from cars driven by foolhardy individuals attempting to plow through the muck. Gullies ten feet wide and fifteen feet deep swallowed up unsuspecting drivers, and an ill-fated car or two was often trapped in them. Driving at night was perilous since only the main roads had street lights.

Villas were flooded. Two nights in a row our friend Keith woke up to a villa four inches deep in water. He saved some of his possessions by putting them up on tables and chairs, but he lost his handwoven rugs. After school, a group of friends got together and bailed him out. We took brooms to start the water moving then pushed the mess right out the front door. When we got it out, the men built a dam so the water couldn't get back in while the rest of us mopped.

About the same time our big old hulk of a gas water heater started act-

ing up. It stood outdoors in back of the villa by the bathroom window, and due to the rain, wind, and blowing sand, the pilot light would not stay lit. Every time we took a shower or washed the dishes, we had to go out and light it, often in the driving rain. On top of that, we ran out of kerosene for our space heater and had to depend on the fireplace for warmth. Cinder block houses, we learned, are great in the summer but cool off quickly in the winter without a heat source. Just when we thought matters couldn't get worse, the boiler at school blew up and for two weeks we had no heat in our classrooms. The boiler was so old that parts were not available, nor were the people with the expertise to repair it.

After a week of this, I was so tired of freezing that I risked the Wrath of Bob and wore a pant suit to school. Bob's dress code, you may recall, required skirts for women, and that was fine during hot weather. Winter was a different story, especially when working all day in an unheated classroom and going home to a cold villa. The day after my audacious act, all of the women on the faculty wore pant suits. And so the trend began.

Bob's dress code also required ties for men. On hot summer days men suffered, but they complied. A few sought relief by wearing Bermuda shorts, but ties stayed on even as temperatures rose to 100° or more. As women started wearing pants, I noticed the men leaving their ties at home. In spite of the changes, most of us still looked professional.

Just a little over a month after we purchased our Kirman carpet in Beirut, we received word from Peter's father that it had arrived safely in Appleton. The 8'x10' carpet entered the U.S. in Green Bay, Wisconsin, all scrunched up in a burlap bag. When Peter's Dad went to pick it up, the customs agent told him he had to open it. Ed said, "Open it yourself. And make sure you put it back exactly the way you found it." The agent took another look and decided he didn't really need to see it. We were relieved to hear it had arrived home safely.

Living away from twenty-four hour news coverage, we missed the gruesome daily reports of casualties in the closing days of the Vietnam War, but on January 27, 1973, when we heard the news on BBC that the Paris Peace Accord was signed, we rejoiced. I decided to commemorate

105

the occasion with a feast, so I made a pot of shorba, the spicy Libyan soup made from onions, tomatoes, lamb, chick peas, a sprinkling of orzo, and fragrant spices from the souk. They were a blend of ground cinnamon, all-spice, coriander, cumin, and fil-fil, red hot pepper that warranted a warning label. Water couldn't tame a fil-fil fire, so the soup was served with lemon wedges and piles of crusty French bread to mitigate the heat. Too tough for our Midwestern palates, I did not make the five-alarm version.

I mixed hamburger, onions, parsley, oregano, salt, cayenne pepper, and egg whites together to make kofta, formed the mixture into sausage-link shapes around skewers, and put them on the grill. I made tabouli, tzatziki, and hummus, but since I could not hope to equal the taste of fresh-ly baked pita bread, I drove to the bakery for a dozen pitas hot out of the oven. Still puffed up from baking when I put them on the passenger seat, their fragrance filled the car. It required character not to tear into them on the way home. Food is always a good way to celebrate special occasions with family and friends, and our guests enjoyed the feast. Dishes we had not heard of a couple of years earlier were becoming favorites.

Soon after this, a four-day holiday was announced at OCS, and while both teachers and students welcomed a break, too much time off had dis-advantages. Teachers anxious to get through demanding curricula found it frustrating to be faced with a four-day holiday just as they embarked on Caesar's campaigns, made the first incision in a frog, or introduced irra-tional numbers. It was hard to build up momentum in three and four-day weeks, and the pressure to complete courses was compounded by the pos-sibility that at any time we could be evacuated on a twenty-four hour notice. Just to be safe, we always kept our gas tanks full, our laundry up to date, and our official papers in order. The last week of January we scored the first five-day work week in ages, went home exhausted, but got more accomplished in one week than we had in the past month.

Sometimes these breaks were a blessing. The Lunar New Year was upon us, so we took advantage of a three-day weekend to go to Ghat, an oasis about 575 miles by air southwest of Tripoli and roughly forty-five miles from the Algerian border. Ghat is located in the Fezzan, one of the

three major regions of Libya. Tripolitania, where we lived along the coast with the majority of the country's population is in the Northwest, and Cyrenaica, the third region, is in the East. The purpose of our visit was a pilgrimage to see rare prehistoric cave paintings. Ghat had no hotel, so we wore grubby clothes and carried sleeping bags and backpacks with toothbrush, deodorant, and a little food.

At 8:00 on a Friday morning we took off in a beat up Yugoslavian Fokker that vibrated every minute of the 2 1/2 hour flight, but what a view we had as we looked out our windows. As far as the eye could see, sand dunes spread out like soft undulating ocean waves. Passengers with maps of Libya helped the crew navigate the way to our destination, and about 11:30 a.m. we touched down on a landing strip of packed sand and were immediately engulfed in a cloud of fine grit. The airport ground crew arrived in a Land Rover and started to tie the front landing gear onto the vehicle to turn the plane around, a mistake which our captain brought to a quick halt. The airport terminal was a small, square, cinder block building, and when we stepped inside, the wet, shiny tile floor still smelled of the oil that had recently been used to clean it. The whole village, or so it seemed, was there to greet us. They were completely isolated from civilization except for one flight a week that brought in supplies. They gave us a warm welcome, and we were delighted to step out into warmth and sunshine after a month of rain.

Our hosts shuttled us in Land Rovers to our sleeping quarters, three huge eighteen-man army tents with rows of iron cots lined up on each side for fifty of us. They sat us down and fed us bread, cheese, Pepsi, and tea. After lunch we stopped at a Garamanti grave site, then went on to caves and wadis where we saw breathtaking paintings of elephants, bison, giraffes, cows, ostriches, hunters, the sun and moon, all dating from 12,000 B.C. to A.D. 100. Declared a UNESCO World Heritage Site in 1985, regrettably many of the paintings have recently been looted or destroyed by vandals carving their initials over the ancient paintings or spraying them with graffiti. Thousands of years of history destroyed in a heartbeat.

The Land Rover ride to the prehistoric paintings was an experience in itself. First, I felt as if I had gotten on a vibrating machine for two more hours and was gratified to have some natural padding. Next, we got stuck in loose sand but followed the standard procedure of lifting the vehicle and filling the ruts in with sand time after time until we reached a level from which we could drive away. As a precaution, a goatskin filled with water for the radiator was attached to each side of the vehicle, but we did not need it. Finally, throughout the adventure, sand blew into the Land Rover from all directions, and when we returned to camp our hair was completely white. Malish. It was worth every minute.

That evening, dinner consisted of four goats roasted in an open pit by the Fezzanis and served to us in hunks as we stood around the fire. The animals were skinned, but otherwise whole: head, horns, feet, entrails. The eyeballs were reserved for honored guests, and thankful not to be in that category, I bit into my chunk of meat. Half-raw and unseasoned, the taste immediately triggered my gag reflex. I could not eat it, nor could several others in our group. Fortunately, Alex, the headmaster of the German school had smuggled a bottle of lime vodka in his sleeping bag, and that night we passed it up and down the line of cots taking one sip apiece to fool our stomachs into feeling comfortable enough to go to sleep.

The next day we drove to the Ubari Sand Sea and climbed a three-hundred foot sand dune. We were as excited as a bunch of kids to make what we thought might be the first footprint ever on the smooth surface of sand. Every time I took a step up the dune, I slid six steps back. Coming down was almost like skiing. I took off and used my feet as brakes when needed. Some rolled down, but I had to protect my camera. We were all full of sand by the time we reached the bottom of the dune, but we were so exhilarated we didn't care. We brushed it off as best we could.

Ghat had no real tourist shops, but one of the locals had a room full of trinkets, collectibles, and Tuareg artifacts in his villa. I spotted a Maria Theresa taler and was so surprised to find it in a place so remote, I bought it to use for a key chain. We left the "shop," and as we walked along the road of sand, a young man came up beside us shouting and gesticulating.

He said our school nurse had shortchanged the shopkeeper. She hadn't of course, so our hosts appointed someone to find a man who could mediate the disagreement. He returned in no time with a young Fezzani who spoke impeccable English. Cordial and welcoming as the rest of our hosts, he soon had the misunderstanding ironed out. Turns out our handsome young mediator had studied at Harvard.

We returned home from our adventure about 9:00 p.m. exhausted, sunburned, but feeling privileged to meet such hospitable people and see sights so rare. The night before we left for Ghat, I had set our alarm an hour earlier than usual to make sure we got on the flight. I was so enthralled with our experiences that I forgot to change the alarm back to our usual 6:30 a.m. wakeup, so I got up an hour early. I thought I felt a little more tired than usual, but I showered, dressed, and was ready to go to work by 6:00. Malish. I took a cat nap on the couch until it was time to leave.

After getting thawed out during warm, sunny days in Ghat, on February 5, 1973, it snowed in Tripoli. Well, not actually snow, but hail and lots of it. It accumulated in 1–2 foot drifts along the sides of the buildings on campus. Some of my students had never seen anything like it before, so I let them out of class to experience the novelty first hand. They lost whatever cool junior high students had, made slushy snowballs, and threw them at each other.

On February 21, 1973, on a regularly scheduled flight from Tripoli to Cairo, Libyan Arab Airline 114 was shot down by Israeli fighter jets. Controversy went on for days over who did what, but according to reports we heard on the BBC, the LAA's French pilot thought that he was flying over Egypt and that the planes were MIGs. In fact, he was over the Israeli-occupied Sinai and the planes were Israeli fighters. Israeli pilots claimed the French pilot disregarded all signals to land. Libya called the shooting a criminal act. Only five of the 113 passengers including the co-pilot survived, and tension in our ex-pat community was high.

At times like this, we called or wrote to our families and told them not to worry about the news they heard, and for the most part our day-to-day

lives went on as usual. When we knew there was controversy, we stocked up on supplies and stayed close to home. Americans who went downtown and got harassed during times of political unrest were more or less asking for it. It was best to keep a low profile until the storm passed.

After upsetting international incidents such as this, we appreciated days when nothing exciting was going on, days to read books, do school-work, enjoy a dull evening at home. They were hard to come by. To relieve tension, we looked for ways to have fun and entertain ourselves. One Friday night the ninth-grade boys played the male faculty in a packed, spir-ited game of basketball. The "old" men on the gym floor, many of whom had not played since grammar school, provided great entertainment and showed a surprising degree of skill. Everyone laughed at the teachers, but they ended up winning by a few points. It was a rare occasion, just like Friday night games at home. Everybody loved it.

My mother's birthday was February 22, and I had written to tell her I would call right after school on Thursday to wish her Happy Birthday. That would be 8:00 or 9:00 p.m. in Iowa if my call got through right away. Since we had no phone at home, I had to go to the post office on Zavia Road, give the number to the man behind the counter, wait for him to dial, and if I was lucky, he would shout "Unitiduh Staytis" and point to one of the phones on the bank against the wall. Sometimes one got a connection immediately. Other times, people could try for days and not get through. I was lucky. I got through, wished Mom a Happy Birthday, and assured her that all was well with us in spite of the news.

My phone call from the post office was standard procedure among expats. None of our friends had a phone. When we wanted to talk, we hopped in the car and drove to each other's houses, day or night. Sometimes we just honked the horn, got out, and chatted over the villa wall. Other times we went inside, got started talking, and stayed late into the night. We never turned each other away, and unless the visitors were drunks, bores, or whiners, we were always happy to see them. We got to know each other very well, and hard as it may be to believe today when everyone on the face of the globe is attached to a smartphone, we discov-

ered the peaceful, quiet delights of living in a home without a telephone.

As spring approached, we enjoyed a few nice days. Some were windy and blustery, others veritable blizzards of sand. On those days I wore a hood over my face when I went out and understood why Tuaregs kept their faces covered. The good news was that we finally got our water heater fixed. It had been a perennial problem, so it seemed like a luxury to turn on the tap and get hot water.

Although we had been lucky to escape it so far, we came down with a case of diarrhea, a malady so common in our community it had its own name. Tripoli Trots. The causes were myriad, but after some deliberation, I traced our problem to T-bone steaks I bought from a butcher that I didn't usually patronize. It was the only thing we had eaten that was different from our usual fare. It did not bother Gus, so he dined on T-bone steak while we settled for hamburger.

The meat in Tripoli was often suspect. It was not aged and had a pungent odor, not the slightly nutty smell of good, aged meat. Some cuts were the color of a jaundiced bruise, and meat shops were awash with blood on the floor, the counter, and the elbows and apron of the butcher. The shades of red and the stages of coagulation depended on how long the blood had been standing. The number of flies depended on the season.

One of my first missions when I arrived in Tripoli was locating and cultivating a butcher. They were the high priests of shop keepers, and once an expatriate found a butcher, she stayed with him for the duration. One might cheat on him now and then as I did, but I put my face in often enough to be considered a regular. I could strengthen my relationship with the butcher by slipping a bottle of whiskey or a carton of Marlboros over the counter with the payment. My tall, dark, handsome butcher was obviously doing well. He drove a Mercedes.

On days when the meat supply was plentiful, the aisles of the market were crowded and the sound of voices and meat cleavers filled the air. On a good day at the meat market, I had a choice of beef, lamb, camel, goat, rabbit, pigeon, chicken, duck, and turkey. On these days, I bought as much as I could carry, up to sixty pounds at a time of hamburger, filet, T-Bones,

prime rib roasts, sirloins, contra-filet, stew meat, and occasionally a leg of lamb from New Zealand. Every cut cost the equivalent of $1.50 a pound. A pound of hamburger cost the same as a pound of filet mignon. The exception was Libyan lamb which could cost up to $70.00 for one prized leg. Although all meat cost the same, the good cuts were reserved for preferred customers, me included. Also, during meat shortages, my butcher kept me supplied. Sometimes only lamb was available, bad news for families from the Southwest. Many of them would rather eat popcorn. On days when meat was in short supply, the market was deserted. Giant hooves, moist convoluted intestines, and flaccid tongues lolled about in glass display cases. Not a pretty sight.

About Gus. On March 1, 1973, our happy wanderer disappeared. He had been running away often recently, so one night when we drove off, we circled the block to see what he was up to. As we approached our villa, we saw that he had crawled like a cat halfway up the front gate and was ready to take a dive onto the street. He saw us, got a guilty look on his face, and did a half gainer back into the yard. He had been gone for three days now, and we were afraid that someone had picked him up. He would go to anybody.

That same day in the Sudan, one Belgian and two American diplomats were murdered by Black September terrorists. The killers stormed a reception at the Saudi Arabian Embassy in Khartoum, seized a group of hostages, and demanded the release of Sirhan Sirhan and terrorists in Israeli and European prisons. When Nixon wouldn't negotiate, the U.S. Ambassador to Sudan was taken to the basement and killed. U.S. Deputy Chief of Mission to Sudan and the Belgian Chargé d'affaires met the same end. Arafat gave his blessing. We were beginning to fear that the terror would never end.

The following week, our spirits were lifted by the annual Spring Bazaar on the OCS campus. The entire school, including the gym, over-

flowed with homemade goodies, ice cream, candies, and crafts. At least forty booths sold everything from Sloppy Joes to cupcakes to kitchen witches. Hot dogs were flown in especially for the event, and hamburgers and chili cost twenty piastres, about sixty cents. A can of Dr. Pepper or root beer, both novelties in Libya, cost ten piastres.

Young and old alike enjoyed raffles, book sales, cakewalks, Pink Elephant sales, plant sales, and bake sales. People lined up for the Boy Scout Dunking Booth, face painting, even a sweet and sour booth. Water pistols, water balloons, helium balloons, putting range, soccer competitions, and Go Karts kept the community entertained for a day. In its heyday, as many as four-thousand people flocked to the Bazaar, and in four hours it usually raised $20,000. The proceeds went to Youth Clubs and Little League baseball teams.

By the middle of March, spring was finally trying to break through. Every day brought a new bud or blade of grass. I planted several packets of flower seeds, and within a week they were an inch high. Almost anything grew in Libya as long as it was watered. I once stuck a poinsettia branch in the ground to support a pepper plant, and to my surprise the poinsettia flourished and the pepper died. By April, the orange tree in our back yard was laden with blossoms, and when the French doors in the kitchen were open, their fragrance filled the whole villa. When Mobrouk made tea, he plucked a handful of blossoms off the tree and crushed them into his cup. It smelled delicious.

Feeling the need to get in shape for spring, I borrowed a bicycle from a friend and started riding the streets of our neighborhood when I got home from school. As a precaution, I carried a stick to beat off the "pye-dogs," white, wolflike, wild canines that ran in packs in the desert and often made their way into town. Some were brawny, others emaciated, all were dangerous and often rabid. During mating season, they cruised the streets in large groups at night. If we returned home late and found them in front of the villa gate, we circled the block until they were gone. Periodically, dog-catchers conducted a roundup and gassed them. Our Gus still hadn't returned, and we shuddered to think that he may have fallen in with one of

these gangs. We hoped that he was just off on one of his romantic escapades.

The first weekend in April we made a grocery run to Malta and returned laden with ham, pork chops, bacon, salami, powdered and brown sugar, and avocados from Israel, not allowed in Libya. When we went through customs at Tripoli International Airport, the agent did not question our pork and avocados but asked me, "Where were you born?" I replied, "Iowa." He tried again. "Where were you born?" Once more, I said, "Iowa." After two more tries, he shook his head and waved me through, dismayed by my ignorance. I knew why he was confused, but it was late and I didn't want to take the time to explain that "iowa" means "yes" in Arabic. We arrived home at 2:30 a.m. Sunday, were in bed by 3:00 and up again at 6:30 to get ready for school. Just the thought of all that pork lifted my spirits and sustained me through the day. That night we had friends over for pork chops, mashed potatoes and gravy, baked corn, candied yams, and graham cracker cream pie. We were living high on the hog.

The most eagerly anticipated event of the year for students at the Oil Companies School was Field Day, usually held during the second week of April. It gave students and teachers a break from academics and was a welcome reminder that the end of the year was near. Students first reported to their homerooms to collect tickets for a free Pepsi and two hamburgers and chips for lunch, then they made their way to the gym for a short meeting. After a brief review of the ground rules, everyone dashed to the playing field like horses charging out of the starting gate. Students spent the entire day outdoors competing in athletic events: 50, 100, 220, 440 and 600-yard dash, 440 and 880-yard relay, standing and running broad jump, shot put, discus, high jump, and mile run. Teachers kept score.

Less challenging events were saved for the afternoon when the temperature rose and energies were spent. Students who did not win competitions or break records during the morning's events got a chance to shine in wheelbarrow races, sack races, three-legged races, balloon toss, egg toss, and the teacher-carry. The day culminated in a tug of war, first between homerooms, then between faculty and students. A faculty member stood at

the center line with a hose ready to douse the hot, sand-covered losers. At the end of the day, we all assembled in the gym and dissolved on the cool floor as trophies were awarded to the victors of the day. Roasted, then cooled, everyone went home feeling like a winner.

Easter vacation was approaching, and since we had explored Tripolitania and visited the Fezzan but had not yet checked out the eastern part of the country, we decided to take a camping trip to Cyrenaica. Other than reading in the Bible that Simon of Cyrene carried the cross of Jesus Christ, I had little knowledge of the place. Now we looked forward to feasting our eyes on hundreds of square miles of Greek ruins and magnificent scenery. After nights of planning, Tom and Doris, Peter and I, and the Nemeth family headed east in two stuffed-to-the-ceiling VW bugs and one Hungarian Embassy Peugeot. The first night out we stayed at Marsa el Brega, an Esso Oil Camp ten hours east of Tripoli. About two-thousand Americans lived there in a gated community. One had to have written permission to get onto the compound and pass through a checkpoint to enter or leave. We had been invited to stay with a family who formerly lived in Tripoli. They took us on a tour of the entire camp, bought us dinner at their club, and let us sleep on their living room floor. The villas were lovely. Rumor had it that each kitchen came complete with a still. Everyone we talked to seemed to enjoy living there.

The next day we continued on to the ancient Greek and Roman ruins of Cyrene and Apollonia. We drove through the breathtaking hairpin curves, twists, inclines, and downward slopes of the Jabal al Akhdar, the Green Mountains. They rose up gradually from desert and pre-desert terrain and were covered with juniper, mastic, and oak trees. We stopped to take in a view every bit as magnificent as Big Sur, and as we began our descent to Cyrene, a vast, majestic heap of ruins appeared on two ridges divided by a wadi. Drawing closer, we could see the modern town of Shahat nestled in the midst of this ancient grandeur.

Cyrene was founded in 631 B.C. by Greeks from the island of Thera, known today as Santorini. On the eastern ridge, about two-thousand feet above sea level, stood the temple of Zeus and the amphitheater. On the western ridge was the agora, and down the wadi that separated the two hills, the Greek theater and the temple of the primary god, Apollo, whose Delphic oracle had led to the founding of Cyrene. For the temple of their revered Apollo, the Greeks chose a setting with a backdrop of wooded hills and a spectacular view of vast rolling plains opening up to the sea in the north. A major consideration in choosing this site was water, still filling the bathing pool after two-thousand years. Fresh air, excellent climate, and a wealth of flora attracted early settlers. The city, known for its love of science, philosophy, and architecture, reached its peak about 400 B.C. During our visit, the fields were covered with poppies and the hillsides with wild flowers. The stillness was broken only by the buzzing of bees feasting on pink oleander.

Not another soul was in sight, so we explored the ruins at our leisure: temples, theater, forum, baths. We found baths with dressing rooms, steam rooms, and little cubicles that looked like private sitz baths. The latrines, all designed to be flushed by water, were sized for both adults and children. We walked with care around worn, precious mosaics of wild animals, men harvesting grain, and from the Byzantine period, Noah releasing a dove from the Ark. We saw the House of Jason, now the ruins of a mansion that in its day might have housed a Rockefeller.

After we had explored the ruins of Cyrene, we returned to our cars and made the ten-mile tortuous 1,800-foot descent over two escarpments to Apollonia. By that time, we noticed that we were being followed by what we assumed was the Libyan secret service, presumably because the Nemeths had diplomatic plates. We started playing games with them, trying to lose them. We cut off the road and concealed our cars behind bushes until they drove by, then continued on our way. They waited on the side of the road several hundred yards ahead, and as we passed by they turned their heads and covered their faces with their hands so we wouldn't recognize them. A far cry from 007, they eventually decided that we did not pose

116

a threat and left us alone.

Late in the afternoon we made it to Apollonia, a port built by early settlers and named to honor Apollo. When we learned that as much as a third of the ancient city was under water, we had the urge to don masks and flippers and dive for treasure, but we needed to locate a campsite for the night. Apollonia, like Cyrene, showed the wear of time, earthquakes, raids, and rebellions, but the softened sandstone ruins and timeless green-veined cipollino marble columns stirred us deeply. We knew that we were looking at treasures few had witnessed.

That night a ghibli descended on us with winds of 60 mph, so strong I could not stand upright. To keep our tents from blowing away, we tied them to the bumpers of our cars. All night long we huddled in our tents listening to the unrelenting wind and pelting sand and prayed we wouldn't blow away. We made it through the night, then packed up our gear and headed home in a sand storm so thick we could not see more than twenty feet ahead. When we stopped to see the Roman ruins at Tolmeitha we discovered that the sand had scoured the paint off our license plates. We found temporary relief from the sweltering heat and blistering sand in an immense Roman water reservoir, now a cool, dark, dry cistern with magnificent vaulted ceilings. Tired and encrusted in sand, we got back on the road, and as we approached Benghazi gave up the idea of camping and checked into a hotel in for the night. The last night out, we found a beautiful quiet place in the desert, set up our tents, and as Mrs. Nemeth started to make her special scrambled eggs, peppers, and Hungarian salami for dinner, the gas stove on which she was cooking suddenly and without warning blew up in the tent. Fortunately, no one was hurt and the delicious food was spared. Finally, after 1,200 miles of adventure, tired and badly in need of a shower, we arrived in Tripoli full of stories to tell and wonders to recall. It was good to be home.

Being so grubby during our camping trip put me in the mood to wash clothes and clean house, so along with Mobrouk, I started giving the villa a spring cleaning. Mobrouk loved to buff the marble floors, polish windows, wash clothes, and iron. He did not clean our bathroom. That was my

responsibility. A common local attitude was that bathrooms were dirty, one did dirty things in them, so why clean them? When we first started exploring Libya, we made the mistake of stopping at gas stations to use the bathroom, a bad decision. They were so filthy they made us gag, the stench so putrid it turned our faces red and made our eyes water. We learned early on that it was better to find a bush.

<p style="text-align:center">***</p>

As the 1973 school year came to a close, it was time to do some soul searching. Our original plan was to stay in Libya for three years, save enough money to buy a car and make a downpayment on a house, then return to the States and find teaching jobs. Now it was time to weigh the pros and the cons. Biannual cholera shots left our arms stiff and sore and I came to dread them, but the discomfort went away in a day or two. Then there was the heat. During the month of May, we experienced several days of 110°, 112°, and 116° temperatures. Afternoons in the classroom were tough but not unbearable, and during the weekends I kept the villa comfortable by getting up early, opening all the windows, then closing everything up about 9:30 a.m. and turning on a couple of fans. Unless the hot spell was prolonged, the stucco villa walls stayed fairly cool. Mobrouk taught me not to work during the day when it was so hot but wait until the sun went down.

Then came an unbearable hot spell of 126° temperatures for five days in a row that left us with our tongues hanging out. The oil companies lost their air-conditioning, so they closed their doors and sent people home. We should have done the same at OCS. Instead we closed the windows and doors of the classrooms and turned on the fans which did nothing but circulate the hot air and sand. Perspiration ran down our backs and noses, down our legs and into our shoes. Students nursed the now tepid water from Clorox bottles of frozen water they carried to school in limp athletic socks. Some got sick. As the afternoons progressed, we could only sit quietly and endure, captives in our communal sauna. When the wind finally

changed on the evening of the fifth day, I went out to our back yard, collapsed in my lawn chair under the stars, and let the cool sea breeze bathe my wilted body.

I missed my family, lilacs, plums, blueberries, iris, all things purple. I missed robins, squirrels, cottage cheese, doughnuts, pickled herring, and my Mom's pies. I missed the English language. We had enjoyed our travels, our friends, and our students, and over the course of three years we found we were able to live on one-third of our salary, use one-third for travel, and send a third home for my parents to deposit in our savings account. When we first arrived in Tripoli in the fall of 1970, the exchange rate was $2.80 per Libyan pound. In the spring of 1973, it was $3.37. We decided to stay for one more year.

The Oil Companies School paid us in Libyan dinar and our salaries were deposited directly into the bank, in our case a small neighborhood branch of the Sahara Bank on Zavia Road. The building was less than imposing, a standard buff-colored cinder block square with dirty plate glass windows. Every month after payday we went down to get a draft for whatever amount we were able to send home, up to 90%. As with the butcher, it was important to cultivate the banker. Groveling and glad-handing were always well received. Men were usually better served than women. The bookkeeping was generally accurate, but if one found a discrepancy, it was best to act puzzled about it or ignore it. Usually the error was in the customer's favor. At one time, our account showed an excess of over two-thousand dinar, $6,800.00 at the exchange rate of $3.37 to the dinar. Rather than point out the mistake and risk alienating the staff, we simply left the money untouched. Several months later, they caught it. We acted surprised and duly grateful and were relieved to have the discrepancy resolved.

After looking for, asking about, and hoping for his return, we finally resigned ourselves to the fact that Gus was gone for good. In two short years we had become attached to two sweet dogs and lost them, so we both agreed. That's it. No more dogs. We found some consolation in dog sitting for Jerry-Piggy, a part-beagle, part-dachshund whose owners were on

vacation. JP had an endearing personality and got so excited when we came home that she turned around in circles for at least three minutes. It warmed our hearts. Then one afternoon I turned the sprinkler on to water the grass in the back yard and what should emerge from the mimosa tree but a mother cat and two surprised wet kittens, one pure white, the other spotted. The mother was so protective of her babies that I was tempted to feed her, but I refrained. We would soon leave for summer vacation, and I didn't want them to become dependent on me.

During the last couple of weeks of school when the kids were used up, I saved what I hoped would be high-interest topics: speech, the history of the English language, the development of writing. Speech gave students a chance to get out of their seats and move around. One ninth-grader brought her music to school and taught the whole class how to do the Funky Chicken. We discussed theories of language beginning and read a small paperback entitled *The Tree of Language* to learn about the history of the English language and see the close relationship of the Indo-European family of languages. For the study of the Development of Writing, we shared a single copy of Oscar Ogg's 26 *Letters*. All other information came from research and experimentation, and instead of a test, students submitted early writing projects. Using only natural substances such as roots and berries, students reproduced cave paintings on rocks they found lying around streets and construction sites. Some looked so real we were tempted to bury them behind the classroom and leave them for posterity. Other students made tablets of clay and inscribed them with cuneiform characters. A few used Stone Age scrapers their fathers had picked up in the oil fields of the Sahara and made parchment out of sheepskin. They inscribed the finished product with Latin characters, rolled it up in mini-scrolls, and tied it with string. Several students made paper out of papyrus. Since the plant grew in our back yards, I brought bunches to school and we peeled it, sliced it thin, pounded it, smoothed it out, and pressed it down with heavy books. When it was dry, the students wrote messages in hieroglyphics.

The chaos and confusion of the closing days of the school year includ-

ed the usual preparation of finals, correcting papers, calculating grades, issuing report cards, and closing out our classrooms and villas for the summer. Not expected was notification that our principal's residence visa and work permit expired on May 10, so he had to leave the country while his papers were being processed. That left the faculty in charge of graduation ceremonies which included the valedictorian, salutatorian, guest speakers, band, chorus, diplomas, candelabra, corsages and boutonnieres, *Pomp and Circumstance,* and a formal tea. Teachers pitched in together on things that needed to be done, and willing mothers helped with the decorations and tea. Then as we started packing our suitcases to leave for the summer, the Libyan government decreed that all passports had to be in both Arabic and English. Before we had a chance to panic, we were told that it would not affect those of us leaving for vacation. We could deal with it when we returned.

On June 8, 1973, I taught my last class of the year and ten days later Peter and I boarded a plane to Spain to visit the Alhambra, reputed to be the most beautiful piece of Moorish architecture surviving in the West. It was a magnificent palace of marble and alabaster, pillars and arches, filigree walls, tiles of blue, yellow, red, gold, and brown. We were not disappointed. After our visit, we took a hair-raising bus ride to Torremolinos, found it too touristy, returned to Madrid, and on June 29 boarded an Iberian 747 Jumbo Jet to New York City. It was our first flight on a 747, and we wondered how anything that big could stay in the air. We took off on schedule but became concerned when we realized that we were just circling Madrid. Before we had a chance to ask about it, the pilot announced that the plane was experiencing mechanical difficulties and passengers should prepare for a crash landing. He told us to fasten our seat belts, remove glasses, and put our heads between our knees. As we circled Madrid jettisoning fuel, stewardesses began throwing blankets and pillows in every direction. Peter's face was as white as a sheet, and my knees were

121

shaking so badly I had to hold them to keep them still. When Peter asked if I thought I should take out my contact lenses, we both laughed. If the plane crashed, what difference would it make? As we approached the runway, I checked for the nearest exit and through the windows saw fire trucks and ambulances lined up ready for the rescue. We landed, rushed off the plane, and soon discovered that we had lost an entire landing strut, wheels included, on takeoff. Fortunately, plenty of wheels remained for a safe landing.

Passengers were herded into a terminal while another plane was readied for our departure, and within a couple of hours we were back in the air. As we boarded the second plane, I noticed that its name was *Vasco Da Gama*. The one we had evacuated was the *Don Quixote*. That seemed appropriate. The young man in the seat next to me had been completely composed throughout the entire emergency. When I asked him how he remained so calm, he told me it was only the second time he had flown and he knew that statistically, chances were that he would not go down. We laughed, and I told him I would have appreciated that information earlier. When we landed in New York, I was so glad to be on American soil I wanted to kiss the ground. Relieved to be off the plane and looking forward to hearing everyone speak English, I went up to the TWA lounge for a cup of coffee. I don't know what I expected, but I was a little disappointed when all I heard was small talk.

My mom and dad were in Norway the first part of the summer visiting my father's family, so we took a flight to Appleton, Wisconsin, to see Peter's parents, Ed and Farney Nowell, and their dog Nellie. Ed was working at a furniture factory at the time, and Farney was a nurse at Lawrence University, the second oldest co-ed college in the United States. The population of Appleton in 1973 was about 56,000, many of whom were employed by the paper industry. Harry Houdini grew up in Appleton, and novelist Edna Ferber graduated from Peter's alma mater, Appleton High School. At home with Ed and Farney, we got updates on the family and the Green Bay Packers, feasted on crispy grill-fried smelt, and went out for Marc's Big Boy hamburgers and hot fudge sundaes.

After a couple of weeks with Ed and Farney, we rented a car and drove 329 miles to my hometown, Clear Lake, Iowa, where my parents, Torger and Gladys Froiland, were home waiting for us with news of the family in Hommersåk, the small village in southern Norway where my father grew up. In addition to news, they brought home sardines, knekkebrød, and Freia chocolate which we enjoyed along with back yard picnics of fried chicken, potato salad, fresh corn on the cob and tomatoes from my father's garden, and my mom's apple pie. Clear Lake's population at the time was just a little over six-thousand, but it made international history the night of February 3, 1959, when Buddy Holly, Ritchie Valens, and J.P. Richardson, the "Big Bopper," gave their last performance at the Surf Ballroom. They died along with their pilot Roger Peterson when their chartered Beechcraft *Bonanza* crashed in a cornfield near the city a few minutes after takeoff. The tragedy was immortalized as "The Day the Music Died" in Don McClean's *American Pie*, but it lives on in Clear Lake, Iowa. Every February since 1979 the Surf has hosted a Winter Dance Party that draws thousands of fans from all over the U.S. and England to honor the musicians. The only exception was 2021 when, like most large gatherings, the event was cancelled due to COVID-19.

When it was time to return to Libya, we regretted leaving the U.S. and our families but had our fill of the names Ehrlichman, Haldeman, Dean, and Watergate. We packed our suitcases with new clothes, toiletries, and canned bacon and headed back to Tripoli.

When classes resumed at OCS in the fall of 1973, enrollment was down to four-hundred students, kindergarten through grade nine. The drop in numbers was due to the nationalization of the oil companies. Our future was uncertain. We could get smaller, or we could grow if the companies brought in more employees. Average class size was now fifteen, great from the standpoint of student-teacher ratio, but depressing when walking down the deserted halls. The campus had the feel of a ghost town. We were con-

123

cerned that government authorities would come to the campus, look around and decide we didn't need that much space, so we did everything we could to appear fully occupied.

I taught my 8th and 9th grade English classes in Room 3, stored my precious books in the room next door and set it up to look as if students could walk in at any moment. The Petroleum Wives Club opened a library in a classroom near the parking lot, and instead of rehearsing in the gym, our band director was given a room of his own next to the sixth-grade classrooms. Andy was pleased, but the sixth-grade teachers were not. Junior high band rehearsals next door to a sixth-grade class were not conducive to teaching or learning. In spite of the changes, students seemed happy to be back and the first week of school went smoothly.

Faculty was reduced from three to two in most junior high departments, including English. My student load was 102, down from 169 in 1970. OCS students got a double dose of English: grammar and composition five days a week, and literature every other day. This year my colleague taught literature with titles ranging from *The Outsiders* to *Julius Caesar*. That left me with composition, my preference, and grammar which I also loved. I taught a quasi-transformational version, popular at the time, covering structures as advanced as participles, gerunds, infinitives, and subordinate clauses. Students mostly endured it, but occasionally I saw a light on a young scholar's face that said, "I get it!" That made my day.

Early one evening a week or two after school began our doorbell rang. It was Lisa, one of our eighth-grade students looking mournful and holding a little ball of fur in her hands. We knew what was coming. After Josephine and Gus, we vowed never to have another dog and told her so, but when she looked up at Peter with her big blue eyes and said, "Please, please take this puppy or we'll have to kill it," he replied, "Give me that dog."

"That dog" was a Doxiepoo, a cross between a dachshund and a poodle. She had the shape of a dachshund, a black Brillo Pad coat, tan paws, and tan and white markings on her sweet little face. When we took her into

124

our living room, one of my first thoughts was, "This poor carpet after training three dogs in three years." That changed the minute I stretched out on the carpet on my stomach and she put her little nose next to mine. She would become the love of our lives. We named our new puppy Gretchen.

The first weekend in October, thirty OCS faculty members got together for an overnight campout at Garabuli, the picturesque deserted beach a couple of hour's drive east of Tripoli. Our group included three babies, three older kids, and four dogs: a boxer, a dachshund, a wire-haired terrier, and baby Gretchen. We traveled together in a fourteen-vehicle caravan, all VW beetles except for one VW van and a lonely Toyota. We swam, shared tasty homemade food, and sang around the campfire late into the night. The weather was too delightful for tents, so we bedded down on the beach under the stars. I had read that there are 70 sextillion stars in the visible universe. Looking up at the sky, it was easy to believe. We arranged our sleeping bags in a giant circle and said goodnight, Walton style. Goodnight, Keith. Goodnight, Ellie. Goodnight, Gloria.

Goodnight, Bill. Goodnight, Pete. "How many stars do you think you can see with the naked eye?" Millions, Gloria. "What do you suppose keeps them up there?" Good night, Gloria. "Do you think it has anything to do with gravity?" Good night, Gloria! The moon was so bright we had to cover our faces to get to sleep.

Gretchen was on wake-up detail the next morning, going from sleeping bag to sleeping bag waking everyone with a wet nose in the face. I woke up, jumped into the smooth as glass Mediterranean, then went up to the campfire for a good hot cup of coffee and homemade rolls. Everyone brought food, everyone pitched in and helped with the babies. We enjoyed pleasant 80° temperatures during the day, a refreshingly cool night, lots of swimming, lots of sun, and a resort class beach all to ourselves. As for Gretchen, when we got home she spent the afternoon lying on her back, paws up in the air under a shade tree in the front yard. The poor girl was plumb worn out. Shortly thereafter, she got her first bath. The sudsing went well, but not the rinsing. She cried like a baby, so mournful I almost cried.

Shortly after we returned home we were shocked to hear that while we were enjoying the weekend on an idyllic Mediterranean beach, Libya's neighbors to the east had engaged in a brutal war. It was launched by Egypt, Syria, and a coalition of Arab forces against Israel on Yom Kippur, the holiest day in the Jewish calendar, and caught the Israelis off guard. We heard reports of twenty-thousand casualties in six days. It seemed like such a waste. We hoped that the sacrifice of life had been great enough so those involved would stand back, look at the blood they'd spilled, and stop the killing.

Life in our little community did not change, and we did not feel in any danger. We called our families in the U.S. and told them not to be concerned about us. The Libyans were as friendly as always, and life went on as usual. Libya did not want to get involved in the fighting, but supplied Egypt with oil. A rumor circulated that Libya would also send food, if needed, so I stocked up on food and supplies, just in case. Periods of relative peace were all too short in this area, and for the sake of the people of Egypt, Syria, and Israel, we hoped the conflict would be quickly resolved. Not until later did we learn the full ugly ramifications of what came to be known as the Yom Kippur War.

On the local front, we were fighting bugs. Amoebic dysentery was under control, but the new battle was infectious hepatitis. Two of our teachers had it. Our science teacher went to the bathroom, fell and cracked his head on the floor, and since the disease can be transmitted through water contaminated with fecal matter, doctors worried about infection as well as brain damage and concussion. Don was evacuated to London on a special plane called in from Paris at a cost of $10,000.00.

The other teacher was in a local hospital. He sometimes used other people's coffee cups in the faculty lounge, so we all took our cups home and sterilized them with boiling water and Clorox. We took precautions by keeping everything extra clean, washing our hands thoroughly and often, getting more rest, eating nourishing meals, and taking vitamins. Cholera remained a concern as well, and we still got shots every March and September. Italy had a cholera problem earlier in the fall, but Libya had

escaped so far. Our two faculty members recovered from hepatitis and returned to work, and outside of an occasional attack of Tripoli Trots, most of us stayed healthy.

Back home in the U.S. people were sick and tired of hearing news about Spiro Agnew and Watergate. Agnew was charged with bribery, tax evasion, and extortion, both as governor of Maryland and as vice president of the United States. Our little ex-pat community saw him as a perfect example of the oxymoron "honest politician" and wished he would admit his guilt, resign, and be done with it. But even as evidence piled up against him, he vehemently protested his innocence and made it clear that he had no intention of quitting. At last, on October 10, 1973, Spiro Agnew threw in the towel, resigned his office, and received a $10,000 fine plus three years' probation. He went down in history as the only vice president of the United States of America to resign in disgrace. Weary Americans were relieved to put the issue to rest, and although we were often hungry for news from home, we were reminded that being out of touch could have its advantages.

The weather in Tripoli was typically hot until the last week of October, then it suddenly turned cold. It took a while for the body to adjust, but the cool weather felt good. We put a blanket on the bed, took sweaters out of drawers, and one afternoon early in November when we came home from school we fired up the space heater. The next morning, I woke up about 4:30 and smelled strong fumes. We got up and ran through the villa throwing open every window and door. A strong wind had come up during the night and blew the fire out, so all the kerosene fumes backed up into the villa. It took a half hour to get the air halfway breathable again, but we were thankful that I woke up when I did. We turned the stove off until we could get it cleaned and checked, then that afternoon Mobrouk brought in wood for the fireplace, our only other source of heat.

We had recently given Mobrouk a raise. When he started to work for

127

us in 1971 his salary was $30.00 a month. He had been faithful during the year and the cost of living had gone up, so we raised his salary to six pounds, about $20.40, a week. We bought a used electric floor buffer from a family leaving Tripoli, and he took to it like a bee to honey. I complimented him on his buffing, so he gave the white marble floors a skating rink shine every time he came to work. Friends who came to visit commented on them. That made him proud.

Although Mobrouk was employed as a houseboy, he was not a boy. He was our age. He spoke the Libyan dialect of Arabic and knew enough Italian and English to work as a houseboy, but he could neither read nor write. I found this out accidentally when I asked him to read a scrap of paper with Arabic writing on it. He shook his head, embarrassed that he couldn't read it. I felt ashamed for asking. By this time we knew each other well enough for him to suggest that I had been in Libya too long not to speak the language. I agreed. I knew enough market place Arabic to get along in the souk, but not enough to carry on an everyday, much less intellectual conversation. And so Mobrouk, whose name itself means "Congratulations!" took on the role of teacher. We practiced the numbers 1–5 and beyond: *wahed, etneen, talatah, arabah, khumsah*. The days of the week were easy to remember, especially Friday, *Juma*, due to regular visits to the locally famous *Souk Al-Juma*, "Friday Souk."

Sabaah Al-Kair, Ahlan wah Sahlan, and *Marhaba* were all forms of "Hello," as was *Keif Hailik*, "How are you?"

Kwais Kateer, "Very good," was the usual answer followed by *Enta*? "And you?" "Good- bye" was always *Maasalama*.

Khoobza was "bread," *guhwah* "coffee," *shahee* "tea," *shorba* "soup," and *moya* "water." *Shoof*! meant "look," *emshee* "get out of here," *maboul* stood for "crazy," and *gaddesh* was "how much does it cost." *Schwayah, schwayah* meant "a little bit" or "slow down," and *Ahlan wah sahlan* was a way to greet guests who came to visit. In time I could string a few Arabic words into a sentence such as *Min fudlik, ateeni pepsi*? "Please could I have a Pepsi?" Occasionally I would latch onto a more sophisticated word like *mumtazz*, "excellent," but that was rare. I am still at loss to find a total-

ly adequate English translation for one of the most important words in the Arabic language, *Malish*. It means "what the heck" or "never mind," but there is simply no English word as useful or satisfying to communicate exasperation and futility as *Malish*.

In November of 1973 we saw history in the making when we came home from school to a paved street and sidewalk in front of our villa. Gone was the frontier boomtown ambiance, and in its place was a smooth road on which to drive cars and ride bikes. In addition, we looked forward to less sand in our villa. As it stood, we could dust a table and immediately after draw a line in the sand on it with our finger. It was interesting to watch a country grow. If we stayed in Libya long enough, we might possibly end up with all the comforts of home.

As we contemplated these thoughts, Bob Waldum announced that he was leaving the Oil Companies School to start a school in Rome. He planned to hire a few OCS staff members, and we all agreed what we would say if he offered us jobs. Yes. The pay would not come close to what we were earning in Libya, but Peter and I had always maintained that we would not stay at any job just for the money. The people we knew who had done that ended up hating the place, hating the people, and hating their lives. We hoped to leave Libya with the same good feeling we had when we arrived. The friends we made were like family, we visited places we had longed to see, learned to navigate the desert by the sun and stars, and sat up until dawn in our back yard sharing stories with friends. We had enjoyed our stay and saved quite a bit of money by our standards, so when Bob Waldum offered us a job at the Mediterranean School of Rome, we did not hesitate. We said yes.

As we waited for more details about Bob's plans, we gradually picked up a few more students at OCS, but we were still rattling around on campus. I took 150 English students on a field trip to a movie theater downtown to see *Macbeth*, the Roman Polanski version full of sword fights, rolling heads, and gallons of spilled blood. The boys loved it. The girls covered their eyes and had to be reminded that the red stuff was only ketchup. Still, cultural opportunities were so rare in Libya that one had to

take advantage of them when they came along. Not that our students were deprived. Quite the opposite. While their friends in the States were taking field trips to Washington, D.C., New York City, and Disneyland, OCS students were exploring the ancient Roman cities of Leptis Magna and Sabratha. A privileged few flew out to the desert with their parents to visit the site of the *Lady Be Good,* an American B-24D Liberator bomber that disappeared after a bombing run on Naples in 1943. Fifteen years later, it was found bellied into the desert sand 440 miles southeast of Benghazi. Except for a break in the middle of the fuselage and an engine that had been knocked loose, the plane was intact. Flight logs and supplies were found in the cabin just as they were left, but no trace of the nine member crew was discovered until 1960. I never saw the *Lady*, but years later I visited the Air Force Museum at Wright Patterson Air Force Base in Dayton, Ohio, and in a corner of the World War II wing was an exhibit with sand from the engine of the *Lady Be Good*, the first aid kit, mess kit, compass, nose wheel and tire, hydraulic components and parts, maps, flight reports, radio data sheet, navigator's log, and a canteen that I was told still contained water which one of the crew put in it in 1943. The stained glass window of the *Lady Be Good* from the chapel at Wheelus Air Force Base conveyed a hallowed feeling to the exhibit.

The French Club traveled to Tunis every year, practicing their French and visiting the remains of ancient Carthage. Families traveling to and from Libya commonly stopped in London or Rome. In London, students attended stage plays, visited the British National Museum, shopped at Harrods, and had lunch at the Hard Rock Cafe. In Rome, they explored the Colosseum and strolled the Via Veneto, wonders they could only dream of back home in Eggemoggin, Maine, Muleshoe, Texas, Bugtussle, Oklahoma, or Early, Iowa.

As December approached, cold weather gripped Tripoli. It was our second winter with no heat at school, but knowing what to expect we piled on warm sweaters, slacks, even coats in the classroom. Malish. A rare Christmas gift of a bottle of Johnnie Walker Red Label scotch from the Spanish Ambassador warmed our spirits. His daughter, Ana, was in my

English class, and although I didn't care for scotch, I appreciated his generosity. When the word got out, I suddenly became popular.

Before leaving for Christmas vacation, Peter and I invited twenty-seven friends over for a Norwegian smorgasbord. The menu included eggnog, ham and cheese cubes on toothpicks attached to a styrofoam Christmas tree, toast tips, 120 potato cakes, rye, wheat and sesame crackers, fresh shrimp, three-hundred meat balls, herring, sardines, anchovies, caviar, sliced hard-boiled eggs, cheeses - including goat cheese, sliced tomatoes, cauliflower, and green peppers. For dessert I served Norwegian favorites: sviske suppe, rice pudding, sandbakkels, krumkake, rosettes, lefse, and waffles. I gave a personalized homemade gift of little hand-painted breadboards to everyone. Mobrouk came in to help clean up the next day. Our guests seemed to enjoy themselves, some even declaring it was their favorite party of the year. During December, people couldn't get enough of celebrating. Other than the nights we had guests, we hadn't been home one night in three weeks.

By December 21 the Christmas rush was over, we had our suitcases packed and were waiting for a ride to Tripoli International Airport for a 4:00 p.m. flight to Rome. The Nemeths, our Hungarian friends, picked us up in the embassy limousine, took us to their house for lunch, then to the airport. Never having ridden in a limousine before, I felt like royalty. I was glad to leave Tripoli for a rest, but our anticipation was damped by the December 17 hijacking of Pan Am Flight 110 by Palestinian terrorists at the Leonardo da Vinci International Airport in Rome. They threw hand grenades through the front and rear doors of the plane, and the smoke that filled the cabin took the lives of thirty-one people including the wife of the Captain and fourteen Aramco employees and family members. The incident caused reservations about traveling to Rome, especially moving there. As far as I can determine, the fate of the terrorists is still not clear.

Before leaving Libya, Bob told us he would take us to the site he had chosen for the Mediterranean School of Rome and show us the city. The school was 99% approved to open. We would know for sure in a month or so. I was in the market for a winter coat, so Peter and I spent the first part

of the day in Rome shopping. I walked into a shop and my eye landed on a brown three-quarter length leather coat with fur collar and cuffs. The minute I tried it on, I knew it was for me. It caressed my shoulders and made me look tall and slim. My heart was set on it before I asked the price, 540,000 lire. $900.00. Out of my price range.

Later when we met Bob, he showed us the blueprints for the Mediterranean School of Rome, then put us in his Thunderbird and drove like a maniac to the building site of his new school. I guessed that one had to drive that way in Rome in order to survive, but I hadn't had a ride like that since high school. After inspecting the building site, we had dinner at a marvelous fish restaurant, all the time watching the clock since a midnight curfew was in effect. All vehicles had to be off the street by 12:00, a result of the so-called "fuel shortage." We ended up running late, so Bob let us off at the top of the Spanish Steps and after saying goodnight, we walked down the stairs to the Hotel d'Inghilterre. The hotel was warm and cozy, apparently not feeling the need to economize on heat.

From Rome we took a flight to Zurich, then boarded a train for a relaxing ride to Englelberg. We had hoped to stay at the Schweizerhof, a cozy hotel in the center of the village where we had stayed one summer and vowed to return one day. Unfortunately, we waited too long to make our reservations, so we had to make do with the unknown to us Ring Hotel. It was modern and had about as much atmosphere as a hospital.

Engelberg itself did not disappoint. Looking down on the charming village was Mt. Titlis, 10,623 feet, the highest peak in Central Switzerland and snow-covered year round. We skied the lower mountain of Gerschnialp, 4,140 feet, Peter on the intermediate and advanced runs and me on the bunny slopes. My history with the sport went back to leather-strap bindings, high-buckle overshoes, and five-foot wooden skis that my brother and I shared when skiing a hill in Iowa with the glorified name of the Garden of Eden. Every exhilarating minute-and-a-half ride down the hill in Iowa was followed by a half-hour trudge back up to the top. In Engelberg we had the luxury of a pony lift or a T-bar.

Christmas Eve was bittersweet. As usual, we called our parents, but

this time my father was out delivering my Mother's Christmas cookies to friends and neighbors, so I did not get to hear his voice. I never really wanted to be any place but home on Christmas Eve. The rest of the year I could handle, but I got desperately homesick on Christmas Eve. After we called our parents, we got dressed up and went down to the dining room for a seven-course dinner. The tables were set with china and crystal, a freshly-cut pine tree was adorned with real white candles and tended by a man with a water bucket. When roving violinists came to our table and played "Silent Night," I had such a lump in my throat I couldn't eat. I used my white linen napkin to dry the tears streaming down my face. Our waiter was kind enough to ask if I was O.K. I said I would be.

From the minute we checked into the Ring Hotel we could see dollar signs spinning in the manager's eyes. We were not his favorite guests because we didn't go into the bar and spend fifty dollars every night. We were too busy soaking in the tub and nursing our sore muscles from skiing. When we were informed that the management was going to charge every-one $41.50 extra for the New Year's meal, we declined. His highness, the manager, called us at 8:00 p.m. to berate us for not participating. We vowed that if we returned to Switzerland we would find a small hotel that served schnitzel on New Years Eve and hosts who weren't out to bleed money out of their guests and inflict victims with seven-course tasteless meals.

Malish. For a week we basked in beautiful winter weather, six inches of heavy snow the day after Christmas, trees covered with frost, and some mornings so hazy we couldn't see the mountains. And it was good to feel cold again.

1974

We got bumped from our Saturday flight back to Tripoli and had to leave on Thursday with only two hours' notice, so instead of shopping for Christmas gifts for our family as planned, we spent the last minutes of our stay in Zurich racing around buying $70 worth of salami and bacon. Gifts would have to wait until summer. When we got back to Tripoli, we found a Christmas package from my parents, opened by customs officials, but apparently intact. It cost $6.10 to send, and we were charged $3 customs. At the time it seemed like a lot of money, but it was a treat to get a surprise from home.

While we were away, Mobrouk slipped on a banana peel and sprained his knee. He blamed this and anything else bad that happened to him on the Egyptians living and working in Libya. This normally gentle, mild-mannered man despised them. If anything went wrong, an Egyptian did it, including throwing a banana peel on the ground for him to trip on. It was hard to keep a straight face when he told me.

School was going strong again. We even got a few new students, so the future looked brighter for the Oil Companies School. About this time, Bob arrived in Tripoli with definite offers to teach at the Mediterranean School of Rome, one we couldn't refuse. It looked as if this would be our last year in Tripoli. We would know for certain on February 1. The thought of starting a school was a dream, and we were so excited we could barely contain ourselves. Bob seemed happy too when we said we would come in spite of a $3,000 cut in salary. We would have a furnished apartment and pay no rent or utilities. I looked forward to working with Bob again. OCS was not the same without him.

In anticipation of our move, Peter and I found a tutor, a British woman named Rita who came to our villa one evening a week to teach us Italian. Skender, the athletic director, and his wife Carol had been hired to go to

Rome as well, so they joined us. Sixth-grade teacher Keith had been hired too, but he said he already knew enough Italian. Rita sat at the head of our dining room table trying her best to instruct us in the language, but we had a hard time being serious when we discovered that the melodious sounding "spuma de barba" meant "shaving cream," "biancheria" was "underwear," and "stanza da bagno" meant "bathroom." How could such beautiful sounding words describe such mundane objects? During class, we were as rowdy as responsible adults dared to be. When the word *cappuccino* came up, Skender wrote a note and slipped it under the table to Carol: "Dear Blonde Lady, Meet me after class for a cup of chino. Signed, An Admirer." We all learned some basics, but after a few weeks Skender and Peter were affectionately written off as gold-plated bastards and iconoclasts.

Our sweet little Gretchen developed a terrible cough shortly after we returned from Christmas vacation. The Libyans had just celebrated the Eid al-Adha, the feast commemorating the sacrifice of Abraham, and once again sheep hide, fur, and blood littered the ground everywhere, including our front yard. I suspected that Gretchen had swallowed some fur, but after a miserable week I knew it was something more serious. She was listless, coughed all the time, and had a high temperature. We were afraid we were going to lose her, so we took her to the vet. The diagnosis was a cold. We gave her cough medicine and Vitamin C pills, fed her chicken soup, and had the vet gave her five penicillin shots. She had more doctoring in four days than we had in the four years we lived in Libya, but it worked. If we went to Rome, she would come with us.

On February 1, just hours before Oil Company School contracts were to be signed for the upcoming year, a cable arrived for Nowell, Brame, and Carter saying:

SCHOOL NOT AVAILABLE FOR CURRENT SCHOOL YEAR STOP DO NOT CHANGE PRESENT STATUS STOP SEE YOU SUNDAY. BOB

Our anticipation for the move to Rome was short-lived. We were dis-

135

appointed of course. We found out later that the Mediterranean School of Rome had most likely been shot down by the Vatican before it even got started. Several expatriate schools with Catholic church connections were already established in Rome, and they wanted to keep business coming their way. Our friends sympathized with us. They knew how much we were looking forward to going. Malish. We had two white T-shirts with Mediterranean School of Rome imprinted on them in red, a few Italian words and phrases in our lexicon, and memories of a lovely dream. Arrivederci, Roma.

<p align="center">***</p>

At the end of February we received an unexpected holiday. Unfortunately, the cause was nothing to celebrate. Several cases of viral meningitis and scarlet fever had been diagnosed in the Libyan schools, and to avoid the spread of meningitis in particular, all schools were closed, including ours. It was a smart move on the part of the Libyan government. The disease was thought to have been carried back from Mecca by pilgrims, all of whom kissed the Black Stone. I knew absolutely nothing about the disease, and in those pre-Internet days could find very little information about it. It seemed to affect children more than adults. For prevention, we were told to avoid crowds and get plenty of rest and fresh air. We did better than that. We got out of the country.

We booked a flight to Malta and checked into the Midas Hotel in Sliema, a small cozy hotel that had become a home away from home for OCS faculty. Our host was Ed, a short, good- natured man who treated us all as if we were family. If we needed to store food in his refrigerator or freeze our meat before returning to Tripoli, he accommodated us. He always welcomed us with a cheery smile. Most people headed straight down to the bar when they arrived. I was usually dying for a glass of fresh milk, unavailable in Tripoli. Ed knew what we needed and did his best to provide it at a reasonable price. Malta was feeling the energy crisis at the time. We had an electric heater in our hotel room, but the place was cold.

Fortunately, we brought plenty of warm clothing. A taxi driver told us it hadn't been like this since WWII.

We spent a week eating pork chops and going to movies, enjoyable in spite of the freezing cold theaters. We bought meat galore to take back to Tripoli: twelve pounds of ham, a nine-pound pork roast, twelve pork chops, five pounds of spare ribs, two pounds of ground pork, and two pounds of bacon. Pork cost thirty cents a pound. At Foodland, one of the more upscale grocery stores in Giorgimpopoli, I once found ham for $10.00 a pound, or $1.00 per thin slice. I wasn't that desperate.

We enjoyed the flight back to Tripoli from Malta and got all of our pork through customs with no problem. Customs officials were always on the lookout for pork, booze, and books. They controlled our entry to such an extent that we never felt safe until we were home and had our treasures stashed away. Getting contraband through Tripoli International Airport customs became a game, and I got good at it. While waiting for my luggage, I scanned the customs area to locate an older seasoned-looking inspector. If necessary, I waited for one to become available. I avoided the young unproven ones who equated success with making people flinch, squirm, and grovel. They knew about Tampax, but took great pleasure in pulling a plug out of the box, dangling it in the air in front of a terminal full of people, and at the top of their voices, shout, "What is this? What is this?" Once when they did this to us, Peter replied with a smile, "You stick it up your ass." Fortunately, the customs official did not understand. Looking smug, if not triumphant, he returned the plug to the box, closed the suitcase, and waved us through.

Alcohol was the hottest item smuggled into the country, and people used imaginative methods to get it in. One woman filled her inflatable bra with booze. Some women tucked a flask of whiskey against their buttocks and prayed that their panty hose would hold it in place. One woman brought vodka into the country in baggies. She threw a couple of goldfish in each bag and declared them as tropical fish. They were belly-up by the time she arrived, but she had her martini that night. We never smuggled booze into the country, but we did bring home the bacon. If caught with

pork, the worst that could happen was confiscation. Booze could mean deportation. We needed our jobs.

All schools were back in session the day after we returned, and it felt good to be back in our classrooms. The bugs were contained, but everyone was still being careful not to eat fresh fruit and vegetables, drink contaminated water, or mix in crowds. Soon after we returned, word got out that a shipload of food from the States was docked in Tripoli harbor. We rejoiced at the news. Fresh shipments meant fully stocked shelves in our neighborhood stores, so immediately after school I stopped at Sharif's and bought Campbell's Soup, Cream of Wheat, Special K, Grape Nuts, jelly beans, gumdrops, cake mixes, and frosting. A toilet paper shortage was anticipated, so I stocked up. Since the boxes were right off the boat, I looked forward to bug-free cereal. When I first arrived in Tripoli, I was appalled when I found bugs in my cereal, flour, grains, and spices. Now, if I found little surprises in the flour, I sifted them out. If I poured milk on a bowl of Special K and bugs floated to the top, I just skimmed them off, gave thanks, and ate.

<center>***</center>

At the beginning of March one entire weekend was set aside for the OCS Basketball Festival. All homework was suspended, and every waking hour between Friday afternoon and Sunday night was packed with fun and games. Most of the American community spent the whole weekend in the gymnasium. Skender, our esteemed Athletic Director, brought in the De La Salle and Verdala basketball teams and their coaches from Malta, and their games against our varsity boys were the featured events of the weekend. Just for fun, the male faculty played the ninth-grade boys and the female faculty played the ninth-grade girls. If we didn't play well, we played hard. The crowd was noisy and rambunctious, ready to cheer for anyone or anything. Cheerleaders dressed in green and white, the school colors, yelled, "We're from OCS, couldn't be prouder. If ya' can't hear us, we'll yell a little louder!" The OCS Band, Tripoli Twirler square dancers, and trampoline

<center>138</center>

artists provided halftime entertainment. Volunteers sold popcorn and egg rolls, fried nearly a thousand hamburgers, and sold hundreds of cases of Pepsi. It was a rare occasion. Our bodies were tired, but our spirits were high when the weekend was over. We all went home physically exhausted, but in every other way energized.

Along with warmer March temperatures came days of torrential rain and window rattling winds. Our kitchen ceiling sprang a leak, and water gushed under the French doors into the dining room. Power was out for hours at a time. We wrestled with heavy sopping carpets, opened the French doors and pushed the water out with brooms and mops, then went to school where we found more of the same. By that time, we desperately needed a cup of coffee, so we caught rain water and brewed a pot on the Bunsen burner in Don's science lab. We had read that Ralph Nader envisioned all expatriates dressed in furs and gambling in casinos on the Riviera. At times like this, we could have set him straight.

<p style="text-align:center">***</p>

Easter break gave us a respite from recent ups and downs. As planned, we left with our friends Skender and Carol for Beirut and Cyprus on April 12. Beirut was a shopping mecca, but Skender was not a shopper so he stood outside the shops taking in the street scene and schmoozing with the locals. When he was approached by hucksters wanting to sell him rugs, jewels, or antiques, and he said, "No, I'm not interested, but I have a buddy inside the shop who would really like to talk to you." So every time we left a shop, a half-dozen hawkers descended on Peter who got them laughing and sent them on their way.

Skender and Peter were a natural-born comedy act. Our last evening in Beirut we booked tickets for the Casino, and when their bus picked us up we were all laughing and having such a good time that our guide asked the guys to be in that night's show. He did not need to twist their arms. Before the show, they were called backstage and asked to take off their shirts, socks, and other items they were wearing. The stage hands plastered

the clothes to the front of their bodies and later, in front of a thousand people, a magician whipped off their socks, ties, glasses, suspenders, t-shirts, and finally their shirts. The audience went wild. Skender and Peter stayed cool. Carol and I laughed so hard that tears streamed down our faces. The show continued with a space craft dropping from the ceiling and a mermaid swimming in a huge aquarium, but our favorites were the stars from OCS. When the bus took us back to the city it was already getting light, so we finished the evening with breakfast at the Holiday Inn. That afternoon at 5:00 we boarded a plane for Nicosia.

Easter was the most important celebration of the year on the island of Cyprus. Everywhere we looked, people were roasting lambs - in homes, in restaurants, on open barbecue pits on barren hillsides. It was a memorable sight. Cyprus, the third largest island in the Mediterranean, is still inhabited by both Greeks and Turks. At the time, Greeks outnumbered Turks four to one, and while Turks were farmers and owned more land, Greeks controlled trade and industry and appeared generally wealthier. Most of the Turks living in the capital of Nicosia were blended into the general population, but rural villages were divided into sectors. So was the island. We rented a Land Rover and had to pass through several checkpoints on the way to Famagusta, a city famous for walls dating back to the 15th Century. On the way we saw rustic houses made of stone and hillsides covered with olive trees, cypress, and pine. We encountered the U.N. Peacekeeping Force a number of times. They had been on the island for ten years as the conflict between Greeks and Turks continued. Decades later the island is still divided, Greeks in the south, Turks in the north. Attempts at reunification by the UN have failed multiple times.

We visited Paphos where, according to legend, Aphrodite rose out of the sea in a cloud of foam. It is also the place where the apostle Paul caused a stir when he told the Jewish sorcerer Elymus he was going to go blind, and the sorcerer immediately lost his sight. The island was one of the earliest to embrace Christianity. Along with Malta and Rhodes, the Knights of St. John had a presence in Cyprus for a brief period.

Everyone on the island seemed to speak English, the result of British

occupation, no doubt. We went to a restaurant and joined people dancing with exuberance and smashing plates on the floor. It was not spontaneous. We had to buy the plates in advance.

<p style="text-align:center">***</p>

We came home to find Gretchen full of ticks. They were in her eyes, in her ears, all over her body. We had left her with a neighbor we thought we could trust. We were wrong. We could not fathom how anyone who professed to love animals and had several pets of her own could allow such a thing to happen. We carefully removed all the ticks from our sweet little Gretchen, bathed her, and gave her all kinds of love and attention. This would not happen again.

The first weekend after we returned from Easter vacation I got up early and went down to the Italian Market. I bought two kilos of shrimp, all kinds of vegetables, and bourik, the pastry shell that we all used to make egg rolls. It was a soft fresh phyllo pastry sold by little old men sitting on low stools in the doorways of the market. The pastry was round, six inches in diameter, about the size of a burrito. North Africans plopped an egg on it, folded it over, sealed the edges with egg white and deep fried it. It was served with lemon wedges and if cooked just right, the outside was crisp and the egg yolk inside ran down your arm as you bit into it. Few things ever tasted so good.

My neighbor and I made ten dozen egg rolls with the bourik and shrimp I bought, five dozen for them, five dozen for us. Two kilos of shrimp, about 4 1/2 pounds, took two hours to peel and yielded six cups of meat. They were small, sweet, and delicious, much like Maine shrimp. We put a mixture of shrimp, bean sprouts, and a little hamburger in the bourik, wrapped the pastry up, sealed it with egg white, and deep fried it. They made a tasty lunch.

All the people who went to Egypt at Easter came back with amoebic dysentery, apparently from eating contaminated food. Human waste was used for fertilizer in many of these countries, so one was well advised to

stay away from salads, fruit, water, anything that didn't have the daylights cooked or boiled out of it. Only Keith came back healthy, but he wouldn't admit he had diarrhea if it were dribbling down his leg.

Back on campus, the atmosphere was one of unrest. Once again the dress code was an issue, but this time the complaints came from our girls. From the time OCS first opened its doors, girls were required to wear skirts while boys were allowed to wear whatever they wanted. As the years passed, boys started coming to school in faded, ragged jeans, tacky tank tops, and threadbare T-shirts. Girls, however, were expected to look their "Sunday Best." A recent concession from the administration allowed girls to wear pants, but they had to be dress pants. Now this privilege had been taken away from them because, according to the principal, they were starting to look as sloppy as the boys. This did not set well with the girls. Why, they asked, should girls be expected to look halfway decent when the male population of the junior high looked "absolutely sick with long, uncombed hair, grubby jeans, tattered shirts, and an overall slovenly appearance."

Finally the girls took their case to the *The Pipeline*, the student newspaper which the teachers in the English Department took turns editing and publishing. They collaborated on an editorial that got everyone's attention and it resulted in a victory of sorts. From that point on, girls and boys started to dress about the same.

The one and only run-in I ever had with Bob Waldum occurred over an article in *The Pipeline*. This issue was also over fashion, so to speak. Shortly after I arrived at OCS, I took my turn as faculty advisor of the paper, and in an interview of fellow classmates one student reporter asked the question, "What do you think of hot pants?"

One student replied, "They're better than Mo pants."

"Mo–short for Mohammed–pants" were the white baggy pants worn by Libyans. The pant legs were like balloons and had enough fabric under the crotch to fashion a small tent. Some foreigners held them up for ridicule, irreverently calling them forty-day pants, suggesting that they could hold forty days of human waste.

I had edited the paper carefully, taken out the offending remark, and

put the revised copy in my filing cabinet ready for publication the following day. During the night, I was attacked by a flu bug, and when I knew I could not make it to class, I wrote instructions to the substitute and to my students to wait until I returned to print the paper. The students couldn't resist the opportunity to slip the remark back in, print the paper, and circulate it during the last period of the day. The sub, who wasn't aware of the offending remark, did not stop them.

When I returned the next day, I received a summons from Bob, something that made a grown man tremble. I entered his air-conditioned office, took a couple of shaky steps across the Persian carpet, and sat down in front of his massive, highly polished desk. Bob waved the paper in the air and said, "What's this?" I explained the events of the day before, but he didn't buy it. The student's remark was insulting, and Bob was rightly incensed. I insisted that I would never let such a thing pass. Finally, though reluctant to concede, I felt he accepted my explanation.

I got up to leave, and as I reached the door, I turned and saw him shuffling papers behind the SMILE–HAPPY BOSS sign on his desk. Without looking up, he said, "Just make sure it doesn't happen again." I quietly said, "Right," and slipped out the door, happy to be alive. Bob was commonly known by two names. SOB and Sweet Old Bob. He lived up to both.

Bob cultivated a laid back atmosphere on campus, but he ran a tight ship. He had to. He was scrupulous in his observation of the customs of the host country. It was rumored that Dr. Taeb, the Minister of Free Education, met with Bob one day in the superintendent's office and during the course of their conversation, he admired Bob's Rolex watch. In accordance with Arab custom, Bob unsnapped the watch, took it off his wrist, and handed it across the desk to him. It was such a classy story we wanted to believe it. If true, it paid off. Dr. Taeb was the man who decided which private schools could continue to operate in Libya. Ours did. While other foreign schools were shut down or nationalized, our doors remained open.

The first week of May our faculty lounge was the scene of panic because we had missed Mother's Day. Everyone rushed out to send cables

and make phone calls. Thanks to advertisers, it was impossible to miss a holiday in the States, but here we had no one to remind us. Outside of Halloween, Christmas, and Easter, the only way we remembered other holidays is if someone accidentally thought of it. It was amusing to see grown ups, including me, in a panic over their mothers. One would think it was the end of the world. We weren't the only ones scurrying around to let our Moms know we remembered them. The kids were too, even the bad guys. We saw one of them, a ninth grader, on his way home from school on Zavia Road with a monster plant for his Mom. He had dropped it, so we stopped to help him put it back together. He seemed nervous about it. He may have stolen it, or he might have been afraid we would spread the word that he was really a nice guy, at least when it came to his mother. Bottom line, the kids were just like us. We wanted to let our mothers know that we loved them.

<p style="text-align:center">***</p>

Rumors were a part of daily life in Tripoli. Gaddafi had three wives, his second in command Jalloud was a womanizer, a meat shortage was imminent, we would be without water for two days, Americans were going to be evacuated, our school was going to be closed. On campus, our Junior High faculty lounge was commonly known as Rumor Control Headquarters. The lounge was furnished with Goodwill-style couches, a work/lunch table and chairs, a coffee pot, and Alitalia ashtrays, always full of butts. It had a refrigerator for our lunches, a typewriter, a mimeograph machine, and mailboxes for notes from the office and mail from home. It was the only air-conditioned room in the wing and was directly across from the principal's office. Principal Jim didn't come in often, although one morning he came in and fired a starting gun to get us to our first period class on time. Students sometimes came to the door but never crossed the invisible line into the room itself. Teachers congregated in the lounge several times a day to run off tests, correct papers, use the bathroom, touch base, and of course, catch up on the latest rumors.

Sometimes, when rumors ran dry, we started them ourselves then timed them to see how long they took to reach the elementary lounge. Once we started a rumor that the water would be shut off for two days. That barely caused a stir, so we came up with a juicier one that the voltage was going to be changed from 110 to 220. That worked a little better. The best one was started after the government decreed that all passports had to be in Arabic. We added to the outrage by telling certain *bona fide* rumor mongers that all incoming mail would have to be in Arabic, and that we would have to send our friends and families self-addressed envelopes if we wanted to receive mail. That one took less than hour to reach the elementary lounge and created a satisfying uproar.

At times our conversations were more elevated. After months of observation, we reached the conclusion that the dominant partner in a relationship was always referred to first: Torger and Gladys, Pete and Ellie, John and Sandy, Tom and Doris. But, when the female dominated, her name came first, as in Peggy and Ray, Patty and Dennis, and Farney and Ed. Great minds at work.

The faculty room was more of a lair than a lounge. The atmosphere could be described as anything from rowdy to perverse. Teachers who had sensitive ears and feelings ducked in quickly, got their mail, and left. The regulars ruled. A couple of men spent so much time in their favorite chairs that their heads left grease spots on the upholstery.

Hoping to find more shrimp, I went to the Italian Market on the weekend but had no luck. I could have bought a sting ray, shark, swordfish, sardines, squid, octopus, or a moray eel that looked like a big, fat ugly snake. I settled for a relatively clean chicken. Usually they came with everything but the feathers. When I got home, I hacked off the feet, emptied out the guts and gizzard, picked out pin feathers, singed fine hairs, and cut the bird into pieces. They were free range, probably had to work for their food, and in spite of the gross job of cleaning them, they were some of the best

chickens I have ever tasted.

Food prices were becoming staggering. I rarely bought anything canned. Yankee thrift had taught me to "Use it up, wear it out, make it do, or do without." Imported food had a 45% markup. One small can of Crisco was $3.95. Eggs were 15¢ apiece, but I could still get a bargain at the vegetable souk. I bought beautiful lettuce, carrots, tomatoes, radishes, and a couple of pounds of fresh apricots for about $2.50. Superintendent John went to the Board to ask for a raise or an increase in our cost of living allotment. All the oil company employees got a 7% increase. It cost as much for us to live as it did for them.

By the middle of May, everyone was anxious for the school year to end. With just a few weeks remaining in the year, most of the students stopped working. Just a few faithfuls kept at it to the bitter end. We were discouraged with this group of ninth graders. Graduation was coming up soon and with few exceptions, no one was sorry to see the class go. Many were lazy, negative, smart-alecky, and foul-mouthed. They walked into a classroom, sized up the situation, and if the teacher didn't let them know who was boss, they took over. They flashed switchblades in class, broke into a first year teacher's classroom at night, wrote dirty words on her blackboard, and left cigarette butts on her desk. They drove her out of the profession.

I had most of these characters in my homeroom, but they knew that I did not put up with any nonsense. If they got out of line, they had to stay after school and wash walls and windows, sand desks, mop floors, polish door knobs, and clean out lockers. Nobody left until the place was spotless. Near my desk was a baseball bat that a Little Leaguer had left after the previous season. It sent a message to behave.

Some parents were at least part of the problem. These students ran the show at home and assumed they could do the same at school. A friend told me that the mother of two brothers in the bunch above was displeased with her sons' English grades and announced at a Friday night cocktail party that she was going to beat the shit out of me. Her sons were not scholars, but we got along fine. Malish. Next year promised to be better.

To be fair, most of the parents we dealt with were a good bunch, polite and cooperative. They chaperoned field trips, coached volleyball, sewed costumes, ran errands, baked brownies. Most of them encouraged teachers to have high standards in their classrooms, and many helped us implement and maintain valuable school programs. Now and then, Mobil wives served Sloppy Joes for lunch on the school lawn, making an otherwise run-of-the mill day memorable. Parents came to Parent Teacher Conferences in droves. Some brought their own translators.

Before we left for summer vacation, we had a few special friends over for pork roast, the nine-pounder that we bought on our last trip to Malta and kept in the freezer. I decided I had better use it before we left for the summer. Sometimes the power went off while ex-pats were away and they came back to refrigerators and freezers full of rotten food. I didn't want to risk that. We had the usual trimmings: mashed potatoes and gravy, baked corn, fresh green beans, apple salad, and apple pie. When school was officially closed, a friend and I had a pizza party for friends who were leaving Libya. We had to make enough pizza for fifty people, so we put the pizza dough in a giant bowl, covered it with a dish towel, and placed it on the patio outside the kitchen door. We discovered that in 90° heat, dough rises in minutes.

This time we were determined to find a good home for Gretchen before we left for the summer. We were lucky. Superintendent John and his wife Winnie agreed to care for her. They had a dog from the same litter, so Gretchen and her sister got to spend the summer together. Before going home to visit our parents in Iowa and Wisconsin, we went to Tunisia and spent the day in the beautiful village of Sidi Bou Saïd a few miles north of Tunis. Situated high on a cliff overlooking the sea, it had cobbled streets, stone steps, and stucco buildings that gleamed white and blue in the brilliant sunshine. We got the feeling that life would be perfect if only we could live there. We were traveling with Keith who loved food and knew

the best restaurants in Tunis. When traveling with Keith, we never went hungry.

Friends from Yugoslavia had invited us to visit them, so we spent a few days relaxing days at their home in Zagreb. Tocs was an agricultural advisor to the Libyan government and Tyana was a doctor. Their daughter, Iva, was our student. Tyana's accounts of doctoring Libyans always contained an element of surprise. She once asked a Libyan patient for a stool sample, and when he returned the following week, he presented her with a huge glass container full of it. His whole village must have contributed.

From Zagreb we went to Dubrovnik, took a boat ride on the Adriatic and passed a colony where nudes of all ages were lolling on the rocks soaking up the sun. The old men looked like ancient wrinkled walruses. Keith and Peter took full advantage of the view. It was not a pretty sight. In fact, I had to look away. Most people look better with their clothes on.

The time with our families in Iowa and Wisconsin went all too fast, and we regretted saying goodbye but looked forward to getting away from the daily bombardment of news about Watergate. We didn't care if we heard the names Mitchell, Liddy, Ehrlichman, or Haldeman ever again. In August we boarded a KLM 747 to London where everyone seemed friendly, satisfied, and happy in their work. We checked into the Rembrandt Hotel on Thurloe Place, and after recovering from jet lag we visited the Museum of Natural History, stopped at every bookshop we came across, saw some good films and plays, and visited Hyde Park Corner to hear the speakers. For a special treat, we went to Simpsons-in-the-Strand, a traditional British restaurant with lovely warm oak-paneled walls dating from 1828. Simpsons specialized in roast beef, and after placing our order, a carver arrived at our table with a silver-domed trolley. It opened up to a huge rack of beef from which the waiter carved a generous slice and served it with Yorkshire pudding and vegetables. This was fine dining.

Towards evening on August 8 we walked into the lounge of the Rembrandt Hotel and stood in shock as we watched President Nixon, who had vowed never to resign, announce his resignation on TV. He said, "To leave this office before my term is completed is opposed to every instinct

in my body, but as President of the United States I must put the interests of America first." He was the first U.S. President to resign, but his motives were not entirely altruistic. If he hadn't resigned, he would have been impeached. The most egregious of all his acts was trying to cover up his wrongdoing. If he had come clean about his involvement in Watergate, the public may have forgiven him. The following day Gerald Ford took the oath of office and declared that "our long national nightmare is over." He later pardoned Nixon.

<div align="center">***</div>

We returned to Tripoli about 4:00 on August 11 expecting a blast of hot air when we got off the plane, but it was beautiful, just like a breath of spring. Apparently it had been that way all summer. We hoped it would hold out a few more days.

Gretchen was happy to see us, but she had mixed feelings. After staying with her "sister" all summer, they had gotten very close. Both of them moped around like orphans for a few days, but soon we were a family again. During the last precious days before classes resumed, we enjoyed beautiful sunshine and lived on fresh fruits and vegetables. I cleaned cupboards, closets and drawers, and washed drapes. Every day I went to the beach for a couple of hours. Since our return, we had no hot water so it was back to boiling water for dishes and visiting friends for baths and showers. In a few days a new water heater was installed in its usual place outside our bathroom window. We hoped for better luck this time.

Mobrouk had the villa sparkling. The marble floors were so shiny I could almost see myself in them. The outside of our villa had a new coat of white paint, so the place looked fresh and clean inside and out. Half of our back yard was covered with squash that Mobrouk planted in the spring. It was a bumper crop of the kind used in couscous, and Mobrouk reaped the harvest.

Mobrouk's wife "shook" another baby shortly after we returned. That was his version of giving birth. This baby was number seven, and he was

<div align="center">149</div>

a bit disappointed that it wasn't a boy. He told us that he gave his wife birth control pills, but she flushed them down the toilet. She loved her bambinos. Having a lot of children was a status symbol among Libyan women. At the time, there were few other ways that they could distinguish themselves.

Before I went back to work, Mobrouk invited me to his home to see his wife and new baby. He lived in a typical square concrete block house with small rooms opening onto a central courtyard. The open courtyard provided light for the rooms and a private place for the family to work and play. An open stairway led to a flat rooftop from which one could see the surrounding houses, neighborhood mosque, and streets of sand. The place was clean, well kept, and had little furniture: two beds, a dresser, a wardrobe, two straight-back chairs, and a refrigerator and stove in the kitchen. The floors were covered with straw mats and strewn with colorful pillows. While I sat on the floor with his wife and children, Mobrouk served us store-bought cookies and orange soda.

The children were all good looking and seemed healthy and happy. Aisha, the oldest, fell in love with me and wouldn't leave my side. The younger girl cried her head off every time she looked at me. Mobrouk's wife was young, pretty, and smiled a lot. She was only twenty-six years old and already had seven children. She had beautiful white teeth and long straight black hair which she wore Cleopatra style. They seemed like a happy family. His wife sent me home with a big bowl of couscous topped with chunks of meat. She wanted me to know it was cow meat, not camel. I wished Peter could have gone along, but he would not have been allowed in her presence.

<p style="text-align:center">***</p>

A new principal from Wisconsin joined our staff in the fall of 1974, and we hoped he was a good disciplinarian. After the previous school year, we needed it. Classes seemed to go in cycles. Some years, like last year, I couldn't wait to see the tail end of the graduating class. Other years, I

regretted seeing them go. When I taught at Dubuque Senior High School in the 1960s, my sixty-five year old department chairman, Alma, picked up her paycheck every month, waved it in front of her classes, and said, "O.K. you little farts. I get paid whether you learn or not." During the bad years, I felt like her. During the good years, I felt sorry for anyone who wasn't a teacher. All in all, I couldn't think of anything I'd rather do.

The heat that we knew was coming arrived on the first day of school. That morning we woke up to a temperature of 104° and 98% humidity. It was unbearable in the house, so we had our morning coffee on the back patio. Ours was one of the few faculty villas without air-conditioning, so we used a floor fan in our bedroom. As long as I could sleep at night, I could survive the day. In spite of the heat, we were encouraged. One week into the new school year, the future of OCS looked bright. New students were enrolling every day and our new principal seemed firm, but fair. He laid down the law the first day. No long scraggly hair, no faded-out jeans, no smoking, no tardies. That went for both boys and girls. It looked and felt like a different school. We hoped the spirit would continue.

The first few weeks of classes went smoothly. We had watched enrollment decline after the oil companies were nationalized the previous year. Now Yugoslavs, Turks, Egyptians, Libyans, Germans, Italians, Swedes, and Japanese were filling our classes, some from companies that secured contracts with the Libyan government, others from schools that the government had closed down. Our student body was noticeably more international, now about 50% American instead of 90% when we first arrived. The names in my grade book changed from Shelley, Hillary, and Holly to Snezana, Fauzia, and Yong Hi. Randy, Kevin, and Jeff were replaced by Predrag, Bong-Yong, and Dragomir. The change required a different approach to teaching English, but it made the future of our school more promising. The more students we could get enrolled, the better. If our campus was not fully occupied, we ran the risk of losing it.

Students in Peter's seventh grade American history each chose an American hero to research and present to the class. A Turkish girl dressed up as Johnny Appleseed, a Pakistani was Daniel Boone with buckskin

jacket, moccasins, and a coonskin hat. Gunslingers, outlaws, Indians, Paul Bunyan, and Huck Finn were all represented, but the best by far was Luca, an Italian lad portraying Patrick Henry. He closed his presentation by raising his arm and giving an impassioned cry, "Asa for me, givvah me liberty, or givvah me death!"

Except for meat and eggs, prices were higher this year than ever before, so when October rolled around we began an all out campaign against inflation. Our cost of living had gone up about 17% and we got only a 7% increase in salary, so four families went together to scour the warehouses in downtown Tripoli for essential items. We bought coffee, rice, canned tomatoes, beans, mushrooms, walnuts, cream, ketchup, oil, dish detergent, fifty rolls of toilet paper, napkins, Kleenex, paper towels, Dial soap, Comet, and the bargain of the century, 125 pounds of sugar for $6.00, less than 5¢ a pound. We brought everything to our villa and divided it four ways. Our share of the bill was about $100, a third of what we would normally pay if we bought the products off the shelf of one of the stores in Giorgimpopoli. Besides the savings, I looked forward to the convenience of having a year's supply of many of the items.

Friends who had a date palm brought me a large box of dates, and I spent half a day picking them over. I had to check each one for bugs and worms. They were a mess to clean, but I ended up with a couple of perfect quarts ready to freeze and use in breads and cookies. I started making my own yogurt from Needo, a brand of powdered milk from the Netherlands. I mixed one cup of yogurt as a starter in a bowl of milk, lit the oven just to get it warm, turned it off and left the mixture overnight. In the morning, I had a big bowl of yogurt that tasted better than any commercial product.

In spite of a bottle gas shortage, the kind we used for our cook stove, I lit the oven and baked three blueberry cheesecakes for Ladies Bridge. For the past few years, a dozen of us got together every three weeks or so to play some laid-back hands of bridge. We played for a couple of hours, had

dessert and coffee, and awarded a Booby Prize to the losers. Mostly we relaxed and enjoyed each other's company.

The male counterpart to Ladies Bridge was Men's Poker Night. Six or eight respectable teachers and administrators gathered around a different teacher's dining room table every month to win or lose a little money and make a lot of noise. No women allowed. The guys tipped their chairs back, bragged, bluffed, bet, and on a good night, might win twenty bucks. If luck wasn't with them, they might lose $4.57. The money didn't matter.

When Peter had Poker Night at our house, he set up a bar with ice, Pepsi, and potato chips. I baked a chocolate loaf cake with chocolate frosting for the occasion, then cleared out and went across the street to visit my neighbor, Amy. We sat in the living room with the French windows open, and over the high villa walls we heard the click of plastic poker chips, the banging of fists on the table, and raucous laughter. It sounded like hell week at a frat house. Neighbors probably thought a drunken brawl was going on. Around 11:00, the guys called it quits, had a piece of cake, and went home. It was remarkable to see grown men having so much fun without out a drop of booze.

<p style="text-align:center">***</p>

Embarrassed that I had lived in Libya for four years and could not speak the language, I joined six others and we hired a tutor to teach us Arabic. I knew basic words and phrases, words that Mobrouk had taught me, words I had learned by listening and observing. "Marketplace" Arabic. At our first meeting we were shocked when our tutor started to teach us Egyptian Arabic. She regarded the Libyan dialect as too provincial, but since we had no plans to live in Egypt, we insisted on the Libyan dialect. We were paying the bill so she gave in, but she pitied us. The Arabic alphabet was a challenge. I was learning to read and write all over again.

Between teaching, Italian and Arabic classes, football games, school activities, and social get-togethers, expatriates in our community spent a lot of time together. Day after day we worked side by side. Night after

night we met at the same social functions. We taught, socialized, traveled, and in some cases, lived together. Contact was sometimes excessive, sometimes stifling, but in the back of our minds was the knowledge that we were a little enclave of Americans in a foreign land, and concern for each other usually outweighed individual differences. Since our mothers, fathers, sisters, brothers, aunts, uncles, and cousins were a continent away, we assumed the roles of baby sitters, godparents, confidantes, care givers, consolers. In the absence of family, we became close. Someone once said that friends are relatives that you make for yourself. That proved true for many of us.

During our first years in Tripoli, we rarely accepted dinner invitations from students or socialized with their parents. We were concerned about being compromised in the matter of grades. In time, however, we found people too interesting, too kind, too funny to refuse. The mother of one of the girls in my English class told me that Peter and I had provided dinner table conversation in their home for so long that she felt she owed us a dinner.

One evening we were invited to the U. S. Consulate for dinner, undoubtedly because we had the Consul's daughter in class. The food was not great, but we met the British, French, Italian, and Swedish Ambassadors, as well as three men from Washington, D. C. who were on an inspection tour of the U. S. Embassies in North Africa. They were scheduled to come for a tour of OCS the following week.

One of the highlights of the fall was the arrival of Anthony Quinn in Libya to film *The Prophet*, the life story of Mohammed, later to be released in the West as *The Message*. The film did not do well in the States, but it made Anthony Quinn a star in the Arab world. Mr. Quinn stayed at the Beach Hotel, a few blocks from our villa, and just knowing he was close by provided our community with an air of expectancy. Ex-pats wanted to invite him for dinner but were too shy. Students, however, went right up to his hotel door to get his autograph. He always obliged them.

We invited Mr. Quinn to speak at OCS, but he declined. Instead, his director, Moustapha Akkad, came and talked to the student body about

making movies. A few of our horse-loving students went out to the desert where the movie was being filmed and worked as extras in the horse scenes. Quinn sightings were always being reported. I ran into him browsing at the gritty-floored newsstand just down the street from our villa late one afternoon when I went to pick up my always-a-day-late copy of the *International Herald Tribune*. He looked up and said, " Hello, young lady." I smiled and said, "Hello," but couldn't help it. My feet felt lighter as I walked home.

<center>***</center>

By the end of October, we started to make plans for our Christmas holiday. In fact, as soon as we got the school calendar in the fall, we sat down with friends and planned our trips for the year. We laughed and joked that the only reason we were there was to bank and travel. The Libyan love of holidays rubbed off on us. We observed the usual American holidays: a long weekend for Thanksgiving, two weeks at Christmas, and one week at Easter. Then, in accordance with Libyan law, we celebrated the Eid al-Adha, Eid al-Fitr, the Lunar New Year–1392 by the Moslem calendar, Mohammed's Birthday, Arab League Day, Unification of Libya Day, Sudan Independence Day, Syrian National Day, American Evacuation Day, Italian Evacuation Day, British Evacuation Day, Tobruk Evacuation Day, and others I can't remember. One might wonder how we got anything done, but we managed.

In November, Gretchen went into heat for the second time. She was so adorable and had such a sweet temperament that several people asked for puppies if she had a litter. We had been advised not to let her become pregnant the first time she went into heat, but now she had a boyfriend next door named Snoopy, a somewhat psychotic beagle-dachshund mix. We got together with our neighbors and discussed the possibility of putting Gretchen and Snoopy together. They were all for it. The first time we put them together, neither of them seemed interested. Late one afternoon, however, I heard our neighbor Dianne shouting from her front yard, "He's

<center>155</center>

in her. He's out. He's in her. He's out!" It was Snoopy trying his best to become a father.

For the first time since we arrived in Libya, thieves descended on our neighborhood. One morning our neighbor walked out on the street and discovered the headlights of his car missing. He brushed it off until he went to buy new ones and found that they cost $75.00 each. We hadn't been hit yet, but we kept our outside lights on all night just in case. The police were aware of it and there were stiff fines and sentences for theft, but few burglars were caught.

Tired of pot lucks and progressive dinners for Thanksgiving, nine of us packed up a roast turkey and all the trimmings and headed to the desert for the holiday. The group included best friends Tom, Doris, and Keith, neighbors Dianne and Dave, and school nurse Marge and her husband Don, a Mobil employee, and their poodle Emir. We hoped to find Ghirza, the site of an ancient Roman fortified farm. We had maps and drove on a fairly well-worn track most of the day, but we did not find the ruins. Come nightfall, we set up our tents in the middle of nowhere and huddled together in the largest of the tents for Thanksgiving dinner. We unveiled the turkey that our school nurse had roasted the evening before, cooked our instant mashed potatoes on a Coleman stove, then tied into turkey, potatoes, dressing and gravy, cranberries, and pumpkin pie with whipped cream for dessert. The night was cold, but with stomachs full of good food, we slipped into our Arctic sleeping bags and slept warm and well-fed.

The next day was overcast, and as we got up and looked around, we realized that we had completely lost our bearings. The only point of reference we had was the sun, and it was nowhere to be seen. We knew we needed to head east, but the desert looked the same in every direction. We guessed at a direction and drove until we had only forty minutes of daylight left and less than a quarter of a tank of gas in each vehicle. We did not dare to get off the track because we suspected that we were surrounded

by open mine fields left over from WWII. We had heard that the Bedouin cleared the fields by running herds of sheep through them, but we couldn't take a chance.

Finally, one car ran out of gas and we knew we had to take more desperate measures. We decided that Tom and one other person would head out in his VW bug to reconnoiter, and the rest of us would stay put. We spread leftovers on the hood of the Land Rover and gave thanks that at least we had plenty of food and water. Just before dark, we saw the welcome sight of a white VW bug returning in the distance. Tom had found the blacktop that led back home. Relieved, we packed everything up, hitched the VW with the empty gas tank to the Land Rover, and headed home. We had not gone far before we realized that we had left our school nurse Marge's nippy little poodle Emir behind. We returned to retrieve him, and when we kidded Marge about eating the dog in a pinch, she was not amused. All this drama went on no more than ten miles from the paved road, but it could have been a hundred miles away. We were glad to see civilization again. The next time we went anywhere off the beaten track we took a compass and an extra jerry can of gas.

When we got home we put up a little three-foot artificial Charlie Brown Christmas tree some kids were hauling away to the junkyard on a donkey cart. I asked if I could have it, and they were happy to give it to me. I made some little elves out of pipe cleaners and green and red felt for decorations, and it looked charming. Or so I thought. I started my Christmas baking, one or two things a night until December 14 when we had our annual party. Peter made three-hundred meatballs. I made rosettes and krumkake, lefse, potato cakes, sandbakkels, and other Norwegian goodies. Our forty guests said it was the best smorgasbord ever.

Five days later we boarded Swiss Air for a flight to Zurich then caught a train to Engelberg and checked into the Schweizerhof Hotel, the cozy old Victorian hotel we had stayed in previously. It was in the center of the village, and the price was right: $259 per person for two weeks, room and two meals a day included. Engelberg had an abundance of fresh snow, good for skiers. Our friends Sandy and Roger were with us, as well as sev-

eral single young women on the faculty. One evening a number of handsome men from Switzerland joined us in the lounge, and we noticed a definite look of anticipation on the faces of our gals. Alas, nothing developed. The men were all studying for the priesthood. We enjoyed talking to them and admired their commitment to their calling. We called home just after midnight on Christmas Eve as usual.

1975

We returned to beautiful sunny days in Tripoli, but at first I felt colder at home than I did in Switzerland. After two weeks with no heat, our cinderblock villa felt like a tomb, and the sheets were like ice. When we went up to campus to check our mail, we found a Christmas package from my parents. What fun we had opening it! The Nemeth family and our neighbors, Dave and Dianne, were visiting when I did the honors, and they couldn't believe what came out of that little package. We laughed and laughed as I pulled out each item: gum, billfolds, key chains, socks, a pair of pajamas, all little reminders of home.

The good news at OCS was that we got a 15–20% raise in salary. It was based on the number of years of employment at OCS and the degree held. Nine years was the average length of stay at our school, and nearly half the faculty had master's degrees. We wouldn't know exactly what we were getting until our next check, but we hoped it would take care of the increase in cost of living and allow us to save a little more. Our student population kept growing, and we tried our best to meet the challenge of teaching students from Japan, Germany, Italy, Turkey, Egypt, Italy, Yugoslavia, and Sweden, among others. Peter's seventh grade American History was made up of at least ten different nationalities. One day as the class was discussing the American system of taxation, a girl from Turkey raised her hand and asked what happened to U.S. citizens who didn't pay their taxes. Never letting the truth stand in the way of a good story, Peter began, "Well. The tax collectors take you into a room with no windows. There's a chair in the middle of the room and above it a bare light bulb hanging from the ceiling. A man with a black mask over his head sits you down on the chair and puts a blindfold over your eyes. He asks you why you didn't pay your taxes. You tell him, but he doesn't believe you, so he grabs your hands and rips out your fingernails. Then he breaks your knuck-

les one by one. Crack, crack, crack, crack, crack. Next he cuts off your nose and ears. Finally, he wrings your neck and when he gets all through, he kills you." As the poor, pitiful victim's neck was being wrung, the bell rang and the class tiptoed out of the room. The next day, the students returned, still quiet as mice. As class began, the little Turkish girl raised her hand and asked in a voice just above a whisper, "Tell us again about not paying your taxes?"

The first three-day weekend that rolled around we made another attempt to find Ghirza, the Roman fortified farm that we had searched for the previous Thanksgiving. This time we took plenty of gas, Arctic sleeping bags, and yes, a compass. As we drove in what we believed was the right direction, we came across a rusted out sign. It was in Arabic, but it showed the outline of a mausoleum, so we knew we were on the right track. When the ruins finally came into view, we felt like Lewis and Clark when they reached the Pacific. From a distance, three edifices with columns rose out of a massive pile of rubble. They were the mausoleums we sought, and although most of the farm buildings on the site were in ruins, the reliefs on these structures dating from around A.D. 300 looked so fresh they could have been carved the previous day. Clusters of grapes, eagles, lions, oxen, stylized faces and figures of men were crisp and clear. The desert was a perfect preserver. One of the tombs had an intricately carved door with an inscription above it. I could make out "Pater et Mater Marchi" and the word "Memori," possibly a memorial to Father and Mother Marchi. In ancient times, these farms were the breadbasket of Rome producing grains, figs, dates, almonds, and olives. It was hard to imagine as we surveyed the vast, empty desert and the former grand buildings, now piles of rocks. Climatologists observe the same things happening today as the Sahara moves south and turns soil once used for crops into barren wasteland. We set up camp in the middle of the ruins, and when it grew dark we lit our Coleman lanterns and put them behind the columns of the nearest mausoleum. After a good meal, we basked in its beauty from our campfire.

Back home, our little Gretchen was fat and pregnant. She slept late in the mornings and wanted her meals on time. We waited on her like a princess. Sunday night, January 19, 1975, she gave birth to two puppies, one male and one female, both miniature Snoopys with soft chestnut coats. Peter was visiting friends, and I was out playing bridge with the ladies, so our sweet little girl delivered her babies all by herself in the back bedroom. She had the pups all cleaned up when we got home and acted as if this were an everyday occurrence. One pup was smaller than the other, so we gave them temporary names of "Grunt" and "Runt." A couple of days later on the Libyan equivalent to our Memorial Day, thirty people stopped by, all to see Gretchen and her babies. At the end of the day, we did not have a single clean coffee cup left in the house.

Grunt was thriving, had rolls of fat, and was generally enjoying life. He looked like a baby hippo. Runt was O.K. the first two days, but then she stopped feeding. I had to take the poor little pup away because our new mother started nipping at her and nosing her out of the basket onto the floor. We put the baby in a basket next to the heater, but when I tried to put her back in Gretchen's bed one morning, I found that she had rolled the tiny thing all the way up the hall and left her under our bed. Our vet warned us that she might try to eat the puppy if she got too upset, so we kept her in the basket next to the heater, fed her with an eyedropper, and gave her suppositories to make her poop. One night we got the vet out of bed for a prescription and drove downtown to an all-night pharmacy to get her medicine. The whole community was rooting for her. Poor Gretchen was distraught.

Runt lived a week, but she suffered. In spite of all of our efforts, we had to have her put to sleep. I cried so hard on the way home from the vet that I could barely see to drive. Grunt was feeding for two and getting fatter every day, his eyes were open, and he had just started walking. Every time we looked at him we thought "Fat Albert," so that became his official name. He made cute little puppy growls and barks and although people

161

were waiting in line to adopt him, he was so fat and cuddly that in the end we couldn't bear to part with him. Besides, Gretchen would enjoy his company.

The approach of warm weather inspired us to mobilize for an all-out assault on our villa. Peter took the doors off a huge wardrobe in our spare room, stripped off eight coats of paint, and refinished it for an entertainment center. We stripped the paint off a homemade Italian hutch with shelves on top to store dishes, a thick counter to use as a cutting or pastry board, and cupboard space below. The wood was pine but had a nice grain, so we sanded it down and left it unfinished. We had our couch and one chair upholstered in a champagne color velour, stripped the wax off the marble floors, and shampooed the carpet. All of this was in preparation for a paint job of the interior of our villa that we had been waiting for all year.

On March 8, OCS chief painter Mohammed and his crew arrived on our doorstep and the painting began. On this day they finished the living room ceiling then took off for a three-day weekend. Surveying the mess, we decided to paint the white 14-foot living room walls ourselves. I painted the fireplace and window sashes. Peter did the rest. Now we would have at least one room in which to live while the rest of the villa got painted. Mohammed and his crew were good painters, but they took their time. They began the day by opening the cans of paint and laying out the brushes. Then it was time for tiny cups of sweet hot shahee. After taking a few trial strokes it was time to start cooking macaroni and harissa, seriously hot red pepper paste, for lunch. After that one needed a rest, then a few more strokes and it was tea time, and all things considered late enough to call it a day. Fortunately, we were going with several other faculty members to Tunis for the Maghreb Conference, an annual gathering of North African Teachers, and would be gone a week, all expenses paid. We hoped another room might be finished by the time we got back.

The main speaker at the Conference was Dr. William Glasser, and his subject was "Schools Without Failure." A psychiatrist from Los Angeles, he promoted his "Choice Theory" as a way to improve schools. His theory was that we choose our own behavior and that it comes from within, not

from without as many believed. Our role as teachers was to help students choose good behavior and academic goals. Much of his presentation was common sense, but some of his expectations were unrealistic. He was opposed to failing grades, but at OCS grades were still important to our students and their parents. On one thing we agreed. Grades should never be used as punishment.

We attended meetings most of the time but took a break to visit the Tunis Artisans Center and buy a carpet and a back seat full of Tunisian pottery. On the drive home, we stopped to see the magnificent Roman amphitheater of Thysdrus at El Djem, a massive structure that seemed to rise up out of nowhere. Built in A.D. 238, it loomed like a giant rising up from the olive groves and little white flat-roofed houses that surrounded it. Comparable in size to the Colosseum in Rome, it had a seating capacity of 35,000, but the interior was now just a skeleton, lonely and desolate. Looking around, it was hard to believe that El Djem was once one of the wealthiest cities in North Africa.

When we got home, I thought I was going to die. I had a high fever, and whenever I tried to stand up, I threw up. I traced my condition to contaminated couscous from a roadside restaurant where we stopped for lunch on the way back from Tunis. It tasted delicious, but it was most certainly tainted. I had noticed a can of tomato paste sitting unrefrigerated on a window sill for who knows how long. That should have been my warning. I finally got some liquid Jello down and recovered in a day or two. Contaminated food and bugs were our nemesis in Libya as were germs carried by the blowing sand that found their way into our ears, eyes, mouth, and nostrils. The community was currently fighting the New Zealand flu, but our greatest concern at the moment was for our friend, Keith, who was in the Oil Companies Clinic with hepatitis. He was sent home to his villa with instructions for a month of total bed rest, so along with his many friends, we took care of all of his needs. We brought his meals, ran his errands, made sure he had plenty of books to read, and visited with him until we sensed that he was getting tired and needed to rest. As time went on, complications developed in his condition, and since it

was beyond the expertise of anyone at the Oil Companies Clinic, Keith flew back to the U.S. and checked into the University of Iowa Hospitals. There his doctors diagnosed his problem as "Q Fever," a disease we had never heard of. It was caused by bacteria found in the urine, feces, and milk of infected sheep, goats, and other animals. People could get infected by breathing in contaminated dust from these animals. We had no shortage of them in Libya, but when and where he contracted the disease remained a mystery.

While we were in Tunis, the painters finished the three bedrooms and entrance of our villa, but not the long narrow hallway. Not wanting to wait any longer and anticipating a visit from my parents before the end of the school year, we finished the job ourselves. Since the day we arrived in Libya, our primary contact with my parents had been through the mail. Both of them wrote letters faithfully once a week, sometimes more. My Dad sent clippings of snowstorms, pictures of the family, football scores for the guys in the lounge, and cassette tapes of the family Christmas at home. We had no telephone, but if we needed to make a call, we could place one from the neighborhood post office, keeping in mind the eight hour time difference. My father always enjoyed hearing about our travels and experiences living abroad. Although his foreign travels took him only to his home country of Norway, his interest in and knowledge of other countries was extensive. If he didn't know about the places we visited, he went to the library to research them. From his favorite reading chair at 620 9th Avenue North, he traveled with us everywhere we went.

Now we hoped that they could visit us, so we wrote and told them we would like to spend our annual travel allowance to buy tickets for them to come to Tripoli. Dad was retired, but Mom was still nursing at Mercy Hospital in Mason City, so after some coaxing she arranged for a month off. Our first hurdle was getting tourist visas. The Embassy Visa Service in Washington, D. C., was recommended by our American Consul, so my

parents called to find out what documents they needed. Along with their application, they had to send their passports to Washington by registered mail, and once received, the agency hand-carried the documents to the Libyan Embassy. The initial charge of $32 ended up being much higher, not unexpected in any government dealings.

On March 27, I bought two round trip tickets from Clear Lake, Iowa, to Tripoli, Libya, at KLM, the airline that made the most reliable arrangements in Tripoli. A couple of days later, my parents received them via Telex along with a voucher for an overnight in Amsterdam. I left their return date open in case they decided to visit Zurich or Rome on their way home.

Before they left I sent them this last minute travel advice:

1) Your visa is in your passport. It is a tourist visa good for thirty days.
2) Smallpox is the only shot you need. They are good for three years, so if you got them last year, they should still be good.
3) There is a slim chance that customs will ask if you have had cholera shots, but I wouldn't worry about it.
4) Arrival cards are in Arabic, but the airlines have attached a translation for their passengers. Tear off the translation before you present it to passport control. Shot records do not have to be translated.
5) Be accommodating and friendly to customs officials. They may check your bags, but when they see your friendly faces, they'll probably wave you right through.
6) You can carry twenty kilos in your luggage, about forty-four pounds, each.
7) $300 should be enough money for expenses. Expect prices to be high as you travel. You won't have any expenses here.

I had sent a rather extensive shopping list, but all I really needed was contact lens solution, a thermometer, and a heating pad. Overweight

charges were high, about $6.40 a kilo. If they got a package of pills in the mail from Virginia, I asked them to please bring it along. They were for a woman in our community who couldn't get them in Tripoli and was in desperate need of them.

On May 8, after a short flight to Chicago, Mom and Dad boarded their KLM flight for the first leg of their North African adventure. They enjoyed a one-day layover and an overnight at the Arthur Frommer Hotel in Amsterdam, then flew into Tripoli on May 10, 1975, bringing with them presents and a whole raft of items that we could not get in Libya, including the items I requested and a bathing suit. Mobrouk had the villa sparkling for them, marble floors and counters gleaming.

I borrowed two twin beds for Mom and Dad, put them up in the spare bedroom, and the first morning they woke up to the call to prayer, dogs barking, cats thundering over the roof, and peacocks mating next door. During the day while we were teaching, friends and neighbors stopped by to visit and check to see if they needed anything. My dad took care of Gretchen and Fat Albert, who by this time thought it was his job to carry things all over the villa. We found our shoes and other unexpected items in the middle of the living room floor, and though he was pretty well house trained, he peed on the carpet I had recently bought in Tunis. A whole house to choose from, and he had to pick my new rug.

Mom was in her element with time off and all the necessary ingredients to bake up a storm. Mobrouk enjoyed my mother's baking and cooking, and she enjoyed his cleaning up. Mobrouk thought it was great that Mom was fourteen years younger than my father. He was thinking, of course, that Mom would be able to care for Dad in his old age.

Libyan men were allowed four wives as long as they could provide equally for each one. Mobrouk was satisfied that my father had all he needed with one. He felt personally responsible for taking care of my parents, and they appreciated his many acts of kindness. Every summer that we went home after their visit, we returned to Libya with gifts from my parents for Mobrouk and his family. He was especially proud of his Timex watch. A Rolex couldn't have made him happier.

Soon after they arrived, I gave Mom and Dad a tour of the Oil Companies School, and we attended special programs and activities scheduled during their stay. As we left a softball game one afternoon, a little red-haired girl ran up to my father and asked, "Are you a grandpa?" When he said, "Yes," her eyes lit up, and she ran off to tell her father the good news. Grandparents and babies were rare in our expatriate community. The average age of the faculty was thirty-four, and most of our oil company friends were about the same age. It was exciting to have someone older in our midst.

When our work at school was finished for the day, we explored the city of Tripoli. On Gold Street we walked past shop windows gleaming with 18-karat gold necklaces, bracelets, and earrings. In the covered souk, we chatted with rug dealers sitting cross legged in little cubicles, ready to serve tea and roll out their carpets for prospective buyers. Copper Alley, one of my Dad's favorites, rang with the hammering of copper smiths, their fires blackening the floors of the shops and filling the air with greasy smoke. On Saturday mornings, we wandered through the crowded passageways of the white Mediterranean-style covered Italian Market where I often shopped. We stopped to admire the colorful, mouth watering displays of peaches, grapes, melons, lettuce, tomatoes, radishes, and peppers, all freshly sprinkled with water and glistening under bare light bulbs. We followed our noses to the spice market and stopped to inhale the fragrant mounds of freshly ground red, yellow, and orange savory spices displayed in burlap bags. Fil fil, a red hot pepper spice used in shorba, the most common Libyan soup, was destined to be my father's undoing later in his stay.

The meat market was a ghoulish sight for Midwest eyes. Decapitated heads of camels, goats, and cattle, and whole carcasses of beef and lamb dangled from iron meat hooks in vendors' stalls. Live chickens and rabbits in wire cages waited to be sold. No pork, of course, but the fish market was inviting, especially for a Norwegian. Thick marble counters were covered with grouper, sole, tuna, swordfish, San Piero, sardines, squid, octopus, and piles of shrimp. Here, as in the rest of the market, nary a trace of Saran Wrap was to be found, nor were the clean, well-lit display cases of super-

markets in the U.S. Purchases were wrapped in white butcher paper and carried away in shopping bags brought from home.

On weekends, we visited nearby villages and the magnificent Roman cities of Sabratha and Leptis Magna. During the evenings, we went to the homes of friends who invited my parents as honored guests for dinners and parties. My father tried everything he was offered, but he especially loved the tiny glasses of shahee, sweet tea with mint, and small cups of strong, dark, sweet espresso. We treasured our time together and so did our parents. Everyone treated them like royalty, and now they could put faces and places to the names we wrote about in our letters. On May 27, a few days before they left, Mom and Dad were on hand to share the joy of a baby daughter born to Doris and Tom, a rare event in our community and cause for celebration. It didn't take long for Leanne to become the darling of our little world that was short on babies and grandpas.

Torger and Gladys had a choice of returning to Iowa via Zurich or Rome. They chose Rome, mostly at my father's urging. As they passed through customs in Tripoli and went to board their plane, I saw my mother struggling with a load of carry-ons while my dad ambled along toting one little bag. I chuckled as I watched airport employees rush up not to my mom with her heavy load, but to my dad with an offer to carry his bag. Libyans were good to their old people, especially "shabanis," old men. That may have been the reason that Torger, seventy years old, was treated with great respect. He was even allowed to take pictures wherever he went, unusual in Libya, where some felt that a camera captured the soul.

The trip home was not good. My father got sick in Rome, probably from the shorba served by our Libyan friend Abdu at their going away party. Shorba is a hot, spicy Libyan soup made from onions, tomatoes, lamb, orzo, chick peas, and seasoned with fil fil, red hot pepper that warrants a warning label. The soup is served with lemon wedges and piles of crusty French bread to absorb both the heat and the grease. My father's Norwegian stomach was not up to such abuse.

Torger suffered in Rome, but in spite of his discomfort, he and my mother went on tours and saw the major sights of the city: the Pantheon,

the Colosseum, St. Peter's Basilica. Before they left, my mother fell victim to one of Rome's taxi drivers, notorious for taking off with passengers' belongings. Mom wasn't quick enough to grab her coat when she got out of the cab, so she lost her yellow London Fog raincoat. Finally, when they got home and turned in my father's treasured slides to be developed, they were lost in the process. In spite of all these difficulties, they considered their trip to Libya an adventure of a lifetime.

A few weeks after my parents left, the end of the school year was approaching, and we prepared to do a little traveling ourselves. Before we left for vacation, we took Gretchen to the vet to get spayed, and when she came home, she did not want to be far away from us, so she convalesced under our bed. Albert still got into trouble every time he turned around. In his defense, with his powerful Queen Anne paws, sturdy chest, and threatening bark, he undoubtedly scared away potential intruders. We arranged for Gretchen and Albert to stay with our friends Helen and Spiro and their dog Milo while we were away. It was reassuring to know that they were in good hands.

<p style="text-align:center">***</p>

Looking forward to no more alarm clocks and sack lunches for a couple of months, we flew to Athens the third week of June then on to Rhodes, the largest of the Dodecanese islands. As in Cyprus, we saw the remains of several cultures, the most interesting of which was the medieval city of the Knights of St. John, the Palace of the Grand Masters, the Hospital, and the Street of Knights. In 1309 when the Knights were run out of Cyprus by the Muslims, they moved to Rhodes, made it their headquarters, and set up hospitals for pilgrims en route to the Holy Land. This medieval hospital had a large ward and a number of private rooms, each with a fireplace. The rooms looked inviting but probably weren't as comfortable as they appeared. In 1522 when the Knights were attacked and defeated by Suleiman the Magnificent, they moved from Rhodes to Malta. In 1565, Suleiman came after them, but after an extended siege the Knights defeat-

<p style="text-align:center">169</p>

ed him. The Knights had become a military power as well as a religious, charitable organization. The grand walled fortresses and edifices in Rhodes were similar to those in Malta. Exploring these sites was like unearthing a gem, discovering a treasure, putting together the story of human history.

Rhodes was a dazzling show of sunlight, sea, and sky. From the balcony of our room at the Mediterranean Hotel, we could see beaches full of sunbathers, cruise ships silently slipping in and out of the harbor, and the shoreline of Turkey, our next destination. The Colossus of Rhodes, one of the Seven Wonders of the World, is said to have straddled this harbor until 226 B.C. when it collapsed in an earthquake. In the past, Rhodes was noted for its artists and scholars, but today tourists were the main industry. Just for fun, we walked into the entrance of the grand Casino Rodos and put a drachma into a slot machine. The thing went wild, bright silver drachma raining down in every direction and piling up in a circle around us. People entering the casino joined in our merriment and helped us scoop up our bounty. No longer feeling the need to go inside, we took our winnings and left.

Istanbul was swarming with people, most of whom seemed friendly but unfortunately, very poor. The mosques looked like giant ships on the horizon, the skyline notched by tall, slender minarets. We had visited them and the Topkapi Museum before, but once was not enough. We had to have another look before going to Yuksel Dezyaoglu's shop in the covered bazaar where we bought a brass scale, copper milk and water jugs, and a round copper bath caddy that Turkish ladies once used to carry their toiletries when they went down to the river to bathe. Yuksel guaranteed they would arrive in the U.S. in good order. They did.

We explored the coast of Yugoslavia for a week or so and relaxed at our friends' cottage. They were not home when we arrived, but we had instructions to go to the post office in the nearest village to pick up the key and let ourselves in. We indulged ourselves with huge shrimp, lobster, and local catches, and woke up to ducks and geese honking and hounds baying in the early morning. On the Fourth of July, we celebrated Independence

Day as well as Fighters Day, a state holiday honoring Yugoslavs who rose up against German occupiers on July 4, 1941.

London, our next and final stop, was so packed with tourists that the only lodging we could find was a dumpy little room without a bath. It was clean enough, but I wasn't happy having to get dressed and trundle down the hall to go to the bathroom in the middle of the night. We saw some films and plays, did the requisite shopping, ate at Chinese restaurants, got haircuts, and headed home to Tripoli eighteen days earlier than planned.

Gretchen and Albert were overjoyed to see us when we picked them up from their summer home with Helen, Spiro, and Milo. Gretchen was her same sweet self. Fat Albert had grown physically but was still just a kid, ten years old in human years. It felt good to be back. I had all kinds of projects lined up at home and plenty of time to do them. I took the stove completely apart, cleaned all the cupboards inside and out, defrosted the refrigerator, and caulked the seams of the kitchen tiles where the ants got in. We painted the cupboards, stripped the ugly brown paint off the kitchen table and chairs, and built a shelf on the wall above the stove for things I always needed when I was cooking.

After enduring the heat in our villa for five years, we finally broke down and bought a Carrier air conditioner with enough BTUs that we hoped would cool the whole villa. Since most villas in Libya, including ours, had French windows, we couldn't install the unit in a window. Instead we had to have a hole hacked through a cinderblock wall in the living room, a job that left fine white powder on every surface. Anticipating the mess, we rolled up rugs and draped sheets over the furniture. Once installed, the electricians hooked up the unit, and in a couple of hours we felt cool air. It took a few days to get used to the sound, to having all the windows closed, and to the cooler temperature, but we rose to the occasion. We hoped the villa would stay cleaner since sand would no longer be blowing in through all the windows. We kicked ourselves for waiting so

long to get the AC, but every year we kept thinking we would stay "just one more year." It cost £250 ($750), worth every piastre. Besides, we could sell it when we left the country.

Most of our friends were still on vacation, including Helen and Spiro. Milo stayed with us while they were away, so I gave all three hounds a bath. Our friend Gloria popped in two or three times a day. She was moving to another villa, so I fed her and helped her when she needed it. Our neighbors across the street, George and Amy, were packing up to go back to the States. They were scheduled to leave on June 15 but had to wait all this time for Amy's exit visa. We would miss them. They were in their fifties, older for our ex-pat community, and both had a seasoned attitude toward life and a sense of humor that caught us off guard. I first met George at a neighborhood potluck dinner shortly after we arrived in Libya, and when I introduced myself as an English teacher, he replied that he couldn't stand English teachers. That was the beginning of a long friendship. George worked all day for an oil company, and Amy kept house. Late in the afternoon she walked to Sharif's grocery store two blocks down the street, and if we were home from school she stopped in to visit and have a drink on her way back. We started talking and before we knew it, George was home from work and at the front door retrieving Amy.

Our favorite story about Amy was the Saturday morning she got up at 7:00 and went out the front door for a breath of fresh air. In her driveway was a peacock. She called George, but he said, "Come back to bed. You had too much to drink last night. You're seeing things." She persisted, George got up, and Amy was vindicated. There in their driveway stood a peacock. When George came out, the bird took off. I suspect it was the same one my parents heard from their bedroom window when they were visiting. I hoped it didn't end up on someone's dinner plate. For a pittance the original cost, I bought the lovely yellow brocade love seat that Amy had purchased at Bloomingdales in New York City, and they gave us their washing machine. George and Amy left on August 7, excited as a couple of kids.

About this time, depending on the position of the moon, the Moslem

month of Ramadan was imminent. That meant no food or water for Moslems from sunrise at 5:30 to sunset at 8:30. It was especially brutal when it occurred this time of year. The heat was intense, and the day long. During this time hundreds of automobile accidents occurred daily, so we stayed off the roads as much as possible. Libyan drivers had two speeds, fast and faster, and the most important piece of equipment on their automobiles was the horn.

The heat only added to unrest developing between Libya and Egypt. Libya did not look with favor on President Anwar Sadat's peace efforts and accused his government of aiding rebels trying to overthrow Gaddafi. Migrant workers from Egypt were being deported left and right, and Egyptians living in Libya kept a low profile. We minded our own business.

All was not well in the U.S. either. Two assassination attempts were made on President Gerald Ford, one in Sacramento on September 5 by Squeaky Fromme, a Manson Family member, and another in San Francisco on September 22 by political radical Sara Jane Moore. We heard President Ford's speech on Voice of America after Moore's attempt, and he sounded undaunted. He said he just wanted to get on with his work.

We had seen Mobrouk only once since we got back from summer vacation. One of the gaffirs at school told us that he was having a problem with his little boy. The poor child had sores on his legs and could hardly walk. Ultimately he ended up in the hospital for fifteen days. Doctors had given Mobrouk medicine but he apparently gave it to the boy for a few days, then stopped when he didn't see immediate improvement. Once in the hospital the boy got proper administration of the medication, and the sores on his legs started to heal.

Being in Tripoli before going back to work was like being on vacation. My friend Doris and I made a double batch of moussaka to freeze so we could look forward to coming home to a delicious meal once school started. One afternoon on my daily swim I met an octopus, just a little guy,

173

but he had eight limbs so I gave him the right of way. Skender and Carol had not been out of the country all year, so we hopped in their VW bus and went to Djerba with them and their family for a few days of relaxation, dining out, and shopping for more Tunisian pottery and rugs. Much to everyone's relief, Keith was back looking healthy, feeling good, and ready to enlighten sixth graders again. He was happy to be back in his own home, and we were happy to have him.

Five days before classes began we found out that our enrollment had skyrocketed with the arrival of a group of Danes and Yugoslavs. We weren't sure what the Danes were doing in Libya, perhaps assisting with the building and maintenance of dairies. The Yugoslavs were establishing clinics and working on electricity and harbor projects. We already had 250 more students than last year and fewer teachers. To further complicate the situation, our principal and his wife did not return, a surprise to everyone. We heard that his wife was pregnant and very unhappy in Libya, but he should have informed the school that they weren't coming back. We assumed they had returned to Wisconsin.

A new principal, also from Wisconsin, was on his way. John had been the elementary principal at OCS years ago, and everyone spoke highly of him. He would not arrive until a week after school started, so the opening of the school year promised to be a challenge. In spite of getting up at the crack of dawn, dripping with sweat by the afternoon, and having more students and fewer teachers, it was good to be back at work. Tall blond Danes invaded our campus, Lene and Lone and Jesper and Leif Bo and Lars, forty of them all together. Most of them spoke very little English. We also had Turks, Yugoslavs, Chinese, Japanese, Indians, Pakistanis, Swedes, British, Jordanians, Egyptians, Lebanese, Italians, Bangladeshis, and here and there, a few Americans, perhaps forty per cent school-wide. It made teaching interesting, but our English department had to change its approach to accommodate students still learning the language. I was already out of books for the eighth grade, but we did the best we could and the students were learning, as much from each other as from us.

Peter had ordered copies of Edward McNall Burns' *Western*

Civilization for his world history class, and the censors were reluctant to clear the book, so he started the year with no text. He spent long hours every afternoon after school with Islamic scholars discussing several historical, political, and religious issues that were being challenged, in particular the Virgin Birth and the belief that Jesus is the Messiah. It was, in Peter's opinion, the best text available, so we hoped that he would be successful in getting it cleared.

Our new principal arrived on schedule, a good thing since more students were enrolling every day. John was older than most of our faculty and seemed pleasant and professional. He was quiet, but firm with the students, most of whom were remarkably good. If any kid did goof off, it was usually an American. They took their education less seriously than did our foreign students. Eastern European parents, especially, made great sacrifices to educate their children. Tuition at OCS was £400, about $1,120, for kindergarten and double that for grades 1-9. Children of oil companies personnel automatically had a seat at the school, but everyone else had to pay.

Wealthy Libyans paid cash in advance to make sure their children, sometimes a half-dozen of them, had a seat for years to come. On the other hand, some Eastern European families spent half of their income just to send one child to OCS. Whole families sometimes lived in one hotel room while they were in Libya, cooking their meals on hot plates and doing the dishes in the bathroom sink.

By the end of September, every minute of my life was taken up with school. Our enrollment nearly doubled, as did our student load. My average class size grew from fifteen students to forty-five. I had barely enough room to walk up and down the aisles of my classroom. In many classes, I ran out of books. All I could do was present the information, assign homework, and hope for the best. I still taught Shakespeare, but instead of reading the play as homework, we acted it out. In the role of Macbeth was an Italian, Lady Macbeth was Lebanese, and a Canadian played Banquo. Sveto, Ashraf, Paolo, and Shamel took supporting roles. I was glad that I had ordered some easier titles the previous spring and looked forward to getting copies of *Around the World in Eighty Days, Kon Tiki, Shackleton's*

175

Valiant Voyage, The Outsiders, and *Lord of the Flies*, all with more appropriate reading levels for many of these students. I was told that a teacher had been hired to take two of my English classes. That would reduce my total student load from nearly 200 to 134, still too many. On the bright side, the Grand Mufti of Tripoli pronounced Peter's history text, with a few exceptions, correct and accurate. It was cleared for use in the classroom, and Peter was declared an Islamic scholar.

In spite of the student overload, the students were learning, parents were supportive, and teaching was fun. Early one morning, the head of Alitalia Airlines in Libya arrived in my room before classes began. Impeccably dressed in an Italian suit and tie and oozing style, he stood at attention in front of my desk, clicked the heels of his Ferragamo shoes, bowed from the waist, and handed over his son Luca's weekly English essay as if it were a Unilateral Peace Agreement. I had a rule about late essays in my classroom. Not allowed. No exceptions. No excuses. I heated up the rhetoric by telling my students that even if they were in the hospital in a body cast, a friend or family member had to deliver the paper on time. As Signor d'Alitalia handed the paper to me, I sensed that he thought the requirement somewhat stringent, but the twinkle in his eye told me he didn't disapprove. Signor Alitalia bid me "Bon Giorno," took himself and his Italian charm out the classroom door, and I started my day with a smile.

Our lives were not all work and no play. One weekend in the middle of October we threw a 50s Party at our friend Gloria's new apartment. Sixty-seven people came dressed in circle skirts, pony tails, ducktails, bobby sox, white bucks, saddle shoes, and black leather boots. Guys pulled their Levis down low on their hips, rolled up the sleeves of their T-shirts, and tucked a pack of cigarettes in them. We scrounged up tapes of Buddy Holly, Little Richard, Pat Boone, Bobby Darin, and of course, Elvis Presley. Everybody danced to "Blue Suede Shoes," "Don't Be Cruel," and "You Ain't Nothing But a Hound Dog." Even those who didn't know how to jitterbug joined in the fun. We served chili, drinks, and desserts, and the winner of the "door" prize got just that. A door that Peter had removed from an old armoire. A good time was had by all.

As the end of November approached, our group of campers met to plan this year's Thanksgiving Trek to the desert. This was our second Thanksgiving in the Sahara, and I had the honor of roasting the turkey, something I had never done before. The biggest challenge in the past had been finding a turkey to roast, but this year we arranged to get the birds from the father of Andrew, a towheaded, rosy-cheeked seventh grader from England. Andrew's father had turkeys flown in as chicks from England and raised them specifically for the holiday on the family farm on the outskirts of Tripoli. The word got out, and at the end of October I started taking orders from teachers and parents in the community. On Wednesday, November 19, Andrews's father drove into the school parking lot in his white van, and at 3:30 p.m. we all lined up for our birds, seventy-three of them. I acted as bookkeeper, checking off names and collecting money. The price was about $5.00 a pound, or $65 a bird. We were happy to pay it. I tried not to think of my mom paying a total of $3.60 for hers. These birds were excellent, but semi-plucked and not up to my standards of cleanliness. I was still washing my bird and picking out pin feathers late into the evening. The day before we departed, I stuffed our turkey and roasted it to perfection. The fragrance filled the whole villa.

Our destination this year was Wadi el Khlail, two-hundred miles southeast of Tripoli. It was the site of a dozen or so perfectly preserved prehistoric cave carvings. On the day of departure I loaded the big bird, successfully roasted and stuffed to the gills, into our little white VW bug and we headed out. The last one-hundred miles of the trip were off the main road, so three intrepid VW bugs and one Land Rover persevered over dunes, washboard surfaces, and dried-up river beds before arriving at a place to spend the night. After setting up camp, we gathered in the largest tent and feasted on turkey and dressing, instant mashed potatoes made on the Coleman stove, gravy, squash, green beans, canned cranberry sauce, date pudding, and a choice of pumpkin or pecan pie with whipped cream for dessert. This time we got fancy and brought a white tablecloth for the tent floor, one candle, and two fresh pink carnations. Our traditional Thanksgiving dinner, the most soul-satisfying combination of foods possi-

177

ble, tasted even better in the Sahara.

The following day we stopped at the last inhabited village and picked up our guide, a seventy- two year old man who spoke no English but knew the desert like the palm of his hand. He sat in the front seat of Don's Land Rover, spoke not a word, but motioned with his hand every time we were to make a turn. His face, partly covered by a white wool barracan, was beautiful and timeless. He guided us to the cave carvings, among them two graceful life-sized stags, an elephant, a lion, and birds that appeared to be ostriches, all about 10,000 years old. They were carved at least an inch into the rock, perfectly preserved and still magnificent.

We set up camp near four Bedouin tents surrounded by a few camels and nearly a hundred black goats. Within a couple of hours, four kids were born. One of the Bedouins was struggling to carry all of them in his arms, so I gave him an old green duffel bag that I had brought along. He stuffed the black babies into it, hooked the bag onto his camel saddle, and off they went to his tent with their sweet little heads sticking out of the bag. One of the goats got into our school nurse's tent and left an unwelcome deposit. After much shooing by Marge and laughing by her fellow campers, the goat joined its family.

Our guide asked us for a pan, so we gave him an old skillet which he took to a Bedouin who had started milking one of the goats. The man covered the bottom of the pan with fresh milk, our guide took it to an open fire, held it a few inches above, and stirred until it reached the consistency of scrambled eggs. We regarded this with great interest until he started coming toward us. As a group, we registered the same thought. "Oh, oh. We are going to have to eat this."

Our school nurse was the first to reach for the pan and during the exchange she dropped it, contents and all, onto the desert sand. We felt shame, relief, and regret all at the same time. We'll never know how it tasted. We tried to make amends by giving our guide two Thanksgiving turkey drumsticks. He had brought with him only a canteen, bread and tea, and some blankets on which he slept on the ground near our tents. Rain poured down during the night, but it didn't seem to bother him. He got up in the

morning, lit a fire, fixed his tea, and spread his blankets on the bushes to dry. We looked at our air-mattresses, cots, sleeping bags, Coleman stoves, flashlights, lanterns, tents, and coolers and felt, in a word, like sissies.

When we returned home we received an invitation to dinner from the parents of one of our Libyan students. The menu consisted of traditional Libyan dishes including hummus, tabouli, kofta, rice with pine nuts, and couscous. In contrast to the simple life of the Bedouin, we sat on a floor covered with several layers of Persian carpets, and after dinner we drank sweet tea and were entertained by Libyan dancers. The children of parents such as these had chauffeurs and maids. Many of them reached their teens and still didn't know how to tie their shoelaces. When we had school dances, hairdressers came to their villa to dress their hair. Our student was a sweet boy, well liked, and his family most hospitable. They gave us an enjoyable evening and a first-hand look at the life of the Libyan privileged class.

Ready for a break after a challenging school year and the usual Christmas dances, parties, and activities, on December 14 we went to Tripoli International Airport for a Swiss Air flight to Zurich. We didn't have a hotel reservation in Zurich, but as we stood in line waiting to board the plane we started talking to an ex-pat who recommended the Hotel zum Storchen. It was one of the best tips we ever got. When we arrived in Zurich, we took a cab to the hotel, checked in, and fell in love with the place. Located in the heart of Zurich's old town, the hotel was a former guildhall dating back to 1357. Our room was simple and elegant, the staff hospitable, and the surrounding area full of cathedrals, burgher houses, elegant shops, tempting restaurants, cobblestone streets and alleys, and picturesque squares. In the mornings I opened my window, fed the gulls, and watched river boats drift by on the Limmat River.

One evening I had just finished washing my hair and was about to climb into bed for an early night when we got a call from Bob Waldum. He happened to be in Zurich and asked us out for dinner, an invitation we couldn't refuse. We got dressed, a half hour later he picked us up, and off we went to the Kronnenhalle, a landmark in Zurich famous for works by

179

Chagall, Picasso, and other famous artists on the walls. The place was large, but the atmosphere intimate and cozy. Our booth had its own little lamp with a red shade, and the table was covered with a white linen cloth and set with china and silver. Impeccably dressed waiters and waitresses in black and white uniforms served traditional Swiss dishes from a trolley. At 9:00 p.m., a gracious lady came around to greet all guests. As she moved down the line of booths and tables shaking hands, Bob told us this was the time-honored tradition of Hulda Zumsteg who with her husband Gottlieb, now deceased, had owned the restaurant since 1924. She was the exemplar of grace and charm. Later I discovered that James Joyce was one of the Kronnenhalle's most devoted guests. He and many other celebrities including Richard Strauss, Placido Domingo, and Thomas Mann were regular patrons. After dinner we cruised through the Swiss Alps in a Jaguar that belonged to a friend of Bob's, our destination a new hotel-disco with the incongruous name of Happy Rancho. We were never sure where we would end up with Sweet Old Bob, but we always knew we were in good hands.

The next day we boarded a train for a seven-hour picturesque ride to Zermatt, a charming Alpine village at the foot of the Matterhorn. The mountain, a rugged pyramid with its signature hook at the top, stood 14,692 feet high overlooking the village. Since no cars were allowed, we rode in a sleigh from the train station to the Dom Hotel. The whole village was a winter wonderland with trees and rooftops covered in snow. We spent a week skiing, soaking up the sun, greeting St. Bernards as we walked by them on the street, feeding black squirrels from our balcony, and enjoying the sound of the bells ringing from the cathedral.

As usual, we had arranged to call our families about 6:00 p.m. their time on Christmas Eve. That meant we had to place the calls around midnight, so our hearts sank when our hotel concierge told us they closed their switchboard at 10:00 p.m. We had visions of our families worrying about us as they waited for a call that would never come. At the concierge's suggestion we walked to a posh hotel down the street and asked if they could place the calls for us. They said they would be happy to, so we booked

calls for 12:30 and 1:00 a.m., went back to our hotel, and fell asleep reading. Fortunately, I woke up shortly after midnight so we hustled to the hotel and caught Peter's parents just as they were going out the front door. The switchboard operator got my call through fifteen minutes late, but he did me a favor. If it had been earlier, I would have caught my family in the middle of Christmas Eve dinner. My mom passed the phone to each family member to wish us Merry Christmas. I could hear them as clearly as if they were next door.

1976

A couple of weeks after we returned to Tripoli I found a package in my mailbox. In it was a cassette of Christmas Eve at the Froiland residence. My brother Norm served as the MC passing the microphone around to everyone present. It was wonderful to hear my family's voices again, especially Mom and Dad. All were impressed at how clear we sounded when we called on Christmas Eve from Zermatt, 4,611 miles away. We knew we were missing the most important evening of the year at home, the delectable sweets, the carols, the reading of the nativity.

Everything but the lutefisk. In case you don't know, lutefisk is dried cod soaked in a lye solution, rinsed in cold water, boiled into smelly gelatinous globs, and served with butter and salt. People either love it or hate it. My dad loved it. His brother Emil, sixteen years old when he came to the U.S. with my father in 1929, said of lutefisk, "I never tasted it, but I stepped in some once." This year my ten year-old nephew Rich read the account of the nativity in Luke 2 and hesitated on just three words: Quirinius, espoused, and lineage. The family gathered around the piano to sing Christmas carols, then exchanged gifts. I could hear wrapping paper rustling, the kids chattering away, Gigi barking, and the train rumbling by in the background. It was the next best thing to being there.

The first semester at OCS was over at the end of January, half the year gone already and new students arriving every day. I was fifty students over my maximum, and just as I was thinking how lucky I was to have my standby Mobrouk at home, we got word of a new regulation forbidding Libyans to have more than one job. Mobrouk's primary occupation was with the government, so it was possible he would have to give up his work as houseboy. I did not know how he would support a wife and seven children on one salary, and I did not know how I could get along without his help right now.

After a couple of weeks of uncertainty, we were relieved to hear that

Mobrouk could continue to work. He did not come as often, and never on Friday and Saturday. That was O.K. with me. Those days were our weekend, and I liked lounging around on Friday morning. That was not possible with Mobrouk around. He got us up and moving.

One Sunday he brought his little girl Aisha, seven years old, for a visit. She walked to the store with me, helped me feed the dogs, and jabbered at me the whole time in Arabic. Mobrouk said she went home and told her mom everything she did. She was precious. She is a grown woman now, probably with kids of her own. I wonder if the family ever thinks of me as I do of them. I can only hope that they escaped the bombs and chaos that has gone on in Tripoli far too long.

One evening in March, Mobrouk arrived at our front door with the news that one of his kids tipped over a tea pot and spilled boiling hot tea on their baby girl's face, eyes, and ears. He asked for money and wanted me to come and look at her the next day. I knew little about the treatment of burns, but the next day I talked to the school nurse and went to his home after school. The baby's head was all burned on one side, but it looked clean. They took her to the doctor every other day and seemed optimistic. Fortunately, her eyes were not damaged. The common practice in Libya of brewing tea and coffee on little stoves on the floor was an invitation to disaster, especially with kids around.

I enjoyed seeing Mobrouk's family again. His children were handsome and his wife warm and friendly. They didn't own much, but in terms of family, they were rich. We had coffee and cookies, juice and apples. Their home was every bit as clean as ours. They had only a couple of beds and dressers, no chairs. They sat on straw mats and had a colorful array of pillows on which to recline. It was a cozy arrangement. I took a basket of clothes to his wife, and she gave me three brightly colored throw pillows she had made herself. By the end of the month the baby girl had healed nicely. Just her neck and shoulders had open sores yet, probably due to rubbing from her dress. Mobrouk was happy now that he knew everything was going to be all right.

Our school was growing every day, so I scheduled a conference with the superintendent and was pleased to hear that he had hired another English teacher to take two of my classes. That reduced my student load to 131. Twenty-one teachers were hired for the coming year including two full-time English teachers and two specialists, one in reading, and a long overdue English as a Foreign Language teacher. Last year our student population was 430. At one point, I was the only teacher in the department. When I met Superintendent John at social functions he would ask, "How is my favorite English teacher?" We laughed as I replied, "John, I am your only English teacher!" This year our enrollment was nearly 800. We were gratified that reinforcements, mostly couples, were coming. We also looked forward to a 10% pay increase.

Our students were making great progress, especially those who couldn't speak a word of English at the beginning of the school year. They were now chattering away, many of them with an American accent. It was remarkable how fast they learned at that age, as much from each other as from books and teachers. Some got left behind, of course. One fourteen year-old girl in my class spoke Arabic, English, and Italian at an elementary level, but she would never enjoy the command of fluent expression or understanding in any one of them. A sixteen year-old Turkish boy read at the second grade level. We had our work cut out for us.

The Yugoslavs and Chinese were the stars of English grammar. Since their acquisition of the language was through grammar, they outperformed most native English speakers. Few Americans could touch them. They mostly endured this aspect of the course, though by ninth grade some of them finally understood it. Some even liked it. One day as we were discussing subordinate clauses functioning as adverbs, a ninth-grade boy looked up over his glasses from his front row seat and said, "You mean that's all there is to it?" The whole system of grammar, which Doug could easily take or leave, fell into place. It was music to my ears.

As nationalities became more diverse, academic competition between

groups increased. Foreign students took their education seriously, and American students benefited from their example. The Yugoslavs and Asians were highly disciplined and always seemed to come out on top. When we saw their work we marveled. We joked among ourselves that we were always looking for a dumb Yugoslav. We never found one.

Students were generally well behaved, and as our classrooms filled with different nationalities, conduct kept improving. The tradition of respect for teachers in European and Asian countries rubbed off on many of our American students. It made our job easier, but we still had our share of problems to keep us on our toes. These were kids, not angels. One week we refereed fist fights, disabled stink bombs, treated black eyes, and dealt with irate parents. Our principal was in a daze by the time the week was over. I had to break up a fight between two eighth-graders outside my classroom door. One of them ended up with a black eye, but he deserved it. He was a bully. A student in Roger's math class raided his desk and stole his grade book. The thief returned it two days later wrapped in newspaper, all of his math grades changed to "A." One seventh-grader captured flies and put them in his mouth while they were still alive. One hot day in Arabic class, he caught a big juicy black one, put it in his mouth, went up to his dozing Arabic teacher's desk, opened his mouth slowly and asked, "M-a-a-a-y I go to the bathroom?" The fly escaped from Jimmy's mouth just as his teacher woke up, and the poor man went wild. The week following these breaches of the peace, the kids were on their best behavior. Nobody made a false move.

Peter was covering his unit on Oriental seclusion at this time. He relished this unit because he could play the role of the male chauvinist, proclaiming that women should be seen and not heard, and not seen that often. He played his part so well that the girls who came from his class to mine stopped in my doorway, threw up their arms, and cried, "You poor woman! He probably plays reveille to get you up in the morning!"

The fly trick probably qualified as a prank, but some problems were more serious. A couple of graffiti artists bought a can of spray paint and wrote *Jehudis kwais*, "Jews are good," on the school walls. Any reference

to Jews or Israel was taboo in Libya, and If the authorities had seen this before it was painted over, our school could have been shut down. Possession and use of drugs was a serious offense, but it was not widespread. In the U.S. if a student was caught with drugs, he could be suspended or sent to counseling. In Libya, the student's father would lose his job and his whole family given twenty-four hours to pack up and leave the country.

Ex-pat women in Tripoli were always on guard in public for pinchers, bum-biters, and flashers, but now the single women on our faculty were having a creepier problem. Flashers came to their bedroom windows at night, ran their keys across the bars, and waited for their prey to come to the window to investigate. When a sleepy face appeared from behind the curtains, the flashers dropped their drawers, exposed themselves, and began the midnight show. Waking any teacher in the middle of the night is not a good idea, but getting one up to witness such an exhibition was a death wish.

Finding a solution to the problem became a community effort. Fortunately for the flashers, the possession of firearms was illegal in Libya, and since we didn't have phones, calling the police was out of the question. Even if they came, chances of catching the culprit were slim. Screaming was useless, as was banging on walls, ringing bells, or blowing whistles. A good-sized, unintimidated, willing male living within shouting distance might help, but such a person was seldom available.

The solution to the problem turned out to be, at last, not a loaded gun, but a loaded camera. When the ghouls stood outside the bedroom window making a racket and preparing for the show, the women grabbed a camera, drew the curtains, aimed, and shot. The flasher got flashed. The results were nothing short of a miracle. Caught with their pants down, the lowlifes usually tripped over their own pant legs trying to get away. When the film was developed, the pictures were never very clear. They would not stand

up as evidence in a civilized court of law, but the flashers didn't know that. Our single ladies now kept cameras at their bedsides and we hoped, were able to lie down to pleasant dreams.

In early March spring weather returned, and the usual neighborhood sounds drifted in through the open windows: barking dogs, bleating goats, honking peacocks, and the crazy lady wailing from the asylum down the road. It took a while to readjust to all the noise. A wild twenty-four hour wind storm blew lemons from our neighbor's tree right over the wall into our yard, a welcome windfall. A mighty gust blew our space heater out while we were at school, and by the time we got home the fumes had backed up throughout the villa. Gretchen and Albert charged into the villa ahead of us, coughed a couple of times, and bolted back out the door. We opened every window to let the place air out and used our fireplace for heat until the wind calmed down. The sea was ferocious. I felt for those who had to be out on it. Days like this were best for staying home, baking bread, and enjoying the fragrance and warmth from the oven.

We finally got George and Amy's old warhorse of a Sears washing machine hooked up and running. Our old one barely agitated enough to dissolve the soap. This one was so lively I got sprayed if I didn't keep the lid closed. It didn't look like much on the outside, but it worked its heart out. George was happy with his job in Houston. Amy hated it. She much preferred Tripoli to Texas.

<p style="text-align:center">***</p>

Always on the lookout for ways to entertain ourselves, a dozen or so friends decided to form a Gourmet Club. It was a silly idea considering that meat and everyday staples were currently difficult to find. I sometimes stood in line for an hour, all for a few sausages and some stew meat. Eggs were in short supply and so was chicken. After scrounging around for hours and finding two of them, I heard that a warning had been issued not to eat them, so I had to throw them away. Still, we forged ahead with our plans. We had plenty of fruit, vegetables, cheese, and bread. As it turned

out, we needn't have worried. By late March, fifteen planes arrived at the Tripoli airport loaded with meat, and everyone was happy. Life returned to our version of normal.

We divided into teams, chose themes, planned our "gourmet" meals, sewed tablecloths and napkins, cut fresh flowers, and made centerpieces for each occasion. Each team went to great lengths to keep the menu a secret, so the days leading up to the meal were full of suspense. Some of our efforts were more successful than others. We had a Thanksgiving feast of pumpkin soup, chicken baked in parchment, and lemon ice in pretty little fresh lemon halves. In honor of St. Patrick's Day we had a brunch of crepes filled with spinach, scrambled eggs, tomatoes, green peppers, and ham previously smuggled in from Malta. We had chicken livers with pineapple, Irish soda bread, and cherry strudel, the crust flaky and delicate and the cherries sweet and tart.

The booby prize went to the Mongolian Hot Pot dinner. Picture fondue, but instead of dipping chunks of bread into melted cheese, twelve hungry people sat around the table filling little wire baskets with thin slices of meat and vegetables and dipping them into hot broth to cook. It was, shall we say, a leisurely process allowing plenty of time for socializing. Some warded off starvation with rice. Others longed for a peanut butter sandwich, anything to sustain them while the food was cooking.

The winner was a meal with a Russian theme. The team raided their larders, pulled out all the stops, and served blinis with smoked salmon and caviar, borscht, radish salad, chicken with walnuts, rice with dried fruit, and black bread. Just when we thought we had experienced the ultimate in fine dining, out came the *shashlik*, cubes of meat marinated in pomegranate juice and grilled on skewers. Such a meal deserved to be topped off with a shot of vodka, but none was available. Undaunted, our chefs improvised weeks in advance by flavoring white lightning with anise, lemon, cherry, and peach. We finished the evening by raising our glasses and toasting the cooks.

Alas, not everyone appreciated our culinary efforts. Peter, for one, charged through our front door every time we got home declaring, "I'm

starved," then headed directly to the kitchen to scramble himself a half-dozen eggs. Our Gourmet Club disbanded in the spring, and plans for a gourmet picnic in the fall never materialized. Malish. It was fun while it lasted.

I was reading a biography of Alexander the Great and was struck by the account of one of his soldiers who acted dishonorably and was summoned to appear before "The Great One." When asked his name, the soldier replied, "Alexander." Alexander the Great considered this for a moment, then turned to the soldier and said, "I order you to change your conduct, or change your name." One source claimed that at the age of thirty, Alexander the Great sat down by the banks of the Indus River and cried. He had no more worlds to conquer.

Not so for us. We headed for the desert again, this time leading an excursion to Ghirza for friends who wanted to see the ruins. A couple of hours into the trip the police turned us back. Two kilometers of the North African highway were under water and no one was allowed to pass. It was so late that instead of heading home, we decided to set up camp in the rain. To save time we put up just one tent and everyone piled into it. I was lucky enough to get a dry spot, but poor Peter spent the night under a leak in the roof and by morning his sleeping bag was completely soaked through.

We didn't see what we hoped to, but we stopped to explore a couple of villages on the way home. In Misurata I found an old hand-woven 8x10 foot Bedouin carpet that had recently served as the floor in a nomad tent. It was made of goat hair which shrinks up when it rains and repels water. It was filthy, still full of chicken feathers and who knows what else. When we got home, I left it on the clothes line for a day and went out to beat it regularly. Then I sprayed it with Baygon and watched to see if any small inhabitants jumped out. Finally, I took it to the cleaner and was satisfied that it was fit to bring in the house. Primitive and attractive, it found a new home under our dining room table.

We had better luck with plans to go to Sicily for Easter vacation. We booked rooms at the Hôtel Timèo in Taormina, sight unseen, got up at 5:00 a.m. on April 17 and along with Tom, Doris, and Leanne, now a year old, flew from Tripoli to Catania, rented a car, and arrived in Taormina about 11:00 a.m. The minute we saw our hotel we knew we had found a treasure. Snugged up against the surrounding cliffs was an old Mediterranean-style stucco building with a lobby of parquet floors, high vaulted ceilings, Persian carpets, exquisite antiques, and priceless paintings. From the verandahs one could enjoy the spectacular view of the Mediterranean on the left and Mt. Etna on the right. An ancient Greek theater stood directly behind the hotel, and the grounds were full of iris, poppies, birds of paradise, poinsettias, rhododendrons, calla lilies, geraniums, African violets, daisies, marigolds, cactus, cypress, orange and lemon trees. The air was filled with the fragrance of lavender and roses. We patted ourselves on the back for making such a lucky choice.

The Hôtel Timèo's history went back to 1874 hosting kings, emperors, authors, and artists who came to paint the intoxicating beauty of the place. Kaiser Wilhelm II of Germany and Edward VII of England both stayed at the Timèo, as did Tennessee Wiliiams and Truman Capote. D.H. Lawrence stayed four years while he wrote *Lady Chatterly's Lover.* During World War II the hotel was requisitioned for several years by the British Royal Air Force, and in 1943 the Timèo along with much of Taormina was damaged by heavy bombing. The hotel passed through several hands and renovations but is still thriving today as the Belmond Grand Hotel Timèo.

After checking into the hotel we strolled through the village. One street led to another and we didn't get back to the hotel until nearly 6:30 p.m. We were almost too tired to dress and go down for dinner, but we made the effort and were rewarded with a delicious homemade vegetable soup, mashed potatoes, and the forbidden-in-Libya pork chops and gravy. That alone would have been worth the trip. The next morning we came down for breakfast and found sweet little decorated Easter eggs at our places on the table.

Later in the morning we drove up to Mt. Etna. Perfectly comfortable

in light jackets in the village, by the time we got to the top of the mountain it was snowing and we were trembling with cold. We could see snow on top of the volcano from the hotel but were so charmed by the air of spring below that we didn't even think of taking warm clothing. Doris and I and the baby stayed at the lodge, but Tom and Peter took the cable car to the top. A week later they were sorry. Tom had to stay home from school one day with a nasty cold. Peter toughed it out.

We spent the afternoon wandering through the sunny streets of Taormina looking at quaint restaurants and shops selling wood carvings, Florentine trays, and embroidered table cloths. Little old ladies dressed in black sat outside their shops making lace. Leanne was at such an adorable age that as we strolled along, women in black crossed themselves when they saw her. We stopped for a bite at a small restaurant and decided to order our food in Italian. We ordered a sandwich successfully, then our mouths watering for fresh, sweet strawberries, we ordered one serving of *fagiolo* apiece for dessert. The waiter soon appeared with four large plates of pale slimy beans swimming in their own juices. Highly embarrassed, we apologized, sent them back and tried again, this time in English. We thought the word for strawberry was *fagiolo*, but as we discovered, it is *fragole*.

I fell in love with Taormina and wanted to stay forever. It was beautiful and quiet, no barking dogs, no mosques, no peacocks in heat. Coming from the desert, it seemed like the Garden of Eden. The night before we left Sicily we celebrated with a pork roast dinner. It wasn't on the menu, but the chef was kind enough to prepare one especially for our table. It was a feast to remember. We were humble school teachers from Libya, yet we were treated like royalty.

Along with wood carvings, trays, and table cloths, we packed two canned hams, twelve packs of bacon, four packs of bologna, one salami, and four packs of dried, smoked ham in our luggage, turned in our car, and boarded a plane for Tripoli. We ran the risk of having our contraband taken away at customs, but lucky for us the agents on duty were not interested. Mobrouk had the house sparkling clean when we returned, and two happy

faces were waiting for us. Especially Gretchen. She and Albie did a good job of guarding the villa. Mobrouk fed them while we were gone.

It seemed as if Libya had everyone mad at her at the time—Tunisia and Egypt among them. As long as we weren't the target, we were gratified. One thing we never did as Americans was meddle in local politics. We had plenty of problems of our own without getting involved in their affairs. One perennial problem was the mail. My father's most recent letter came already opened, a rubber band around the envelope. The censors may have been curious about the clippings inside and were undoubtedly disappointed when all they found were basketball scores.

As June approached we began the process of closing up for another year at OCS. We teachers were dragged out and had black circles around our eyes. The kids were bright-eyed and bushy-tailed. In one way it didn't seem possible that the year was over. We usually had a couple of weeks of unbearably hot weather before the end of school, but not this year. We even got a good crop of grass going in our back yard. The front was too shady to grow grass, so we had it covered with crushed rock. It looked better than bare dirt.

Our plan for the summer was to fly to Morocco with friends Keith and Helen for a few days before going home to spend several weeks with our families. We had not seen them for a year but kept in touch through regular letters and rare phone calls. We were often out of touch with events going on in our own country but followed the election news on Voice of America. We had never heard of Jimmy Carter.

After finishing up at school and making arrangements for the care of our villa and four-footed friends, we flew from Tripoli to Casablanca. The city did not live up to our dreams and expectations, so we stayed only one night. Traffic jams and high-rise buildings held no interest for us. Malish. We rented a car and plotted a course that looked like a baggy circle: Casablanca, Rabat, Meknès, Fèz, Marrakech, Casablanca. Each city we

192

visited was more intriguing than the last: Rabat, the capital of Morocco and residence of King Hassan II; Meknès and Fèz, both royal cities. We spent hours in Fez wandering through the medina, a labyrinth of dark, narrow cobbled streets within the old walled city. One could get lost in this maze, so we hired a guide. No vehicles, not even bicycles were permitted in these crowded alleys. Only donkeys. We had to flatten ourselves against the wall several times to let the dear little animals squeeze by with their heavy loads. Moroccan men were dressed in hooded robes called *jellabas*, and on their feet were bright yellow backless shoes with pointed toes. The women wore caftans. Some wore veils, others just covered their heads with scarves. The streets were lined with cubbyhole-sized shops stuffed with tooled-leather goods, brass and copper trays, candlesticks, teapots, braziers, woven blankets and rugs, and embroidered tablecloths.

We visited the University of al-Qarawiyyin, the oldest Arab university in existence, a center of learning since the 9th century. The interior was quiet and serene, full of richly colored tiles and keyhole arches that opened onto a cool, central courtyard. Our next stop, the tannery, was less sublime. In fact, it was the foulest smelling place we had ever encountered. Tanners were boiling cowhides, camel hides, and goatskins in more than a hundred open-air vats of rank-smelling dye. Men and boys in bare feet stomped the muck to make sure the hide was colored evenly, then they transferred the soggy mess to other vats with tanning chemicals.The heat was oppressive and the smell unbearable. Our guide gave us a sprig of mint to stick up each nostril to keep us from gagging. More pleasant was the fragrance of ground cardamom, mace, nutmeg, ginger, saffron, and cinnamon from the Street of Spices.

Since we were traveling with Keith, we could always rely on him to choose an excellent place to eat. We feasted on couscous and *tagine*, a tasty dish of meat, fish, or vegetables in a sauce of butter, onions, spices, almonds, raisins, and honey. Our favorite dish was *bastilla*, a mixture of pigeon, onions, parsley, spices, and ground hard-boiled eggs baked in layers of thin, flaky phyllo pastry. It was served hot and sprinkled with powdered sugar and cinnamon. Dinner was always followed by sweet mint tea

193

served in little glasses along with dates, almonds, and mounds of fresh fruit.

Leaving the cities, we drove by fields of red earth, groves of olive and almond trees, and the spectacular Atlas Mountains. The ancient Greeks believed the mountains to be the home of Atlas, the Titan god who held up the world. We stopped to visit Volubilis, the ruins of a Roman city that in its prime was comparable in size and beauty to Carthage and Leptis Magna. We did a double take when we saw a good-sized swastika in one of the mosaic floors, a sight rare in Africa but common in Western Europe since the Bronze Age. The symbol is of Sanskrit origin and means "fortune, luck, or well-being," but it still strikes terror in the hearts of people today.

Churchill called Marrakech the "Paris of the Sahara," and while the city might lack the grandeur of France, it did not lack variety. It had something for everyone, especially at the Djemaa el Fna, or Assembly of the Nobodies, a large open city square the size of a couple of football fields. Here, at dusk, storytellers, scribes, fortune tellers, dancers, musicians, acrobats, snake charmers, falconers, dentists, and medicine men assembled. Water sellers carrying goatskin bags of water and shiny brass cups hooked to a strap across their chest sold one cup for five centimes, about a penny. The place reminded me of the Court of Miracles in *The Hunchback of Notre Dame*, "a hideous wen, a sink, a monstrous hive into which no honest man dare venture." The square was dark, but from the stalls of food vendors, lanterns spread their glow over rows of oranges, cauldrons of soup, and sweet pastries. The air was dense with mystery.

Our hotel, the Es Saadi, was a paradise. Es Saadi means "the contented one." Former guest Winston Churchill said that "Marrakesh is simply the nicest place on Earth to spend an afternoon." In 1943 he and Roosevelt took a break from a summit with wartime leaders to visit his beloved city and later often returned to paint what he called ". . . the most lovely spot in the world." We couldn't disagree. We all agreed that we had saved the best till last. We returned to Casablanca and the following day boarded a Royal Air Moroc flight to the States. We stretched out on a bank of seats

and except for being awakened for a delicious meal and gracious service, slept most of the way home.

<p style="text-align:center">***</p>

At 620 9th Avenue North, my father's sister Marie, matriarch of the Frøyland family, and her son Kjell were visiting from Norway so every bed was filled. We slept on the couch, enjoyed catching up on family news, and celebrated the Bicentennial of the United States of America in Clear Lake, the town with the longest consecutive running July 4th Celebration in the State of Iowa. Main Street was closed at 10:00 on the button, people set up their chairs along the parade route, and with the Clear Lake High School Band and Drum and Bugle Corps leading, everyone from presidential candidates to the Pork Queen waved to cheering, flag-waving bystanders. The carnival was up and running early, and during the day visitors could listen to free concerts in the City Park. At 10 p.m. people on shore and in boats celebrated the end of the day's festivities by watching the biggest fireworks display in the Midwest.

After a visit that always seemed too short, we said goodbye to the Froilands, rented a car, and drove to Appleton to spend a couple of weeks with the Nowells. We got updated on family news, the Green Bay Packers and coach Bart Starr, watched *Happy Days, Laverne & Shirley*, and *M*A*S*H** episodes, and CBS News with Walter Cronkite. Along with other news, he reported that Steven Jobs and Stephen Wozniak, entrepreneurs in Mountain View, California, had started making personal computers in their garage with capital of $1,300.00.

We shopped at the nearby Piggly Wiggly, a.k.a The Pig, and compared prices with those we paid in Libya. Fresh milk which we could not get in Tripoli was $1.65 a gallon, eggs were 84 cents a dozen, and coffee $1.69 a pound. Most of the prices of goods we bought in Libya were three times higher—if we could find them. The middle of August we packed our bags including clothes, toiletries, a Mr. Coffee, crock pot, and lefse grill, said our goodbyes, and returned to Libya to begin our seventh year at OCS.

<p style="text-align:center">195</p>

Our return flight on TWA could not live up to our Royal Air Moroc flight to the States in June. We travelled via London and Rome, and the farther south we went, the less likely people were to queue up and the more likely they were to use their elbows boarding a plane. Malish. We had a wonderful summer.

Everything in Tripoli was as we left it. The weather was miserably hot, so I was thankful for the air conditioner. It cooled down the entire villa and blocked out the street noise. Ramadan began on August 25. No food, no water for Moslems from sunup to sundown for a month. In the unbearable heat, it was pitiful to watch. One day Mobrouk started to dust the furniture with Easy Off oven cleaner. He said his head was a little crazy from fasting.

We started our school year with twenty-two more teachers on the staff, so we had high hopes for the year. Four new teachers were hired for the English Department, so my teaching load promised to be normal. Last year students were hanging out of the windows. This year my largest class so far was nineteen and my smallest was twelve. I was sure we would pick up more students as the year went on, but with twenty-two new teachers our class loads looked reasonable. Forty new students in the junior high spoke little or no English, so we still had our work cut out for us.

To make life easier at home, we decided to invest in a freezer with friends Tom and Doris. We found a large Westinghouse upright for £166, about $500, and each paid half. We agreed to keep the freezer at our villa and divide the storage space equally. We hoped it would be a time saver, and perhaps when food was short, a lifesaver. Once delivered I needed to stock it, so I planned a trip to the Italian market to buy meat and shrimp, green beans, green peppers, and peaches, all in season.

At the end of August, former OCS teacher and good friend Doug returned to Tripoli, this time as an employee of Intairdril. He had left Libya to teach in Guam and during his stay became engaged to the lovely

Sinfurosa Cruz, currently on her way to Malta where they hoped to get married. In the meantime, Doug and his roommate invited us for a dinner of dishes that he learned to cook on the island. His specialties included fried squid, egg plant, zucchini, squash, peppers, and some curious tasting cream puffs. The guys worked hard on the meal and it tasted good, but I was sick all night. I should have known. It was the squid. I forgot until I felt that heavy churning in my gut that my stomach tolerates only shrimp, lobster, and crab. I am allergic to all other exotic sea creatures: squid, octopus, clams, oysters, mussels, scallops. If I eat them in any form, my temperature sky-rockets, I lose everything, then all is well again.

In October, Doug's fiancée arrived in Malta only to find out that they had to post bans and wait six weeks before getting married. Not happy with that, the next option was getting a visa for Sindy to enter Libya, next to impossible unless she was visiting a relative. After some creative finagling at the American Consulate, she entered the country as Peter's cousin, and on Thursday, October 28, the Consulate informed Doug that the necessary papers were ready. Two days later, Doug and Sindy were married by the Baptist minister in a simple ceremony in front of our fireplace. In about twenty-four hours we prepared a reception for forty or so people. Friends brought food, Ellen lent us her silver punch bowl and cups, and I made a wedding cake that even without the little bride and groom on top, passed for the real thing. The wedding ceremony lasted ten minutes. The party afterwards lasted ten hours. We all made it to work the next day. Doug and Sindy celebrated their 44th anniversary in 2020.

At the same time we were preparing for the wedding, we were going to the Oil Companies Clinic in a steady stream to donate blood for Bob Waldum, the founder of our school. In August we received the first of the sad news. Because he had lost quite a bit of weight, Bob flew home to the Marshfield Clinic in Wisconsin for a routine check up. The doctors found a malignant tumor on his left kidney. They operated, removed the kidney,

and we prayed that they took all the cancer with it. The middle of October we heard that Bob had returned to Marshfield, and this time the doctors confirmed that the cancer had reached the lymph nodes. In two weeks, he lost twenty-five pounds. He could not eat, but against the wishes of his doctors and family, in spite of weight loss and pain, he made his way to London.

A week later Bob was back in Tripoli. He barely made it, not even able to walk unaided from the plane to the terminal. He went to stay with his brother Donn and wife Mary, and when I called to see if he wanted company, he said he'd rather wait. He sounded a hundred years old. Mary said that he still couldn't eat. When we went out to see Bob a few days later, he was even worse than I expected. One look told me he was not going to make it. At first I was angry at the clinic in Wisconsin for letting him go in that condition, but it didn't take me long to realize that Bob had come home to be with those he loved. No one could have stopped him.

After a complete transfusion at the Oil Companies Clinic the first week of November, the color came back to Bob's cheeks, and we were encouraged. He even sat up in bed and told Ole and Lena jokes. Unfortunately, the transfusions were to no avail. In just a short time, his condition deteriorated to the point that he was hallucinating and didn't recognize us. If there was ever any doubt, we knew now that he had come home to die, an act of uncommon courage. We spent every waking hour on the verge of tears.

On Friday, November 12, accompanied by Donn and Doc Lyons from the Oil Companies Clinic, Bob flew from Tripoli to his sister's home in Black River Falls, Wisconsin. He survived the trip but saw no purpose in returning to the Marshfield Clinic. It was only a matter of time. Sad as it was, I felt better about him being at home. If he had stayed in Tripoli, I believe we would always wonder whether something could have been done to help him. It couldn't.

On Wednesday, November 16, 1976, Bob Waldum died. He was fifty-one years old. We thought Bob might last until Christmas, but he couldn't even make it to Thanksgiving. He was buried in the Riverside Cemetery in

Black River Falls on November 19. Superintendent John Monson represented our school at the funeral, and faculty members and friends organized a memorial service for him in the OCS gym.

Bob was a good friend and the best of administrators. He understood people. When I got to know Bob well, I asked him about his criteria for hiring teachers. His rule was simple. He had to be able to communicate with the person he hired. He knew who was likely to survive, if not thrive in Libya. He sensed who would fit in with the existing faculty. He created balance in his staff. He hired some couples, some singles, all highly qualified. Even though we rarely saw Bob in the classroom, he was always the main link in the chain. He did what most administrators found impossible. He left his teachers alone. He hired us to teach, and we did. Occasionally Bob would come back from a recruiting trip to the States with innovative ideas about rotating class schedules, scope and sequence in curriculum, behavior adjustment, or unlocking creative potential. If he insisted that we try something new, we complied, but we always thought, "Stick to the PR, Bob. Let us do our job." He usually did. How we missed him.

On Tuesday, November 23, feeling lost and helpless because we couldn't attend Bob's funeral, teachers, students, parents, gaffirs, Libyans, and friends in the oil community gathered in the gym that Bob had built to mourn his death and honor his memory. We sang "In the Garden," his favorite hymn.

I come to the garden alone,
While the dew is still on the roses
And the voice I hear, falling on my ear
The Son of God discloses
And He walks with me, and He talks with me
And He tells me I am His own.
And the joy we share as we tarry there,
None other has ever known.

It was the evening before Thanksgiving break, and Peter concluded

the service with this eulogy:

Before we leave for the holidays, there is one more thing we should think about. Thanksgiving is a family holiday. It's a day usually spent with our families, either in anticipation of the large dinner or simply because it's nice to be together. It is a family day.

Right now I would like you to look about you and think about all the people who are sitting here. Whether you realize it or not, you are looking at what is probably the largest family in the whole of Libya. This, of course, is your school family.

The man who originated this school family was Mr. Robert Waldum.

This man who, through his sense of responsibility, his sincerity, his dedication, built our school from a villa and a few teachers in 1959 to more than fifty rooms, gym and library, and more than fifty teachers by 1970, to what it is today: the center of our academic life and the center of our community.

He dedicated his educational philosophy to you.
He dedicated his teachers to you.
He dedicated his educational goals to you.
He dedicated his personality, his aspirations, his love to you.
In so doing, you and I, this school, this community became
Mr. Waldum's family.

Not so very long ago, August, in fact, Mr. Waldum became seriously ill. So serious, it required major surgery. Knowing how serious it was, a few weeks ago Mr. Waldum came home to his family. To see them. To be near them. As you know, Mr. Waldum passed away last week. That is our loss.

Today—Thanksgiving—I think it quite fitting to think of Mr. Waldum and his family and, as a part of his family, thank him.

Thank him for what he gave to all of us.

In the days that followed we all felt we wanted to do something that would in a small way honor Bob. First, the faculty commissioned a portrait for the library so we could continue to see his face smiling down on us. Soon, in his honor we added to the library, "The Waldum Collection," a group of books on Africa and the Mideast. Finally, we initiated a scholarship in his name and ordered a plaque to be placed outside his office in his memory. But nothing would take the place of Sweet Old Bob.

<p style="text-align:center">***</p>

While all of this was going on, the Libyan government nationalized our Teen Club, including the beach, club house, and tennis courts that the kids and many adults used for recreation. It affected the entire community. Skender and Superintendent John scoured beach properties for alternate sites and found two possibilities, one near the bowling alley close by, the other 9 1/2 kilometers west of Giorgimpopoli, past the recently constructed Tourist City that many ex-pats now called home.

As if we needed more misery, Tom and Doris' villa was burglarized. The thieves took about $700.00 worth of gold jewelry, a brand new camera with Doug and Sindy's wedding pictures still in it, and some money. They tore the place up badly. Doug's place was burgled too. The thief got in through his bathroom window while he was gone and stole £50, about $150.00. So far we had no problems. Gretchen and Albert sounded so fierce that strangers hurried right on by our place. If they looked over the villa wall and saw the source of the racket, they would realize our little guardians couldn't inflict too much damage. Still, they were loud and they meant business.

The Eid al-Adha, the Feast of Abraham, began at the end of November. This was the Big Eid, a.ka. Eid al-Kabir. The Little Eid was Eid al-Fitr and came at the end of Ramadan. Both Eids and Ramadan were lunar holidays. Mobrouk bought a sheep at a cost of £70, about $210.00, a major expense since he and his wife were expecting baby number eight soon. He said his head was crazy from so many kids.

When the Eid was over and autumn started setting in, life began to get back to normal. It was chilly in the evenings and mornings, but perfect for a sweater during the day. We needed to get used to cold weather again. Soon the evenings would be cold and stay that way for the better part of the day. We still had no heat in our classrooms. Fortunately, they warmed up a few degrees from body heat once they filled with students.

We decided to forgo our traditional trip to the desert for Thanksgiving. It was too close to the Christmas smørgasbord we were planning with Roger and Sandy on December 3, and with Bob gone our hearts weren't really in it. Instead we had a Thanksgiving potluck with friends and used time to gather and prepare food for the Christmas festivities. One Monday afternoon at 5:00 I went down to our fisherman by the sea and bought fourteen kilos of shrimp right off the boat.

That night, Roger, Peter, and I sat around our picnic table in the front yard for two hours peeling over thirty pounds of shrimp by the light of a Coleman lantern. The shrimp were big and delicious, and Gretchen loved them. She looked up at us with that sweet little face and asked, "Could I have one?" As soon as we threw one up in the air for her to catch, she ate it, sat right back down beside us, and asked for another. It was hard to refuse.

One weekend we made over four-hundred bite-size meatballs, and the following Saturday Roger and I made over a hundred potato cakes while Sandy and Peter sat at the kitchen table making fun of us. We sampled quite a few and declared them light and tasty. Sandy agreed, but Peter suggested that they could be put to better use shingling the roof. All of our Norwegian baked goodies turned out the best ever, so we compiled a cook book of the recipes we used, most of them from our mothers, and gave them as gifts. We invited everyone to take goodies home in a "doggie bag," a small brown paper bag with a hand-painted rosemaling design.

Our Christmas vacations plans were to fly to Switzerland, spend a few

days in Zurich, then take the train to Davos for a week of skiing. Before we left I had to give poor Gretchen an enema. I don't know what caused her problem, but she was miserable. I put her bottom in a pan of warm, soapy water and that did the trick. She was so sweet and thankful. It could have been worse. Donn's dog Olaf swallowed a bone and it got stuck you-know-where. Donn had to reach in with his hand to get it out.

Davos was a place for serious skiers. The runs were so long that skiers of my caliber were lucky to get in two runs a day. That included stops along the way to admire the scenery, have lunch, and rest. The site of the Spengler Cup, an annual invitational ice hockey tournament, Davos was at the end of a valley and surrounded by rugged 10,000 foot mountains, tall pines trees, and an abundance of snow this year. It had been a health resort since 1865, both climate and altitude perfect for patients with tuberculosis. Robert Louis Stevenson finished writing *Treasure Island* in this beautiful setting.

Our hotel, the Sunstar Park, had a big swimming pool and sauna on the ground floor, and it was a rare experience for me to look out the plate glass windows at the snow as I swam in the warm pool. It was considered rude to wear swim suits in a European sauna, so I complied. We bought a little Christmas tree for our room, a two-footer in a clay pot. It had small red candles on it, real ones which we lit on Christmas Eve. It was difficult to be away from our families this time of year, but we tried to make the best of it. We called home after midnight, but this year more than ever before, we missed being there. I looked forward to the day when we could celebrate together again.

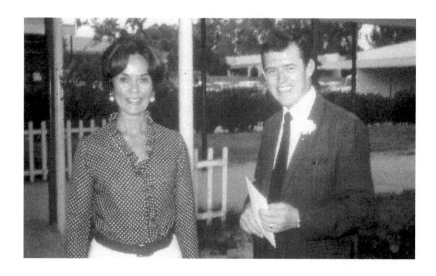

Eleanor and Peter Nowell. Oil Companies School Graduation, 1971. Taken near the entrance of the campus.

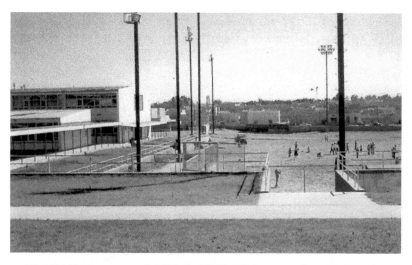

The OCS Campus and Athletic Field. Lights were installed on the playing field in 1971 for night games. Two-story wing on the left is the elementary building. Photograph Gray Tappan.

Bob Waldum. On campus Bob Waldum was all business, but after hours he enjoyed socializing with his staff. Here he inspects the stovetop still of one of his teachers.

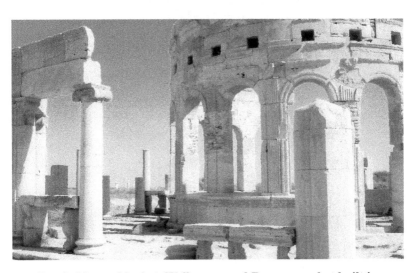

Leptis Magna Market. Well-preserved Roman market built in 9–8 B.C. for farmers and merchants of the area to erect stalls and sell their goods. Photograph Tom Mohr.

OEA Beer Label. Pre-September 1, 1969 Revolution beer label. Post-revolution beer was alcohol free. Oea was the ancient Phoenician name for Tripoli. Photograph Tom Mohr.

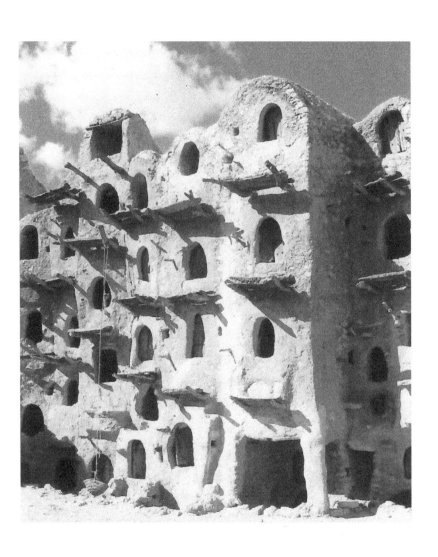

Grain Bank at Kabao. Still in use after centuries to store olive oil, barley, and wheat. Photograph Tom Mohr.

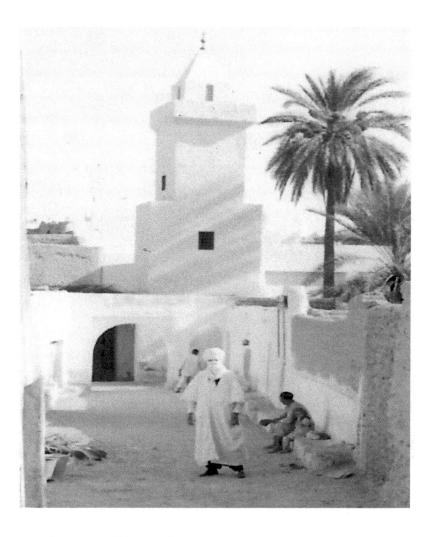

Ghadames Old Town Street. A Taureg stops for a photograph on a sand street of Ghadames. Men used the ground level, women the rooftops as streets to avoid being seen by men. Photograph Eleanor Andrews.

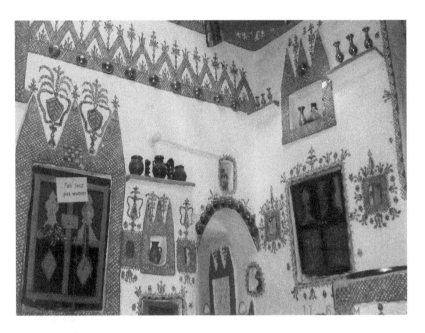

Ghadames Old Town Dwelling Interior. In contrast to the simple
white exteriors of buildings, the interiors are rampant with design
and color, mostly red. Photograph Tom Mohr.

The Lady of Garian. Detail of the 30' long wall mural in a former Italian barracks in Garian. The mural started in Tripoli, Lebanon, and continued across the North African coast. Demolished after the Revolution. Photograph Peter Nowell.

Mohrs at Ghirza Sign. A happy Tom and Doris Mohr. We knew we
were on the right track to Ghirza when we saw this sign. "Observation
of the Remnants of Lebda" and "The Archaeological City of Ghirza."
Photograph Eleanor Andrews.

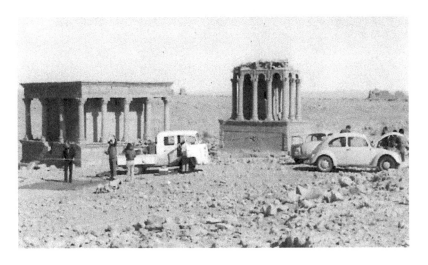

Ghirza at Last. Setting up camp in front of two mausoleums at the
ancient Roman settlement of Ghirza. Roman fortified farm buildings
in the distance. Photograph Tom Mohr.

Larry Land Rover. Our intrepid Land Rover on a trip to Wadi al Moud in 1979 with Lady Brogan. Photograph Eleanor Andrews.

Desert Guide. Our seventy-two year old guide to the prehistoric cave carvings at Wadi el Khlail. He spoke no English but knew the desert like the palm of his hand. Photograph Eleanor Andrews.

Mobrouk. Our houseboy for ten years. My father took this picture during my parents' visit in 1975. On the back of the picture is the note "Thanks for everything." Photograph Torger Froiland.

1977

We returned to Tripoli on December 31, and when we arrived at the airport I couldn't tear my coat and gloves off fast enough. It was 75°, unusually warm and sunny for January and a marked contrast to 32° and eight inches of snow on the ground in Zurich. At midnight on New Year's Eve, all power in Tripoli was cut off for about fifteen minutes, the ships in the harbor blasted their horns, and fireworks filled the night sky. We had never been in Tripoli on New Year's Eve before and were not aware of this tradition. It was a joyous sound. We felt as if we had been welcomed home.

We overslept on our first day back to work as did several others. We got so used to sleeping late during vacation that we didn't hear the alarm. Or maybe we ignored it. Every once in a while, we had to buy a different alarm clock because we got conditioned to the sound of the old one and slept right through it. Since the power was so undependable, electric snooze alarm clocks were not an option. We didn't have a phone, so if we overslept, the superintendent or principal had to come and get us. It was both embarrassing and funny. We somehow managed to get to class on time. We just missed our morning coffee. Our students, on the other hand, were right on time and working so hard that at the end of the marking period our honor roll doubled. Principal Mike made free popcorn for all junior high students as a reward.

A couple of weeks after we returned, Mobrouk handed us a letter asking for a raise. Since he could neither read nor write, he had a friend write it for him.

Dear Mr. Noma

After your agreement to pay the increase
I received (24) Dinars for two weeks
(12 Dinars per week) then 3 weeks
wages 10 dinars per week
May I ask why did you cut 2 Dinars

from the amount you agreed to pay
that is 12 Dinars per week
Thanking you
Yours
Mabrouk

We were confused by the letter but gave him the £2 a week he request-
ed. This raised his wages to a dinar an hour, about $3.34, more than the
local going rate for houseboys. His job as a gofer at the Ministry of
Information paid about half that amount. Mobrouk went into a slump once
or twice a year, but after a week or two he was usually back on the job.
Besides, he was expecting his eighth bambino, so he needed the money.
Shortly after he got his raise, he bought a used VW. We hoped it wasn't a
lemon.

By the end of January we were ready for another camping trip, our
destination this time the two-thousand year old deserted Berber village of
Forsada. Abandoned ten years before our visit, the village was perched on
a high cliff of the Nafusa Mountains and overlooked a beautiful vast val-
ley. The walls along the escarpment were weathered and crumbling and the
village full of desolate, roofless, empty dwellings and gaping open spaces
where doorways and windows once stood. Uneven winding paths led us
past cubby holes carved into the eroding cliffs. Rocks and rubble in vary-
ing shades of sandstone covered the steep slopes and surrounding hillsides.
A few windblown palms and scrub brush provided the only color. In the
middle of all this desolation was a huge old olive press, still in operation.

We chose a campsite in a nearby olive grove, set up our tents, and
towards evening built a campfire to cook Boy Scout burgers for dinner:
hamburger patties, sliced potatoes, chopped onions, and sliced carrots
wrapped in packets of sturdy foil and placed on the hot coals around the
fire. A camping favorite, they were tasty and satisfying after a day of
exploring. After dinner, Peter played the guitar and we sang songs until
about 10:00 p.m., then retired to our warm, cozy Arctic sleeping bags.
Even when days were warm, nights were cold in the desert.

When we camped, it was tradition for the men to get up first, start a
small fire, and get the coffee going. I waited in my sleeping bag until I

heard the men talking and the fire crackling. One by one we got up, found a bush, then congregated around the fire to warm ourselves, have a cup of coffee, and enjoy the sunrise. On this morning our school nurse suddenly felt something moving in her pant leg. She was tempted to swat it but instead lifted up her pant leg and discovered a scorpion crawling up to her knee. Marge flicked it off and thanked the Lord she looked before she swatted. Although a scorpion sting could kill a baby, it was usually not fatal to adults. It could make one downright miserable, however, and we had nothing in our medical kit to counteract it.

<p style="text-align:center">***</p>

At this time we were experiencing some of the warmest winter weather in Libya in twenty-six years. The average daytime temperature was 70°, good for camping, but bad for farmers. Both the wheat and barley crops were totally withered. If we got lots of rain soon, farmers hoped to reap enough crops for grazing to save sheep, camels, cows, and donkeys. If not, the coming year could bring serious food shortages. In an effort to encourage everyone to conserve water, the government levied a ten-dinar fine for washing cars. Rumor had it that we would face a meat shortage again in the spring, so Doris and I went to the Italian market during the weekend but found nary a bone. Anxious to get our freezer stocked, we resolved to try again soon.

One morning in February I woke up at 4:00 a.m. with pain in my lower abdomen. My first thought was food poisoning. The next two days I felt the pain off and on but ignored it. Day three I was fed up, so I went to the Oil Companies Clinic where Dr. Shah diagnosed my condition as a urinary infection and sent me home with pills. I took them and felt worse.

That night I didn't sleep, so after we got up I dropped Peter off at school and drove myself to the clinic. Doc Lyons, the man who accompanied Bob Waldum to Black River Falls, was on duty, and after a thorough examination he declared that my appendix had to come out. He set up an appointment with the surgeon at 3:00 p.m., and I went home to rest. When Peter finished his classes, he drove me to the clinic and as we waited, an employee of one of the oil companies came into the lobby and asked what was wrong. When I told him it was my appendix he said, "Whatever you

<p style="text-align:center">217</p>

do, don't have the surgery here. Go to Rome. Go to London. Go any place but here." By that time I was too weary to care. I just wanted it over with. Besides, my appendix would probably have ruptured by the time I got to either place. At 7:30 nurses came to wheel me into the operating room and assured me along the way that my surgeon, Dr. Thalwart, was very good. They were right. By 8:00 my appendix was out, the sharp pain was gone, and other than being stiff in the middle, I felt fine.

Dr. Thalwart wanted to keep me in the clinic several days, but at my request he discharged me at the end of day three. I had no major complaints about my care. The nurses were friendly and attentive, and aids were constantly working to rid the place of flies, cockroaches, and sand. They mopped the floors several times a day with an industrial disinfectant, changed sheets daily, and delivered food and beverages on clean trays. Dr. Thalwart was from Pakistan, but most of the doctors at the clinic were British, one we dubbed "Dr. Filth" because he constantly complained that everything was, "Filthy, just filthy." Some declared the Oil Companies Clinic no better than a first-aid station, but it was the closest thing to a hospital we had in Tripoli. It was not the Mayo Clinic, but it served its purpose.

Home felt like heaven. Peter, Mobrouk, and my close friends pampered me. Students, teachers, and friends in the community sent so many presents and flowers that our villa looked like a funeral parlor. While recuperating I passed the time sewing, mending, and reading. I joined Gretchen and Albert for a sun bath in the back yard every afternoon. They were somewhat put out when I appropriated their chair, but we enjoyed each other's company. Later in my recovery I had a "gourmet" dinner ready for Peter when he got home from work every day: soufflés, stroganoffs, rice pilaf. He said he appreciated it but would be happy when I went back to work so we could eat normally again.

One week after the surgery I went to the clinic to have my stitches removed. Only a tiny one-inch scar remained from the appendectomy and other than an admonition not to lift anything heavy, I was cleared to go back to work. I had missed nine days of classes and felt tired at the end of the first day back, but other than that, I had no complaints. A month later I got a bill from the clinic for my appendectomy, about $650.00. I was surprised since we had a group Blue Cross insurance plan that should have

covered it. The surgery cost $175.00 and a semiprivate room around $60 a day, a bargain compared to prices today. I ended up paying it, then in November, nine months after my surgery, I got a letter from Blue Cross telling me they made a mistake and sent my $650 to a woman in Lubbock, Texas. I filled out the required forms, but I don't recall ever being reimbursed.

<p style="text-align:center">***</p>

One evening shortly after my return to work, I was home alone lying on the couch reading when I heard noises on the front patio. Someone was trying to break in. Peter was at school playing softball, my neighbors were gone, and I had no phone. I felt trapped. I did not go to the window to investigate, but my protectors, Gretchen and Albert, started barking and I went around the house turning lights on and off and making a racket. The intruder went away. The next day I reported the incident at school, and within a week we had black wrought iron security bars on all of our villa windows and doors. Better known as burglar bars, they were decorated with hearts and scrolls, and they made me feel safe, not confined.

One Thursday night, the night before the Moslem holy day, a Libyan driver cut directly in front of Peter as he was driving home from downtown Tripoli. Peter swerved to get out of his way and ran into a retaining wall by the sea. The passenger side of our car was demolished. If I had been along, I would not have survived. Peter came out of it with a couple of scrapes and a sore shoulder, but our little VW Bug was totaled. The whole frame was sprung and one entire wheel was gone. The car was not worth repairing, so Doug and Peter stripped it down and sold the seats, tires, lights, chrome, engine, even the windows. We later used the proceeds to buy our third car in Libya, a white Toyota Corolla.

The driver of the other car never looked back. He probably didn't have insurance, but even if he had, experience told us not to count on collecting. The first year we were in Tripoli, a Libyan driver roared through an intersection near our villa and ran right into Freddie the Fiat. Villa walls were so high in our neighborhood that every intersection was blind. Drivers were supposed to slow down, honk their horns, and look before entering. This driver didn't. He came flying through from Peter's left and

hit Freddie over the rear wheel well. The impact was hard enough to spin the car a full 360°. The police came, decided that it was the Libyan's fault, and told him, "You pay." As an afterthought, they asked the Libyan if he had insurance, and he replied "No." The police then asked Peter if he had insurance, and when he answered "No" they said, " You pay for your car. He pays for his." Libyan street justice. Malish.

<center>***</center>

Easter Vacation arrived the beginning of April and we joined our friends Donn and Mary for a trip to Malta, Sicily, Naples, and Rome. The day we left Tripoli it was close to 100°, so we packed accordingly. That was a mistake. The rest of the world was still cold, and we froze the entire time we were away. I threw one heavy sweater in my suitcase "just in case" and wore it every minute of the trip. Taormina was lovely, as usual, and when we left Sicily, our Alitalia pilot bent the rules and gave us a thrill by flying us directly over Mt. Etna. The day was clear, and we could see deep into the crater. Some ancient Greeks believed that Hephaestus lived in the fiery depths of Mt. Etna. We imagined him busy at his forge that day.

The highlight of the trip was our visit to Pompeii, the almost perfectly preserved Roman city buried under eighteen feet of ash during the eruption of Mt. Vesuvius. The 4,203 foot volcano was not considered active since it had been silent for a thousand years, but on August 24, A.D. 79, at about 1:00 p.m., it erupted and began spewing ash and pumice into the air. It didn't quit for eleven hours and left 160 acres in ruin. When the city was excavated, archeologists found perfectly preserved villas, shops with signs intact, two-thousand year-old loaves of bread, jewelry, baths, theaters, mummified dogs, a horse, and people engaged in everyday activities. The most touching sight was a mother holding what looked like an eight year-old child. It is thought that the woman was of noble birth and the child an invalid. She may have had a chance to escape, but it appeared that she chose to protect her child with her own body, an act of love preserved for posterity. We were overcome by sadness at the sight.

On the Amalfi Coast we spent one night at the San Pietro Hotel. Before he died, Bob Waldum told us we had to go there. I'm glad we did. Everything about it was remarkable. The entrance to the hotel was a little

<center>220</center>

white chapel on the side of the road, so inconspicuous we almost missed it. Inside the chapel was a small elevator which we took for the 1.5 minute ride down to the lobby. When the doors opened, we were greeted by the hotel dog, a friendly brown Labrador. The lobby was light and spacious with terra cotta tiled floors and ceilings dripping with bougainvilleas. The rooms varied in size, decor, and price. One had a bathtub so large that a life preserver ring was provided, just in case. The hotel was nestled into the bottom of a steep cliff and overlooked the Amalfi Coast. The water was crystal clear. We had found paradise. We looked for Bob's name in the guest book and were pleased to find it. We were reluctant to leave but had agreed to meet Gloria and others in Rome, so on we went. It was not a hardship. Rome never disappoints.

Gretchen and Albert were happy to see us when we returned. They had become inseparable. Albert was the stronger of the two, but Gretchen was the boss. She groomed him, made sure he had no ticks, and put him in his place when he got out of line. They played all day and stood guard all night. Until Albert arrived, Gretchen slept in the house, but Albie was afraid he'd miss something going on in the yard, so we moved their beds out to the covered front patio. One night they would not stop barking. We opened the bedroom window and shushed them several times, but they kept it up. Finally Peter went outside and found them both worrying a petrified little hedgehog to death. He was rolled up into a prickly ball to protect himself, and the dogs couldn't get at him. That frustrated them no end, so Peter came inside, got a dustpan, scooped up the spiny little creature and deposited it outside the front gate. At last we were all able to get back to sleep.

We enjoyed a number of "First Annual" events in Tripoli, even if they happened only once. Since we knew we could be evacuated on short notice at any time, calling these events "annual" probably contributed to a sense of permanence. We had a First Annual Bridge Marathon, British Grand National, Dart Tournament, and Christmas Sing-Along, to name a few. To celebrate Peter's thirty-eighth birthday we added the First Annual Cribbage Tournament. We invited fourteen friends for lunch and an after-

noon of cribbage. I started ten days ahead to cure my own pastrami, bake two kinds of rye bread, make coleslaw, potato salad, deviled eggs, and baked beans. We had beet pickles, sauerkraut, huge kosher dills, Swiss cheese, carrots, tomatoes, and radishes. Dessert was Peter's favorite chocolate cake with chopped maraschino cherries and walnuts and chocolate frosting. It was a welcome change from beef and chicken, our main fare, and people loaded up their plates. I was so pleased with my experiment with pastrami that I decided to make sourdough starter, but just when it was ready to use, Mobrouk threw it out. He didn't think it smelled healthy. We had a good laugh, and he promised to leave it alone next time.

With the advent of spring, the fragrance of orange blossoms once again filled the air and turned our thoughts to end-of-the-year school activities, spring cleaning, and summer travel. Other than the peacock next door honking full blast at 4:00 a.m., life was good. On a sun-filled day at the beginning of March, a record four-thousand people turned out for the annual Bazaar on the OCS campus. The Garden Club, Bookstore, and Country Store were among forty booths that sold everything from potted plants to Sloppy Joes. The American Consulate sold hot dogs, and kids and grownups enjoyed dart throws, sponge throws, and raffles. At the end of the day happy visitors went home with handicrafts, cakes, and 800 dinar in prizes.

At home, we finally got around to carpeting our bedroom and hall with the green carpet that George and Amy gave us when they left Libya in August of 1975. It looked and felt nice. Next we attacked the ghaffir's quarters, the small servant's shed in the corner of our back yard. It had room for a cot and cooking stove and a commode which I doubt had ever been cleaned. It was cockroach heaven, a disgusting job that had haunted me for seven years. After throwing out all the junk and disinfecting the place, Peter put a fresh coat of paint on the walls and floor. We thought we might use it for a workroom or storage area, but that never materialized. Many ex-pats, teachers included, set up their stills in these quarters. We did not have the desire, skill, or the expertise to get into that. We concentrated on making bad beer and wine.

Mobrouk and I worked on cleaning kitchen appliances. He loved to use Big Wally, a great all-purpose foam cleaner popular the 1970s, and was so lavish with its use he almost asphyxiated both of us. Big Wally was

advertised as the answer for those who disliked housework but wanted a clean house. As with many products one grew to love, we could no longer find it for reasons unknown. We got our yard sprayed for ticks, roaches, and snails, so Gretchen and Albert had to go next door for twenty-four hours. We arranged early for two ninth-grade girls to take care of them during the summer. They were dependable and loved dogs, so we would not have to worry.

One morning at school I discovered a shy, thin, white, defeated looking pye-dog behind my room. She was one of the stray wolf-like dogs that roamed the streets of Tripoli in packs, but this one was not dangerous. She had dug a hole in the ground right outside the classroom window and given birth to a litter of five pups. I brought scraps of bread, meat, and milk to her every morning and soon she waited outside my door, guarding the area like a sentry. My students started bringing food for her and tried to find homes for the pups. I was tempted, but I already had two. We called her "Mama Dog."

The head dog on campus was Scruffy, a well-fed friendly German Shepherd mix who had the run of the place. At lunchtime, he made the rounds of the homerooms looking for handouts. He was never disappointed. He got kimchi from Bonghjon, falafel from Nadia, tabouleh from Taher, salami and green peppers from Hedvig, and part of a peanut butter and jelly sandwich from Marci. Scruffy wasn't particular. He sought out cool rooms during the day and stretched out for quiet naps during exams. He was appointed Honorary Captain of the Safety Patrol and frequently got his picture in the yearbook. Everyone loved him.

Mobrouk's wife had a baby boy on April 30, their eighth. Four girls and four boys. He came to work about 6:00 p.m. and was still washing clothes at 8:00. We tried to get him to go home, but he was too hyper. He may have needed the peace and quiet of our villa. A couple of weeks later I went down to see his new baby during the "Abraham" Eid. I did not know before I went that he planned to honor me by killing a sheep while I was there. I noticed him sharpening his knife in the courtyard while I was visiting with his family, and knew what was coming. I couldn't stand to

see anything suffer, much less die, so I had to excuse myself. He was sweet about it. He even brought us a leg of lamb. We plugged it with garlic and basted it with lemon and salt. It was delicious.

Every spring both teachers and students eagerly anticipated the annual Teachers' Appreciation Day. On this day the National Junior Honor Society members brought gourmet lunches to their teachers and served them at their desks or as a group in the library. Some even brought wine. Knowing they were in our good graces, students escorted us to the gym after lunch and roasted us in an hour-long program. They chose well known formats like the *Academy Awards*, the *Newly-Oldy Wed Game*, or the *Mr. and Mrs. World Competition* which included muscle, bathing suit, talent, and intelligence competitions, all of which provided a goldmine of opportunities for satire. This year's take off was *The Gong Show*. Students imitated teachers singing and dancing and judges hit a gong to stop them. The result was an hour of nonstop laughter.

We had known for some time that Tom and Doris were expecting twins and we had arranged for Leanne to stay with us when they arrived, so when our doorbell rang at 3:30 a.m. on Sunday, May 15, we knew exactly what was happening. The twins were on their way. Doris stayed in the car while Tom brought a sleepy little Leanne to our front door, then they sped to the Oil Companies Clinic. Leanne, now just a few days shy of two years old, crawled into our bed with her "blankie" and was not the least concerned about waking up in a different house. She helped me feed Gretchen and Albert then ate her breakfast like a little lady. At 7:40 a.m. twins Amy and Robert arrived at the Oil Companies Clinic, both healthy and happy. Tom and Doris were delighted and so were we.

By this time, we had waited nearly an entire month to get our new Toyota. We were scheduled to pick it up on May 4, but it hadn't yet arrived at the dealer. Determined to get answers, we went to the port authority and were told it would be another week. Fortunately, Tom let us use his old Volkswagen, and on May 16 we finally got our new car. It seemed like a limousine after riding in a VW the past few years. Peter washed it every day and treated it like a china teapot. It was good to have our own wheels again.

Fair weather held out until the end of May. Except for one beastly hot day, we didn't need fans at home or at school. Just as we were starting to

take it for granted, the heat arrived like a blast from hell. Daytime temperatures were 100,° so all fans and air-conditioners were back in operation. Additional staff had made the whole year easier, but teaching during the spring was harder than any other time of year. Classrooms were hot and students were used up. Weather, holidays, and local politics taught me to cover the most demanding part of my curriculum early. By the end of the year, no one was interested in subordinate clauses or *Julius Caesar*. I usually concluded the year with speech, but this year I tried *Fahrenheit 451, Pigman,* and *The Outsiders*, all high-interest, easy reading novels, and a couple of plays, *Camelot* and *Man of La Mancha*. Students took parts, read the plays out loud in class, dramatized selected scenes, and listened to the soundtracks. The plays introduced students to literary icons Don Quixote and King Arthur and gave them a chance to get out of their seats and move around. I would miss this group of ninth graders. Many of them had been in my class three years in a row. They were almost like family. Students were by far the school's greatest asset. From kindergarten through grade nine they were eager, competitive, and well-mannered. Exceptions? Of course. But from a teacher's point of view, they were a dream.

In June we received news that any mail sent to Libya required SPLAJ to be added to the address. It stood for Socialist People's Libyan Arab Jamahiria, an Arabic word which translated to "union of the masses." Gaddafi was attempting to restructure Libyan government and society by forming "people's committees" which he said would give power to the people. He claimed this was a step above democracy. He wrote the *Green Book* as a guide, changed the flag to solid green, and on March 2, formally announced the name change at a General People's Congress in Sebha. We were warned that letters wouldn't get into the country without SPLAJ on them, so we informed our families immediately.

The last week or two before summer break I was buried in end-of-the-year tasks. I worked a couple of nights in my classroom vacuuming the sand from all my books and shelves. I inventoried my books, a big job since in my room alone students had a thousand paperbacks from which to choose. As long as the title was available and could clear Libyan customs, I was free to order classroom sets of every title I taught. When the cleaning was finished, I took my first swim of the season. Ah, refreshing.

225

After spending hours planning and coordinating our summer travels, we settled on an itinerary. We had received a letter from my father with the news that in June he was headed to Hommersåk, the village in Norway where he was born. Realizing this might be a once-in-a- lifetime chance to meet him in his native land, Norway was our first stop.

In Minneapolis, my Dad boarded a charter flight to Oslo and arrived in Hommersåk on June 13. We flew to Amsterdam, rented a car and drove to Denmark, took the ferry to Kristiansand, and made our way to Hommersåk. Along the way we stopped in Heidi, Germany, for a day to visit Alex, the former headmaster of the German school in Tripoli and his wife Heidi. We drove by pastures full of beautiful Holstein cattle in Schleswig-Holstein, prosperous looking farms with sturdy buildings, cozy Old Mother Hubbard-style cottages, luscious fields full of cabbages, and fat pigs lolling in clover. The farther north we got, the colder it was, but it felt pleasant to be out of Libya. Although we had never felt personally threatened, we sensed a freedom in the outside world that we didn't experience there.

We knew that Norwegians traveling to Denmark filled their trunks with canned hams, bacon, any kind of meat that wouldn't spoil before they got home, so we did the same. Cheap in Denmark, expensive in Norway, meat was always a welcome gift. About 5:00 p.m. on Wednesday, June 22, 1977, we arrived in Hommersåk. Our first stop was Frøyland, the little white wooden 1850 house with a red tile roof that was the center of the universe for all Froilands. As usual the door was open, but no one was home, so we started walking to Tante Margit's. As soon as we reached the main road, we saw my father. The native son was just returning from afternoon coffee and cakes with sister Margit and her husband Arne. After a good long hug that I can still feel, we headed back to Margit's to celebrate with the first of numerous rounds of coffee and cakes.

My father's home base was the tiny bedroom right off the kitchen of Frøyland. Just large enough for two single beds and a wood burning stove, the room had a large window with a view of the stone fence surrounding the yard and the old oak tree where my father used to swing. It was a room full of memories of his grandmother Anne Marie who spent her days card-

226

ing, spinning, and knitting mittens and socks for all twelve kids in the family, plus the adults. Her room was a haven for my father when he was a child. He found peace in her company and looked forward to the piece of rock candy waiting for him when he stepped into her little world.

The attic at Frøyland held memories, too. One of the three small rooms at the top of the steep stairs held the wooden cradle in which all twelve siblings were rocked when they came into this world. In a larger room with open rafters stood a row of "adorable little beds" where the brothers and sisters slept, close as Happy, Sneezy, Bashful, Sleepy, Dopey, Grumpy, and Doc. Like these characters from *Snow White and the Seven Dwarfs*, close living during their childhood established a bond that lasted from cradle to grave.

During the month of June, Norway was lush and green. The air was fresh, and a breathtaking display of rhododendrons, azaleas, and lupine ran rampant throughout the countryside. As we walked the narrow path to the family lake, Frøylandsvatnet, my father plucked a blåklokke (bluebell) blossom from a plant growing beside the stone fence. He put it in his mouth and shot it into the air with a giant puff. He was like a kid again. He pointed out the woods, the mountains, the lake where he swam and fished, the sea and the fjords that were his companions as he grew up. He showed us the boundaries of the old farm and the burial mound from the Viking Age behind the barn, a special place preserved for posterity.

The old barn still smelled of animals, hay, and straw. When my dad was young, the family kept five or six milk cows, twenty sheep, a fjord horse that sometimes had a colt or filly, and two pigs, one for the house at Christmas, and one to sell. The pigs were sleek and tame as dogs, and the family loved them. They fed them small boiled potatoes, oats, and barley. On butchering day, the kids were so distressed they went into the house and hid. They didn't even dare to peek out of the window. Growing up, food was sometimes hard to come by, especially during World War I. Bread was a real problem for twelve hungry kids, but the family got more sugar and coffee than they needed, so they traded it with neighbors for flour. They had plenty of fish—fresh, salted, dried, pickled—so they never went to bed hungry.

Before we left Hommersåk, we walked around the land that my dad inherited, and he took us to the white wooden schoolhouse that he had

attended. We visited the graves of my grandparents just inside the gate of Riske Kirkegård, then we worshiped together in the church where my father was baptized and my grandfather served as custodian and song leader for fifty years.

We enjoyed our time with the family in Norway. My maiden aunts treated my father like a king, waiting on him hand and foot. I could see why he loved to visit. They fussed over us and kept us well fed. During the week, most meals included fish: salmon, sei, cod, fish balls, seikage. Meat was saved for Sunday *middag*: roast lamb, pork, or beef served with potatoes, carrots, cauliflower, Brussels sprouts, and delicious brown gravy. Bread was good and plentiful. So was cheese and *syltetøy*, jam in a variety of flavors, all tasty. The coffee pot was always on, and my aunts kept the cream cakes coming. If they didn't feed us eight times a day, they felt they weren't doing their job. The only person missing in Norway was my mom. A cranky nursing supervisor at the hospital where she worked would not give her time off to accompany my dad.

Our second destination was Russia, a trip we had planned months earlier with our friend Keith. Just before we left Libya we had gotten word from Intourist in London that we were cleared to leave for Russia on July 7, so we made sure we were there before that date. London was crowded with tourists and exhaust fumes were so thick it was hard to breathe. We saw a few plays and films, watched the Wimbledon women's and men's finals on TV, and went to Speaker's Corner in Hyde Park on Sunday morning to listen to everyone from socialists to revivalists pontificating. An old British gentleman standing beside us called it an open-air lunatic asylum.

On July 4 Keith arrived. We had our passports, visas, and tickets ready, so we were anxious to be on our way. We bought airsick pills in case the Aeroflot ride was bumpy, but we didn't need them. On July 10 about 6:30 p.m. we arrived in Moscow in a shiny new streamlined Aeroflot jet. Customs officials at the airport in Moscow looked stern, but we who were Libyan-trained were not intimidated.

All of our meals, transportation, and accommodations were booked in advance by Magnolia Tours. We checked into the massive Hotel Ukraina,

an intimidating Gothic structure, and were directed to an upper floor accessible only by an antiquated elevator. Before entering our room we had to pass by a little old lady wearing a babushka. She sat all day at a desk and monitored the coming and going of guests. We got the impression that if we made a false move, she would roll up her copy of *Pravda* and straighten us out. Our room was large but bare, and we had no lock our door. We had a private bath but only one tea towel for the two of us to dry off after bathing. The toilet paper was more like wax paper than Charmin. Today the Ukraina is a five-star luxury hotel with all the amenities. Times have changed.

Moscow was built on a grand scale, the buildings massive and the avenues wide but virtually deserted since at this time few people could afford cars. We did not see a piece of litter anywhere on the streets, and the subway stations looked like world-renowned art galleries. Marble walls, mosaics, sculptures, and stained glass glowed under crystal chandeliers. Muscovites took great pride in them and would not dream of littering or defacing walls with graffiti.

The most distinctive building was St. Basil's Cathedral with its onion domes of different shapes and colors. Napoleon once stabled his horses there and wanted to tear the building down. Fortunately, he didn't get his way. Other than that, Moscow was Moscow. We saw the Kremlin, which means *citadel*, spread out over an area of sixty-five acres. Red Square and the Lenin Mausoleum were pretty much as we expected from pictures we had seen. Statues of Lenin were ubiquitous. Moscow State University buildings were designed by the architect of the Ukraina Hotel and looked equally intimidating. We visited the Exhibition of Economic Achievement, a permanent fair with displays ranging from Sputniks to setting hens, then wandered through GUM, *Gosudarstvennyy Universalnyy Magazin*, the huge state department store where one could buy anything from car tires to crochet hooks, if they were in stock. We saw the stadium of the upcoming 1980 Olympics, spent one evening at the Bolshoi Ballet and another at the State Circus where we saw bears, horses, even trained cows. Most of our sightseeing was structured, but one day we boarded a bus near our hotel and took it to the end of the line. We didn't know where we were going, but we ended up near a brick apartment building where people were lined up on the sidewalk to buy chickens.

Our journey into Asia—Tashkent and Samarkand—turned out to be a test of physical endurance. People dropped like flies from dysentery, some from drinking the water, others from eating contaminated food. Two of our group ended up in the hospital. As it turned out, Moscow was the only place one could safely drink the water. How, we wondered, could a country that could send men into outer space not provide clean, safe drinking water for its people.

Tashkent, the capital of the Uzbek Republic, was once a flourishing center of trade until earthquakes and modernization removed anything of real interest. People seemed poor and downtrodden. The shops were grim. I ran out of toothpaste and stopped at the local GUM to buy a tube, but they were out of stock. Both Tashkent and Samarkand had large populations of Uzbeks, different both culturally and racially from the Russians. The men sported wispy mustaches and wore padded coats, high boots, and fur hats. Their eyes were slanted and their faces leathery. The Moslem influence was obvious.

Samarkand was truly a place of splendor. Located on the Silk Road between China and the West, it was once a renowned center of learning with an observatory, mosques, madrasas, and mausoleums. Tamerlane led this "turquoise city" to its zenith in the late 14th and early 15th Century and left magnificent examples of Islamic architecture for posterity. The most famous of these was Gur-e Amir, Tamerlane's tomb. Built in the early 1400s of native baked clay, it had a 112-foot-high bulb-shaped dome covered with exquisite turquoise, green, yellow, and gold tiles and mosaics. Tamerlane's tomb was restored in 1958, but the mausoleums of other family members had fallen into a sad state of disrepair. The towers were leaning and grass was growing out of the domes.

"Tamerlane" is the European version of "Timur the Lame," a name he acquired from injuries in his youth, possibly wounds in battle. He was one of history's cruelest, most notorious conquerors. He conquered the cities of Delhi, Baghdad, Aleppo, and Damascus, to name a few, and massacred their inhabitants. He enjoyed stacking the skulls of his enemies into pyramids. He captured rulers and paraded their wives naked before his courts. He was never known to laugh. While he was getting ready to attack China in 1405, he died at the age of sixty-nine. His empire did not survive, but his reputation rivals that of Ghengis Khan. It didn't seem right that a man

so cruel should have such a magnificent resting place, and it seems ironic that the descendants of the people he terrorized are the ones who restored his tomb. Uzbeks today consider him a hero.

During our visit to this magnificent place I was cursed with diarrhea. I spent much of the day curled up on a park bench cradling my stomach. The rest of the time I spent in a variety of toilets and outhouses. Two things I learned. Diarrhea is a challenge when using squat toilets, and *Pravda* doesn't flush. I finally gave up and returned to my hotel room where our tour guides immediately cut off my intake of food and water. Keith gave me a roll of toilet paper that he brought along. Now that is a friend.

Our next stop was Dushanbe, the capital of the Tadzhik Republic and the cultural and industrial center of the area. Located in a valley at the foot of the Hissar Mountains and close to the border of Afghanistan, it was touted as a model modern Russian city. Its name came from the word "Monday," the day on which the market was held at this location in earlier times. The new city was built in 1925 and had wide avenues, parks, ballet and opera theaters, and amusement parks. Since it was earthquake country, the buildings were only two or three stories high. Compared to Samarkand, it was not especially interesting.

One sunny afternoon our guides took us on a picnic in the mountains. They spread tablecloths on the ground by the river and served us bread, cheese, tomatoes, slices of watermelon, and bottled water. I was still on a diet of plain rice and tea, and my constitution was benefiting from it. Not so others in our group. Tony, a young British man in our group, was taken to the local hospital with an acute case of dysentery. His wife reported that the hospital was out of toilet paper. They were using cotton batting.

On interior flights we no longer traveled on streamlined jets and dined on caviar. We flew on planes that felt like vibrating machines and ate rubber drumsticks. Our group, mostly British and Scots, was kept separate from the local passengers. We were seated in the front of the aircraft with a heavy curtain drawn between us and the locals. As we flew over this country I looked down and thought to myself how vast and beautiful it was. One could not help but regret that our governments should have such great differences.

As tourists, we were allowed to shop in Barioskas, duty free shops. We could buy vodka, Beluga caviar, Heineken beer, even a fur coat if we

had the desire and the dollars. Only once did we see a woman we assumed was Russian ride up in a limousine to shop in a Barioska. She was dressed in a fur coat, and we guessed that she was the wife of a government official who had foreign currency. So much for the classless society.

Leningrad, our last stop, was founded in 1703 by Peter the Great as Sankt Pieter Burkh or St. Petersburgh. It was the capital of Russia in 1712 and has gone through several name changes since. After World War I it was given the more "Russian" name of Petrograd, then five days after Lenin died in 1924, it was changed to its present name to honor the "Father of Bolshevism." It is on the Neva River and appeared more European than Russian.

We stayed at the Rossiya Hotel, the most modern and well-appointed hotel we had stayed at so far. I was still on a diet of rice and tea but contemplated trying some well-cooked food soon. I vowed, however, never again to eat any fresh foods when traveling in remote areas. Not even bottled drinks could be trusted in some of the places we visited. Several people in our group drank only vodka which was both cheap and dependable.

The most impressive buildings in Leningrad were the Winter Palace and the Hermitage. Rightly called the Louvre of Russia, it is said that if one visited the collection and spent one minute on each piece, it would take at least twelve years to get through it. The building itself was breathtaking with its ornate façade, marble staircases, doorknobs of semi-precious stones, and chandeliers of silver and gold. The collection included works by Leonardo da Vinci, Titian, Rembrandt, Raphael, Rubins, and the French Impressionists. Armand Hammer, the force behind Occidental Petroleum Company which had an operation in Libya, gave the Hermitage a Goya worth a million dollars in 1972. He was an entrepreneur, art collector, philanthropist, and unofficial ambassador to the Soviet Union. The biggest surprise in the museum was a small room on the top floor that contained a couple of dozen early blue and gray Picassos. They were obviously not a source of great pride to the curators. In fact, they had been kept in the cellar until Stalin died.

Since we didn't have twelve years to spend, we visited the highlights and went on to the Peter and Paul Cathedral and Fortress, Nevsky Prospekt, and eighteen miles west of Leningrad, Petrodvorets, a former royal summer estate that was bombed out during the German siege of

World War II but was now restored to its original splendor. Thousands of buildings were damaged or destroyed in Leningrad during the siege, and over a million people died. They ate dogs, cats, rats, leather, and coffee grounds to survive. They rightly considered themselves heroes. Peter went to visit the *Aurora*, the ship that signaled the start of the Revolution in 1917 with a single blank round. A pack of Winstons got him aboard.

Of the cities we visited in Russia, my least favorite was Moscow. It was immense, gray, oppressive, intimidating. Leningrad seemed more relaxed and open, possibly because ports gave them more contact with the outside world. It was a city of incomparable treasure. Some of the saddest sights we saw in Russia were the churches that had been converted to museums. It broke my heart to pay admission to get into them. We even heard rumors of a museum of atheism. In Leningrad, a city of two million, only fifteen small churches were functioning, but Lenin was worshiped like a god. We probably saw more statues of him in two weeks than we had of Jesus Christ in a lifetime. Everywhere we went in Russia people asked for chewing gum which they didn't produce, blue jeans, cosmetics, cigarettes, and dollars. I had my usual supply of gum, but wished I had brought a suitcase full. Russians were dying for anything different and would buy the clothes right off our backs. Many in our group just gave their clothes away. Mine were too small to be of much use to anyone.

We got back to London about 1:00 p.m. on July 24, one planeload of happy people. We all felt that the trip was interesting, educational, and worthwhile, but we were glad to be back in Merrie Olde England. After a day of shopping and one to have physicals, we boarded a sleeper from Victoria Station and took the long way home via the Orient Express route making short stops in Paris, Budapest, Zagreb, and Rome. This was not the famous Orient Express train, but it felt like it to us. We had a compartment with recliner seats that converted into comfortable single beds with smooth, white sheets and clean soft blankets and pillows. It was like a dream to wake up and look out the window at Cologne and other cities as we passed through them in the middle of the night. In the morning, the porter served us fresh coffee, juice, and rolls on a silver tray. We felt spoiled.

In Rome we checked into the Hotel Victoria Roma, Bob Waldum's favorite. In fact, when we registered with our Tripoli address, the

concierge asked if we knew Bob. We were pleased but not surprised that the staff still remembered him. During our stay I reveled in the luxurious shops, cafés, and restaurants on the Via Veneto. Each morning I started the day at my favorite sidewalk café with a cappuccino and the *International Herald Tribune*. From my little table, I watched people walking by in black leather pants and studded jackets. They were a far cry from the padded jackets and babushkas we saw much of the summer, and they made me smile. In a capitalistic frenzy, I went into a designer shop on the Veneto and bought two beautiful dresses, proceeded to Bruno Magli for shoes to match, and finally, completed the outfits with a purse and two belts at Gucci. At Gucci, the young Japanese woman ahead of me was buying a belt and asked the clerk how much it cost. He said 2,000, and she pulled out $2,000. Of course, he meant lire and told her so. I hoped she learned the difference.

By the middle of August we were home and busy getting our villa up and running again. My washing machine died during the summer and laundromats had not yet reached the shores of Tripoli, so I ended up washing two suitcases full of dirty clothes by hand. Temperatures were in the 100s and for a change, it was humid. Usually sweat on my arms dried so fast it tickled, but now it was impossible to step outside without getting drenched. It seemed more like the tropics than the desert. Our back yard was overgrown with grass about three-feet tall, but Mobrouk had the villa in good shape. We were luckier than most. Houseboys often took the summer off when their employers left, or didn't report for work until a day or two before they came back. Tom and Doris' houseboy didn't show up one time. They found dirty dishes in the sink, and since their power had gone off for a couple of weeks during the summer they were met by the stench of two refrigerator freezers full of rotten meat. It was not the welcome they anticipated after traveling straight through from Washington, D. C. with three little ones.

To add insult to injury, all the meat was currently going to the army and civilians were out of luck. I had emptied our freezer before we left, so I spent two mornings hanging out at my butcher's stall in the Italian

Market. The second day he finally took me aside and gave me about sixty pounds: twelve pounds of hamburger, a two-foot long sirloin, two filet mignons, a rump roast, and two legs of lamb. Being a loyal customer paid off.

We got little news of the outside world in Russia, but as soon as we returned to London we started hearing about hostilities between Libya and Egypt. We were not surprised since relations between the two countries had been shaky, especially since President Sadat's peace efforts after the Yom Kippur War in 1973. In June of 1977 Gaddafi ordered the 225,000 Egyptians working and living in Libya to leave the country by July 1 or be arrested. Both countries accused each other of trying to overthrow each other's governments, and demonstrators attacked both embassies. Libya closed the Egyptian Consulate in Benghazi, and Egypt retaliated by sending troops to the Libyan border. Gaddafi accused Egypt of provoking a war so that it could seize control of Libya's oil fields and made the first strike on July 21. Egypt retaliated, beat back the Libyans, and destroyed most of their equipment. The four-day confrontation along the border resulted in four-hundred Libyans dead or wounded. Egyptian casualties were about one-hundred. Mediation brought about a cease fire followed by an armistice. Prisoners of war were exchanged, and eventually tensions between the two countries relaxed. We witnessed a great deal of hostility towards the Egyptians since our return, but the Libyans were as friendly as usual to us and we were not concerned for our safety. We hoped the hostilities were over.

Once again on September 1 Libyans celebrated the anniversary of the Great First of September Revolution commemorating the overthrow of King Idris in 1969. Libyans who supported the King spent the day yearning for the past. Before the coup, one of our friends slowed down every time he drove by the King's Palace late at night and said, "Goodnight Big I." For most Libyans, it was a day to watch frogmen, tanks, planes, and soldiers with weapons parade through the streets. Reruns would be played on TV for the remainder of the year. I couldn't help wishing that Libyan children had something else to watch, something like *The Muppets*. Then remembered Miss Piggy. She would not get past the censors. For us, it meant a day off. We spent the day doing projects around the house and helping teachers who just arrived get settled in their villas and classrooms.

Everything went so well during the first week of school we could hardly believe our good fortune. This time of year, our classrooms got uncomfortably warm during the afternoon, but the thought of a cool swim at the end of the day got us through. The Teen Club where we used to swim was taken over by the government during the summer, so I joined the Underwater Club, a private beach just five minutes from home. The club had small sailboats, not the kind one could use to sail to the southern coast of France, but large enough for people to enjoy locally. It had places to fish, a swimming pool, tennis courts, soccer field, and a club house where we could buy a sandwich and a Pepsi. It seemed wrong to have to pay to swim in the sea, but the coastline had gotten so developed that I would have to drive thirteen kilometers just to find a place to get into the water. A horrible, rotten, lousy, inconsiderate cold bug floating around Tripoli hit me and several others the first weekend of school. It settled in the chest, and we who had it sounded as if we were in the last stages of consumption. I couldn't wait to get rid of it so I could get back to my afternoon swim.

Writers Workshop was added to the curriculum as an English elective this year, and I was lucky enough to be assigned to teach it. Seventeen students signed up, did their writing in class, and produced good work. We started with poems and went on to descriptive paragraphs, short stories, and one-act plays. Wendy wrote a tanka that I recall to this day:

There is never joy
in living in solitude
people are needed
to bring you love and comfort
reach out and get together.

Rick wrote a poem called "Heat," a student's impression of a hot day at school.

> In the scorching heat of the day
> kids wander through the halls of the school
> in and out of the endless mazes of green poles
> trying to find their next class.
> But the heat
> makes it too hot to think
> so at every break kids huddle near
> the water fountain
> drinking the cool, cool water.

I could almost taste that cool water. To this day I cannot pass a drinking fountain without taking a sip.

The end of Ramadan was expected the middle of September and would bring a two or three-day holiday, depending on the moon. When the new moon was sighted, the month of fasting was over and widespread joy and celebration began. Men and boys assembled in the streets and squares of villages in fresh long white shirts, vest, trousers and caps, a refreshing sight against whitewashed concrete block buildings and brilliant blue sky. By the end of the month, the temperature was cooling down but the air was still somewhat humid and muggy. We still had our AC on to keep out the street noise and cut down on the humidity. Our first rainfall of the year washed the grime off the buildings and made the trees and flowers look fresh and clean again. A week later a welcome rain poured down most of one day. After that the days remained warm and sunny, but the nights were cold. The Med stayed warm enough for a refreshing swim, but the air was cool when getting out. Some hardy individuals swam all year long.

The first week in October we had a three-day weekend compliments of Italian Evacuation Day, so we went to Djerba with Donn and Mary to buy a case of spaghetti. The Libyan product disintegrated in the water when it was boiled. As usual, I found a few pieces of Tunisian pottery to add to my collection. When we got home Peter and I started researching options for travel to East Africa and Cairo during Christmas vacation. The East Africa safari was my idea. Cairo was Peter's. He kept mumbling

about how much cheaper and easier it would be to go to the London Zoo, but I paid no attention. I longed to see animals in the wild.

One major project of the fall was disposing of a thirty-foot mimosa tree in our back yard. Our landlady, a mystery woman living in Benghazi reputed to own several villas, told her agent to have the tree cut down some time ago, but the man never came through. Tired of waiting, Peter and Doug attached a cable to the top of the tree and pulled it down with one mighty yank. Since it was dead and had no root support, it broke off right at the bottom. The next day workers from school came and dragged the carcass away. The tree was full of yellow jackets. Now their home was gone and the poor things were completely confused. We spent the after-noon spraying and swatting. Peter got stung twice in the neck, but had no ill effects. I was glad to have the thing gone. It was a breeding place for all kinds of little beasties: bees, wood ticks, and cockroaches. Shortly after, the landlord's agent had a giant mulberry tree in our front yard removed. When the fruit was ripe, the front yard and sidewalk were covered in white squishy berries. They got on the soles of our shoes, stained the sidewalk, and filled the air with a fetid odor as they rotted in the heat. Now, not a trace remained. A forty year-old tree, gone forever. We would miss the shade but not the mess.

By November crickets started chirping during the early hours of the evening, a pleasing sound that along with the rich smells of fall reminded me of autumn evenings on the farm in Iowa when I was young. We got out winter clothes and did some projects around the house. The school installed a new Heavy Duty Sears washing machine in our villa and replaced the electric water heater which stood outside unprotected in the wind and the rain. It had completely corroded. When appliances wore out in Libya, they were just thrown away, often on the side of the road.

We started getting organized for our safari: visas, traveler's checks, airline tickets, vaccines. Alitalia's manager had two sons graduate from OCS with honors and he wanted to show his gratitude to their "fantastic" teachers, so he gave us a "fantastic" price on our tickets. We were informed that we had to take malaria pills for two weeks before, during, and after the trip and get yellow fever, typhoid-paratyphoid, and cholera booster shots before we left. This was in addition to our annual cholera shots. Libya had no reported cases of the disease, but some had been

reported in the Middle East. It was best to take precautions.

In early November Donn and Mary's beautiful villa in Gargour—where the rich folks lived—was nationalized and they had to get out by the end of the month. The previous year Gaddafi declared that every Libyan adult deserved to own a home, not a bad idea, but those who owned multiple properties, including our landlady, were out of luck. They had to hand their houses over to the state who in turn sold them for an affordable price. Those who rented villas, including the Oil Companies School, did not know from day to day if their homes would be nationalized.

Fortunately, Donn & Mary found an apartment to rent on the sixth-floor of the Oasis Building where they both worked. It had a spectacular view of the coastline, harbor, and city, and was a perfect place to watch the sea, ships, clouds, and storms. Moving, however, would be a challenge. In addition to the usual belongings that would fit into any ranch-style home in an affluent Houston suburb, they had an organ that Bob had bought for his sister Arline in Black River Falls. It would not fit in the elevator of their apartment building and they couldn't carry it up six flights of stairs, so I volunteered to keep it in our villa until they moved back to the States. The four of us spent weekends cleaning and painting their apartment and moving furniture. Donn borrowed a pickup truck from Oasis, and the guys shuttled tables, chairs, and couches from house to apartment through congested Tripoli traffic. Mary and I followed directly behind, our cars packed to the gills. Donn navigated his way through the busy traffic circles of Tripoli with Peter kicked back in a recliner reading the *International Herald Tribune*. It was a sight to remember.

On November 16, one year after Bob's death, students, teachers, parents, and members of the community gathered on the lawn of the school to dedicate a plaque in his memory. The plaque read:

Dedicated to the Honored Memory
of
ROBERT R. WALDUM
Founder and Superintendent of the
Oil Companies School
1959-1973
For His Vision and Leadership

Peter and Gloria gave speeches, and Helen and I were in charge of the coffee afterwards. Come spring, we planned to present a scholarship in Bob's memory to a deserving student. The winner did not have to be an honor student, but had to work hard to reach his or her fullest potential, be actively concerned about people, issues, problems of society, and world affairs, possess a positive attitude toward life, and work diligently to promote good relations between peers. Sweet Old Bob would approve.

On Thanksgiving Day, once again we packed the bird and all the trimmings in the Land Rover and VWs and headed to the desert, this time south of Mizdeh in search of Roman ruins in the Wadi Nefed. The route was mostly a camel track, but we had a good map and found our way with no difficulty. As usual, we were each responsible for one part of the feast. I was not blessed with the honor of roasting the turkey this year, and I missed the lovely fragrance filling the villa. I made the pumpkin pies.

We picked a campsite, set up our tents, and began our feast just after sundown with hot buttered rum. As we sat in the tent warming our hands, faces, and insides before dinner, we heard the roar of an engine just outside the front flap. Without saying a word, each camper calmly found a place to hide the rum and held our breath as our school nurse's husband Don stepped outside to investigate. In less than a minute, he returned with a British geologist who had gotten lost in the desert after the sun went down. We offered him food and drink in traditional Bedouin fashion. Shaking his head in wonder, he accepted our hospitality. We brought out the treasured turkey and dressing, instant mashed potatoes, green bean casserole, squash, cranberries, and pumpkin pie with whipped cream.

"You people do this for fun?" he marveled.

"Every year," we replied.

Again he shook his head. "They pay me a king's ransom to come out here, and you do it for fun?" After dinner, he pitched his tent nearby under the desert moon and stars. Before daylight, he was gone.

After morning coffee and packing up, we continued down the wadi to investigate a Roman fortified farm. That night we set up camp in the middle of nowhere, nary a tree or a bush in sight. At sunrise as we came out of our tents, we were attacked by flies. Our white shirts were covered with them. From all directions a high-pitched ringing sound hit us like an acute case of tinnitus. As the day progressed, the flies became worse. All our

swatting, shooing, killing, spraying, spitting, gyrating, rotating arms like propellers, doing the St. Vitus dance was to no avail. All futile. We were outnumbered. Finally, we retreated to our tents, and there we remained through the heat of the day.

Precisely at sundown, the air became silent. The creatures vanished. We emerged from captivity to relax, stretch our legs, and explore several mausoleums and the remains of a large structure with unusual rounded corners. We built a camp fire, warmed up our leftovers, "washed" our dishes in sand, and retired early. At sunrise, the flies were back. We deduced that camel and sheep droppings from the animals of Bedouin who had passed by previously were the culprit and vowed to choose our campsites more carefully in the future. We understood why ancient people believed the myth that the sun gives birth to flies.

December 11 was the Moslem New Year 1378, so we had the day off and used it to prepare for a Christmas season replete with programs, parties, dances, and open houses. I ordered a real Christmas tree, a medium-sized one for about $16.50, but did not bake a single cookie. In preparation for our trip to East Africa we started taking malaria pills, got a cholera shot in one arm, and a yellow fever and a typhoid shot in the other. The cholera arm ached for a day or two, but other than that we felt no discomfort.

This year the OCS music and drama departments presented an outdoor Living Nativity on the OCS athletic field. It was a natural choice with such easy access to camels, sheep, and donkeys. The principal simply requested the animals needed in the daily bulletin. *The Morning Announcements* for December 4, 1977, read: "We are in need of live animals for the Junior High Christmas program. If anyone has access to a camel or knows where we can get one to use the night of December 14, please see Mr. Corcoran." An obliging Libyan parent came through.

The night of the pageant we took our folding chairs and blankets and set them up on a platform overlooking the athletic field. Field lights poured down on the players as a narrator related the familiar story of the nativity from the Gospel of Luke. The Holy Family on this night included the Virgin Mary from Yugoslavia, Joseph from Jordan, and from Libya a

wonderfully arrogant Herod robed in crimson velvet and wearing a crown. The three kings were from Georgia, Greece, and Nebraska. The animals were especially amorous for some reason and did what came naturally in front of an amused audience.

On December 16 we left on the 6:30 p.m. Alitalia flight to Rome, waited in the airport until 1:00 a.m., then boarded a plane for a seven-hour flight to Nairobi. We arrived at 9:15 the next morning and were taken directly to the New Stanley Hotel. Eleven of us were traveling together, and we spent the first day resting as best we could. The ghosts of big game hunters lurked in the dark wainscoted corners of the bar of the hotel. We wouldn't have been surprised to see Stewart Granger walking through the door.

The next day we drove north to Nyeri for lunch at the Outspan Hotel. We served ourselves from long linen-covered tables laden with fruits and meats and sat down to tables set with china, silver, and crystal. Such elegance in the middle of the wilderness was a pleasant surprise. We were reluctant to leave this luxury, but our destination was equally tantalizing. We left our luggage at the Outspan and with just the clothes on our backs boarded a Land Rover to Treetops, the game lookout lodge on the slopes of the Aberdare Mountains.

We were met by the lodge hunter at the edge of the woods and walked the last few meters to the lodge. Our guide carried a gun and warned us to keep as quiet as possible and not to tease the baboons that roamed the place freely. The lodge was weathered and rustic, like an overgrown tree house. It was about forty feet off the ground, and we had to climb a ladder to get to our quarters. A plaque at the foot of the ladder informed us that Princess Elizabeth was here on February 5,1952, the day before her father King George VI died and she succeeded to the throne of England.

The lodge had two floors, a rooftop terrace overlooking the trees, a salt lick, and a watering hole. Shortly after we arrived, we were served fresh pineapple and shortbread on the terrace. Monkeys came right up on the railing, mooned us with their blue butts, and asked for a handout. Bush babies, adorable little primates about the size of a squirrel, came right up

to the deck where we stood. Their big round eyes and cute little faces turned our hearts to putty.

After a dinner of consommé, a choice of Nile Perch or roast leg of lamb with mint sauce and currant jelly, potatoes and vegetables, fruit salad and ice cream, cheese and biscuits, and *kahawa*—coffee, we went to our rooms to wait for the animals. The rooms were closet-size with built in bunks and a single window looking out onto the watering hole where animals came to drink and bathe. The first animal sighted was a warthog, followed by a baboon. In no time, the watering hole was surrounded by Cape buffalo, bushbuck, and waterbuck. Then an elephant and a rhino arrived. It was like living out a childhood fantasy to stand by the window of our little cubby hole and see the animals moving about undisturbed throughout the night. In the morning we gathered family-style around a long table and started our day with good, strong fresh Kenyan coffee, bread rolls, pineapple, and bacon.

From Treetops we went back to the Outspan to pick up our luggage then drove south through Masai Country to the Amboseli Game Preserve, now known as Amboseli National Park, just beneath the snow-capped dome of Africa's highest mountain, Mt. Kilimanjaro. Along the way, two ostriches ran down the road in front of us. The male was black and white, the female brown. They had long flexible wings and looked as if they were waving their arms as they ran, at times up to 60 mph according to our guide. We saw zebras, lions, Thompson's gazelles, two elegant giraffes, and weavers' nests hanging like little round globes from the branches of acacia trees. We slept in tents at the Amboseli Safari Camp and spent the evening around the open fire pit singing Kum ba Yah and other songs with a group of Russian tourists. Later, the Russians invited us into their tent for caviar, and since we had no eating utensils we dipped it out of the jars with little triangles of heavy paper.

We left Amboseli, crossed the Kuku Plains and Shetani lava flow, and entered the western sector of Tsavo National Park, Kenya's largest game sanctuary, famous for its large herds of elephant. We saw about twenty elephants and several hippos bathing in a lake. The elephants had stripped the trees bare in many locations. We stopped in a Masai Village, and for two hundred shillings per van, we were allowed to visit their huts and take pictures. The village was a series of low huts built around a corral for their

cattle, the mainstay of their existence. They drank cow's blood and milk, and the huts were constructed out of dried cattle dung. The prevailing odor was of dried dung and was not unpleasant. The huts were circular and so low that at 5'3" I could not stand up straight. Six people lived in an area of about ten square feet. The government offered them modern apartments, but they wanted nothing to do with them. The Masai were tall and slim. Some had holes in their ear lobes large enough to hold film canisters, an apparent fashion statement. From a distance, I saw a tall naked Masai warrior leaning on his spear, bathing in a pool of water. It was a handsome sight.

I loved the high mountains and sweeping valleys of Kenya. It was rugged, beautiful, and the sight of all those animals roaming free was good for the soul. On the way to Voi Lodge, we stopped at Mzumi Springs, saw several hippos, then continued to Crocodile Point where heaps of the scaly creatures lay sunbathing on the rocks. Some were partially immersed in the mocha-colored water. We took two game runs a day, everyone in our group except me anxious to see a kill. When we were in danger of seeing a kill, I covered my eyes.

We usually called our parents on Christmas Eve, but this year we were at Samburu Lodge north of Nairobi and the only contact with the outside world was by radio. On the morning of December 24 we went on a game run and saw two cheetahs, a herd of sixty giraffes, elephants, two lions, water buffalo, waterbucks, ostrich, and a large band of Grevy's zebras. The male zebra brought up the rear and was extremely dangerous.

At noon we had a delicious ham and pork chop lunch at Samburu Lodge. Our enjoyment was slightly diminished by an unpleasant odor drifting through the windows, but we didn't pay much attention to it. Later that afternoon we went on the last game run of the safari and saw gazelle, gerenuk, hartebeest, a large herd of reticulated giraffes, and two cheetahs. They were concealed in the bush, but our guide Samson spotted them out of the corner of his eye when they flicked their ears.

Before dinner on Christmas Eve, all the guests in the lodge lined up behind a low retaining wall just outside the dining hall. On the other side of the wall, crocodiles began to slither and slide and soon the river bank was teeming with them. They shot out of the river, rested a moment, then lowered their nostrils into piles of fetid meat that the lodge keeper had

scattered along the bank to attract them. That explained the odor we had noticed during lunch. Decomposed shanks, skulls, and ribs were ripened to a putrid mass. The crocodiles snatched a quick mouthful, swallowed, then relaxed while the morsel slithered down their six-foot bodies. Their yellow elevated eyes glowed in the dusk. Their mouths looked like chain saws. Their legs were tiny in proportion to the rest of their bodies, so they did not move any great distance on the bank, but they were fast. I was glad to be on my side of the wall.

I don't remember what we had for dinner, but the gray stone walls of the dining hall were decorated with red and white streamers, and from the top of a tarnished silver tree a tinsel angel looked down on cakes and teacups in honor of Christmas. About 8:30 p.m. we went to a small hut for a church service conducted by an Italian missionary who had been in Kenya for twenty years. By 10:30 p.m., we were all tucked in bed beneath mosquito nets. I fell asleep thinking of weaver's nests, elephant-stripped trees, back sides of aardwolves, slender ebony Masai warriors bathing naked in mocha rivers, prancing dik-diks, and baboons hopping through high grass. About 1:30 a.m. a game officer pounded on our door telling us there was a leopard across the river, and at 6:00 a.m. monkeys gamboling on our thatched-roofed bungalow awakened us to Christmas morning. We got up, packed our bags, and boarded vans to Nairobi where eleven of us enjoyed a special Christmas dinner provided by the New Stanley Hotel. We drew names and gave each other small presents. We were all good friends. That made being away from home during the holidays easier for all of us.

The following day we had a 5:00 a.m. flight to Cairo via Addis Ababa. Much to our dismay, we discovered that we were traveling on Ethiopian Airlines. Our fears were warranted. As soon as we reached the mountains, our plane started having mechanical difficulties. I looked down at those dark rugged peaks and steep gorges and thought, "I really don't want to end up here." Peter was sitting between our friend Gloria and me, and we each grabbed one of his hands and held on for dear life as we limped back to Addis Ababa. All passengers were escorted to the terminal where we waited for hours while our plane was being "repaired." We did not want to board the same plane again, but we had no choice. Towards evening, we got back on the same aircraft thinking, "These are the people we're going

to die with." As soon as we reached an altitude of twenty-thousand feet, the same problem returned. Resigned to the worst, we were overjoyed when we made it to Cairo. We landed, gave thanks, and vowed never to fly Ethiopian Airlines again.

In Cairo we stayed at the Meridien, a lovely hotel on the banks of the Nile. West German flags were flying throughout the city for Chancellor Helmut Schmidt's visit with President Anwar Sadat, and the streets were full of signs supporting Sadat and his negotiations with Israel. The *Egyptian Gazette* reported that Jimmy Carter was due to arrive soon. Everyone seemed to be in a good mood. We visited Giza twice, once in the morning, then back again at night for a Sound and Lights program in front of the pyramids and Sphinx. Peter and I huddled together with a German couple, the only other people in the audience. The program gave us goose-bumps.

A remarkable sight on the banks of the Nile, about eleven miles wide in Cairo, was a dark, rich, strip of soil that came to an abrupt end as the desert began. One could stand with one foot on black earth and the other on desert sand. It was a kind of metaphor for people here, either very rich or very poor. People and animals lived together in mud huts along the west side of the Nile. On the east stood luxury hotels.

On New Years Day we called to confirm our flight to Tripoli and found that all flights between Egypt and Libya were canceled indefinitely. Gaddafi wasn't speaking to the Egyptians, so we had no choice but to fly to Rome in order to get home. We booked a flight for the next day, got up at 4:00 a.m. to catch a 7:50 flight, and waited several hours in Rome for a connecting flight to Tripoli. We arrived about 6:00 p.m. and were back on the job the next day.

1978

We got our annual Christmas package from Iowa the day after we returned from vacation. J.C. Penny undies for both of us, a nightgown and robe for me, and brass polish. Our old undies were almost falling off, so we donned our new ones with gratitude and pride. Even though a continent away, Mom always knew what we needed. Some of the gifts were wrapped in English Muffin bags, a reminder of how much I missed them. Bagels, too. As usual, it was a welcome care package with gifts that never ceased to surprise and delight.

Gretchen and Albert were happy to see us. Albie liked to sleep outdoors in the corner of our covered front patio, but now cold temperatures, high winds, and buckets of rain made us worry about Gretchen. She wanted to be inside with us when it was nasty. Albert always preferred the elements. He might come in for a minute or two, but he soon got uncomfortable and restless and asked to go out. He was afraid he'd miss some action in the yard. A bird, maybe. We bought new wool blankets for their beds to keep them warm, cozy, and happy.

We took the last of our malaria pills and hoped we had not come home with any rare disease. We had a full week ahead of us, both at school and at home. Book orders were due, teachers' meetings and Honor Society meetings were scheduled. At home, our landlord's agent knocked on the door to announce that they were going to start repairing the outside of the villa and get it ready for painting. He wanted to paint our villa yellow. We shuddered at the thought and prayed that they would keep it white with blue trim, the only proper colors for the Mediterranean. They also planned to repair the villa walls and raise them higher. That was good. The stucco was getting crumbly in places and higher walls would provide additional security.

About this time my Libyan driver's license was due to expire, so I went with Milad, our school driver, to get a new one at the department of motor vehicles in downtown Tripoli. He did all the leg work and paper work for me ahead of time, but it was still an ordeal. The place was

mobbed, and if he hadn't been with me, I would not even have known which line to stand in. My new license would be valid until 1980. Our Libyan licenses could also come in handy in the States. One of our teachers was pulled over for speeding when she was home on summer vacation. When the officer asked for her license, she handed him her Libyan one. He examined it closely, lowered his head to the open window, and enunciated slowly and carefully, "Do-you- speak-English." She replied, " A l-i-t-t-le." The officer sent her on her way with an admonition to slow down.

The second week of January one of our ninth graders had a devastating accident. Richard, a student in my English class, was playing Tarzan in a tree and saw a loose wire hanging from a limb. Without thinking, he grabbed it. Unfortunately, the wire was live and he was immediately knocked unconscious and fell to the street below. He was first rushed to the Oil Companies Clinic, then after a few days flown to London where his right hand was amputated. It was fried. There was also concern that his kidneys were damaged. He was a red-haired, freckle-faced kid with a pleasant personality. It was sad to think of him facing this tragedy at such a young age. A month later he was still in the hospital in London, but his mother returned to Tripoli with pictures of him. She said that he was doing fine and hoped to be back soon. Students wrote to him all the time, and by the end of April, Richard returned to OCS with a prosthesis. He picked up right where he left off, proof that you can't keep a good man down.

I was often unaware of the problems going on in my students' lives. One of the girls in my seventh grade homeroom was diagnosed with tuberculosis. Treatment was limited in Libya and no airline would allow passengers with TB to fly on their planes, so she was stuck. One of my Polish students seemed distracted for several weeks, engrossed in other things when I thought he needed to be focused on his work. As it turned out, when the time was right, he and his family were planning, for reasons I never knew, to defect to Western Europe with all the money and possessions they could carry through Tripoli International Airport. He was unable to tell anyone his problem. After he was gone, I learned of the burden he was carrying.

In a rare departure from our regular class schedule at OCS, we devot-

ed part of each day for one week to show the American television mini-series *Roots* to all seventh, eighth, and ninth grade students. A member of the community taped the twelve-hour program from the BBC, brought it to Libya, and told us we were welcome to use it. Since we had no auditorium, we set the video up on the stage of the gym and took students down from our English and history classrooms to view it in shifts. They sat on the edge of their folding chairs, captivated by the story of Kunta Kinte. I was too. Later we found out that Alex Haley acknowledged the work was a mixture of fact and fiction, but at the time we did not give much thought to historical accuracy. We were happy not to let the truth stand in the way of a good story.

Dignitaries from Chad and the Sudan arrived in Libya the second week of February. We guessed that Libya had decided to be friends with them again after a longstanding conflict over the border between Libya and Chad. Rumor had it that Sadat was due to arrive shortly. From one day to the next we never knew who was Libya's friend, and who was her enemy. We referred to it as musical countries.

At the same time we were complaining about having to wear a sweater in Libya, my family back home was experiencing one of the most brutally cold winters in Iowa history. The Blizzard of 1978 dumped 30–40 inches of snow on the state with drifts of twenty feet or more. Roads were blocked, trains were stuck in high drifts, and driving treacherous. The average temperature was 12.4° Fahrenheit. Our days had been gray, rainy, and cold and we had no electricity or heat at school, but that paled in comparison. We even got a little hail one day, a cause for excitement. Just as we wished for some good North African sunshine to come out from behind the clouds, a heat wave of 80° arrived, most unusual for February. Usually warm days like this were the result of blasts of hot air coming out of the desert, but this time we had no wind. It was so quiet we could hear a pin drop. This one day of Tripoli sunshine could probably melt Iowa's entire winter accumulation of snow.

About this time I got so lonesome for my family that I went to the Giorgimpopoli Post Office, gave my parents' phone number, 641-357-

4256, to the clerk at the counter, then waited for him to direct me to a booth to talk to Mom, Dad, and Gigi the poodle. When my call came through, the connection was so good it was impossible to believe we were five-thousand miles apart. I was relieved to hear that everyone was well in spite of snow, cold, flu bugs, and back aches. I didn't have anything special on my mind. I just wanted to hear their voices. When we hung up I went back to the clerk, paid for the call, and drove home with a light heart.

In one of our more reckless moments, Peter and I agreed to babysit for Leanne and the twins for a week in March while Tom and Doris went to a teachers' convention in Majorca. I'm not sure why we agreed to do it since I had never even successfully changed a diaper. At the appointed time we moved into their villa and assumed our duties. Peter took the diaper detail since he had experience with two younger sisters. I handled other duties and everything went well, but it was a hectic schedule for the uninitiated. I barely had time to shower and finished the week convinced that life would never be the same again. I had nothing but admiration for parents who worked full-time then came home to care for a family.

Easter vacation was approaching and we needed a break, but our passports were at the Libyan Arab Republic Passports and Aliens Office waiting for exit-re-entry visas. Without them we could not travel outside of Libya. In addition to that, my passport had to go to the Labor Office to get my work permit renewed, so it was doubtful we'd be able to leave the country. As in most countries, government work in Libya took an unpredictable length of time, and until we got our passports back, we couldn't even buy airline tickets or traveler's checks. If we did get out, we planned to go to Rome.

As we waited for the verdict, a Spanish ship arrived in the harbor for the Tripoli International Fair. Word got out that they were serving meals to the public, and although we usually preferred to stay home for dinner rather than go to a restaurant, we went with neighbors John and Peggy and found an elegant dining room, excellent service, and delicious cuisine. No wine or alcohol was served, but Peggy slipped a flask out of her purse when she got her beverage. We tried to look innocent as she poured, and breathed a sigh of relief when no one noticed. A few days later the ship left Tripoli for Argentina and the soccer World Cup Championship in June. As it turned out, Argentina won the title, but not without controversy. The rul-

ing military junta was suspected of bribery to insure their victory. An article by Will Hersey referred to it as "The Dirtiest World Cup of All Time."

A couple of nights later the ladies from school came over to our villa for a style show. One of my neighbors made hand-painted cotton summer dresses, so she brought them over and chose models from the audience to parade them through our living room. After the show, we tried on our favorites and many people walked out with new dresses. I bought one sun dress, but most of the styles were for tall, slim people. That I wasn't.

<p style="text-align:center">***</p>

By the end of March, our passports came through. We flew to Rome, checked into the Hotel Victoria on Via Campania, slept for about twenty-four hours straight, and woke up to the lovely pealing of bells on Easter Sunday. We did not join the throngs of people at the Vatican but heard there were more than 200,000, so many that some fainted standing up. The crowd was packed so tightly it was impossible for anyone to fall over. Pope Paul VI had to cancel some of his Holy Week activities for health reasons. We focused our visit on the Sistine Chapel, St. Peter's, the Catacombs, and of course, food.

It turned out to be Pope Paul VI's last Easter. He died on August 6 and was buried in St. Peter's Basilica six days later. Pope John Paul I was installed as the 264th pontiff three weeks later but served only thirty-three days. He was found dead in his Vatican apartment, and his death gave rise to several conspiracy theories.

<p style="text-align:center">***</p>

We came home to an epidemic of measles, several varieties at once. The kids were dropping like flies. Grown-ups, too. Our next door neighbor, Dianne, was three months pregnant and heard that if she got the measles, there was a chance that the baby could be deformed and she would have to abort. She left for the States and planned to stay there until the whole thing blew over. One of our first grade teachers came down with the seven-day kind. I couldn't remember if I had them but hoped I was immune.

<p style="text-align:center">251</p>

As with any other crisis, we went about our usual daily activities. I gave a going-away dinner for our friend Mary who was on her way to London for three months to attend the Cordon Bleu Gourmet Cookery School. I served spaghetti carbonara, one of our favorite dishes. The sauce was a combination of raw eggs, one per person and one for the pot, a healthy handful of freshly ground Parmesan cheese per person, a glob of cream, and a liberal dose of coarsely ground black pepper. When the pasta was cooked and still hot, I threw the sauce on the noodles and began lifting the mass up with forks until the eggs began to show signs of cooking. While this was going on, I carbonized the daylights out of a pound of chopped bacon, dumped it bubbling hot, grease and all, on top of the eggs and pasta and mixed it well. That finished the cooking. The canned bacon I brought back from the States was greasy stuff, but it made wonderful carbonara. My mouth still waters, but my arteries shrivel at the thought of it.

Meanwhile, the poor little donkey who played a role in last year's Christmas Nativity was still on campus tethered behind my classroom. We kept an eye on him through the window and assumed the gaffirs were feeding him. We wondered why the owner had not come to collect him. It had been over four months.

As the month rolled over from April to May, our calendar filled up with social and cultural activities. We went to an afternoon brunch at the British Ambassador's residence and dined outdoors in a garden so beautiful it was hard to believe we were mere miles from the desert. The British did things up in style. The food was—well, British. Most of our cultural events were performances by students, most of them surprisingly good. We had a concert band that stayed in tune, and our chorus and glee club tackled works like *Jesus Christ Superstar, Oklahoma, HMS Pinafore,* and *You're a Good Man Charley Brown*. Drama students presented *Our Town, The Mouse that Roared,* and *The Man Who Came To Dinner*. We had Talent Shows, Science Fairs, Art Festivals. OCS was not all work and no play. Sometimes it seemed to me that we went overboard on activities, perhaps to compensate for what the students were supposed to be missing back in the States.

252

Since the First Annual Cribbage Tournament was so successful, Peter and I planned another one for the last week of April. We invited eighteen friends, and with the aid of a Cuisinart that I bought from a friend who had recently left Tripoli, I made all kinds of homemade breads: pumpernickel, light rye, sourdough, a raisin braid, muffins, and lefse. My new machine sliced, grated, chopped, shredded, you name it, and I vowed never to be without one again. We served quiche Lorraine, homemade corned beef, filet mignon, scalloped potatoes, fresh fruit salad, and spinach and bacon salad. Everyone was well fed. Some went back for fourths. If a prize was awarded for any of our Annual Events, it could be cash or a highly sought after oil painting by Mahmoud, the school's carpenter. It was a somewhat gaudy large canvas of a bull fighter just about to deliver the coup de grâce. Winners autographed the back, wrote a little message, dated it, rolled it up, and passed it on to the next lucky winner. It was a coveted prize, though to my knowledge it never graced a villa wall. After OCS closed its doors, someone stashed it in their shipment, and for years the painting circulated among former OCS faculty all the way from Norway to Indonesia. For years it lived in our attic in Maine. It was last reported in Florida.

On May 7, I wrote my mother a letter wishing her a Happy Mother's Day and apologizing for being late. I thanked her for being such a good Mom and told her not many days went by that I didn't think of that. One week later we discovered a Hallmark calendar that informed us Mother's Day was on the next Sunday, May 14. We needed someone on the staff to be the Official Mother's Day and Father's Day "reminder." We always forgot. Our contact with the outside world was limited, and on occasions like this we felt out of touch. We listened to VOA and BBC, otherwise known as "Auntie Beeb." We got one day late copies of the *International Herald Tribune* and censored *Time* magazines. We waited for people to get back from the States with all the latest news. Fresh arrivals were like oracles, infinitely more informed than those of us who hadn't been "out" for a while. Anyway, since I sent the letter one week early, Mom got her greeting on time for a change.

Peter promised the young son of some British friends that he would take him on a camping trip, so one weekend he came along with his parents, a friend from Dublin, and our friends Doug and Sindy for an outing in the desert. Our destination this time was Blue Lake, a little tropical par-

adise with palm trees, birds, and bullfrogs surrounded by of a sea of sand. The lake was only about the size of an average house lot but ever so pretty. We had to hike down a gorge to see it, and it was worth the effort. We set up camp under two big olive trees, grilled steaks over an open fire, sang songs and gazed at the stars until 10:00 p.m. A thunderstorm rolled in about 3:30 a.m., but we stayed warm and dry inside our tents.

Ninth graders had sixteen days of schools left, and representatives of boarding schools were coming to campus, mostly from Europe, to recruit students. The representative from College du Leman in Geneva, Switzerland, came to OCS every year. He took Peter and me aside and said he had been watching us and hearing about us from students who had enrolled in College du Leman the past five years. He offered us a job. We were interested and sent a letter back with him but didn't know if we could afford to live there. Switzerland was expensive and their schools didn't pay much, but it was good to know that opportunities existed. A couple of years earlier on the strength of the enthusiasm and performance of an OCS student who had been in his world history class, Peter was offered a job sight unseen teaching history at Kent School in Connecticut. I was ready to go, but I don't think Peter even answered the letter. He was happy where he was.

The owner of the donkey that was in our Christmas program still hadn't shown up to get the little guy. No one seemed to know where he belonged, so he became a fixture outside my classroom window. By now, of course, we had all fallen in love with him. He had been with us so long he got his picture in the yearbook with Principal Corcoran. The caption read, "Here is Mr. C. with his little ass."

<p style="text-align:center">***</p>

The end of the school year was imminent, the weather was becoming hot and miserable, and when the sand storms hit, we all had itchy eyes, runny noses, and aching heads. Everyone looked forward to getting home and flipping on the AC. We had not been to the States for two years, so we planned to go home right after school was out and stay the whole summer. Two years away was too long. I couldn't wait for hamburgers and hot dogs, cottage cheese, pork chops, pickled herring, and Mom's famous pies.

We worked like crazy cleaning the house before we left. We shampooed the carpet and cleaned the cupboards, closets, and drawers. We looked forward to having it all finished and not have to think about doing it when we came back in the fall.

Poor Mobrouk. He was making tea on a little stove on the floor at home and some of his kids came charging through the room and knocked him over. He sprained his ankle and got a nasty burn. The Libyan tea making ceremony could be hazardous. He took the bus and hobbled to work, but I could tell that he was in a lot of pain. I finally talked him into getting in the car, took him home, and told him not to come back until he was healed.

On May 13 we heard that several of the foreign schools in Tripoli had been nationalized by the Libyan government. Of course we wondered if we were next. I had a feeling that we didn't have much longer in Libya and was thankful for the years we had. We had great jobs, possibly the best we'd ever have. We did a lot of traveling, met a lot of interesting people, made some good friends, and saved some money. Thank you, Sweet Old Bob.

Friday, May 19, was christening day for the twins, Robert and Amy. Since their grandparents in Iowa could not be present, Peter and I were godparents for Robert, and Sandy and Roger for Amy. The small Interdenominational Church was booked up for a Youth Festival, so Tom and Doris thought they may need to have the ceremony at home, but it all worked out. After the christening, we all celebrated with a delicious turkey dinner. By lucky coincidence, godson Robert and family live just 165 miles south of us in Wakefield, Rhode Island. Forty-three years later we are still enjoying turkey together at Thanksgiving.

At the end of the school year, Peter had to move from the room he had occupied for eight years to another classroom. When we first arrived, students used to say "Hitler is alive and well in Room 13." They joked that he was the most fair man on campus. He hated everybody. As they soon found out, no one cared more for them. He demanded their best and showed his trust by giving them challenges beyond their years. He did not offer ambivalent feelings. Students either loved him or thought they had encountered Ghengis Khan.

This had been a good year. It was not the most brilliant graduating

class, but it was a good one. We would miss Shamel, Mladen, Aleš, Lisa, Snezana, Julie, Stephan, Christopher, and Richard, of course.

In June we flew from Tripoli to Amsterdam, then on to London to visit museums, see some shows, and meet our friend Mary who was finishing a course in Cordon Bleu cookery. We checked into the Royal Trafalgar Hotel, took a cab to Le Cordon Bleu, and waited outside for her. She soon descended the stairs in her white chef's hat and jacket. Together we enjoyed pub lunches, a visit to Foyles—every book lover's paradise, dining at Simpson's in the Strand, and seeing Billy Daniels in *Bubbling Brown Sugar*. After three busy days, we saw Mary off to Birmingham at Euston Station and we went on to the U.S.

We found our families well, happy to see us, the kids grown an inch or two, and the usual changes one would notice after two years' absence. Some good, some not so good. California tax payers were happy about the break they got with Proposition 13, but nearly 100,000 Equal Rights Amendment demonstrators were unhappy and showed their displeasure on July 9 by marching on Washington, D.C. President Jimmy Carter already had his hands full with an inflation rate of 12.4% and unemployment at 7.1%. We were glad to have jobs.

At 620 9th Avenue North, we indulged in hamburgers and hot dogs, pork chops, mashed potatoes and gravy, and Mom's rhubarb pie. My Dad put a little dish of freshly picked raspberries by my place at the kitchen table every morning, and in the afternoon he went out to his garden to dig potatoes, pull carrots, pick a few ears of sweet corn, and pluck a couple of ripe tomatoes right off the vine for dinner.

We put together a shipment to send to Tripoli, clothes and shoes for us, flea and tick collars for Gretchen and Albie, coffee filters, black peppercorns for spaghetti carbonara, canned bacon and ham, vanilla extract, toothpicks, Sanka, Constant Comment, chocolate chips, and a couple of cans of cranberry sauce and pumpkin pie filling for Thanksgiving. As we shopped we were always aware of how cheap prices were compared to those in Libya. A first class U.S. stamp had gone up from 13 to 15 cents in May, but most prices had changed little in the past couple of years. Not so

for houses. The average price was $62,500, up from $48,000 the previous year.

We had been toying with the idea of investing in property, and shortly before we were scheduled to return to Libya, a cute little brick and stone house in Clear Lake came on the market for $48,000. The owner was an elderly lady named Nettie who had to move to an apartment in nearby Garner. My high school friend Patti had lived in this house, so I knew the place had been lovingly cared for. It stood on a corner lot in a quiet neighborhood, had a picture window, three bedrooms, a finished basement, and a small garden with vintage rhubarb and roses. My mother loved the place, and in the back of my mind was the possibility of my parents moving there. Before heading back to Tripoli, we put a bid on the place. It came to be known as "The White Elephant."

Our summer at home came to an end the last week of August. We flew to Chicago, stood in line at TWA for a flight to New York, and had a rude awakening when the ticket agents demanded to weigh my purse and ended up charging us extra for it. In addition to that, the stewardesses on our flight were rude. Peter asked one of them the flying time to New York, and she said, "God only knows." The lady I was sitting by had a bad cold and wanted the air jet turned off. She made the mistake of asking a stewardess to do it and was told, "Do it yourself." We agreed this would be our last flight on TWA.

On August 23 we arrived in Madrid about 9:00 a.m., checked into the Castellana Hotel, and slept for four or five hours. We got up to do some walking and window shopping and were surprised to find a huge Sears store in the neighborhood. All stores shut down from 2:00–5:00 p.m., then opened again until eight or nine. An early dinner was 10:00 p.m., not my style. We went to a restaurant that had a hog skin of wine in the entrance, a whole hog skin complete with bristles. The snout served as the spigot. We listened to flamenco music and watched the dancers. I got so inspired I bought a set of castanets and taught myself how to use them, but I had no aspirations to the dance.

After relatively cool weather in Iowa, it took a few days to get adjust-

ed to the heat again. The temperatures in southern Europe were in the upper 90s during the day, but the air was dry. After a couple of days in Madrid we left for Rome, Naples, and a few days to relax and read at the lovely Hotel San Pietro in Positano. I was reading *Holocaust* and needed to finish it before returning to Libya where it could be confiscated. One day we took the hydrofoil to Capri at 8:00 in the morning and returned to Positano at 7:00 p.m. On the island, we took a chair lift to the highest point, got out and walked around in the clouds. The villages had narrow cobblestone streets and were overrun with Italian tourists. Every Italian we met was jubilant about John Paul II, the new Pope from Wadowice, Poland. He was the first non-Italian Pope since the 16th century and the first Polish pope in history.

<p style="text-align:center">***</p>

At the beginning of September we returned to Tripoli. The only hang-up was Naples where we stood in line for two hours waiting for our Alitalia flight. That was nothing new, but arriving in Tripoli was. We flew into the glistening new Tripoli International Airport and couldn't believe our eyes. It was as beautiful as the old one was dingy. It was fully air-conditioned, had shiny black marble floors and white imitation leather counters and furniture. We stood in actual lines, and no one pushed or shoved. The workers were pleasant, and getting our baggage and clearing customs took about half the usual time. We wondered if we were in the right country. Our shipment had arrived, but we wouldn't be able to get it for a few days. It was the end of Ramadan, so everyone was feasting and celebrating.

Before school started, we put our classrooms in order. We had seventeen new teachers this year, and those we met on campus seemed like a good addition to the faculty. At home, we got unpacked and resettled. I washed all the screens and windows in the villa, washed the doggie blankets, and gave Gretchen a bath. If she minded, she didn't show it. She trusted us completely. Not so the Tiger. Bathing Albie took two of us and we both ended up with battle scars. Our dogs were well cared for, but not coddled. One of our more eccentric friends had to go back to the States for a couple of months, so she left her poodle with our neighbors. They had to

fry the dog a hamburger every day except Tuesday and Thursday. On those days she got chicken. At night they had to take the dog back to the owner's villa and turn on the air conditioner for her. Another woman in the community took her poodle on the company jet to Geneva just to get it groomed.

Soon after our return Doris and I went to the Italian Market, and since I didn't have much money to last the rest of the month I just bought a leg of lamb and six chickens. When I got home, Peter and I spent two hours cleaning the things. By now, we had it down to a science. He cut them up and I washed all pieces thoroughly, dried them, and wrapped them for the freezer. As I stood hunched over the kitchen sink ripping out the guts, I reminded myself that there were places that sold chicken in pieces and parts all neatly wrapped in cellophane. The only thing missing from our birds were the heads, guts, and most of the feathers.

On a brighter note, I bought a crate of peaches and made pies for the freezer. I had never done that before, but they looked appetizing and smelled good. I got my sourdough starter going and made two sourdough chocolate cakes, one for my friend Doris' birthday and one for the freezer. I made sourdough English muffins and still inspired, chocolate chip cookies from the recipe my Mom left when she came for a visit. The neighbor kids stopped over while I was baking and ate them as fast as I could take them out of the oven. The first week of school our classrooms were like saunas. Sweat dripped off our noses. Our shipment was still sitting in the air freight terminal in the heat, the canned bacon probably fried and the chocolate chips melted.

A month after we put a bid on the house in Clear Lake, we still had not heard if it had been accepted. Finally on September 21 we got an envelope with the news that the house was ours. Enclosed were papers to sign and send back to the U.S. We signed them and had them hand-carried back to the States by our school nurse Marge and husband Don. They promised to mail them from Chicago on October 1. The papers would be a few days late, but it was better than sending them from Tripoli where it was taking ordinary letters twenty days to go to or arrive from the States. Mail service in Libya was so poor that any expatriate leaving the country couldn't escape without a briefcase full of letters from friends in the community to mail to people all over the States.

That same day we got a cable from Realtor Don saying he had found a qualified renter for $300 a month, so we tried to call and tell him to go ahead. Not able to get through, we sent a cable. Realtor Don was used to picking up the phone and getting answers immediately, so every time a question came up and he couldn't get through to us in Libya he called my parents. It caused them a great deal of distress, and I was not happy about it. Finally, on October 8 we had a three-day weekend courtesy of Italian Evacuation Day, so we flew to Malta and I called Don from The Malta Hilton in St. Julian's to resolve all outstanding issues. Once we got all of the house business finalized I hoped my parents would no longer be bothered.

Not so. We had a succession of renters, and every time there was a heavy rain, the basement flooded and the storm sewer backed up. My Mom recruited able members of family to put on their Wellies and dispose of floating Kotex, dog-doo, roots, and all manner of disgusting rubbish. In 1985, thanks to Mom and a diligent real estate agent named Norma, the "White Elephant" was sold. It lived up to its name. Moral of the story? Never try to buy a house when living in a foreign country.

Towards the end of September we heard rumors that Billy Carter was coming to Tripoli. We couldn't imagine why, but it was true and his arrival created a big stir. He was the "official" U.S. representative to the "Libyan-American Friendship Committee Meeting" currently being held in Tripoli. "Why Billy?" we wondered. Lillian we could understand. At sixty-five, she was still making valuable contributions to society as a member of the Peace Corps. From what we gathered, Billy was famous primarily for shelling peanuts and chugging Billy Beer. We wanted to think that President Carter was too kind to insult the Libyans intentionally, but we also knew that Libya was low on the totem pole at the U.S. State Department. Were they sending a message? Ultimately, we concluded that the reason for his presence was pecuniary. Billy, we had heard, would go anywhere for a buck. In this case, a flat $5,000 fee. When Billy arrived at Tripoli International Airport, a delegation of Libyan dignitaries gathered on the tarmac to greet him. It took a while to get the group assembled, and Billy had to pee. Seeing no other alternative, he took a short walk and relieved himself just off the runway. The earthier members of the delegation chuckled. In fact, in a country with 1,100,000 square kilometers of

sand and no rest stops, this was not extraordinary.

Protocol aside, Billy's presence was an unprecedented occasion in our community. Not many "celebrities" came to Libya. Anthony Quinn was an exception. Occasionally Yassar Arafat dropped in for a handout, but that was not remarkable. We heard reports that Billy was entertained lavishly by the Libyans, and the American Consulate had a grand reception for him. Peter attended, but I stayed home to nurse a cold. Even in the best of health, I probably wouldn't have gone. The scotch flowed freely and the American community lapped it up, including those who had been sniggering about Billy since his arrival.

A few days later Billy came to OCS and the entire student body assembled on the lawn to hear him speak. The students' anticipation was transformed to disbelief when they saw a pudgy little man show up dressed in Levis and cowboy boots. This was the brother of the President of the United States? They were further amazed when his speech turned out to be a ten-word grunt. He tried to make up for lack of content and generate good will by giving one of my homeroom girls a kiss. It was not successful. Sarah maintained her composure but couldn't wait to get to the bathroom to wash it off. Twelve year olds don't appreciate kisses from the likes of Billy Carter. Harrison Ford might have been a different story.

As it turned out, Billy accepted a considerable amount of cash from the Libyan government. He denied it at first, but after the FBI opened an investigation he confessed. When the Senate opened hearings on influence peddling, the press descended on the story and "Billygate" was born. Billy was a headache for Brother Jimmy, although few suspected the President of wrong doing. It may have contributed to his losing the election in 1980, but the Iran hostage crisis and a declining economy were the more likely causes. Billy died from pancreatic cancer ten years later. He was fifty-one.

During the summer, our friend John negotiated the sale of a used short-wheel base Land Rover for us from the motor pool of one of the companies in the desert. It was weathered light green with a cream colored roof, had two doors, and a spare tire on the hood. It was loud, drafty, hard steering, rough riding, had no heater, and we loved it. Every time we got

behind the wheel we felt like Lawrence of Arabia. We named our treasure from the desert "Larry."

Every trip in Larry was an adventure. The first weekend in October, Mary and I took our pride and joy to some major warehouses in downtown Tripoli to buy food and supplies. The government was nationalizing all small neighborhood grocery stores, so we anticipated shortages in the near future. Everyone was stocking up, "just in case." We bought some essentials: toilet paper, Kleenex, cans of tomatoes, tomato sauce, peas, and corn. We spotted cases of Campbell's soup which hadn't been on the market for months, so we bought three cases: tomato, vegetable, and mushroom. We also got a case of butter and a 14-inch wheel of Danish Fynbo cheese. We spent the equivalent of $200, a bargain compared to prices we usually paid. Larry was stuffed to the ceiling.

A couple of weekends later, Mary, British friend Carole, and I drove to a nursery about ten miles east of Tripoli to buy plants. It required a trip through downtown Tripoli and as we got well into the city, the sight of three women in a Land Rover on a Saturday morning was too much for a number of young, joyriding Libyan bucks to handle. By the time we reached the outskirts of the city, the guys were close behind honking, laughing, yelling, and waving. We went on our way pretending we didn't notice them, and when we arrived at the nursery they disappeared. I bought a "Ti" plant, one I had admired for some time, and a small evergreen that I planned to put in a large concrete planter and use for a Christmas tree. We were happy with our purchases, but the most exciting part of the trip was the ride. It was the first time I had driven the Land Rover all the way through the city, and although I was a bit intimidated on the way to our destination, I drove home like a veteran. If my passengers were worried, they did not show it.

When I got home, I found that poor Mobrouk had £100 stolen from his back pocket while he was riding the bus. That was $335.00, a month's earnings from his government job. I had never seen anyone so dejected. In time, the government gave half of it back. That was decent. Poor Mobrouk. He was basically honest. Yes, there was that can of Löwenbrau beer that he took from our refrigerator six years ago, but we had left money around the villa and he had never touched a piastre. We gave him money to help him through the month.

By the middle of October the weather started turning fallish, and I loved it. It got dark by 6:30 p.m. and the night air chilled to the bone. Halloween was approaching, so I made six-dozen huge round molasses-oatmeal-raisin-nut cookies and froze them for the little goblins at the end of the month. On the evening of October 31, about fifteen witches, gypsies, goblins, and ghosts rang the doorbell between 6:30 and 8:00 p.m. and cried "trick or treat!" Gretchen and Albert were beside themselves with excitement, and all the goblins were pleased with their big homemade cookie.

We heard rumors of more visitors from the U.S. coming to Tripoli. Having no luck convincing the American government that he did not support terrorism, Ghadaffi reportedly invited popular or influential Americans including Senator Fulbright, Mohammed Ali, and Spiro Agnew to visit. His theory was if he could just talk to the American people, he could get his message across. This reflected the idea in his *Green Book* that citizens should govern themselves. He declared his ideas a step above democracy. As far as we knew, the visits produced no results. We assumed Agnew was checking out business prospects, but who would consider making a deal with him? Dan Rather was rumored to be in the mix, presumably to get the message out.

One day after school, Karima, one of our young Arabic teachers, invited me and four other ladies to her home for a couscous dinner. No men allowed. The food was home-cooked and delicious. We took four hours to eat, stopping to talk and laugh between courses. It was imperative to eat everything to show appreciation for the hostess' hospitality, so we were all stuffed when we left. Karima loved American pies, so I brought her a peach pie to enjoy when she had no company.

Mobrouk was sick with a cold for an entire week, and I was so busy at school I had to let the housework go until the weekend. I got up at 6:00 a.m. Friday and did eight loads of laundry and a bit of yard work. Mobrouk showed up about 10:00 to clean the house and came back the next day to do the ironing. His week away made me realize how different our life would be without him. He was a faithful helper. Sadly, I realized that after

263

seven years, I didn't even know his last name. His wife was expecting another baby in the spring. This would be number nine.

The second weekend in November we had time off to celebrate the Eid al-Adha, the "Abraham" Eid, a bad weekend for thousands of sheep. At the request of friends who had never been to Ghirza, we led an expedition to see the three beautiful 4th Century Roman mausoleums and remains of a fortified farm. It was the Maiden Desert Voyage for our Land Rover, and it passed the test. One of the cars in our caravan, a Citroen, had a flat tire on the way to the ruins and another just as we arrived. The only option was to go back 120 kilometers to the nearest village and get the tires repaired. Peter spent most of the weekend driving on desert tracks with the Citroen's owner and two dead tires. Larry saved the day, the tires were repaired, but Peter felt the effects the next week with a sort of muscular flu. As usual, it took more than that to keep him down.

It was hot and dry in the desert, but on the coast we had more rain in the last two months than in the last five years combined. These rains were fierce, not just plain rain or drizzle, but torrential downpours that flooded roads and houses, including ours. One Friday morning the water poured through the bottom of the French windows and doors in our dining room and soaked the drapes and carpet. We used every towel in the house trying to dam it up. The streets were worse. We drove nothing but the Land Rover, and in spots where there was little or no drainage, water came up through the floorboards. We drove to lunch one afternoon and by the time we got to our hosts' villa, my shoes and the bottoms of my slacks were soaked. Cars were stranded all over, some with water up to the window line. All this was accompanied by horrendous thunder and lightning and the inevitable power failure. By this time, we hardly batted an eye when the power went off. We just got up and lit candles. The only time a power outage irritated me was when I was washing clothes or trying to get work done with an electrical appliance. Otherwise, I just got on with whatever I was doing or found something to do that didn't require light or power. I had become friends with the word *Malish*.

In the midst of this we managed to keep warm and dry most of the

time. We had planned a Thanksgiving feast in the desert, but it was rained out, so we had dinner at our villa. Everyone brought their goodies and we had a good time. I made the dinner rolls and the pies, one pecan and one pumpkin. We all declared we couldn't eat for two days afterward, but that's how one is supposed to feel after Thanksgiving dinner.

This year, to reflect the international character of our students, we had an International Harvest Festival instead of a Thanksgiving program at OCS. We all quit work at noon and filed down to the gym for the festivities. The flags of all the countries represented in our student body were suspended on a heavy duty line across the center of the gym. Students arrived in dirndls, saris, djellabas, kilts, kimonos, bunads, chadris, wooden shoes, and cowboy boots. Every homeroom decorated a long family-style table with place mats, place cards, candles, and flowers, hoping to win the prize for best decorations. Dishes and napkins were paper, cutlery plastic.

The food from all the different countries looked like a spread for the gods. We could choose from egg roll, baba ghanoush, hummus, ratatouille, kartoffelsalat, 36-inch industrial size pizzas, tagine, tortellini, paella valencia, pilaf, beef curry, shish kebab, couscous, paprikash, moussaka, roast turkey, kofta, Swedish meatballs, potato lefse, trifles, Dobosz torte, scones and bannocks, baklava, Turkish delight, Hello Dolly bars, Wacky cake, and mounds of fresh fruit. After we finished our sumptuous lunch, we sang songs and watched a parade of costumes and dances from various countries. Drama students put on short plays, *Anansi* from Africa and *The Haj* from Turkey. The band played "Tijuana Tribute" and the chorus sang "Pick a Bale of Cotton." We reveled in food and laughter most of the afternoon and went home feeling well fed and thanking God for diversity.

At the end of November Peter and Tom drove out to Andrew's father's farm about forty-five minutes from Tripoli to pick up Christmas turkeys for the faculty, over seventy birds again this year. They were good-looking birds, but not totally clean. I was still picking pin feathers from ours at 11:30 p.m. A few days later I stoked up the fires for my Christmas baking. I made seventy-five potato cakes, two-hundred meatballs, Nut Butter Crunch, krumkake and rosettes, and several kinds of breads. I enjoyed the baking since I hadn't done any last year. We invited thirty friends and their kids over for a smørgasbord on December 8. It was not the spread we usually had since some of the ingredients weren't available, but we still had a

nice, full table with homemade breads of rye and wheat and a large Christmas braid full of raisins and nuts. We had meatballs, homemade corned beef, sliced turkey, coleslaw, fresh fruit salad, sliced eggs and caviar, some Norwegian sardines I saved especially for the occasion, beet and dill pickles, a cheese board, and lots of different raw vegetables. The desserts were fruit soup, rice pudding, potato cakes, krumkake, fattigmand, rosettes, sandbakkels, toffee and fudge. All that food made a pretty table and our guests went through it like locusts. No one went away hungry.

It did not look a lot like Christmas in Libya. We had gorgeous days with temperatures in the 80s, but we still got in the spirit of things with concerts, open-houses, sing-alongs, and a candlelight service at the little Interdenominational Church. My mom sent me three tapes of Christmas music to enjoy at home. My favorite? Bing Crosby's "I'm Dreaming of a White Christmas."

Meanwhile, students at OCS had the week off while faculty wrote curriculum for all subjects. It was the most tedious, soul-destroying stuff I had ever done. It was especially futile because we suspected that our work would just end up stuffed away in a drawer or filing cabinet somewhere. The only positive thing about it was getting to work with my friends Keith and Sandy all day. We had some good laughs in spite of the drudgery.

On a Friday night about this time we went out at 7:00 and found the whole side of our Toyota scraped and two deep dents in the roof. The car was parked on the street in front of our villa, and whatever hit it caused something heavy to drop on the roof. We had been home all day and hadn't heard a thing. In fact, when Peter drove it about noon it was O.K. No one stopped to report it, of course. Our Palestinian neighbor said he thought it was the garbage men. The estimate for the damage was about $300. We planned to have it repaired during Christmas vacation. Another *malish*. It was next to impossible to keep a dent-free car in Tripoli.

We weren't the only ones with bad luck. Poor Keith had his villa broken into a second time. Gaddafi decreed that every Libyan was entitled to one villa, regardless of who owned the property, and a few little old neigh-

borhood Libyan ladies took that literally. They had their hearts set on Keith's villa, so they broke in the front door twice, went into the villa, opened drawers and snooped into everything. They did not steal anything but messed things up badly. Keith went to the police, but they were no help. The old gals were determined to get the place one way or another. Keith was almost afraid to leave home. He was not the only victim of what we came to call "squatting," and we were aware that it could happen to any of us. Our landlady, a widow who lived in Benghazi, owned sixteen villas. Libyans could select any one of her rented villas, squat on the property while the occupants were away, and declare ownership. I prayed they wouldn't choose ours.

By the end of December the weather turned cold, forty degrees with a biting wind off the sea. Christmas vacation was not far away and we looked forward to going to Zurich for a few days, then on to Zermatt to ski. Neighbor Dave's parents planned to come to Tripoli to celebrate Christmas and meet their new granddaughter, Kari. She was born at the Oil Companies Clinic in early November, a welcome addition to our school family. We were happy to have a little bambino next door, and we offered to let her grandparents stay in our villa during their visit. That was good for both them and us. Dave's parents would have a place of their own, and we would not have to worry about squatters taking over our villa while we were gone. We'd also have live-in dog sitters for Gretchen and Fat Albert.

We packed our long johns and all the other woolies we could find, and on December 22, Donn drove us to Tripoli International Airport where we met fellow teachers headed in all directions: London, Jordan, Morocco, Malta, Syria. We had reservations at Hotel zum Storchen in Zurich until after Christmas, and the hotel assured us that if my parents wanted to send mail to us there, they would hold it for us. As usual, my mom sent a Care Package full of wonders. It made Christmas Eve and Christmas Day a little less lonesome. The rest of the year I could handle, but those two days away from home were tough.

The Storchen gave each guest a small present and a tiny Christmas tree and candle for the room. On Christmas Eve we were served:

Tartelette de saumon fumè
*
Crème Agnès Sorel
ou
Jus d'oranges
*
Filet de bœuf Mistral
Aubergines provençal
Tomate étuvée
Pommes château
*
Coupe Nougatine
* Bûche de Noël

After dinner, we went back to our room and were like a couple of kids opening the packages Mom sent. Peter got five socks. He couldn't find the sixth one, so we decided he got two pair and a spare. I got a nightgown and a new pair of slippers. Even though we were stuffed, we had to sample her homemade fudge and peanut brittle. At 10:00 p.m. we walked to the majestic 12th century Romanesque Grossmünster just up the street for a beautiful Christmas Eve service. The message was in German, but the songs were familiar Christmas favorites. At midnight we called our families to wish them a Merry Christmas and a Happy New Year, then I put on my cozy new night gown and went to bed. The bells from the Grossmünster rang out all over the city at midnight and again the next morning. I couldn't get enough of them.

On December 28 we took the train to Zermatt, a lovely little remote village, quiet and picturesque. No cars allowed. When we got off the train we were met by a horse-drawn carriage. The driver wrapped us up in a cozy bear skin blanket and drove us to the Hotel Mt. Cervin where we stayed until January 3. I went skiing only once, but I swam every day. The slopes were just too difficult for me. I went up by myself early one morning and Peter watched me from the lodge as I got up and fell, got up and fell, all the way down the slope. A snow cat was right behind me making me nervous, and the run was steeper than I had anticipated. I snowplowed my way down, falling every twenty feet. A man standing beside Peter on

the deck of the lodge made a comment about the poor individual trying to get down the slope, and Peter said, "That's my wife." It was John Denver. They had a good laugh at my expense. Never mind. The air was pure, the food was delicious, and overlooking all was the mighty Matterhorn. The mountains were covered with snow, but in the village, would you believe? Rain.

1979

When we arrived in Tripoli, we experienced a seventy-degree change in temperature from +10° in Zurich to an abnormally high +80° in Tripoli. We left Switzerland bundled up in winter coats, boots, hats, and mittens. Now it was back to shorts and sandals. We were not exactly overjoyed at leaving Switzerland, but we were happy to be in our own bed again. We had sent a small package of Christmas gifts from Zurich to our family in Iowa. For ourselves we bought four packs of bacon and ham, two packs of hot dogs and bologna, one can of shrimp and one of crab, a jar of caviar, and some cheese that was so ripe by the time we got to Tripoli, customs agents just shook their heads and waved us through.

Having neighbor Dave's parents stay in our villa worked out well for all of us. They needed a place to stay, and having our home occupied discouraged squatters. It also allowed us to leave the heater on so we didn't have to come back to a cold villa. When the heat was off for long periods, the cinder blocks and marble floors took at least a week to warm up. Our neighbor's dog Snoopy ran off during the holidays. So did the dogs of two other friends. Our old faithfuls Gretchen and Albert were safe at home, happy to see us.

We unpacked, I washed four suitcases of laundry, hung them on the clothes lines, and in an hour or so everything was dry, including sweaters. I took them in, folded them up, and returned them to drawers and closets. We felt refreshed and revived after a week of exercise and good fresh mountain air. We were ready for the new year.

Our first weekend home was quiet. The only real activity was Mobrouk flying around on Saturday. I stayed out of his way, read a book, and went to watch a video with our friends Tom and Doris. Their next door neighbors had a VCR, so they drilled a hole in their common villa wall, extended a cable through it, and hooked it up to Tom's TV. Every time the neighbors got a video, they told Tom and Doris the title and the time they planned to show it. Tom jumped in his car, rushed over to our villa, rang the doorbell, and from the street hollered *"Marathon Man,"* or whatever

was showing, "Seven o'clock." He took off, we followed close behind, and we were all in our places in the living room when the movie began.

Mobrouk took good care of our villa while we were away, but now his wife was ailing. She was pregnant and bleeding, so she had to stay in bed for a couple of weeks. Her mother was helping at home, but Mobrouk was taking care of her and the eight children in addition to working at our place and the government office. He kept giving his wife birth control pills, but she kept flushing them down the toilet. Now only twenty-six years old, her ninth child was on the way.

<p style="text-align:center">***</p>

By mid-January we were back in the swing of things at OCS. All teachers returned on time, as we were expected to do, but several students and families were stranded in Europe due to heavy snow. In Tripoli we had nippy, gusty winds off the Mediterranean, probably a taste of the severe cold that was hitting Europe. We read that it snowed in Sicily and froze all the blossoms on the almond trees. For the first time since the previous winter, I put on a coat when I left our villa.

The latest food shortage was coffee, so we opened the last can of Butternut from last summer's shipment. Had we known, we could have brought some from Switzerland. I embarked on a coffee quest and found a couple of shops that sold one-pound cans for $10, but I resisted paying that price. Instead, we reduced our consumption to one pot per day and wished we were tea drinkers. That was available for next to nothing.

A meat shortage was now in its third week. Cows' heads and hooves and something that looked like entrails were the only things for sale at the market. Tripe, I suspected. Live rabbits and pigeons were available, but even though I grew up in a family of hunters, I wasn't tempted. Fortunately, we had a filet, leg of lamb, turkey, and several packs of ground beef in our freezer. I planned to use it sparingly until meat was back on the market. Once again, our freezer saved the day. Many people had purposely used up their meat and turned off their freezers in case of a power failure while they were away. I felt sorry for them.

In spite of shortages, on January 20, OCS Villa 12 was the scene of a banquet fit for a king. Sixteen hot dogs smuggled in from Switzerland

were the *pièce de resistance*. I made homemade hot dog buns, Boston baked beans, scalloped potatoes and ham, coleslaw, and pecan pie. We had seven guests, all friends who didn't get out of the country for Christmas. We had no leftovers.

We had lots of cards and letters waiting for us when we first got home from Switzerland, then mail delivery suddenly stopped. We heard that the snag this time was London. Many flights from the U.S. had been canceled due to snow. Tom, our superintendent's son, had just arrived from Decorah, Iowa, and said only one runway was open in Chicago. He had to wait three days for a flight. In Tripoli we had no snow, but the temperature got down to 34°, almost freezing. That was not cold by Iowa standards, but it was when one taught all day in an unheated room as we had for the past five years. I was so cold when we got home from school that we built a fire in the fireplace and kept it going all evening.

When February arrived, we got relief. The temperature rose to the 90s, a drastic change from our chilly January. One day it was so warm we had to turn off the heat in the villa. Not so in Iowa. My Mother had to follow a snow plow to work at Mercy Hospital in neighboring Mason City while I was pulling weeds and planting grass in our backyard.

The orange blossoms were out and driving our sinuses crazy. Peter had a miserable cold, and almost a third of the students at OCS were home with colds and fevers. Few people in the community were 100% healthy at the moment. Our new principal's wife was in the clinic trying to avoid a miscarriage, the band director developed a blind spot in one eye, and another acquaintance was hearing voices and talking back to them. I felt fine and hoped to remain that way.

On a pleasant Saturday morning Doris and I went to the Italian Market and hit the jackpot. We walked away with forty pounds of meat apiece and could barely stagger to the car with our bonanza. We had ordered it the week before, and my tall, dark, handsome butcher who drove a Mercedes had it all wrapped up and waiting. We took it, sight unseen. My share turned out to be one filet, ten pounds of hamburger, one huge tenderloin, the longest strip of sirloin I had ever seen, and a leg of lamb, all top grade.

272

I considered myself lucky, especially when I saw people all over the city standing in line for meat.

A few days later we heard about a place where we could buy chickens, so one day after school I went with Keith and Doris to a spot where they were killing, scalding, plucking, and de-gutting the birds. They couldn't get any fresher than that, so I bought seven of them. When I got home, Peter cut them up and I washed them and got them ready for the freezer. It took only about an hour, but after that I didn't crave chicken any time soon.

The following week seemed long. We had to calculate grades, fill out report cards, update cumulative folders—permanent files that we kept on all students—and all the rest of the end-of-marking period duties. The day after grades came out, a tall man in a gray suit slipped across the threshold of my room, stopped some distance from my desk, turned towards me and announced, "I am the Hungarian Ambassador." Before I had a chance to ask if he had a name, he told me I had made a mistake in my grading. I had "given" his son a B+ in English. He demanded that the grade be changed to an A. I told him that was not the way our system operated. His son, I continued, had earned a B+, an excellent grade. I could tell the man was not used to taking "No" for an answer, but he was talking to a stubborn Norwegian. The grade was not changed. Afterwards, Principal Russ told me I should have responded to his introduction with, "Pleased to meet you. I am the Chairman of the English Department." Why didn't I think of that?

That weekend we took a drive to Sabratha with Donn and Mary. It was a pretty day, and except for a few boy scouts and a Chinese couple, we had the whole place to ourselves. It was quiet, almost eerie when one recalled that it was at one time a flourishing city. It must have been magnificent. Even in ruin, it was beautiful. We packed a few bologna sandwiches, carrots, date pinwheel cookies, a thermos of coffee, and had a little picnic after our hike.

At OCS it was "that time of year" again. Research papers were soon due. The centerpiece of Peter's ninth grade world history course was a three thousand word research paper on a subject of the student's choice.

Many went through the process kicking and screaming, but they changed their tune later when they discovered that he had prepared them in the best possible way for future papers. One of his former students wrote a letter saying, "In April 1972, I handed in a paper, twenty-four pages of handwritten toil about prehistoric man. My sources were H. G. Wells' book *The Outline of History*, William Howell's *Mankind in the Making*, and Pete Nowell's 9th grade history class. I've written many papers since this one, but none with greater pride and only a few with comparable trepidation. I recently dug through a couple of desk drawers and found the paper which had caused my first real spasm of academic determination. Scrawled on the cover page in red are the words: "Footnoting is too shallow. Comments made in class. 'B.' I can't recall the comments made in class, but I remember feeling as honored as H.G. Wells himself when I saw that grade. It has always stood out as one of those moments during which I felt as though nothing was beyond reach." Words like that were music to the ears of a soon-to-be forty year old history teacher.

After research papers were turned in, a video of Cornelius Ryan's *A Bridge Too Far* showed up in our community. An account of the Allied parachute drop behind German lines in Holland in 1944, it just happened to arrive as Peter was bringing World War II to a close in his world history class. He always maintained that students could sleep on their own time, not his, so he rarely showed films in his classes. This was an exception. The students watched the film on the edge of their seats. During a question and answer session when it was finished, a French student named Christopher raised his hand and said, "I don't understand what sounded like "the second asshole" on the bridge. Peter said, "I beg your pardon?" Chris repeated, "The second asshole on the bridge. I don't understand." "Christopher, if you're saying what I think you're saying, I'm going to jump right over this counter and strangle you!" The class was used to this hyperbole but came to the rescue calling out, "No, no, Mr. Nowell! He's French! He's French! He means "assault!" Christopher was spared, and Peter added a French word to his vocabulary.

The first Friday in March we left on a camping trip to Wadi al Moud at 5:30 a.m. and didn't get back until 8:30 Saturday night. We had a good trip, though we didn't get as far as we had hoped. Our plan was to refuel in Mizdeh, about 130 miles south of Tripoli. It was the last village before

the open desert; unfortunately, there was not a drop of gas to be found. We got far enough to see an old Roman watch tower and tomb, the remains of a Turkish fort, plus the remains of some Italian garrisons built during WW II. We were accompanied this time by Olwen Hackett, a seventy-five year old British archeologist who knew every pile of rocks in the Sahara. She was given the title of Lady Brogan by Queen Elizabeth II for her work in excavating Ghirza, the Roman fortified farm that we had visited several times. She was well known in the remotest regions of Libya. In a society where men and women didn't mix in public, it was lovely to see older Libyan men flock around her table when we stopped at the Café Mizdeh for a Pepsi.

Olwen Hackett was rather tall, white-haired, and spry for her age. In Tripoli she drove her own Land Rover. She took notes the whole time, sang songs with us around the campfire, and slept on the ground in her own tent. She picked up shards of pottery, examined them closely, and often shocked us by throwing rejects over her shoulder. They were not old enough, not good enough, or not authentic. Thanks to Lady Brogan, we started referring to anything not worth our consideration as an "Over the Shoulder." Even though we didn't reach our goal, it felt good to get out into the wide open spaces again. On the horizon we saw mesas that reminded us of New Mexico. They had their own special beauty.

Back home in Tripoli, we enjoyed mostly glorious, sunny days punctuated by the occasional downpour and high winds. We had a three-day weekend coming up so we took a short trip to Tunis with Donn and Mary. The first night we went out for dinner I ordered shrimp for an appetizer, shrimp for the entrée, and shrimp for dessert. It was the season, and I couldn't get my fill of them. If my companions were embarrassed, they didn't show it. We visited the Bardo Museum, home of one of the finest collections of Roman mosaics and statues in the world. Among them was the mosaic of Ulysses lashed to the mast of his boat in order to resist the sweet voices of the Sirens. His companions' ears were stopped up with wax to prevent them from abandoning ship. We visited Carthage, about nine miles north of Tunis, but the place was pillaged so often and so thoroughly during the Punic Wars that there was little left to see. In 146 B.C., Romans razed the city, then spread salt on the ground so nothing would ever grow again. As usual, we returned home with a suitcase full of

Tunisian pottery.

While we were away, Tripoli was hit with some nasty, sandy, windy days. Unfortunately, a big blast blew a couple of our windows open, and we came home to sand in every nook and cranny of the villa. The whole place felt gritty. Immediately after I dusted, I could run my finger across the table and draw a line in the sand.

On campus, the man hired to teach English and coach drama decided he was too exhausted to put on the play scheduled for the upcoming week-end. He had a reputation for doing as little as possible in the classroom during the day and partying late into the night. Of course he was tired. Patty, the other English teacher, and I ended up taking over the responsibility for his play. We worked from 7:30 a.m. to 8:00 p.m. every day of the week and until 10:30 p.m. Thursday and Friday, the nights of the performance. We did it for the kids, not for the ne'er-do-well.

1979 was the year of Peter's fortieth birthday, and he had been depressed about it for months. He was the first one of our little group to reach that ripe old age, and we looked forward to rubbing it in. We invited twenty friends over for the Third Annual Cribbage Tournament, and I got busy cooking. I made two big casseroles of scalloped potatoes and ham. Known affectionately as "Cousin Art," my Cuisinart made short work of potato slicing. Dessert was, of course, his favorite: chocolate cake with chopped walnuts and maraschino cherries and chocolate frosting. The morning of March 25, he was awake at 5:30 trying to get in the last few hours of age thirty-nine. He was showered with cards, visits, and ribbing. We enjoyed good food and had a lot of laughs, but all things considered, he had a miserable time. He had me almost dreading forty myself. He was the same way at thirty. I didn't get it. Was there such a thing as a phobia of decades?

It was time once again to calculate grades and start thinking about spring house cleaning. The biggest job was rolling up carpets and sweeping sand from under them. It was surprising how much accumulated during the course of the year. Some people never did it. Not me. I was well trained in the art of cleaning. Mobrouk helped when he could. He and his

wife were expecting their ninth baby any day now, so if he didn't show up, we knew why.

One of the first days of April we met an older couple who had recently returned from the States on a KLM flight. They told us the news about Libya at home sounded just horrible. Our first thought was for our families. We hoped they were not worrying about us. Zealous members of the General People's Committees were taking Gaddafi's philosophy of direct peoples' power to heart by engaging in rallies and protests daily, many choreographed for the press. News reports on the local TV station made it look as if hundreds of people were protesting when in fact only a dozen or so people followed the camera truck so closely it looked like a mob. Busloads of people were paid to show up at a designated place during political pronouncements. We referred to this as a "Tripoli Rent-A-Crowd." Here, as at home, the media pumped up the drama in these events, but our lives went on as usual. We felt removed from the problems. If we ever were in trouble, we would lay low and find a way to contact our families.

A couple of weeks before Easter we had a cold snap accompanied by pouring rain, wild winds, thunder and lightning. After going around in shirtsleeves since early March, we had to get out our woolies again. Our heat had been off for two weeks, so for several nights we had to light a fire in the fireplace. Mobrouk had the firewood all ready to go in a box by the fireplace when we got home from school.

<p style="text-align:center">***</p>

Since Tom and Doris were leaving Tripoli this year, they decided to take the twins home at Easter and leave them with Grandma Ann and Grandpa Harry in Pomeroy, Iowa, until they moved back to Iowa. That would make it easier to get their shipment packed and ready to go. It would also give Tom time to finish the yearbook for which he served as both advisor and photographer.

Our plans were to go to Damascus and Rome with Mary and Donn. The afternoon of Maundy Thursday we boarded Syrian Arab Airlines for Damascus, took a cab from the airport, and about 7:00 that evening checked into the Sheraton Hotel. It was fairly new, centrally located, and

<p style="text-align:center">277</p>

had all the comforts one would expect from an internationally known hotel chain. No rental cars were available to foreigners, so the following day we took a three-and-a-half hour hair-raising taxi ride from Damascus to an 11th century Castle, the Krak des Chevaliers. Crusaders occupied the site early in the 12th century, and in 1142 it was ceded to the Knights Hospitaliers. The "Krak" was situated high on a hill overlooking a valley so vast it was easy to imagine seeing all the way to Jerusalem. It was massive, breathtaking, and reputed to be the best preserved Crusader Castle in the country. Lawrence of Arabia declared the Krak "the most wholly admirable castle in the world." To us it was another wonder of the world. At one time, depending on the source, it housed two, three, or four-thousand knights and their horses. The empty stables looked as if they were still ready for use. The kitchen was immense, the fireplace alone as big as a house. Richard the Lionheart is said to have paid a visit to the castle, and Saladin considered capturing the "Krak," but decided against it once he saw it.

Back in Damascus, we found our way to the end of the Street Called Straight, stopped by the House of Ananias but were disappointed to find it closed. According to the Bible, it was here that Ananias baptized Saul of Tarsus, the persecutor of Jews who was struck blind on his way to Damascus. Saul regained his sight, changed his name to Paul, and instead of killing followers of Christ became His disciple. The site was a gathering place for early Christians. Eventually Ananias was declared a Saint and his house a Sanctuary.

We visited the Mausoleum of the great Moslem warrior Saladin built three years after his death in 1196. It is said that Saladin gave his money the poor and had only one piece of gold and forty pieces of silver when he died, not enough to pay for a funeral. He didn't have to worry. He has two sarcophagi, one wood, one marble, both grand. In Arabic and in English, a plaque on the original wood sarcophagus reads: THE TRUE GRAVE OF VORTUOUS (sic) BODY OF CONQUEROR AL-SULTAN SALAH ALDIN AL-AYOUBI.

We toured the nearby Umayyad Mosque, one of the largest, oldest, and fourth holiest mosque in Islam, built in A.D. 705. I was surprised to find what is claimed to be the skull of John the Baptist in a mosque, but according to legend, it was preserved here in a stately Shrine dedicated to

him. John is recognized as a prophet by both Christians and Moslems. In Arabic his name was Yahya, and the mosque was built on the site of a Christian basilica dedicated to him. Damascus became Christian in 64 B.C. after it was captured by the Romans. Moslems didn't arrive until A.D. 636, and for some time Christians and Moslems worshipped in the same building, Moslems on the east, Christians on the west, hard to imagine today.

After exploring the mosque, we took some time to tour two impressive 17th century Arabic palaces with large courtyards, fountains, brass trays, inlaid furniture, and harem rooms. Back on The Street Called Straight we found shops full of brass, copper, and Persian carpets. Mary and I went into the shop of Mohammed the Rug Dealer, and as we sat on the floor, he offered us coffee or tea while Assistant Abdul started rolling out the carpets. Their beauty took our breath away, but we could not let our feelings show. That would raise the price. When we saw a rug we wanted, we had to look at it as if it were a piece of trash. My heart skipped a beat at a Bouhkara, and with all the indifference I could muster, I asked how much it cost. "For you, my friend, good price," Mohammed said. When I heard it, I registered great shock and made a lower counter-offer. A look of pain came over Mohammed's face, he raised me a quarter, and so the game went on until at last he said, "For you, my friend, last price." I bought my deep red beauty and Mohammed wrapped it up. We parted good friends, both pleased that we had outfoxed each other.

Visiting Damascus was like going back in time. Sources differ on the city's origin, some dating it back to 11,000 B.C., but no evidence exists of a major settlement until 3 B.C. Since then it has been occupied by Aramaeans, Greeks, Romans, Christians, and Arabs, to name a few. Parts of the city looked very poor. Other parts looked as if they hadn't changed much in two thousand years. The city was a mixture of Christian, Moslem, and Jew. All had their quarters, but the people seemed to live in harmony. They were friendly and helpful and appeared to enjoy life. Arabic was the official language, but one could hear Turkish, Armenian, and Kurdish spoken on the streets. My one regret was that the National Museum of Damascus was closed the day we planned to visit. It housed over 5,000 cuneiform tablets, one of the earliest known forms of writing. I knew I would never have another opportunity to see them.

I spent our last night in Damascus in the bathroom of our elegant room in the Sheraton Hotel. I had nausea and diarrhea so bad I didn't know which end to take care of first. I ended up sitting on the commode and throwing up into the waste basket most of the night. I presumed it was the Krak's revenge, a cucumber sandwich I ate in the tea room at the Castle. I dreaded the 7:30 flight to Rome the next morning, but it was a smooth flight and I did not need the plastic bags I had in my purse for emergencies.

As soon as I got to the Victoria Hotel in Rome, I went to bed. The rest of our stay I was up and around but could only drink tea and eat dry toast, a sad state of affairs in the land of lasagna, spaghetti, shrimp, veal parmigiana, and fresh strawberries. We wanted to see the Dying Gaul statue one more time, so we visited the Capitoline Museum. Two days later the museum was bombed by political terrorists. Not since 1972 when a demented Austrian vandalized Michelangelo's Pietà in St. Peter's Basilica had a national treasure been attacked. Politically motivated terrorists had committed thefts and rampant killings, but up until now had left treasured monuments alone. We were beyond sad.

We spent several hours in the catacombs and Pantheon, then as we were walking back to the Victoria Hotel the night before returning to Tripoli we spotted the OCS English teacher who was too tired to put on his play. He was sitting at a sidewalk cafe on the Via Veneto reading a library book. We stopped and said "Hello," and he asked us to join him. We declined, saying that we had to get back to the hotel to pack for an early flight the next morning. He informed us that he still had a few more things he wanted to see, so he wouldn't be in for a few days and would we mind relaying that message and returning his library book for him? We took the book and left with mouths wide open. The unwritten rule for teachers at OCS was go on vacation, have a good time, but never, never fail to be behind your desk the day classes resumed. We had taken redeye flights, rented Land Rovers, and driven through hell to get back on time, and here The Tired One sat with his feet propped up needing a few more days. We were speechless.

A taste of the Sahara greeted us shortly after we got back to Tripoli. The first week of May brought perfectly miserable, hot, sandy days. Shortly after, the weather turned cold, but everything felt gritty. We needed a downpour to freshen up our world. The English teacher who hadn't taught half of the year, was too tired to put on his play, and needed a few extra days of vacation in Rome was fired. The superintendent called me in for a confidential discussion of the situation, and I told him what I had observed. As far as I was concerned, the man had a one year's paid vacation. Fortunately, he was the exception, not the rule.

In May of 1979 the procedure for sending money home to our banks in the U.S. was changed. Instead of going to our local Sahara Bank to get bank drafts and send them in an envelope to my parents as we had done since we arrived in Tripoli, the money would now be cabled directly to our account in Clear Lake Bank & Trust. We preferred to have the draft in our hands, but we had no choice. Cables and telephones had a bad reputation in Libya, and we worried that it could take weeks to find out if our money had arrived. Our worries were warranted. By the end of the month our bank bounced two checks, one to our friend Gloria for $484 and one to the Hotel Victoria in Rome for $100. The money should have been there. We now had to explain, apologize, and pay a $10 penalty to the hotel in Rome, embarrassing since we stayed there often and knew the manager personally. Gloria was no problem. She understood that it was just a mix up, and we wrote her a check. The new cable arrangement promised to be a nightmare. If there was a bright side, this meant our parents wouldn't have to take our monthly drafts to the bank any more. All we could do was hope for the best.

By the middle of May it was time to turn on our air conditioner. It was not too bad outside unless one stood directly in the sun. Then it was beastly. I felt sorry for the physical education teachers who had to teach outside all day. I didn't envy them their jobs at the moment. The good news was the birth of Mobrouk's ninth baby, a boy.

It was also time for another weekend camping trip, this one south and east of Tripoli to see three large Roman fortified farms. They were pretty much a heap of rubble but stood as a reminder that Libya was once the breadbasket of Rome. The weather was mild, but the wind whipped the sand into our eyes, ears, and mouths, got under our nails, into our hair, and

281

into every crease of our garments. I felt like a piece of coarse sandpaper. The Land Rover was in its element plowing over brush and dunes. Neighbor Dave's VW stalled ninety-six kilometers (sixty miles) from nowhere and we had to tow him to the nearest village. We never got out of second gear the whole way. Still, as always, with only the necessities of life to tend to, we found peace and relaxation in the desert. The Bedouin said they didn't believe that man had walked on the moon. Those who have spent a night in the desert under the canopy of the night sky could understand that. There is something mystical about it, something beyond the reach of science and technology.

Since our friends Tom and Doris were leaving Tripoli in a few weeks, two other couples joined us to give them a going away party. The guest list numbered ninety, so we decided to keep it simple. Kofta, a favorite meat kebob of hamburger mixed with cumin, coriander, cinnamon, and cloves was the main dish. The ladies mixed up almost forty pounds of hamburger, formed it around the tip of 250 skewers, then delivered them to the guys on the patio for grilling. It took about three hours, and we had a good time doing it. Tabouli, hummus, pita bread, and fruit completed the menu. Trusty Cousin Art made short work of chopping flat-leaf parsley, tomatoes, and mint for tabouli, we bought hummus and fresh-out-of-the-oven pita bread, and arranged a huge basket of fruit for dessert. The day of the party was a classic Mediterranean beauty, and our patio and back yard looked like a luxurious resort with lounge chairs, colorful umbrellas, and tables laden with food. Well, almost. The neighbor's rooster crowing and sheep bleating brought us back to reality. The party turned out to be a lot of fun, and Tom and Doris were pleased and appreciative. We were glad we did it for them. Anyone who stayed in Tripoli for thirteen years deserved a special sendoff. Oh, how we would miss them.

We were coming down to the home stretch at school. We had three more weeks of classes, but I started giving my finals early. Parents started pulling their kids out of school about this time for summer break. The school frowned on early dismissal, but there was little anyone could do about it. In many cases, vacation time was a company decision. Our stu-

dents were doing well. We had no brilliant scholars in this graduating class, but all were eager, hardworking kids. It had been a good year, possibly the best teaching year I ever had. I did not miss a day of work.

We were still enjoying Libya and the school, but after ten years we were beginning to feel ready for a change. Besides, some of our closest friends had left and we missed them. We tentatively decided to spend one more year in Tripoli and start looking for jobs during the summer. After all this time, we had become attached to OCS, so we knew it would be hard to leave.

Our summer plans included visits to Clear Lake and Appleton and a summer session at Harvard. Before we left we had to make the usual arrangements for doggie care and villa sitters. They were always in high demand, and this year we hit the jackpot. George and Mary Fran, parents of two fine young sons who had attended OCS, needed a place to stay for the summer. George had worked for Marathon for several years, moved back to Findlay, Ohio, but was now in Tripoli on special assignment for the company. Housing had become so hard to find that anyone leaving a villa vacant too long ran the risk of losing it, so if we hadn't found "sitters" ourselves, the school would have put someone in just to retain it. I much preferred having friends in our home. I knew Mary Fran was a meticulous housekeeper and George loved Gretchen and Albert, so I knew he would take good care of them. He came over one evening before we left and we gave him a tour of the villa, showed him where everything was located, and told him how to operate the place with all of its quirks, power surge protector and water heater in particular. I felt comfortable knowing our place was in good hands.

I had my last class of the year on June 6 and spent a couple of days cleaning my classroom. I inventoried, cleaned, and shelved over a thousand books and covered all bookcases with butcher paper for the summer to protect them from sand. The night of graduation was also Mary's thirty-ninth birthday, and she and Donn wanted to see the presentation of the Waldum Memorial Award established in honor of Donn's brother Bob. I invited them for a dinner of filets wrapped in bacon, wild rice, baked stuffed tomatoes, salad, and fresh strawberry pie instead of a birthday cake. After dinner, we went to the gym and found it decorated with red and white flowers, ribbons, and candles, all by mothers of the graduates. They

also arranged for an elaborate reception after the ceremony. Recipients of the Waldum award did not necessarily need to have the highest GPA, but they had to be an "all-around student, involved in all aspects of student life, two or more years at OCS preferred, responsible, dependable in academics and social life." The winner, Lisa, exemplified all those qualities. Besides that, she was beautiful.

I was looking forward to seeing my family in Iowa and sampling choice produce from my Dad's garden. My crop this year was not edible. I planted sunflowers along the back villa wall in February, but only one of them survived. Albert knocked down the rest of the seedlings while chasing cats. The survivor grew ten feet tall and had a stalk as wide as a small tree trunk. Unfortunately, it turned its back on me. The sun favored our Libyan neighbors, so they got to look at my lovely flower.

We left for the States the middle of June, spent a couple of weeks with our families in Clear Lake and Appleton, then the last week of July flew to Boston where we had both signed up for a course at Harvard. Mine was "The How of Art: Understanding Creative Process," exploring what goes on in the mind while in the process of writing, painting, or composing. The class met from 3:00–5:00 p.m. every day in a beautiful new library, and the professor provided tea and coffee. We had quite a bit of reading to do, a couple of written exercises every day, and a creative project. More important than the product was recording what went on in our minds as we did it. We had no tests, no final, and could elect a Pass/Fail grade. I wasn't completely comfortable with that but decided to give it a try. I had visions of sitting on the banks of the Charles River getting inspired to write and hoped to get most of my work finished during the day so we could go to films, lectures, and concerts during the evening. That did not occur.

Peter missed his first history class since he was trying to find housing. Most of the dorms were set up for singles, but after a week in motels, the housing office finally found us a "suite." Read "dump." Since we were "from" Libya, we were assigned foreign student housing in Winthrop Hall 25A. The rooms had bare walls, bare wood floors, no curtains and no screens on two windows, a couch with the stuffing spilling out, a couple

of hard chairs, two desks, a fireplace, and two iron cots in separate bed-rooms. We ended each day calling "Goodnight" to each other from our lit-tle beds. The exterior of the building was beautiful New England ivy-cov-ered brick with white trim. The "suite" was filthy. The bathtub was black and so were my feet when I made the mistake of walking barefoot across the floor. We even had to take out the garbage left by the last occupant. The only things we dared to touch were the sheets and towels that we got from campus laundry. Our misery was compounded by temperatures in the 90s with 80-90% humidity.

On the bright side, the location couldn't have been better. We could walk any place we wanted. A half-block up the street was an Olympic size swimming pool. Elsie's Coffee Shop was a block away, and a grocery store was just up the street. I could walk to my classes, and they were going well. I decided to write a half-dozen short stories about little old ladies for my creative project.

Since Peter was auditing his course, he did all the washing, ironing, and cleaning. One day when I came back from class, he was dripping with sweat from cleaning out the "suite." The bathroom was now immaculate, and he had washed the floor on his hands and knees. We draped sheets over the furniture and felt that at last we could safely sit down. Peter also washed and ironed our clothes, and the big, black lady in charge of the laundry thought that was the funniest thing she had ever seen. First of all, college kids didn't iron clothes, and to see a grown man doing it was too much for her. She laughed and kept trying to hire him to work for her. Meanwhile, Peter was longing for Mobrouk.

One weekend we rented a car for two days and drove north to upstate Maine where Peter was stationed in the Air Force. He had not been to Presque Isle for twenty years, and we discovered that the base had been closed for several years. It was now an industrial park. We found only one man left on the base that Peter knew and they spent several hours talking. The drive north on I-95 was beautiful, all woody, clean, and cool. Parts of Maine were uninhabited and some parts virtually unexplored. We drove by field after field of potatoes in Aroostook County and enjoyed them with our lobster for dinner.

The first week of August we finally got a welcome break in the weath-er. It was cool, dry, and breezy. A couple of nights I even had to cover

myself with a sheet. It made life much more bearable; still, we were counting the days. Only nine left. We had a flight to London booked out of Logan at 9:00 p.m. on August 17, then on to Tripoli the 25th. George and Mary Fran would be leaving soon after we returned, so we needed to get back to take care of Gretchen and Albie, our little orphans. I had rough drafts written for six of my stories and reworked one per day. None would win the O. Henry Award.

A call to the Clear Lake Bank and Trust informed us that the cable transfer of two months' savings sent in May from the Sahara Bank in Tripoli had not yet shown up in our account. Superintendent John sent us a letter saying that he had been to the Sahara Bank to reorder the transfer, but in September it was still missing. For nine years we had sent drafts to my parents in a plain ordinary envelope and had no problems. How we longed for the good old days.

Before we left Boston we took the "T" into the city to do some shopping for shoes and clothes. Since we were not sending a shipment, the only house supplies we bought were items like Mr. Coffee filters, things that would fit into our suitcases. We rented a car one weekend and went to Plymouth to see the Rock, the Mayflower II, and Plimouth Plantation; Lexington and Concord to see where the first shots of the American Revolution were fired, the Old North Bridge, and the Minuteman Statue; then Salem to tour the Witch House and the House of the Seven Gables. I fell in love with it.

I finished my last class at 5:30 p.m. on Friday, August 17, and by 8:30 we were seated in a plane ready to fly from Logan to London. We were more than happy to be on our way, and the flight was so smooth I slept part of the way. When we arrived, we took a cab to the Royal Trafalgar Hotel on Whitcomb Street. We had stayed there so often that Manuel, the porter, had become a good friend. For years we exchanged Christmas cards. Every night of our stay we looked out of our hotel window at Trafalgar Square and said "Goodnight" to Lord Nelson. Gloria was staying there too, and Keith was in the suburbs staying with friends. One night we all got together for a Chinese dinner. We went to the London Zoo and saw two newborn baby gorillas, Saul and Salome, cuddling and playing and acting cute. We spent the whole week sightseeing, shopping, and going to plays and films, trying to get our quota of culture before going back to the desert.

A Dry and Thirsty Land

It was 104° when we got back to Tripoli, so hot that Gretchen and Albert could barely muster a greeting. The villa was in good shape. George and Mary Fran had taken excellent care of everything. I did a little cooking and baking, polished some copper, and got the place freshened up. Mobrouk had been in the hospital twenty-eight days with a hernia operation, but he had recovered and was back at work. I gave him the small lantern that my parents sent him as a gift. That made him happy.

One of the first missions upon my return was a trip to my butcher at the Italian Market. He didn't have any meat the first time I went, but the next day he had twenty-five kilos, over fifty pounds, of hamburger, filet, sirloin, and T-bones waiting for me. I was glad to get my freezer stocked again in preparation for the shortages that were bound to occur. I also bought a small watermelon and ate the whole thing myself. At the moment we had lovely grapes, melons, pears, fresh figs, and peaches. I bought a case of them and made peach pies for the freezer, then I found a wonderful recipe for peach ice cream. I froze a mixture of fresh peaches and cream in ice cube trays, transferred it to a bowl and beat the daylights out of it with the mixer, then refroze it. It was wonderfully fresh and creamy.

School started the first week of September, and by the end of the week I was exhausted. I was not overworked. I just needed to get back into a routine after three months of vacation. Classes were a bit smaller than they had been the previous year, and our total enrollment was about 875. When we arrived in 1970, 90% of our 1,100 students were American. Now, most of my ninth-graders were Asian or Yugoslavian, children of parents hired to replace American workers who had been reassigned to the U.S. or transferred to other countries. Of the seventy students in my classes, I counted only twelve Americans. School-wide we were running close to 30% American, most of them in the elementary grades. I sometimes wondered how the oil companies could justify supporting a school of this quality for so few American kids, but I was glad they did.

The weather was kind. We got hot, but not dripping with sweat at the end of the day as we usually did this time of year. I spent most of the first weekend baking and cooking for our school lunches. I made eighteen little meat pies, sixty Chinese egg rolls, and three meatloaves to slice for sand-

wiches. Gone were the days when I could go to Elsie's in Cambridge for meatball subs.

Our local post office was working at its usual peak efficiency. Neighbor Dave got a Christmas card dated September 15 of last year, and we had yet to hear from our families at home. My birthday was on September 16, my thirty-ninth, and I had not received a card. September 21 we got a letter that my Mom had mailed on August 20. It took a month to arrive, but my Dad's card and letter took ten days. Malish. Never mind. We were just happy to hear from them.

I was twenty-nine when we came to Libya in 1970. Ten years later I didn't feel any older, though I headed to bed a little earlier most nights. I resolved to enjoy the last year of my thirties. Swimming was the highlight of many days. I often took my mask and flippers to check out the ocean floor. The water where I swam was 20-30 feet deep, the water clear, and the bottom sandy and full of interesting ledges, plants, and an occasional fish. The Med felt cooler already, but I usually swam through September, sometimes the first two weeks of October. The Germans and Brits swam all year long. Most Americans and Italians dropped out early.

Always on a quest for food, one Thursday afternoon I went for a drive and found a little market in a village about ten miles east of Tripoli. Open farmers' markets were held in different locations on different days of the week, and this one was called, no surprise, the Thursday Market. At 4:00 p.m., local farmers brought in their fresh produce and set up shop right on the street. I bought a bunch of limes, fresh dates, peanuts to roast, bags of potatoes and onions, cucumbers, zucchini, tomatoes, mint, parsley, and bananas, all for about $15, and all cheaper and better than anything I would find in shops on Zavia Road. Bill, one of our esteemed science teachers, a.k.a.Willy, told us that local produce may not be particularly nutritious since it was grown in sand, but it tasted good and was good roughage.

The next week Keith and I went to the Tuesday Market on the outskirts of Tripoli where one could buy anything from carrots to camels. We bought a case of peaches and eighteen kilos of green peppers. We divided the peppers, and I went home with a clothes basket full. I stuffed peppers with meat and rice, cut some up in rings, and others in chunks to use for pizza sauce. I made two delicious peach pies and froze the rest in slices. We bought everything right off the truck, fresh, good, and cheap.

Pleasant fall weather was holding out. Days were toasty warm, but not uncomfortable. Good for outings. Every fall the old timers at OCS led a trip about sixty miles east of Tripoli to Leptis Magna for newcomers on the faculty. Everyone brought food, and after a tour of the ruins we went to a nearby beach for a swim and picnic. We took the Land Rover this time. Someone had stolen the gas cap from it while it was parked on the street in front of our villa. Fortunately, we had a spare.

About this time I got a letter from my instructor at Harvard telling me I passed the course with a grade of SAT—Satisfactory—and four graduate credits. He suggested that I write more stories, but now that I look back on them, they were pitiful. More interested in the process than the product, the professor would probably write a dissertation with our findings. I was just as happy that I hadn't opted for a letter grade. In a way, I wished I could use Pass/Fail with my students, but they wanted those A's and B's. So did the parents.

By October we started missing little things we were accustomed to having, especially in the kitchen, and regretted not sending a shipment from the States. This called for a shopping trip to Malta, so we turned our passports in to our government relations man Hafid to take to take to the Libyan Arab Republic (LAR) Passport office for exit re-entry visas. They came through in time for a weekend trip to the island to buy cinnamon, vanilla, plastic bags, aluminum foil, mayonnaise, and items no longer available in local stores. Prices in Libya had suddenly shot up. The price of gas had doubled, and flour, sugar, tea, and all the staples were getting more expensive by the day. The only thing that remained constant was the price of meat. We heard rumors that the government subsidy on everything but meat had been eliminated, so we would be paying the difference. Dog food was no longer available, so we started buying hamburger for Gretchen and Albert and mixed it with rice and vegetables.

When our visas came through and word got out on campus that we were going to Malta, friends came to us with lists requesting everything from alto-saxophone reeds to calculator batteries to hotel reservations. We obliged, and once finished with shopping and filling our suitcases with groceries and supplies, we took a bit of time to enjoy the pretty little island. I loved the buildings of natural stone, the palms and bougainvillea, ships bobbing around at sea, and colorful row boats moored in the harbor. Malta was only an hour's flight from Tripoli, but it seemed like a different world.

A week after we returned, thieves struck again. Our Toyota was parked on the street in front of the villa, and one afternoon when we went out we were shocked to see the right front wheel missing. We hadn't heard a thing, probably because the air conditioner was on. The dogs usually made a racket, but not this time. What could we say? We had a spare. Malish.

The cool weather that we had been enjoying for several days changed abruptly to ten days of an average temperature of 105°, so we were back to bare feet, sun dresses, and air conditioners. Even the sea warmed up by ten degrees, probably due to a shift in currents. October was a planting month in Tripoli, so I planted a few pots of parsley and chives and tried once more to get some grass started. It amazed me that even though vegetables might not be especially nutritious, almost anything would grow in this sand as long as it was watered.

A group of my Junior Honor Society students wanted to take a trip to Cyrene, so they organized a book sale to help pay for it. We took donations of used books and sold them cheap, anywhere from 25¢ to $2.00. By 8:10 a.m. the day of the sale they had already made $203.28. People were dying for books to read. At the end of the day the kids earned enough money to pay for their plane tickets, so I started checking into arrangements to take them during Thanksgiving vacation.

The International Horse Jumping Competition was currently going on at the riding stadium about half way out to the Tripoli airport. We were all aware that horses were prized in Arab society, but not until I went to the Competition with two girlfriends did I get a real glimpse of their passion for horses. We went twice after school, once for the jumping and once to see the Arabian Horse Show. We watched three-hundred Arabs with long

flowing robes charge at breakneck speed around the track. They rode so close together they could grab each others' reins. Some even stood up in their saddles. The bridles and saddles were elaborate, some with stirrups made of solid silver. The stadium was a beautiful new modern structure surrounded by lush green grass, but the complex could not compare with the sight of the magnificent horses. Contenders came from England, Austria, Germany, and Eastern Europe.

Gretchen had been suffering with a chokey cough for a week. It sounded as if something was stuck in her throat. Someone suggested de-worming her, so I did. I thought of taking her to the vet, but I really didn't have much confidence in any of them. The next day she seemed a bit better. The poor little thing almost tipped herself over coughing.

The last weekend of October was warm and beautiful. It just didn't want to get cold and rainy, so what could we do but relax and enjoy it? I got up early one weekend and went down to the Italian market for meat and cheese and found the place loaded with fruit, vegetables, spices. It was a pretty sight. I even found fish. When I got home I decided to take the rest of the day off. I sat in my lounge chair in the back yard with my coffee cup and Gretchen and Albert to keep me company. I tried to write letters, but Albert pestered the daylights out of me, licking my toes and trying to jump up on my lap.

The following week we had three days off for the Eid al-Adha. Libyans who had the means bought a sheep, slit the throat, ate the meat, and tanned the hide. Every part of the animal was used. We went to Tunisia with Donn and Mary, and since we didn't have the required car papers we drove to the border of Libya, parked the car, cleared Libyan customs, walked across no man's land to Tunisia, cleared their customs, hired a taxi to Djerba, and checked into the Hotel Menzel. The next day we rented a car and took a side trip over washboard roads and moonlike surfaces to Matmata, a troglodyte village south of Gabes. Here for over a thousand years, Berbers had escaped from the heat by living underground. Around a large central courtyard dug twenty feet deep into the earth, they hollowed out rooms of various sizes. One of these dwellings had been converted into

the Hôtel Sidi Driss, made famous in the movie *Star Wars*. It was easy to see why George Lucas chose this spot. As we sat in the dark, cave-like lounge talking to other visitors, we felt as if we were on another planet. We would not have been surprised to see Chewbacca walk through the bar room door.

We returned on Saturday to find health problems in our community. Roger, the friend we hosted a smørgasbord with in 1976, was down with infectious hepatitis, and his wife Sandy took a leave of absence to care for him. Neighbor Dave eventually came down with it, although his case was less severe. As a precaution, all teachers were given gamma globulin shots. It worked. No more victims. Many others, however, came down with some sort of virus. Peter stayed home for two days with it, the first time I knew him to miss work. If Keith or Peter didn't make it to class, everybody assumed the world was coming to an end.

On November 4, in violation of international law, a group of five-hundred enraged Iranian students loyal to the Ayatollah Khomeini stormed the American Embassy in Teheran and took ninety hostages. The presumed cause of the attack was objection to President Carter's admitting the overthrown Shah Mohammed Reza Pahlavi into the United States for cancer treatment, but the larger motive was bringing American influence to an end in Iran. We got our initial information from the BBC on our trusty Touring CD KW-Doppelsuper radio, but we soon found pictures at the newsstand of blindfolded American hostages with their hands tied behind their backs and mobs spitting on images of Uncle Sam and the American flag, burning them in the streets, and chanting "Death to America." It shocked and angered Americans and others in our expatriate community, and I recall being horrified and uneasy, but not afraid. Our day to day lives went on as usual. We kept close track of the news and hoped the situation in Iran could be resolved without the hostages getting hurt or worse, killed. We contacted our families and told them not to worry. Relations with local people were good.

Thanksgiving was coming up, and I was still trying to finalize arrangements for my National Junior Honor Society students to go to

Cyrene. Eight members had worked hard all semester selling pencils and holding book sales and bake sales to save enough money for their plane fares, hotel reservations, and ground transportation. The plane tickets and hotel reservations were confirmed, but I was having trouble finding a bus to take us around once we got there. All arrangements came through in the nick of time, and early Thanksgiving morning we boarded a Libyan Arab Airlines plane for Benghazi, 150 miles east of Tripoli. There we got on the small bus we finally managed to hire and made our way to Cyrene and the Cyrenaica Hotel, advertised as first class. It was dank and dark, had no heat, no hot water, no flush toilets. It was the only one in town.

Thursday afternoon we toured the Greek ruins of Cyrenaica, just as magnificent as I remembered them. We had a Jason in our group, so when we reached the House of Jason, our guy went ahead and welcomed us into each of "his" rooms, pointed with pride to the elegant mosaic of the Seasons, and apologized for the missing heads on six otherwise elegant statues of the Muses.

Thanksgiving evening, four Asian students, one Sudanese, one Swede, one Canadian, and one American sat down to dinner around a long family style table with me and a couple of chaperones. Instead of turkey and dressing, mashed potatoes and gravy, cranberries, pumpkin pie and whipped cream, we ate watery spaghetti and rubber chicken. Both food and lodging left much to be desired, but no one could have told us we weren't having a good time. Any mention of Holiday Inns, swimming pools, McDonalds, Burger King, or DQ was met with roars of laughter. The kids made me proud. The excursions during the day were more than glorious enough to make up for the less than desirable food and lodging. Friday we visited Apollonia, Tokra, and Tolmetha. Saturday afternoon about 5:30 we returned to Tripoli where anxious parents were all waiting for their young explorers at the airport.

It was pitch dark when we got up in the morning now. We had long-sleeve shirt weather during the day, but the nights were cold, so we turned the heat on in our villa. Christmas was coming up soon, but I was having trouble finding sugar, so I decided not to do any baking this year. Mobrouk

was trying to find me a fifty kilo bag which I planned to split with Mary. We hoped that would get us through the year.

Gretchen was still having a hard time. It had started with a bad cough, and now she was having trouble breathing. I took her to the vet, but no one was there, so I gave her cough medicine with codeine, warm chicken soup, and kept her inside where it was warm. One of my Libyan students who lived on a farm said he would arrange for a vet to look at her. We were afraid she had a heart problem. It had always been squeaky, but now her stomach was becoming distended during the night. She was such a sweet dog. I wanted desperately to find help for her.

The first week of December our Gretchen started filling up with fluid, her belly almost at the point of bursting. I finally located a vet, and he drained two liters of fluid out of her little body. The vet, a Pakistani, diagnosed her problem as a malfunctioning liver or anemia. I had her on vitamins, Penbritin, and a pill to increase urination. She seemed to be getting better, although she was very weak. She was such a good-natured dog. She never complained about anything. I had her sleeping right by my bed at night. Albert was so jealous of all the extra attention she was getting that he peed on her when I let her outside.

The morning of December 2, 1979, an estimated crowd of 2,000 protesters attacked the American Embassy building in Tripoli. A Consulate since 1972, two floors of the building were damaged, but it was not burned down as reported on one radio broadcast. Some reports stated that windows were shattered, desks overturned, files ransacked, visa applications scattered all over the floors, and typewriters smashed. We later learned that calls made to Libyan authorities were answered with "not to worry." Fortunately all classified documents were burned or shredded, and the staff exited the building through a side door and walked to safety in the nearby Consul's residence or the British Embassy.

Relations between the two countries had vacillated for a number of reasons since Gaddafi came into power. Libya rejected the Camp David Agreements, protested the refusal of the U.S. to deliver transport planes it ordered, and supported the Ayatollah in Iran. The U.S. denounced Libya's

support of terrorist groups. The attack was not a complete surprise. Since Ambassador Joseph Palmer left in November of 1972, no ambassador had been appointed to the post, so we no longer had an Embassy but a Consulate where William L. Eagleton served as Chargé d'Affaires ad interim.

Despite their differences, the two countries stood to benefit each other economically, especially in the oil industry. Many Americans, mostly women and children, chose to leave the country, and those who stayed were advised to keep a low profile. The Oil Companies School closed, but if relations stabilized, classes would resume in January. People-to-people relations had not changed, though we had learned that it was always best to lie low when there was political unrest. Only desperadoes went downtown. Smart people stayed home. Several leaders of the American community met at the Consulate every evening, watched cartoons to relieve stress, and waited for directives from the State Department. Our friend John always stopped by on his way home to update us. Mobrouk and all the Libyans we worked with were embarrassed by the incident. My family had assured us that after all these years they didn't worry when the news about Libya got bad, but this time I called to reassure them that we were O.K.

Since our school was closed, Christmas vacation started early. Anyone who felt the need to leave could do so. We felt anxious, but not threatened, and took our time deciding what to do. Our plans depended on Gretchen. She seemed back to normal. I stopped her medications, but continued the vitamins. If we left the country, our neighbors offered to take care of her and Albert.

Finally, with almost a month off and Gretchen feeling well again, we decided to take advantage of the time to travel. We booked a flight to London, packed our bags, and the morning of our flight, Gretchen sat patiently in a little alcove beside the bathroom waiting for me to come out of the shower. She always knew when we were going away, even before we took our suitcases out. I gave her a love pat on the head and let her out to join Albie in the yard. We dressed, grabbed our bags, and headed to the airport.

In London, we checked into the Flemings Hotel on Half Moon Street, saw some plays, listened to church bells, did several brass rubbings at the St. James Church, and reveled in the festive Christmas lights and decora-

tions. A few days later, our friends Judy and Andy arrived, and when the time was right, they told us that our sweet little Gretchen had died. We were devastated. She had seemed to be her old self again. The last time I saw her she was sitting in the middle of the back yard with her face to the sun. Apparently she died just hours after we left. We managed to get through the day without breaking down, but the minute we got back to the hotel we closed the door, reached for each other, and sobbed. We cried long into the night. Andy said poor Albert was howling and trying to get Gretchen up after she had died. Our neighbors discovered our sweet girl and buried her in our back yard under the bougainvillea. They took Albie to their home and cared for him until we returned. The cause of death was congestive heart failure. We lost a precious friend. We felt sorrow, guilt, and to this day I miss her. Every time I think of her my heart melts.

With heavy hearts we went to Zurich as planned to meet our friends John and Ellen and their son Mark, then took a train to Davos to ski, but our hearts weren't in it. Peter and Mark took the more difficult runs on Jakobshorn, I stayed on the bunnies, and John and Ellen joined us wearing the new ski duds they had bought in Zurich. Peter and Mark were tearing down the slopes in their beat up Levi's, and the snappy dressers and I were barely able to stand up. We all felt better after a week in the mountains. We got plenty of exercise and were more than well fed.

When we returned to Zurich we found a Love Package from home waiting at the Hotel zum Storchen. Inside was Mom's homemade fudge, divinity, peanut brittle, peanuts, pecans, Triscuits, a candle, a pair of socks for Peter, a copy of the *Clear Lake Mirror-Reporter, Farmer's Almanac,* and *American Gothic Cookbook.* All the goodies were fresh and delicious, and the taste of home was greatly appreciated.

We decided to take the train to Rome, an eleven-hour trip including one change in Milan. I looked forward to reading, seeing lots of beautiful scenery, remembering my dear Gretchen, and feasting on the goodies my Mom sent. We left at 9:00 a.m. and got to Rome at 8:00 p.m. It cost about one-third the price of a plane ticket. When we got to Rome, we read the newspaper for the first time in over a week. News about the Russians invading Afghanistan made us wonder what the next year would bring.

1980

When classes resumed at OCS in January of 1980, we found that a few families had left the country as a result of political tensions experienced during the storming of the American Consulate in December. The student population still hovered around 875, and I had the same seventy or so students I had before the holiday. Of those, only a dozen were Americans. I was working with the same group that I took to Cyrenaica, and with kids like that it was hard to go wrong. Most of them would graduate this year. They were a remarkable bunch, and I would miss them.

Our January was cold and dry. By the end of the month the days started warming up, but the temperature was in the 30s at night. It was pitch black when we went to school in the mornings. Most of my free time since we got back from our extended Christmas vacation was spent in stocking the cupboards. Libya was gradually shutting down little privately owned shops and opening up big government controlled supermarkets. In the meantime, we hadn't been able to find butter, eggs, cheese, flour, meat, cooking oil, and laundry soap. One day after school a couple of friends and I drove around for two and a half hours trying to find butter. No luck. We found only ghee, no substitute.

Mobrouk finally saved the day by taking me to a shiny new supermarket near his home. The shelves were fully stocked and the prices cheap, but the store was quite a distance from Giorgimpopoli where most of us lived. We all played detective, locating the new stores and buying extra for our friends when we came across items that were hard to find. I scored on the meat and eggs, the home economics teacher found flour, Willy the science teacher bought us a whole wheel of Fynbo cheese, and neighbor Peg tracked down some butter. Once again our larders were full. No one starved and we were all pleased with ourselves for discovering hard-to-find items. We wondered what we would do for a pastime when we moved to a place where we could walk into a store and find anything we wanted.

After eight months, we finally tracked down the cables from Sahara Bank that had never arrived in our account in the Clear Lake Bank & Trust. In May of 1979 we ordered a transfer of two months' savings and assumed it would be sent in one cable. Instead, Sahara Bank sent two cables in the amount of $1,500 each on the same day. Bank of America, which had been handling the transfers, refused to honor them. They thought we were trying to pull a fast one. Finally they decided it was legitimate and on January 19, 1980, they forwarded the total amount to our account. They did not pay us the interest we could have earned, but at this point we were just relieved that the money had finally arrived.

As a daughter of the Midwest it never ceased to amaze me that on the first day of February I could sit in the sun in my back yard enjoying perfect weather. The lack of rain so far was going to cause problems later on, but meanwhile we enjoyed clear blue skies and balmy temperatures. I planted zinnias and got the ground ready for pumpkins, melons, cucumbers, and Mrs. Burpee pea seeds from my Dad. We now had six poinsettia shoots in our yard. They could grow ten to fifteen feet tall, but if they thrived we would not be in Libya long enough to see them.

I missed Gretchen. Poor Albie was lost without her. So were we. She was the rock, the calm in the storm in our household.

The Ninth Annual Basketball Festival took place the second weekend of February. Two De LaSalle boys' teams flew from Malta to Tripoli to compete with the OCS teams in two full days of basketball. Games were played with gusto, some won, some lost, but both spectators and teams enjoyed the competition. OCS girls played two games against the women's faculty. The teachers lost, much to the delight of the spectators. I played my usual sixty seconds and didn't score a point. Peter and I had the Malta coaches over for lunch, old toothless Brother Edward and young Brother Frank. Both were kind, pleasant men. They gave us a beautiful hardbound picture book of Malta, our favorite island.

Our annual National Junior Honor Society Induction Ceremony prom-

ised to be a good one again this year. The title of the program was "The Oracle of NJHS," inspired, no doubt, by the trip to the Greek ruins in Cyrenaica last Thanksgiving. We inducted twenty-four new members, the largest group of inductees for some time. The "old" members were all excited, wondering who was going to "get in." I could still remember the thrill of getting a letter saying I had been elected to the National Honor Society in high school. It was a defining moment in my early academic life. It told me that I was at least as intelligent as some of my classmates and was a pretty good kid to boot. It made me want to do better. I hoped it would be just as meaningful for these kids.

One afternoon after school, I had my first encounter with socialized medicine. The filling in one of my back molars was crumbling, so I got the name of a dentist from one of my students and went to a Hungarian clinic to have it replaced. I had to wait an hour, but when the job was done, all I had to do was sign my name. It was an odd sensation to walk out without paying. I felt like a thief.

By early March, my garden was taking off. Zinnias, straw flowers, dill, parsley, and radishes were poking their heads up in neat little rows. I loved to see things grow. I never had the best of luck gardening, but it wasn't for lack of trying. Our weather had been strange recently. One day it was like the middle of summer, the next day it was bitter cold. It confused our plants and messed up our sinuses.

One evening a neighbor brought over a fuzzy little puppy and I was sorely tempted to take him, but I resisted. Albert would have to go it alone. He missed Gretchen terribly. So did we. We put him together with the neighbor's dog several times a week to play and they enjoyed each other's company, but it wasn't the same as having Mom by his side. Our neighbor's little daughter was absolutely in love with Fat Albert. Every time she came out of their front door we could hear her piping, "Abie, Abie."

Once again, we had a Malta shopping list and I wanted to make an

uninterrupted call home to check on my Dad's health, so we flew to the island and spent a chilly, windy weekend at the Malta Hilton in St. Julians. I usually had good luck at the post office in Giorgimpopoli, but lately it had been difficult to get a telephone line to the States. People often waited four to six hours, sometimes days, for their calls to go through. I had never waited over twenty minutes, but I wanted a secure line and the comfort of talking in the privacy of my own room. I was relieved to hear that my Dad had some polyps removed from his colon and the prognosis was good. He was seventy-five, feeling "as good as a 75-year-old could hope for," and planning a trip to Norway in July with his thirteen-year-old grandson Richard. We wanted my Dad to be in good health for what would probably be his last trip to visit the land of his birth and see his family. Knowing that a trip to Norway was in his not too distant future usually guaranteed a speedy recovery.

The weather was so stormy on Malta that waves crashed up over the retaining walls on the waterfront. Still, the weekend was an enjoyable change from Tripoli. We had a successful shopping trip and got all of our treasures home with no problem. Customs didn't seem a bit interested. Our purchases filled the entire kitchen counter: mayonnaise, canned hams, spices, brown sugar, powdered sugar, cereal, chewing gum, and floor wax for Mobrouk. He got upset when he couldn't keep our marble floors gleaming. Windows were a different story. He smeared the dirt and grime around the glass a bit, then stood back and surveyed his work with pride. In that area he did not shine. He loved to wash and iron clothes. We learned the hard way not to leave any article of clothing lying on a chair or bed. If we did, it went in the wash. I made the mistake of leaving my full length Royal Stewart wool skirt from the Scotch House in London draped over a chair one evening. The next day Mobrouk washed it, in hot water of course, and it came out minus the pleats and two sizes too small. Once he threw a pair of panty hose I had left on the bed into a wash with bleach, and they came out striped. I used twenty-five pair a year, only in the winter, and I was down to my last two pair. I had to be careful. I couldn't afford to lose another pair.

The weather was beautiful and all my vegetables were growing like crazy, especially the radishes. We looked forward to sampling some of the produce before we left for summer break. The rest would be Mobrouk's. School was going fine. I started a composition unit in all my classes, one I enjoyed teaching more than anything else. I looked forward to reading my students' writings, and it was an area in which I always saw a great deal of improvement.

A week after I made the call from Malta we got a cable from my Mom saying that the doctors found no malignancy and my Dad was given a clean bill of health. Mom sent the cable on March 11, it arrived at OCS at 8:00 a.m. the next day, and Superintendent John hand-delivered the news to me in my classroom. We were relieved to hear that all the tests proved negative and hoped my Dad would be in good shape to go to Norway. It is hard to keep a good Viking down, so we were optimistic.

Mail was slow again, so whenever possible we sent letters with friends who were traveling abroad. Friends John and Ellen were going to the States for a month, and before they left Ellen came over to say good-bye. We weren't home, so she decided to write a note and leave it on the front door. As she was writing, Albert peed on her foot and into her shoe. She handled it with her usual good humor. She decided that Albie was in love with her.

Neighbors John and Peg were flying to London, and the night before they left they invited us over for a pork roast dinner in honor of Peter's birthday which was coming up soon. John was a pilot with Libyan Arab Airlines and his bags weren't checked at customs, so every once in a while he smuggled in a pork chop or roast. Some pilots smuggled in booze. Cautious ones decided it wasn't worth the risk.

After a week of balmy spring weather, it suddenly turned cold again. Peter turned the heater back on, and we declared it the shortest spring we ever had. The days were dreary, but our spirits were high. Easter Vacation

was coming on April 6, and we were headed to Jordan to visit the ancient city of Petra and other sights and wonders. In a travel brochure, I saw a picture of a man sitting on top of the Dead Sea drinking his morning coffee and reading the newspaper. I had to try that.

Early Good Friday morning we boarded Royal Jordanian Airlines for a flight to Amman. We stopped in Benghazi, and while some immigration issues were sorted out we discovered that the co-pilot was our pilot neighbor John's friend. This got us a trip to the cockpit on the last leg of the flight. When we arrived in Amman I kept seeing signs for hotels and restaurants named "Philadelphia." I discovered that the city was once called Philadelphia, named for Ptolemy II Philadelphus around 200 B.C., but was changed back to Amman, closer to the Biblical "Rabbah Ammon," in A.D. 600.

We checked into the Holiday Inn and arranged transportation to Petra the next day. Up at 6:30 the next morning, we had breakfast and were on the road an hour later. As we approached Petra our driver stopped to show us what was supposedly the rock that Moses struck to provide water for the Israelites on their way through the desert. That was highly disputed, but we didn't argue. We had come to see Petra, the ancient capital of the Nabateans, a flourishing commercial center on the caravan route from Arabia to China about the time of Christ. The ancient wonder could be reached only by foot or on horses led by Bedouins through a mile-long winding narrow defile called "The Siq." I chose to go by horse. The ravine was so narrow and deep that at times I could not see the sky. It was no more than fifteen feet wide in some places. This constricted passage likely made the city impenetrable.

The Siq opened up onto a cathedral-like city of rose-red sandstone. Over a thousand temples, tombs, and dwellings were carved into the stone. The façades were Greco-Roman in style and included sculpted columns, niches, statues, and urns. Some of the buildings were 120 feet high. The most impressive of these was the Treasury, thought for some time to contain the treasure of pharaohs but later believed to be just a tomb.

As impressive as the buildings was the stone itself with streaks of

white, yellow, red, light and dark blue, and dark brown. The grain looked like fine wood or marble. Erosion had created some bizarre formations, and the combination of sculpted stone and crude rock was a rare sight. Shifts in trade routes caused Petra's decline, and it had not become a popular tourist site until about 1812. People today were still living in caves chiseled out of the sides of cliffs. The entire time I was there I kept asking myself, "Why have I waited so long to come here?" One could not leave the place without a sense of wonder. In 1985 Petra was decreed a World Heritage Site and *Smithsonian Magazine* declared it one of the twenty-eight places in the world people should visit before they die.

Later in the evening after I had taken a shower, I noticed some big red welts forming on my legs. When they began to itch, I called friends who had taken the tour on horseback with us. My fears were confirmed. We were covered with flea bites. Malish. It was a small price to pay for such a glorious experience.

It was true. It was possible to sit upright in, or should I say on the Dead Sea. The problem was standing back up. The water was so saline that I had to roll over on my stomach and bob my body back and forth to get on my feet again. I doubted that anyone could ever drown in it. It was one of the saltiest lakes in the world, so salty it burned the tongue. It is 1,300 feet below sea level, one of the lowest bodies of water on Earth. After my swim, I did not bother to change at the Dead Sea Bath House, but put on my clothes and rode the fifty miles back to Amman with a salt-encrusted body. We stopped to look at the Jordan River where long ago John baptized Jesus. Three-thousand years ago this spot was probably a mighty rushing river, but today the Israelites would have had no problem crossing over it to the Promised Land. We saw Jericho off in the distance and wished we could go there. Unfortunately, Israel was off limits for people working in Libya.

We were traveling with our friends Mary and Donn, and our next stop was Greece. Before we left Tripoli, Mary promised a friend she would buy a mink jacket for her in Athens, famous for fur coats at cheap prices. The pelts were Canadian, the labor Greek. We stopped to look in Ontario Furs,

a shop on the corner across from Syntagma Square. As soon as we got through the door, a diminutive elderly Greek man brought out a bottle of Metaxa, and as he poured, Mary started trying on minks. Before we knew it, Donn and Peter were trying on coats just for fun. Mary found a mink jacket for her friend, then decided on one for herself plus a full-length fox coat for good measure. By this time, we were all getting into the spirit of things and decided that Donn would look dashing at football games in a long muskrat number. Peter tried on a short beaver model that suited him perfectly. We ended up walking out of the store with five fur coats. We laughed as we crossed the street, and looking back, we saw the little man with the half-empty Metaxa bottle standing in the doorway of the shop. He was laughing too. Since I preferred fur on animals, I spent my money on a 5' x 7' hand-woven tapestry from the National Welfare Organization of Athens. It was a lovely piece in beautiful muted shades of blue, green, yellow, and wheat. Besides, if I needed a fur coat to keep me warm, I knew of a few I could borrow.

We got the coats through Libyan customs with no problem. We had to laugh. Customs officials went to great lengths to sniff out a pork chop, but they let five fur coats go by unchallenged. We christened Donn's coat "Muskrat Ramble" and Peter's "Little Beaver." To my knowledge, neither of them ever used the coats. My tapestry, on the other hand, still hangs on my dining room wall.

Fur coats were the last thing we needed in Libya at the moment. We were enjoying beautiful spring weather, and I was helping myself to radishes out of my own garden. I hoped to have some fresh peas and possibly some beans before we left for summer vacation. I was proud of myself. This was the first time I had planted a garden and been able to enjoy the fruits of my labor.

Shortly after we got back from Easter vacation, an oil company employee returned from the States with a VHS tape of Harry Reasoner's

60 Minutes interview with Colonel Gaddafi. We gathered in small groups to watch a young, charismatic looking Colonel and observe the huge portraits of him that were ubiquitous in downtown Tripoli. Gaddafi declared himself a teacher and shared his wisdom in the *Green Book* which was "required" reading for all Libyans. He periodically went out to the desert to spend time in his tent, pray, and reconnect with his roots. The video showed the same footage of tanks, missiles, and planes that we saw on TV every year in parades celebrating the Great First of September Revolution. Most of the equipment was Russian and beyond the ability of the Libyan military to operate. On Israel, Gaddafi's position was clear. Any Jew who had moved to the State of Israel after 1948 had to leave. Period. Harry presented a country where the economy was booming and every Libyan was entitled to a house and a car, free medical care, and education. He surreptitiously added that Gaddafi had four villas and regularly arranged for the demise of his opponents. None of this was news to us, but rumors that Harry had smuggled in a hair tonic bottle filled with gin for his night cap was welcome grist for local gossip. He probably needed it.

A week later we were shocked by news of the aborted rescue mission in Iran. On April 24, in an attempt to rescue the 52 hostages held captive in the American Embassy in Tehran since November 4, 1979, President Carter ordered Operation Eagle Claw. The mission was a failure. No hostages were freed. The BBC reported that the mission was cancelled after three of the eight helicopters sent in for the rescue failed. Eight U.S. servicemen were killed and others injured when one of the helicopters attempting to leave collided with a C-130 transport plane. We had so hoped that the crisis could be resolved without loss of life. The sight of the blindfolded hostages paraded outside the American Embassy profoundly disturbed us as I was certain it did every other American. Equally concerning for us was Gaddafi's position that any American aggression against Iran would involve him. We met with close friends sharing whatever news we heard and discussing the gravity of the situation. We felt devastated, helpless.

All spring we had been blasted off and on by strong winds and blow-

ing sand, but that was the least of our worries. In early May, six OCS teachers were deported. Their passports were pulled at random by the Libyan government, and the deportees were given forty-eight hours to pack up and leave the country. Some had accumulated over a decade's worth of goods and memories. Overnight, professional teachers became political pawns, put into play because their names were at the beginning of the alphabet. Since their last name began with "B," Helen and Spiro were among the six. We stayed up most of the night helping the "outlaws" pack and wondered, along with them, "Why?" It was impossible for them not to think they had done something wrong. Since they had signed contracts for the next year, they collected an entire year's salary in advance, but that was no compensation for the trauma they suffered. It was a stressful time for all of us, but we went ahead with plans to finish the school year as scheduled. After that, it was anybody's guess. The deportees were chosen at random, but the reason for deportation was never discovered. Gaddafi may have been flexing his muscles in retaliation for the U.S. declaring Libya a state sponsor of terrorism after the attack on our Consulate in 1979. As far as we knew, diplomatic ties between the two countries were terminated.

Our heads still spinning from recent troubles, the following week we were faced with a new crisis. Gaddafi announced a change in Libyan currency, had new five and ten dinar notes printed, seized all money in bank accounts in excess of $3,300.00, and gave everybody one week to exchange the old bills they had on hand. His goal was putting a crimp in the black market and rousting out millions of uncirculated bills, so this created a serious problem for those who had been hoarding money. By midnight of May 17, everyone who wanted to exchange dinar had to turn in an account of the cash they had on hand. For days, no money was in circulation, the shelves in the stores were empty, and throngs of people stood in line outside the banks, day and night, waiting to exchange old notes for new. Some fainted. We all had a quota, a limit of total dinar we could exchange. Some Libyans arrived at the bank with pickup trucks full of old dinar, most of them worthless. One exasperated man dumped a pile of bills on the street and made a bonfire out of them. Most Libyans didn't seem

overly concerned about government mandates as long as they could do their jobs, enjoy their families, and gather around the fire in the evening to drink shahee, but they were incensed that the government was messing with their money. Gaddafi had his hands full. I stood in line for five hours to turn in my quota of old bills. Since we did not have that much cash on hand, we exchanged dinar for Libyan friends who were stuck with a surplus. It was much faster for women to get the job done than it was for men, yet I went to the bank at 12:30 p.m. and didn't walk out with my new bills until 5:30. When I got home, all I could think of was a nice bucket of warm soapy water to soak my sore feet.

The last unit for the year in my English classes was the Development of Writing. The students enjoyed it, and so did I. They made paper from papyrus and parchment from sheep hides, both locally available. They created rock paintings, wrote messages in hieroglyphics, and carved cuneiform symbols in little clay tablets. They used only natural substances, and it was sometimes hard to tell that their projects weren't authentic. It was a good unit to finish the year since it involved quite a bit of activity.

Although we loved the school and friends we made in Libya, we had been considering a move for the last couple of years. Recent events motivated us to start checking for jobs elsewhere and find a place at home to land in case we were given twenty-four hours to evacuate. We narrowed our search for a place to live in the States somewhere between Portsmouth, New Hampshire, and Portland, Maine, then made an appointment to interview with International Schools Services in New York on June 18. We made plane reservations, packed several carpets in a trunk to send to my parents as unaccompanied air freight, made sure Albie was taken care of, and arranged for a villa sitter.

All set to go, our plans changed abruptly when a painful misfortune struck our small school community. The day before graduation the father of Sarah, one our ninth grade students, died unexpectedly. Sarah and her

family had fled to Libya during the civil war in Sudan, her mother had died when she was ten, and now at the age of fifteen, her father died. Sarah was a bright student, at the top of her class, popular with her classmates, a member of NJHS, and the current year's recipient of the Citizenship Award and Oxy Mothers' Award. Now, except for two older sisters and a brother, she was alone in the world. The family could not return to the Sudan, their future in Libya was uncertain, and no school for a student of her caliber was available to continue her education in Tripoli. At such a late date it would be hard to find a suitable boarding school for her in Europe, so that left few options. Peter and I talked it over and made a decision. She would come to the States with us and we would find a place for her to complete her high school education. We discussed it with her family, and they were both grateful and relieved. Sarah's older sister, Nouna, would come as soon as possible to join her. Sarah went through her final days at OCS devastated, but brave. If her father had lived just one more day, he would have seen his daughter graduate with honors.

Members of the community got involved in the effort, one in particular, the head of Conoco in Tripoli. Brooks had connections at the American Embassy in London and made an appointment for Sarah and me to meet with a staff member there on June 10. Peter stayed behind to wrap things up at home, and Sarah and I left for London on June 9. When we arrived at Heathrow Airport, I had Sarah go through passport control ahead of me, thinking that it was a good idea for her to get as much travel experience as she could on her own. After she finished and I stepped up with my passport, the officer in charge asked me if I was transporting Sarah as my servant. I assured him that I was not. He did not look entirely convinced.

Thanks to Brooks, we met with a representative at the American Embassy the following day. Sarah confidently and correctly answered the questions put to her. The only mistake she made was telling the official that she might want to stay in the States indefinitely. He immediately replied, "Never say that. That could jeopardize your chances of getting in the country at all." In the end, Sarah got her visa and we continued to New York where we met Peter at the New York Hilton. We interviewed with the

International Schools Services, and on June 15 our friends Donn and Mary arrived. We spent a few days in the city visiting the exhibit of the ancient terra cotta Chinese warrior statues at the Metropolitan Museum, shopping on Orchard Street, eating at New York delis and Adam's Rib, and going to see *The Shining* and *The Empire Strikes Back.*

From New York Peter, Sarah, and I flew to Portland, Maine, where within a matter of days we found a condominium on the southern coast just waiting for us. It was a Cape Cod style home in the small town of Wells in a new development called Flintlock Village. The name Flintlock Village was chosen to suggest colonial tradition, each unit named after a Maine hero who fought in the American Revolution. Ours was named after 2nd Lieutenant Elisha Allen who served in Captain James Littlefield's 8th Company. Just off U.S. Route 1, we had a beautiful view of the woods and a mile-wide marsh between us and the ocean. The place was small and simple, but we couldn't have been happier. Real Estate Richard, the man who sold us the place, probably never had an easier sale.

After signing the preliminary papers we flew to the Midwest to spend time with our families. My dad and his grandson Richard had not yet returned from Norway, so we visited the Nowells in Appleton first. When the travelers returned to Iowa, we drove to Clear Lake for a grand reunion and tales of hauling in fishing nets on the North Sea with no life preservers on board and doting aunts trying to kill a thirteen year old with kindness and cream cakes. It would be my father's last trip to the place of his birth, and he lived on those memories the rest of his life.

After numerous inquiries, we settled on Iowa City to enroll Sarah in public school and her sister Nouna, who had gotten clearance to join Sarah in the U.S. a few weeks earlier, at the University of Iowa. Comfortable that our brave little lady was in good hands, we returned to Maine to finalize the purchase of our condominium. We were determined not to repeat the White Elephant experience.

August 22, 1980, we finished signing all papers and spent the first night under our own roof. We had no furniture, only a TV set with rabbit ears and Peter's antique rocker. We slept on the living room floor. A few

days before we left for Libya, I went to the Wells IGA for a few groceries and was overwhelmed by the abundance of food. I walked through brightly lit aisles of bug-free cereals, past freezers full of chocolate, vanilla, and strawberry ice cream, shelves of cleaning supplies, baggies, Kleenex and paper towels, cases of clean, cellophane wrapped beef, pork, lamb, and chicken, bacon galore, coolers with gallons of fresh clean milk and boxes of real butter. It was a feast for the eyes. If I could take this one store back to Tripoli, the locals would descend on it like locusts and empty it out in a heartbeat. I happened to pause by a man who was holding an empty shopping basket and perusing twenty different kinds of soup. He looked at me, threw up his hands in despair and said, "I just can't find anything I want to eat." Oh, really.

My U.S. shopping list was long, so we got a shipment ready to send to Tripoli. We were allowed a four-hundred pound air shipment each year. Many years we gave our allowance to friends, but this year we needed it, as you can see.

1. Natural Yeast
2. Cake Flour
3. Chocolate Chips
4. Hot Cups
5. Paper Plates, dinner size
6. Woolite
7. Vanilla, the real stuff (not sold in Libya since some drank it)
8. Rod for kitchen valence, 4–5 feet
9. Pastry brushes
10. Toyota windshield-wiper blades
11. Mr. Coffee filters
13. Hooks for Christmas tree ornaments
14. White cotton thread
15. Disposable rubber gloves, size medium
16. Plug for bathroom sink, 2"
17. Acrylic Spray

18. Postage stamps (for letters sent with friends traveling to U.S.)
19. Extension cords (one long white, one short black)
20. Vegetable and flower seeds
21. Sprinklers
22. Garden Hose
23. Nozzle
24. Panty hose
25. Book of droodles
26. Contact Lens Wetting Solution.

As hard as it was to leave our new home, I felt secure knowing that we had a place to store the worldly goods we had scattered around three states and Canada, and more important, a place to light if we didn't find another job overseas or had to leave Libya on short notice.

<center>***</center>

On September 3, classes resumed at OCS with 505 students from fifty different countries. In the ninth grade alone we had students from 28 countries including Iran and Libya, neither of which had good relations with the U.S. at the moment. We had the usual beginning of the year activities, Open House, Parent Teacher Conferences, and Halloween celebrations. Parent Teacher Conferences were well attended by parents of elementary students, but by the time students reached the ninth grade, their parents knew the ropes and often didn't bother to come. Some students had never heard of Halloween, but when we explained that it involved costumes, pumpkins, witches & wizards, bobbing for apples, treats, and a dance, they jumped right on board.

On November 5 we got the news that Ronald Reagan had defeated Jimmy Carter in the 1980 Presidential Election. The electoral vote was 489 to 49, a landslide. We assumed that the defeat was in part an indictment of Carter for the failed attempt to rescue the Iran hostages, but the economy, inflation, long gas lines, and high interest rates during his term in office

<center>311</center>

undoubtedly played a role. I did not have strong feelings for either candidate, but I was concerned about our country's image abroad. My Mom, on the other hand, was delighted. She was a dyed-in-the-wool Republican, my Dad a loyal Democrat. When he came home from work on election day the first question Mom asked him was, "Did you vote?" If he answered yes, she jumped in the car and went to the nearest polling place to cancel out his vote. If he said no, she took her time deciding.

Seven members of our National Junior Honor Society wanted to take a trip to Ghadames, so they went to work selling pens and pencils to raise funds for expenses. Ghadames, the Jewel of the Desert, was the large oasis southwest of Tripoli that I had visited before. Inhabited by Tuaregs, it was a place guaranteed to provide a lasting memory for anyone lucky enough to travel there. The Libyan New Year was celebrated the second week of November, so Peter, math teacher Glenn, and I took advantage of the three-day weekend to make the trip.

Ghadames was 372 miles from Tripoli, about nine hours' drive on the Gharyan Road, the only overland way to get there. We packed our tents, sleeping bags, and camping gear, and knowing we would find no Super 8s, McDonalds, or Burger Kings along the way, we made huge pots of chili and Sloppy Joes to freeze and take with us in coolers. The bus we rented came with a driver, and since the journey was long, we stopped whenever we needed to find a bush. When we came across large Hollywood-style dunes, we let the students get out of the bus, climb to the top, and slide down. Students complained about the long bus ride, but when we arrived at the old city with its white stucco buildings and dark winding corridors, they changed their tune. We camped both nights, built a fire, dined on chili the first night and Sloppy Joes the next. On the way home we found a perfect camping spot on a ledge overlooking a vast valley. After we set up camp we discovered tank tracks in the sand nearby, traces of the Libyan army. The tracks were not exactly fresh, so we felt safe, but I shudder to think of it now. After dinner, we turned in for a quiet night of rest under the desert sky.

When we returned to Tripoli, we found a letter from Sarah and Nouna,

the first news we had since we dropped them off in Iowa City in August. Sarah was president of the International Club in her high school, and Nouna was working on a graduate degree at the University of Iowa. Both of them were getting straight A's. They were adjusting to their new life, but Sarah got waves of homesickness. That was to be expected. I was happy that they were doing all right. The next time I saw Sarah was in an interview with Brian Lamb on C-Span on July 3, 2005. She had become an American citizen and was following in Peter's footsteps teaching American History and Government. She did well for herself.

In Libya things were looking up. We were enjoying a magnificent fall. Warm days and cool nights. Nothing new going on. Everything quiet and peaceful. We had a good group of students, and so far the school year had been uneventful. I hoped we could get through the year without any major interruptions.

In addition to that, sending money out of the country got easier. The accounts of all faculty members were moved to the main branch of the Sahara Bank in downtown Tripoli, and all of our cable transfers would now be sent home directly from London. It promised to be a more efficient and less frustrating way to do business.

Just as we began to wonder how much better life could get, a family leaving Libya asked us if we wanted to buy their 42" TV set and VCR player. They didn't have to ask twice. We bought both, and for the first time during our ten years in Libya we had a TV set in our living room. There was little to watch on television except reruns of the Great September 1 Revolution Parade and festivities, but we could now borrow videos that people brought into the country and watch them in the comfort of our own home. We started with ten episodes of *Shōgun*, a current TV miniseries based on the novel by James Clavell and broadcast on NBC at home. Richard Chamberlain played the part of John Blackthorne, an English navigator who was shipwrecked off the coast of Japan and held

prisoner by Samurai nobles. We held our breath watching him struggle to adapt to a foreign culture, learn a new language, endure torture and betrayal, and barely escape attempts on his life. The story wove history, drama, and suspense into a gripping story, and watching it in our own living room was an unprecedented pleasure.

The frosting on the cake was the new method of calling home. After ten years of going to the post office to place a call, wait for the call to go through and go to a phone booth when our line was ready, we could now go to the school, pick up the phone in the principal's office, dial the international code and 515-357-4256, and hear my parents' friendly voices in Iowa. It seemed almost too easy and made our families seem a little closer.

We were getting used to this stretch of easy living, but on the last day of November things changed. It turned cold overnight in North Africa, and my hands, feet, and nose were freezing. One day we were in shirtsleeves, the next we needed sweaters. At home, we started our heater and stood by it to warm up. The marble and stucco in the villa got cold as ice when the temperature dropped, but once warmed through, it stayed that way.

More serious, members of Gaddafi's General People's Committees were becoming bolder, more widespread, and openly hostile. Instead of our usual Thanksgiving camping trip to the desert, five families went together and enjoyed a big beautiful bird and all the trimmings in the dining room of our villa. We also invited a couple of bachelors who didn't have plans for the day. We paid $65.00 for our turkey, $5.00 a pound. Back home in Iowa, my Mom bought a thirteen-pound turkey for a total of $3.60. I missed the traditional camping trip, but we no longer felt as free or safe to travel as we once did. Groups of vigilantes could stop anyone and demand to search the vehicle for who knows what. Just the thought of it made me angry and uncomfortable. Even though we were doing nothing wrong, it took the joy out of exploring if one had to worry about thugs going through camping gear, food, and provisions. The good times of past years were slowly being squeezed out of our little world.

At OCS everyone was preparing for Christmas programs, but a com-

munity disaster brought that to an abrupt halt. On December 12 one of the school janitors came to our front door about 8:30 p.m. to tell us the gym was on fire. Peter rushed to campus in the Land Rover, and I jumped in the Toyota and raced over to tell Superintendent John who with his wife Ruth was hosting a Christmas Open House. From there I drove to the campus and joined a handful of people standing at a distance silently watching the gym go up in flames. Pieces of burning insulation flew off the roof into the night sky as we stood by helpless, watching an old friend burn. By dawn, the gym was gone. The destruction was complete. Investigators determined the cause of the fire to be faulty wiring on the stage, not sabotage as some feared. No other buildings were affected and no one was hurt, but the shock was almost physical. The gym was our community center. Thousands of people used it every week. It was our dance hall, theater, auditorium, basketball court, and PE classroom. Throughout its life, it gave us memories of Proms, graduation, plays, concerts, award ceremonies, festivals, and memorial services. The news spread as quickly as the fire. Plans had to be changed, and everyone made the best of it; still, it was demoralizing to see the burned out hulk standing there. By the end of the year the board made plans for a new building, but nothing could replace our old gym.

Christmas parties and programs were modified as were celebrations in homes. We decorated our Christmas tree, a mini-pine that I bought a couple of years earlier and kept potted just for the holiday. It was about four feet high and no beauty, but a local scraggly tree now cost $75.00, prohibitively expensive. Besides, it was a shame to cut down any healthy tree in Libya. I did very little baking - potato cakes, krumkake, sandbakkels, and rosettes - but skipped the usual party. I brought a tray of goodies to our faculty luncheon and gave some to our ghaffirs, as I did every year. Some of them, Feturi, Salah, Hassan, and Mafud Ali, a.k.a. Charlie Brown, were good old friends.

On December 21 we boarded a KLM flight from Tripoli to London via Amsterdam. Since we did not have enough time to make our connecting flight to London, the airline gave us a free night at the Marriott in

Amsterdam, not a hardship as far as we were concerned. While planning our Christmas vacation, I came across a travel magazine with an ad for the Parkwood Hotel near Marble Arch. The ad showed a picture of a handsome Regency townhouse close to Oxford Street and Hyde Park. The room rate was $20 per person, per day, full English breakfast included. That was about half the price of most suitable hotels in London. We decided to try it.

Duncan and Linda, the managers, let us make ourselves at home. The hotel had no real lobby, just a desk and a couple of easy chairs and only eighteen beds. The rooms were simple, clean, and pleasant. Walking down the stairs for breakfast we passed copies of paintings by Edward Lear, 19th Century artist and writer of limericks and nonsense poems, the most famous of which is "The Owl and the Pussy-cat." Lear once lived at a sister hotel close by. Breakfast was a feast of eggs, bacon, sausage, hash browns, baked beans, grilled tomatoes, kippers, toast, and tea or coffee, enough to hold us for most of the day.

On Christmas Day, Boxing Day, and New Year's Day everything in this city of millions shut down. It got dark at 4:00 in the afternoon and the city seemed deserted and lonely. As usual we called home on Christmas Eve to wish our family Merry Christmas and thank my Mom for the package of goodies she sent to us in care of the hotel. We always looked forward to opening her packages. One never knew what treats would be lurking in the little nooks and crannies. This time our favorites were peppernuts and peanut brittle, both delicious. My family had joined other Americans on Christmas Eve remembering the hostages in Iran by shining lights or burning candles for 417 seconds, one second for each day of captivity.

Except for the holidays, we were busy shopping and going to museums, films, and plays. We saw the movies *Elephant Man* and *Airplane*! I visited Harrods, Liberty, Fortnum & Mason, and Marks & Spencer, my favorite stores. I found two $300 cashmere skirts for $80 each, four blouses, and a red vest sweater. English wools were the best, but usually too expensive for me to consider buying. Thousands of lights decorated the

façades of shops on Regent Street, and crowds stood in front of the windows of Harrods and Selfridges to marvel at their elaborate displays. On Trafalgar Square, the Christmas tree that Norway gave Britain every year for their support during WWII was draped in lights, strolling carolers sang and a brass band played favorite Christmas songs. Salvation Army kettles, church bells, and millions of lights made the city feel like a wonderland.

We called the American School of London and asked about prospective openings. They were fully staffed and had a waiting list, but the principal said he would send us an application. Math and science positions were opening up; unfortunately, both of our fields were saturated. We were having a good year in Tripoli but still felt the need to look, listen, and write letters.

The Parkwood, normally quiet, was next door to an apartment building where an alarm rang nonstop for forty-eight hours. The occupants were obviously deaf or had gone away for the holidays. No one could get in to shut the blasted thing off. Malish. The Parkwood was a gem. We had found ourselves a new home in London.

A few days before our holiday ended, I went to Marks and Spencer and spent one hundred dollars on canned bacon, ham, chocolate chips, Hershey bars, two big bags of dry roasted peanuts, furniture polish, and spray starch for Mobrouk. We packed these treasures between layers of dirty laundry and hoped to have no problems clearing them through Libyan customs. On New Year's Day we went for a walk in Hyde Park, watched *True Grit* on TV, and went to the Carvery for dinner. The following day we left for Amsterdam, spent the night at the Marriott compliments of KLM, and got up at 5:00 a.m. the next day for an 8:00 flight to Tripoli. I looked forward to getting home.

1981

We returned to wild weather in Libya, the worst storms since 1948. Nalut, one of the mountain villages, got a meter and a half of snow, and other villages with any elevation to speak of got the same. Libyans were like fish out of water. They were experts at handling sand, but helpless when it came to snow. The roads to Nalut were impassable for forty-eight hours, so food and water had to be airlifted into the village. The temperature was 0° and all pipes were frozen. Near our villa, the waves were eight meters high, and the seas took a buoy marker weighing several tons from the Tripoli harbor and threw it into the channel.

The record breaking storm brought news reports of thirty-seven foot waves and eighty-seven mph winds in Benghazi, hurricane force according to the Beaufort Wind Scale. In Tripoli we were being pulverized by sand and worrying about windows blowing out. Several days we were without power for eight-hour stretches. Once again, our water heater gave up the ghost, so we grabbed our soap and towels and made the rounds to friends and neighbors for showers. To avoid wearing out our welcome we picked a different friend for each outage. We were all like family, so we thought nothing of it at the time. During the dark and stormy nights I curled up by the fire and read *Elephant Man*.

In spite of the weather, spirits were high after hearing the news from Tehran of the release of the American hostages after 444 horrific days in captivity. We knew it was a day of rejoicing in the U.S. and we wished we could be there to hear and see the coverage. Along with the families of the fifty-two hostages, we were beside ourselves with joy.

Our latest food crisis was a shortage of eggs. They were as hard to

find as hens' teeth, pun intended. One evening as I was waiting in the audience at school for a student program to begin, a friend stopped by my seat and whispered in my ear that the Saba Shop had eggs. I immediately left the room, jumped into the car, and headed for the Saba Shop. I entered the store pretending to be browsing, looking for olive oil or garbonzo beans, then when the shop was empty, I approached Mr. Saba and asked if he had "Dehee," eggs. He went to the door leading to the back of the shop, parted the curtain, and returned with a tray of the coveted little jewels. He charged me the regular price, and I left the shop with my treasure. As I crossed the street to my car, passersby screeched to a halt in the middle of the sand street and looked out of their car windows as if they had seen a vision. They pulled over to the side of the road and made a mad dash into the shop. I'm afraid I gave Mr. Saba more business than he bargained for, but it was hard to camouflage a tray of twenty-four eggs. I drove home pleased with myself, and every time I opened my refrigerator door, I patted myself on the back for yet another victory. We used them sparingly.

Our friends Mary and Donn were planning to leave Libya in the spring, so on weekends Mary and I started visiting some of the places she wanted to see once more before she left Tripoli. We went to the Villa Volpi, a beautiful residence where the Italian Contessa Anna Maria Cicogna Volpi lived until 1969 when she was kicked out of Libya with other Italians. The villa was built by the Karamanlis in the late 18th century and was now an Islamic museum housing Ottoman artifacts. The ceilings, courtyards, fountains, and pools all showed a heavy Turkish influence. The courtyard was full of bougainvillea, jasmine, papyrus, palms, and water lilies. It was a little paradise.

We stopped at our friend Vera's for coffee and scones then went to a small Protestant cemetery by the harbor where five American sailors from the USS Intrepid were buried. It was a sad little cemetery with only about

twenty-five graves, mostly diplomats from the late 1800s. One ancient olive tree provided scant shade for the tombstones.

One weekend Peter, Donn, and friend Brooks joined Mary and me on a trip to Misurata, a village about 130 miles east of Tripoli. It was known among ex-pats as "Miserable Rotten," and was locally famous for hand woven rugs. Mary bought two. I bought none. I had no place to put them. We walked through the vegetable souk, bought fresh hot bread from the baker and tore pieces off to eat as we wandered the streets of the village.

We found a sheltered area near the sea for a picnic and afterwards climbed a huge sand dune. When we got to the top we were nearly blown over by the wind, but we had a spectacular view of the Mediterranean. We went on to Zliten, Mobrouk's home town, and saw the remains of Dar Buk Amar, a Roman villa, and finally to Leptis Magna to see the amphitheater and the harbor. We knew they were near military installations and off limits, but we decided to take a chance. We shouldn't have. Soldiers descended on us within minutes, lined the men up against the ancient Roman harbor wall and held their guns on them. Mary and I were told to stand off to one side. Brooks spoke Arabic, and after a short exchange was allowed to leave and get his car. He returned in no time, threw all the car doors open, and said, "Don't talk. Just get in." We did that, and he roared off. We didn't feel afraid at the time, but in retrospect, we should have. We were pushing our luck.

Peter and I were still wrestling with our decision for the next school year. Sixteen teachers had resigned and I felt that our days in Tripoli were numbered, but it was unsettling to leave when the job market was so tight. At last, on Thursday, January 22, 1981, we resigned our positions as teach-

ers of history and English at the Oil Companies School. It was a traumatic experience. I didn't sleep for a week. We had to turn down a 21% increase in salary which made it even harder. Still, we hoped we had made the right decision. Superintendent John suggested that we stay one more year, but we had to make the break sometime. We were notified of overseas openings in Jiddah, Singapore, Karachi, and London. People keep reassuring us that we would find jobs, but being unemployed was scary.

We were worried about Mobrouk. Finding him another job would be difficult. Teachers who had been in Libya for years already had help, and most of the new arrivals weren't in the market for a houseboy. We would miss Mobrouk, not only for his help but also for his friendship. After all these years, he had become like one of the family.

Once again, the weather got our attention and became a more immediate concern. We had snow in the mountains and students told us it had been reported at the airport. Lightning flashed, thunder rattled the windows, and poor little Albie cowered under the blankets in his basket on the patio. For the first time in his life, he asked to come inside, probably because Gretchen wasn't with him. It was weather not fit for dogs. A few days later we had a cold spell, so cold that several people were found frozen to death in the mountains. Emergency units were called from Tripoli to determine why people in tents, perhaps Bedouin, were not waking up. They had frozen in their sleep.

The week of Super Bowl XV we all congregated at the home of an OCS family to watch the game. The family had a fellow oil company employee videotape the game in the States and bring it into Libya the following day. We had soup and sandwiches and watched the Oakland

Raiders whip the Philadelphia Eagles, 27-10. We all purposely refrained from listening to the game on the radio so the score would be a surprise.

The first week of February we drove to school, parked in our usual spot, taught a full day of classes and came out to find the door of the driver's side of our Toyota crushed. Several people witnessed the deed from a classroom window but didn't get a good look at the party responsible. It was most likely a school employee, but no one owned up to it. We thought the school might pick up the tab, but no luck. We didn't have insurance, and since the only way to get behind the steering wheel was to scoot in though the passenger side, we had little choice. We had to get it fixed. Never mind. Another *malish* to add to the list.

We had been living with the decision to resign for a couple of weeks, and most of the time it felt right. The most positive lead we had was the Singapore American School with openings in both history and English. The pay was not outstanding, but the jobs looked good and the place, according to all reports, was a paradise. People were trying to talk us into staying, but I was comfortable with the decision to leave. Peter would probably have stayed forever.

Our villa was starting to show signs of moving. Since Donn and Mary were returning to the States about the same time we were and had no weight limit, they let us add some of our treasures to their shipment. We packed up our Indian carved screen, a large painting, two trunks of brass and copper, then loaded everything into our Land Rover and headed downtown. The load was heavy, but with the help of the elevator Peter managed to lug it up to their apartment on the sixth floor of the Oasis Building. The school gave us six-hundred kilos (1,323 pounds) of unaccompanied air freight to the U.S. We hoped that would cover the remainder of our shipment. When Peter totaled up the value of all the earthly goods we had invested in our villa over the past eleven years, it added up to over

322

$14,000. The school bought most of the basics - bedroom set, drapes, love seat - and we already had buyers for our vehicles, TV, VCR, freezer, sewing machine, Cuisinart, vacuum, buffer. Appliances, kitchen supplies, and electronic equipment were always in great demand. Price was no object, but like most families who left Libya, we charged buyers only what we had paid for the items.

<center>***</center>

So far this year the weather had brought hurricane force winds, snow in the mountains, thunder, lightning, and torrential rains. Finally, after being stuck inside for so long we felt like moles, the sun won out. We had several toasty days in a row of famous Tripoli sunshine, and it felt good. I opened all the windows and returned the sweaters to the closet, at least for the time being. One fine weekend, Brooks, Mary, and I celebrated the return of the sun with a walking tour of the old city of Tripoli. First, we visited an ancient school for Koranic scholars. The setting was quiet and serene, and inside were little monk-like cells for each individual scholar. We continued on to the courtyards of several old caravanserai. Under layers of sand and dust we could make out patches of colorful mosaics on the floors and walls, still beautiful after all these years. The crumbling old structures were picturesque, even in ruin. The walls, balconies, and staircases were in desperate need of repair, but it was easy to imagine them in their original splendor. Outside, the streets were lined with black plastic garbage bags that birds and critters had ripped open. We stepped over egg shells, orange peels, damp twisted Winston wrappings, and paper towels stained with coffee grounds, blood, and who knows what else. All food for flies and stray cats.

As often in our explorations, we were the only visitors. The only other

<center>323</center>

human we saw was a rheumy-eyed *shabani* scraping his way down the narrow, baked, sand streets. He wore a wheat-colored barracan and old crusted shoes with the backs worn flat. His heels were yellow, cracked and calloused. He may have been a self-appointed watchman.

We stopped at the tiny Greek Orthodox church of St. George that Helen and Spiro attended during their stay and concluded the tour with the Gurgi and Karamanli mosques. Their sleek white minarets looked like rockets ready to launch into the blue Mediterranean sky. The exteriors of the mosques were simple, but the interiors were as elaborate and intriguing as the Middle East itself, a busy combination of richly colored hand-painted tiles, hand-carved wood, ornate Persian carpets, domes, and dim lights.

When I got home, Peter and science teacher Willy were in our back yard working on the water heater again. This time the problem was the pilot. It would not stay lit. Every night, Peter had to come home from school, drain it, then fire it up for baths, showers, and laundry. I heated water on the stove to do the dishes, three or four kettles for some sessions.

Our letters of application for jobs were in the mail, my National Junior Honor Society program was organized, and just as life began settling down a bit we found out that we had two interviews scheduled in Athens on February 25, one with the superintendent of the Singapore American School and one with the American Community School of Athens. We made plane reservations to leave on the 24th, but Olympic Airways employees went on strike and our flight was canceled. The morning of the 25th we got up at 5:00 and drove out to Tripoli International Airport to try again, but there we sat for hours waiting to get to Benghazi, a.k.a. "Benghastly," and catch our connecting flight to Athens. As it turned out,

the cause of the delay was a major earthquake fifty miles south of Athens. This was not starting out well.

By some miracle we made it to Athens on time and had our interviews. Dr. Lyden from Singapore was exhausted from a head cold, being on the road for a month, and from the earthquake he had been through the night before. It measured 6.6 on the Richter scale, damaged the Parthenon and other antiquities, cracked the exterior wall of the Hilton, and broke several windows. Guests were evacuated twice, once at 11:00 p.m. and once at 4:00 a.m. The hotel was 60% occupied the day of the quake, 20% the day after. Turns out, we were lucky our flight was canceled.

Singapore American School was about twice the size of OCS and went through grade twelve. It had a reputation of being one of the finest schools in the international system, and Singapore looked like a beautiful place to live. Dr. Lyden told us he would let us know in two weeks if we had jobs. We interviewed with Mr. Dorbis at the American School of Athens, but no matter how much I loved this city, I was afraid we couldn't afford to teach here. The salaries were low and the cost of living high. The campus looked a bit untidy and the atmosphere seemed somewhat hectic, but the positions looked good.

After our interview with Mr. Dorbis, we walked through the market area and saw stall after stall of beautiful fruits and vegetables, meats, fish, ducks, and chickens. I wanted to pack up a truckload and take it back to Tripoli, but I settled for twelve apples, six pears, two bags of pistachios, and a package of wieners.

We appeared to be the only Westerners on our flight back to Tripoli. The plane was an airbus, huge and wobbly, full of laborers and a Libyan bride still dressed in her finery. Our luggage came with us, but we had to wait five hours for it once we arrived in Tripoli. The terminal looked like an evacuation center, full of men who had been in Libya to cash in on the

labor market and were now returning to Egypt, Chad, Tunisia, Morocco, and the Sudan. The men were going through customs loaded with radios, TVs, and VCRs, ready to return home as heroes. All their earthly goods were rolled up in blankets or packed in bulging cardboard boxes, but before they could leave the country, they had to endure the cruel scrutiny of power-mad customs officials who regarded the laborers with disdain and pawed through their possessions as if they were rubbish. We saw a Palestinian who was slapped so hard on the cheek that it brought tears to his eyes. He had to stand there and take it. It was all we could do to keep from grabbing the slapper and shaking him.

Donn and Mary were still around when we got back, waiting stoically for their bank clearance, a requirement for final exits. Finally, on February 28, Mary went to the bank at 8:45 a.m. and came back at 1:00 p.m. with the magic piece of paper that said they were cleared at last to leave the country. We spent the last hour in their apartment, then reluctantly took them to the airport. After all that waiting, their final exit went quickly. When I took a shower that night, I broke down and cried. Everything seemed to hit me all at once: seeing dear friends leave, moving, looking for a job. The next morning I walked out of the villa at 5:00 to the smell of damp charcoal burning, a familiar smell of spring in Tripoli. The birds were singing their hearts out and for the first time in almost eleven years, I had a beautiful crop of grass in the back yard. It was probably due to all the rain we had during the winter more than my expertise as a gardener. I hated to go back inside, but I had to get ready for school.

<p style="text-align:center">***</p>

The month of March brought ups and downs in everything including the weather. One day it was hot, the next day cold. One weekend I mowed

and raked the back yard, trimmed the poinsettia trees, and put up the umbrella. We sat outside laughing, eating strawberries, and drinking iced tea with visitors who dropped by. The next day it turned so cold I had to come home from school and change into warmer clothes. It couldn't seem to make up its mind. The latest rumor was that everyone would be without water for two days while we were switched over to a new city water system. That was a long time to be without water when one considered dishes, baths, and toilets, so we filled the bathtub, buckets, every vessel in the house. Nothing happened, but we heard that it was still in the plans for the future. If so, we would fill everything up again.

One spring afternoon the whole school gathered in the new recreation building to watch the drama students perform *The Wizard of Oz*. The place was packed, and the show was good. The cast was multinational, including one Iranian. Farhad enrolled shortly after the hostage crisis in Iran was resolved and was terrified to enter an American school. He needn't have worried. He had friends in no time. When it comes to overlooking differences, kids beat grownups every time. Our student body was now made up of forty-nine nationalities including Danes, Yugoslavs, Norwegians, British, French, Somalis, Indians, Pakistanis, Hungarians, Turks, Swedes, Spaniards, Chinese, Japanese, Jordanians, Egyptians, Lebanese, Italians, Bangladeshis, Australians, Portuguese, Syrians, Palestinians, Hungarians, Finns, and Brazilians. We had our own little United Nations.

Speculation had it that all the small neighborhood shops on which we had grown to depend were being closed for good. I dashed home for a bite of lunch and on my way stopped at the Green Shop for oranges, carrots, apples, and cucumbers. It was hard to imagine life without the kindly, dyspeptic, chain-smoking owner Ramadan who had been propped up behind the cash register for the last eleven years. The shop exuded the healthful aroma of freshly baked white loaf bread and cinnamon rolls, his specialty.

I had stopped there regularly for produce, and on occasion was rewarded with such prizes as pancake syrup, Bisquick, and Tide hidden away on his back shelves. We hoped the rumor wasn't true.

One weekend I cooked all day for a joint birthday party for Peter and farewell party for our neighbor Peg, another dear friend who was leaving. I scrounged around and found the makings for a respectable dinner of chicken a l'orange, brown rice with pine nuts, fresh carrots, coleslaw, homemade rye bread, and Bonga-bonga for dessert. It was a dessert we had at the Buca Lapi in Florence years ago, tiny cream puffs filled with vanilla custard, drizzled with warm chocolate sauce, and surrounded by fresh strawberries. When dinner was finished, we agreed that even Julia Child would declare it fine dining.

The next weekend I stayed home and finished *The Key To Rebecca*. It was the calm in the storm these days, a place to jump in and lose myself. We had gotten telexes from several schools that we had applied to saying that they were fully staffed for next year, and Saturday morning our friend Brooks arrived with the news that we did not have jobs in Singapore. He had just received a telex from the Conoco office in Singapore. Word got around, and lots of friends stopped by to cheer us up. It helped, but our hopes were dashed and our weekend ruined. We watched *Zulu Dawn* to drown our misery.

The following Thursday at 9:00 p.m. a Libyan bursting with authority came to our front door with papers laying claim to our villa. A Libyan family had decided they wanted OCS Villa 12, and since our landlady in Benghazi owned sixteen villas, they were entitled to one of them. It looked as if we would have to move. We had been lucky to live in the same place, on the same street during our stay, and our home was full of memories. Ah well, I thought. We were planning to leave anyway. If we had only twenty-four hours to get out of the villa, we would get through our packing in

a hurry. Fortunately, due to some fast talking by business manager Roger & administrative assistant Don, we got a reprieve and were able to stay in our villa for the duration. In fact, the school would be able keep the place as long as they needed it, and our friends Rick and Barb could move in when we left. I was prepared to move if we had to, but I was relieved and pleased that I would be able to finish out my time in Libya in the place I had called home for eleven years.

<p style="text-align:center">***</p>

The rumor was true. Most of the small food shops in our neighborhood were closed, so Peter and I went to the new government stores on a mission to find coffee and whatever else was available. The buildings were cavernous, bright and shiny, but we found only laundry soap, olive oil, and cans of tuna on the shelves. I was pretty sure the food was out there, but where to find it? Since we were not going out of the country at Easter, a friend and I spent an entire day on a quest to restock our cupboards. We went to Fowzi's, the Darah Market, Sager Market, and our old standby, the Italian Market. We were not successful. We heard a rumor that the Darah Market had green apples, so we joined a long line and waited for an hour to buy a bag. We had been eating oranges for so long that the thought of a crisp, green apple made us lose our heads. Sad to say, by the time we reached the head of the line, they were gone. As we stood in line waiting, an eighty year old *shabani* walked by and patted me on the bottom. I was speechless.

Meanwhile, just putting dinner on the table for the two of us was becoming increasingly difficult. One day when we got home from work I made beef chow mein, but it was so bad we couldn't eat it. Instead, we opened a package of Kraft dinner that Peter had gotten as a Christmas

present. Soon after, we sat down to another inedible dinner of pea soup and meat too tough to chew. The last straw was chicken-fried steak. After the first bite, without a word we both stood up from the table, went to the kitchen, and dumped the nasty stuff into the garbage. I gave up. Rumor had it that all the good food was going to the army, so I lit the oven, baked some rye bread, brownies, and peanut butter cookies, made yogurt, custard, and fruit salad. The Bedouin existed on bread, dates, tea, sugar, and milk. We could do that too. Plus cookies.

The past few weeks had been rather tense for our whole faculty, so we did the only reasonable thing. Got silly. During difficult times, anything could set us off. This time, it was hamburger buns. Our principal ordered eight-hundred of them from the Homs Bakery for an upcoming school event, and he asked our band director to drive out to get them and bag them up for the freezer. Andy suddenly got "too busy," so the rest of us came to the rescue. The Homs Bakery was fifteen kilometers west of Tripoli and famous for its lighter, sweeter, softer sandwich loaves, glazed doughnuts, large sweet rolls with cinnamon and raisins, and the main attraction, hamburger buns. Everything was baked in a different order every day, and nothing was ever available at the same time. It was not unusual to see cars parked on the side of the road and a line of people in front of the baker's window. The atmosphere was always convivial and we always met friends there, some we hadn't seen for a long time. The aroma was sweet and wholesome, and the anticipation of Homs Bakery bread on the table made waiting worth while.

As soon as the guys came back to campus with their eight-hundred buns, we all pitched in and soon the entire school freezer was full of them. To remind Andy of his indebtedness to us, for days we made sure he found buns everywhere he looked: on the end of his baton, in his briefcase, in his pockets, in his mail box. We even talked his wife into putting one on his

330

pillow. A humble hamburger bun provided us with a week's worth of laughs. It reminded us of the reason we had stayed in Libya for more than the two, possibly three years we had planned. We had students that most teachers could only dream of and colleagues always ready for a laugh, often at themselves.

Sometimes when we sat around talking about nothing in particular we assigned nicknames for people at school and in the community. You have already met Dr. Filth of the Oil Companies Clinic who earned his sobriquet by endlessly complaining that "Everything is filthy, just filthy." A dress-alike elementary teaching couple we labeled The Twins. A handsome young bachelor from Ohio became known as "Purgood" thanks to his unfailing reply to the question, "How are you?" Pur good. Andy the band director whose real name was Arvid became Starvid-Arvid, just because it rhymed. For reasons unknown, we all called Mahmoud, an especially friendly janitor, Charlie Brown. A tiny couple employed by an oil company became known as The Muppets. One single gal, a child of the 60s, was dubbed Free Spirit, and an administrator who left his position and went back to the States without telling anyone was thereafter referred to as Mad Dog. We were not always kind.

<p style="text-align:center">***</p>

Staying home at Easter instead of traveling to Rome, Malta, Beirut, or Cyrenaica was relaxing. It was a luxury to sleep in on mornings when I usually had to work. I swam at the Underwater Club every day, read books, watched videos, and went to friends' houses for dinner. Every morning I got up early, exercised, made coffee and played with Albie. Only two other times we did not leave the country at Easter. The first was 1973 when we took our camping trip to Cyrenaica, and the second in 1975 when my par-

ents came to visit. I enjoyed my vacation at home. Now I wondered why I hadn't done it more often.

I also did a bit of work. Fellow rug owners assured me that Persian rugs needed a bath every year, so I washed my Persian and Tunisian carpets with a mild detergent and soft brush and rinsed them off with the garden hose. They got so heavy that I needed help hanging them over the villa wall to dry, but in this hot, dry climate they dried in a day or two. I regarded carpets with awe and treated mine with kid gloves, but I heard that in parts of the Middle East they were laid face down on the sand fresh off the loom and camels walked over them to make them pliable. I needn't have worried.

I set aside one lovely late April day for packing. The birds were singing and a gentle breeze was blowing through the French windows. This I would miss. I started going through drawers sorting socks and silverware, deciding what stayed and what would go. I took an inventory of the kitchen and decided to take as many of my utensils as our weight limit allowed. It would be expensive to replace all of the handy gadgets that I had collected throughout the years. I packed a trunk with all of our "valuables," rugs, crystal, porcelain, silver, and looked forward to letting them find their places in our new home. That would take a while. Our belongings were spread out from Maine to California to Iowa and Canada. It took eleven years to accumulate the things we needed to make life comfortable during our stay in Libya, and only a few short weeks to dispose of them. Many items went to friends and Mobrouk.

That evening our power went off again. That was nothing new, but the cause of this one was a power surge so strong it melted our fuse box. When we told our neighbor across the street, he came to the rescue. He got a shunt transformer from the oil company where he was employed, had it installed, and in no time we were back in business. We could hear it cor-

recting constantly. It made a regular slurping sound like a suction device in an operating theater, but it kept the voltage steady and we were thankful for it.

It was starting to register that we were leaving. It was scary.

The first full week in May we had our annual Field Day. I woke up at 4:00 a.m. listening to rain on the roof, but the day turned out nice and hot, just the way it was supposed to for track and field events. The day started with competitions in running, jumping, and throwing. Teachers served Sloppy Joes for lunch, students cooled off under the water sprinkler, spent the afternoon competing in novelty events, and finished the day with a tug of war between homerooms. My homeroom got creamed, but Peter's was the ninth grade winner. Actually, there were no losers. Everyone had a great time.

When we got home, I tore into the book inventory and Peter took down the drapes. When they were down, he got so depressed he cried. Donn had given them to us when we had the villa interior painted, rich gold pinch-pleated drapes that had never been used. They covered almost an entire wall, and the living room looked bare without them. Judy and Andy were having the inside of their villa painted, so we decided to pass the drapes on to them. We went over to help them move furniture at 6:00 that evening and ended up talking until 1:00 in the morning. What is it about moving and house painting that inspires people to sit around until the wee hours solving the world's problems?

That weekend we drove to Sabratha Shipping and Stevedoring in downtown Tripoli and made an appointment for them to pack us up on May 14. It took us two hours to get through Tripoli traffic, and two minutes

to make the appointment. On the way home we stopped at one of the new superstores to look for trunks, but no luck. After seeing the way the packers threw Donn and Mary's possessions into crates, we decided to do most of the packing ourselves. We were thorough. We typed up an inventory of every last cassette and spatula.

Soon after, I took Albie to the vet to get started on shots and other requirements for the trip home. It was a disaster. He peed all over the vet's office and almost destroyed the interior of the car and me. I had to change clothes when I got home. What would he do, I wondered, caged up in the hold of an airplane on the long journey home?

On May 14, packing-out day, Peter met the Sabratha Shipping crew at the Giorgimpopili post office at 9:15 a.m. and brought them home. They worked quickly, but just when we thought they were finished, the censors decided they wanted to see our cassettes. Peter had to rip open two crates to find them. They found nothing of interest, so he repacked the crates and both shipment and crew were on their way by 10:00 a.m. The packing crates weighed more than the actual goods, but we managed to stay under our six-hundred kilo weight limit. We were instructed to go to the cargo terminal at Logan Airport to claim the shipment when it arrived about the first of July. The school paid for door to door shipping, so it would be loaded on a truck in Boston and delivered to Maine. We hoped everything would arrive in good shape.

Meanwhile at school, the NJHS had its annual Teacher Appreciation Day. This year, the students served lunch to the junior high faculty in the new recreation building and roasted us afterwards with Mother Goose rhymes rewritten to portray each teacher. I received a gift of flowers for my "retirement." Peter was named "Teacher of the Year" and given a gold Dunhill lighter. He was delighted.

So much was going on that I missed Mother's Day again. Fortunately,

the kids came to the rescue and told me during the day, so I called home to wish my mom a Happy Mother's Day. It was good to hear her voice. I looked forward to being able to pick up the phone whenever I wanted, not having to worry about time zones, and getting calls through without waiting. The following day I woke up about 4:00 a.m. feeling too hot with the covers on and too cold without, a sure sign a ghibli was on the way. By 1:30 in the afternoon, it got nasty and made us all restless. Fortunately, it lasted only one day. Shocking things seemed to happen during the month of May. Our ex-pat community had more expulsions, and everyone was speculating about repercussions from that. Yet another villa on our street was broken into. During our stay in Libya, ours was the only villa on the block that had not been burgled. For that we thanked Gretchen and Albert, the world's best surveillance team. Worst of all, we heard the news that Turkish terrorist Mehmet Ali Ağca attempted to assassinate Pope John Paul II as he was entering St. Peter's Square on May 13. Although the dearly beloved Pope was struck four times and lost a lot of blood, he survived. We were pulling for him.

On the bright side, our friends Skender, Carol, and Keith had a farewell party for us and gave us a Turkish rug as a going away gift. At home, I started taking Albie on walks with a leash to see if there was any chance of him adhering to doggie protocol. Much to my surprise, he seemed to enjoy it. I was encouraged. Most important, we got our final exit visa on May 17, Norwegian Constitution Day. The visa was valid for one month, so we had to be out of Libya by June 16. All of our belongings were sold or given away, our shipment was gone, our papers were in order. The major concern now was bank clearance. That was always a nightmare. Each day I found myself fluctuating between angst and euphoria.

One fine weekend morning near the end of May I got up feeling refreshed. When I looked out the bedroom window, a bright white moon

was still shining through the tree branches. The villa looked empty, but sparkling. It was so bare that our voices echoed off the walls. Since it was the weekend, I decided to take the day off, sit on the couch with my books and coffee, and watch the day begin. The birds were in fine form as usual, and it promised to be a lovely day. I spent the afternoon in the back yard enjoying the sunshine and reading *Music for Chameleons*, went for a swim, then ended a perfect day at Paul's, one of our bachelor friends, for a barbecue and cribbage.

The last day of May I woke up feeling sad about leaving. I was restless. Having no job was new to me, and I didn't like it. That evening we stopped at the Prom for a short time, and although the theme of the dance, "Please Don't Go," wasn't intended for us, it hit home. We drove from the dance to a farewell dinner in downtown Tripoli, and when we left the party about midnight, few cars were on the road. After driving several blocks we saw headlights in the rear view mirror. The driver honked his horn and flashed his lights, but since the streets were nearly deserted, we did not stop. Soon he tried to cut us off and we realized that we were being trailed by vigilantes, three young men in a pick up truck. Gaddafi had given Libyans the authority to stop anyone they pleased if they felt something was amiss, a perfect excuse for desperados to intimidate expatriates. These self-appointed enforcers of the Colonel's decree followed us all the way home, often endangering themselves and us. When we got to our villa gate, we had to make a decision. Deal with these tough guys ourselves or go to the police station and let them handle it. We opted for the police, drove to the closest station on Zavia Road, went in and explained why we were there.

The police sent the vigilantes packing and began asking us questions. What is your name? We told them. Where do you live? Giorgimpopoli. What do you do? *Ana medreset fe cherkat al betrol* (I am a teacher at the

Oil Companies School). Where were you? Downtown Tripoli. What were you doing? Having dinner with friends. What are their names? Ted and Alice (made up). Where do they live? We don't know the address. The police wanted to send me home, most likely because I was a woman, but they wanted to keep Peter. They probably suspected him of drinking or other dastardly deeds, but I refused to go without him. I had heard of husbands being incarcerated without cause and taking forever to get out, and in fifteen days we had to leave the country. We argued back and forth civilly for at least an hour, and finally my Norwegian stubbornness prevailed. The police allowed us to leave together but followed us home and came back later to check on us. To their credit, they were never impolite. I was brave as a trooper though the whole ordeal, but I woke up the next morning trembling.

We had hot, ghibli weather our last days in Libya. One day when I got home from school, I felt so grungy I submerged myself in the bathtub then took a shower. Our friend Keith, a sixth grade teacher, decided he had listened to the junior high band next door to his classroom long enough, so he went to Superintendent John in protest. To my dismay, the band was reassigned to Room #1, two doors down from me. I added this to the list of reasons to leave the country. Every morning at 8:00 students hammered away at "Rhinestone Cowboy." To this day I hate that song. My classes were the highlight of my days. We made "paper" from the papyrus I cut in my neighbor's back yard and composed messages in hieroglyphics to write on them. They looked authentic.

With heavy hearts, we gave up on the idea of taking Albie back to the States with us. He could not tolerate closed spaces, not even for a minute. Putting him in a cage on a flight to Amsterdam, changing planes, and keeping him locked up all the way across the Atlantic would be cruel. I knew he could be sedated, but he would have to stay that way for days. I was left

with two alternatives. Put him to sleep or try to find a home for him. The thought of snuffing out all that life destroyed me. I didn't know what to do.

June 3 was graduation day at the Oil Companies School. Our last. Tears came to my eyes as we rehearsed in the morning. Since the gym burned down and the recreation building was not large enough to handle the crowd, we held the ceremony outside. I read the names of the graduates, Superintendent John handed them their diplomas, and together Peter and I presented the Waldum Memorial Award to Gloria, a ninth grader who exemplified all the requirements of the award. Yukiko, our elegant graduate from Tokyo, played her flute against a backdrop of corrugated tin and the burned out hulk of a gym, a triumph of beauty over ashes. Although the setting left much to be desired, it was a memorable ceremony.

Superintendent John presented us with certificates for "Eleven Years of Dedicated Service To OCS." He gave me a letter commending me for an excellent English Department and thanking me for the stability I had given it and the improvements I had initiated the last eleven years. He said the school would not be the same without us and wished us the best as we went back to our home in Maine. He looked forward to visiting us one day for a lobster dinner.

At home, friends stopped by often and stayed late. Sometimes, both of us felt like hiding. All of the papers pertaining to our departure were stacked in piles on the dining room table, and our villa had the look of a military command post. To escape, I checked out Doctorow's *Loon Lake* from the Petroleum Wives Club Library.

At last, we found a home for Fat Albert. Mahmoud, the student who tried to help me find a vet for Gretchen, was eager to adopt him. He lived on a farm, loved animals, and had an uncle who was a vet. I felt that Albie would be in good hands. When we took him to the farm, Albie was skeptical at first, but we had Mahmoud feed him a couple of pieces of meat loaf

that I had made, and he seemed encouraged. I said goodbye, cried all the way home, and was despondent for days. People who stopped by were upset not to find Albie in the yard. We were, too. To this day I agonize over the decision, sometimes in the middle of the night.

Getting out of Libya turned out to be as challenging as getting into the country. On Saturday, June 6, Peter went to the Sahara Bank with high hopes. His mission was to withdraw our remaining balance, close out the account, and get our final clearance for departure by the 16th. Lines were long and nerves were short, and he waited for hours only to be told, "*Boukra*." "Tomorrow." Sunday, he started the proceedings again, beating a path between Sahara Bank on Zavia Road and Central Bank in downtown Tripoli. Same story. "Tomorrow." When he went back on Monday, the man in charge threw the papers on the counter and said, "One week."

Sahara Bank employees had a reputation for asserting their authority and making people grovel for their money. They regularly maintained they were missing a vital document, but the holdup was often a clerk reveling in his little moment of authority. They loved to make the worn out supplicants lose their cool. Monday, a woman at the end of her rope whispered, "Bastard," under her breath. The bank got deadly quiet. Everyone silently agreed with her but knew she was doomed. She was immediately hauled off to the police station just down the street. What would happen to her we did not know. It was a humiliating, frustrating experience, but we were captives. Until we were cleared by the bank, we couldn't even make plane reservations.

Always the optimist, Peter was back at the Central Bank of Libya at 8:05 Tuesday morning. He took a number and began his wait. When he got to the teller and turned in his number, the man didn't even look up, the ultimate insult. He muttered, "Later," in Arabic. As if in apology, the man at the next window said, "Tomorrow, or the day after." We were resigned to

wait as long as necessary.

Later in the day we stopped by the OCS campus and saw Roger, the school's business manager, and Mohammed, a wealthy Libyan with ties to the American community. Mohammed knew about our problem and had paid a visit to the Central Bank of Libya that morning. Miracle of miracles, he got the papers we needed and we were cleared for exit that very afternoon. We were stunned. Peter had engaged in battle for five days with no results. Mohammed accomplished our clearance with the wave of a hand. He knew the right people. For his kindness, we located a $70 black market bottle of Johnny Walker Red Label and gave it to him along with our sincere gratitude.

June 11 was American Forces Evacuation Day. We kept a low profile, as usual. I went to the Underwater Club hoping to swim, but it was closed for the holiday. I had gone the day before and got caught with my expired 1980 membership card, but since I was leaving the country in a couple of days, I got a reprieve. I had been thinking of everything I missed in the last ten years (including three leap years) and 174 days. Christmas at 620 in Iowa, fresh milk, hot dogs, pork roast, paper towels, Ziploc bags, the Sunday paper, red barns, cozy houses built of wood, white churches with tall steeples, the family growing up, oak trees, lush green pastures of grass, vast fields of wheat and corn waving in the breeze, and our beautiful flag.

At the same time, I was already beginning to feel nostalgic about the time we had spent in Libya. We came for two, possibly three years, and ended up staying nearly eleven. We would miss the people. They were childlike and emotional, had tempers you wouldn't believe, were full of life, and proud. I would miss our friends, the school, my students, Mobrouk, Gretchen and Albert, the weather, the Mediterranean, puffed up pita bread fresh out of the oven, Thanksgiving in the desert, quiet nights under the stars, exploring whole Roman cities and fortified farms by our-

selves. Our storehouse of memories was overflowing.

I would not miss the militarism, the police on every corner, arbitrary regulations, being intimidated by vigilantes, censorship, customs officials, ghiblis, power outages, the water heater that would never stay lit, scrounging for food. I would never again open my refrigerator door without marveling at the sight of milk, butter, and eggs.

Looking back, we had pretty much missed the 70s: Watergate, Spiro Agnew's disgrace, Nixon's resignation, most of the Vietnam War. Elvis died while we were gone. So did Jack Benny. We escaped the freezing winters, the so-called fuel shortage of '73, waiting in line for an hour for gas and getting to the pump just as attendants put up a sign saying, "Out of gas." We had BBC to thank for most of our news including Carter's election and the Iran hostages. We missed *Mash, The Muppets, Little House on the Prairie,* and *The Waltons,* of which we would enjoy on reruns.

The day before we left Libya, Brooks got us out of bed at 7:00 a.m., several friends from school dropped by, and we made one last round to the homes of several of our friends. I was dying to take one last swim in the Mediterranean, but I didn't have time. Finally, dear and faithful Mobrouk arrived. He ironed my dress and polished Peter's shoes, one last act of kindness. He and Peter hugged and cried like brothers. Since I was a woman, I could only shake his hand. Knowing we would never see him again made parting even more painful. I hoped Allah would bless him and his family. M'assalama, dear friend.

For years these words, written by a student from the class of 1963, stood on a polished brass plaque outside the superintendent's office at OCS.

OCS Alma Mater

We are proud to share thy honor,
Proud to bear thy name,
And we stand in awe and reverence;
Praise thee, OCS
In the midst of the sandy desert,
Beside the shining sea,
Stands a school that fills our hearts
With pleasant memories.

Lynn Birney '63.

One morning in 1979 we arrived on campus and discovered that the plaque had been removed during the night. We never found out who took it. Very likely, it ended up at Grabby Feely's.

On Saturday, June 13, 1981, we flew out of Tripoli International Airport for the last time. We presented our bags and papers to the customs authorities and went through our final exit without a hitch. *Alhamdulillah*. We would be forever grateful to this desert land that yielded us a lifetime of memories and a school that gave us friends that we treasure to this day.

In December of 1981, President Reagan asked all Americans to leave Libya. Most did. The school was restaffed by Canadians and eventually administered by Libyans. As relations between the U. S. and Libya deteriorated the school was eventually renamed, "The School of American Aggression and Libyan Martyrdom." But for those of us who were there for her glory days, the school will always remain OCS, a place that fills our hearts with pleasant memories.

Peter M. Nowell
1939–1983

Mr. Nowell was one of the few teachers in the true sense of the word that I have ever had. Not only did he teach me history, but he instilled in me a reason to care about the world around us. He made us all feel like we could and would change the world for the better, and it was our duty. Most of all, I will never forget his laugh.

Jennifer Reifel
OCS ALUMNA 1979–1980

Sources

Ambassador. Oil Companies School Yearbook, 1969–1981.

Andrews, Eleanor Froiland. Letters to Torger and Gladys Froiland, 1970–1981.

Blunsum, Terence. *Libya the Country and Its People*. London: Queen Anne Press, 1968.

Brogan, Olwen and D. J. Smith. Ghirza, *A Libyan Settlement in the Roman Period*. London: Cambridge University Press Online, 2015.

Distillers in Saudi Arabia. *The Blue Book, Perfected Techniques on the Ebullition of Sugar, Water & a Suitable Catalyst to Form an Acceptable Aramco Imbibable Potion Appropriate for Consumption/Or How to Make Good Booze.*

The Guide to Libya. Compiled by Ahmed M. Ashiurakis. Tripoli, Libya: Dar Al-Farjani, 1974.

McClendon, Dennis E. *The Lady Be Good*. Fallbrook, CA: Aero Publishers, Inc., 1962.

Oil Companies School (OCS) A Brief History. Internet Article.

Roberts, Kenneth. *Lydia Bailey*. New York: Doubleday & Company, 1947.

Todd, Mabel Loomis. *Tripoli the Mysterious*. Boston: Small, Maynard And Company, 1912.

Tully, Richard, Esq. *Letters Written During a Ten Years' Residence at the Court of Tripoli*. London: Arthur Barker Limited, 1957. First published in Great Britain, 1816.

Waldum, Mary. Diaries.

www.ocslibya.com

CPSIA information can be obtained
at www.ICGtesting.com
Printed in the USA
BVHW060301200122
626624BV00017B/2276